Leisure.

the new complete guide to
night and low-light
photography

LEE FROST

the new complete guide to

night and low-light photography

D&C
David and Charles

A DAVID & CHARLES BOOK

Copyright © David & Charles Limited 2011
David & Charles is an F+W Media, Inc. company
4700 East Galbraith Road
Cincinnati, OH 45236

First published in the UK in 2011

Text and illustrations copyright © Lee Frost 2011

A catalogue record for this book is available from the British Library.

ISBN-13: 978-0-7153-3904-6

ISBN-10: 0-7153-3904-4

Printed in China by RR Donnelley
for David & Charles
Brunel House Newton Abbot Devon

Commissioning Editor Neil Baber
Editor Verity Muir
Project Editor Cathy Joseph
Senior Designer Jodie Lystor
Production Manager Bev Richardson

David & Charles publish high quality books
on a wide range of subjects.
For more great book ideas visit: www.rubooks.co.uk

CONTENTS

INTRODUCTION

I was searching through a collection of photographs recently when it struck me that almost without exception, all my personal favourites had been taken either at dusk, dawn or somewhere in between – but never in the middle of the day.

An image from the Isle of Lewis reminded me of a trip to the Outer Hebrides last year when every day my alarm was set for 2.50am so I'd have enough time to get up, out and on location in time for the 4.15am sunrise. Another, from the same trip, took me back to a beach on Harris where I was shooting at 11.30pm and it was still twilight. While a more recent trip to Iceland could have resulted in no sleep at all because real darkness never came and shooting through the night was a certainty.

Clearly, there's no time for slumber if you want to make the most of the light. But even when the daylight does eventually disappear, sleep can wait, because there's always the urban landscape to keep you inspired, basking in the super-saturated glow of manmade illumination. You don't even need 'light' in the way we normally think of it in order to create amazing images. The night sky is full of opportunities – if you can keep your eyes open!

What makes low-light photography so fascinating is the challenge and uncertainty of it. Working in conditions where light is in short supply tests your skills and equipment to the very limit, but the images that result will repay this effort a thousand times over because, where light's concerned, it's quality that counts, not quantity. More often than not, the less there is the better.

I started shooting low-light images almost three decades ago, using an all-manual 35mm film camera and a rickety tripod. Success was rare and failure frequent,

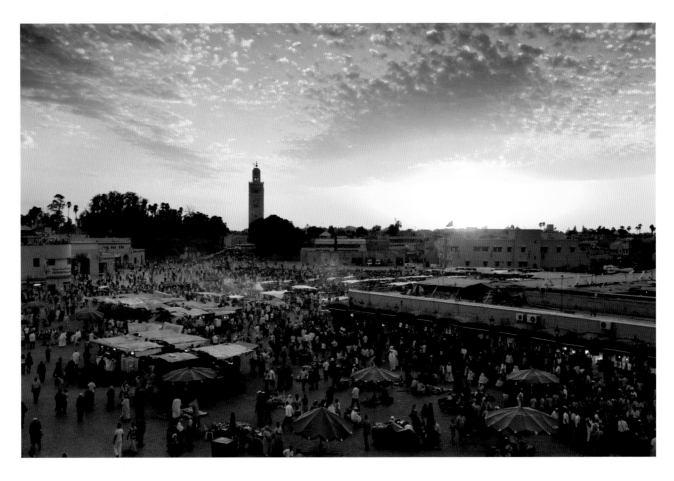

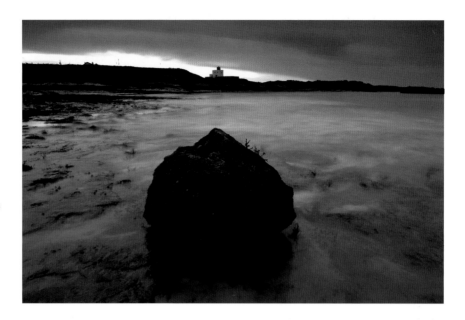

simply because technology, though advanced, still had a way to go. It's a rather different story today, in this wonderful digital age. Not only are digital cameras capable of producing perfectly exposed images in pretty much any situation, and focusing accurately in almost total darkness, but image quality at high ISOs is better than it ever was with film, which extends your low-light shooting options considerably and makes it possible to take photographs in situations that were once impossible.

Best of all, you get to see your photographs seconds after taking them. This not only allows you to check for mistakes and rectify them on the spot, but also encourages experimentation. Once you know you've got 'the shot' you can try something different – look for another subject, try a different camera angle or viewpoint, instead of over-shooting the same scene because you're not sure if you've got a perfect photograph.

I was often guilty of that, especially when working in low-light, and usually ended-up with far too many images that were similar or identical. Now I'm shooting digitally I produce a more varied range of images, which is handy in low-light situations where time is often of the essence.

The immediacy of digital imaging, and the fact that there is no longer a cost implication every time you trip the shutter, also inspires you to try new techniques and keep shooting way beyond the point you would probably have stopped with film. In both cases this can lead to surprising results and provide immense satisfaction.

In short, successful photography has never been easier – so make the most of it!

The aim of this book is to help you do just that by exploring the fascinating world of low-light and night photography and explaining, in an easy-to-understand way, how you can produce similar results yourself – no matter what your level of interest or experience is.

The initial chapters deal with equipment, detailing which type of cameras, lenses, flashguns and filters are best for low-light and night photography, and how to keep your camera steady, whether handholding or using supports, so you produce pin-sharp images every time. Next, we take a detailed look at the most important ingredient in photography: light. We explore the factors affecting its quality and quantity before moving on to exposure and metering, explaining how your camera's metering system works, understanding histograms and how to deal with tricky lighting.

Digital image processing is a vital aspect of modern photography so we will also take an in-depth look at the main issues – whether to shoot RAW or JPEG, processing RAW files, enhancing digital images, storage and back-up of your growing image collection and how to print your digital low-light images.

Finally, this information and advice is applied to a wide range of low-light subjects and techniques, from photographing towns and cities to capturing people indoors and low-light action; shooting the sky at night to painting with light. Creative digital techniques are also covered – converting your images to black and white, stitching panoramas, creating stunning HDR images, adding grain, blending exposures and more.

Illustrated with over 250 inspirational images, *The New Complete Guide to Night and Low-Light Photography* is essential reading for all creative photographers.

Lee Frost
Northumberland

EQUIPMENT

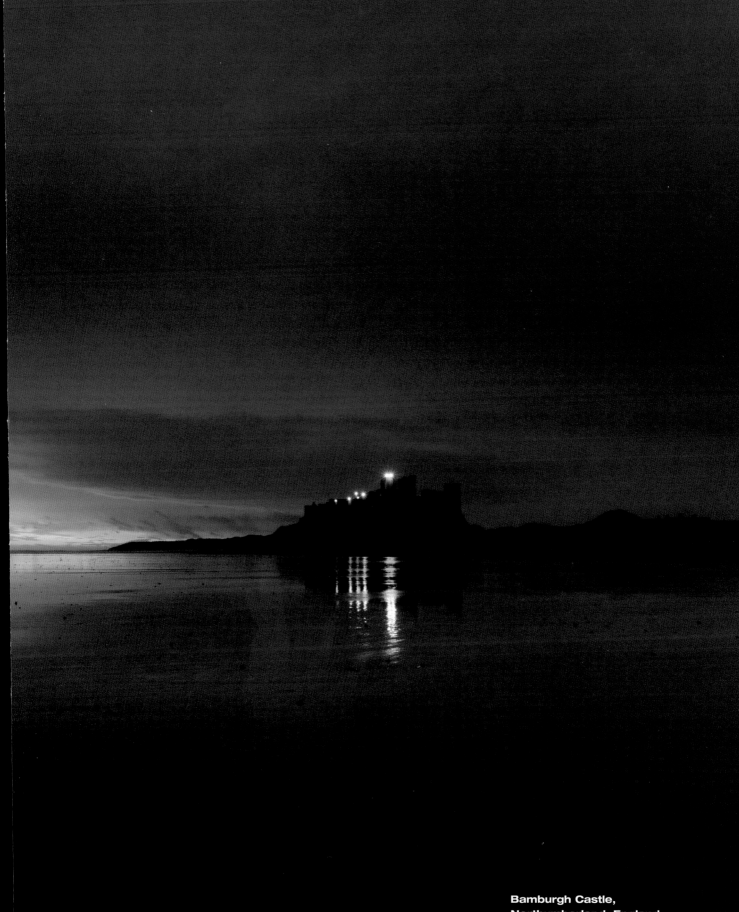

**Bamburgh Castle,
Northumberland, England**
CANON EOS 1DS MKIII WITH 16–35MM
ZOOM, 0.6ND HARD GRAD, TRIPOD, 3.2
SECONDS AT F/8, ISO100

CHOOSING A DIGITAL CAMERA

In the good old days of film, it was rare to find a serious photographer who owned just one camera. Two, three, even four wasn't uncommon because each type served a different purpose and played an important role.

The 35mm SLR (Single Lens Reflex) was the mainstay of most enthusiasts and professionals, being relatively compact and light, quick to use, bristling with the latest features and backed-up by an arsenal of lenses and accessories. But image quality from a 35mm negative or slide had its limits, so for subjects where high image quality is important – such as landscape and architecture – a medium-format or even large-format cameras would be used. Specialist panoramic cameras were also popular, while novelty 'toy' cameras such as the Holga, instant Polaroid cameras and old-fashioned pinhole cameras provided additional creative options.

I embraced them all, at one time owning and using 20 or more different cameras and loving each one for its

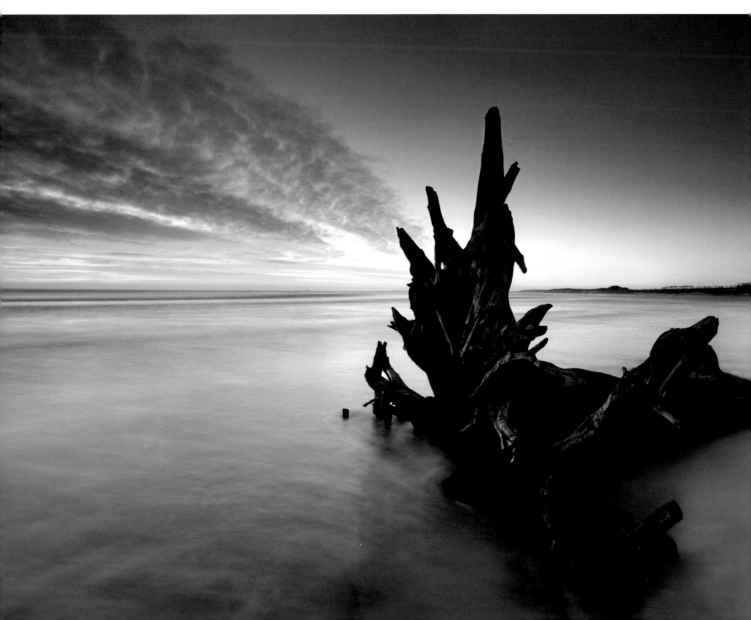

unique characteristics. However, all that has changed now. Thanks to rapid advances in digital technology, it's no longer necessary to own a cupboard full of cameras. I'd say that 98 per cent of my images are now created using a single digital SLR (the mighty Canon EOS 1DS MKIII) and the remaining two per cent are courtesy of either a digital compact or an infrared-modified digital SLR.

Has my photography suffered as a result of this dramatic reduction in my equipment? Far from it. I'd say that my images are better than ever, and I'm more inspired and exicted by photography than ever before. Thanks to the creative possibilities offered by imaging software, and the superb image quality that the latest digital SLRs are capable of, it's no longer necessary to carry a huge variety of cameras around – one size fits all.

SENSOR SIZE

Only a small number of digital SLRs in production boast a full-frame sensor, which at approximately 24×36mm is the same size as a 35mm film frame. The majority of models have a sensor that is smaller, so a magnification factor has to be applied to calculate the effective focal length of a lens when it is used on non full-frame cameras – usually 1.5× or 1.6× for DSLRs and 2× for Micro 4/3rds cameras (see page 25).

▲ Modern digital SLRs like the Canon EOS 5D MKII bring all the latest technology together in one compact body and allow you to produce successful images in pretty much any situation.

◀ **Alnmouth Beach, Northumberland, England**
Having spent so many years working with film, I was a reluctant convert to digital capture, however I very quickly realized the benefit of pixels over silver – especially in low light conditions, where I often find myself working. Modern digital SLRs seem capable of drawing more colour and detail from low-light scenes than film ever was, and the fact that I can see my images seconds after capturing them has been a revelation. I'd say my photography has improved since switching to digital.
CANON EOS 1DS MKIII, 16–35MM ZOOM, TRIPOD, 0.9ND HARD GRAD, 4 SECONDS AT F/11, ISO100

THE DIGITAL SLR

There has never been a better time to buy a digital SLR. Even the most basic entry-level models will amaze and astound you with their features and capability, while more expensive pro-sumer and pro models need to be used to be believed.

The main area of improvement is image quality. Increased pixel resolution and better performance at high ISO combine to produce images of superb quality, above anything 35mm could achieve. This technology is getting better all the time. There really is no such thing as a poor quality DSLR any more.

The main benefit of the SLR camera design for any kind of photography is that through-the-lens viewing is possible, which makes operation quick and easy. A reflex mirror inside the body bounces light passing through the lens up to a glass prism (pentaprism) housed in the top of the camera, which directs the light to the optical viewfinder, allowing you to see a realistic image of your subject with the camera to your eye.

Digital compacts differ in that they lack an internal mirror and pentaprism to keep the size and weight down. As a result, the vast majority have no optical viewfinder and instead use Live View technology, where a realtime image of what the lens is seeing is displayed on the camera's rear screen (LCD) and images are composed by looking at the screen.

There is definitely a place for digital compacts in the world of night and low-light photography (see panel, page 15) and I regularly use one myself, but in terms of versatility, control and system back-up, nothing beats the digital SLR (DSLR).

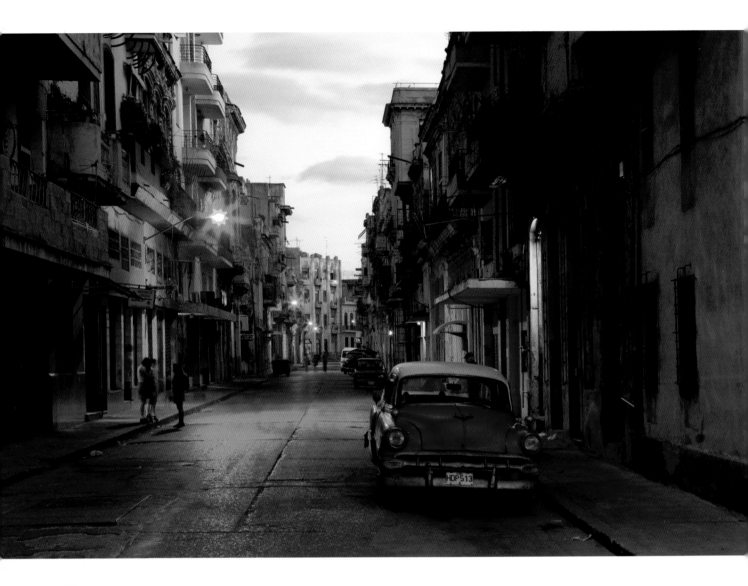

Havana, Cuba
The image quality modern digital cameras are capable of is staggering. Even a modest DSLR can match the quality of a medium-format film camera but be a fraction of the weight, while sophisticated metering means that perfect exposed images can be expected in all but the trickiest conditions.
CANON EOS 1DS MKIII, 24–70MM ZOOM, TRIPOD AND 0.6ND HARD GRAD, 6 SECONDS AT F/11, ISO200

Here's a rundown of the features you should consider when buying a digital SLR to use for low-light and night photography.

① **Pixel resolution** The number of pixels tends to be the main consideration when choosing a new camera. The greater the number, the better the image quality and the bigger you can print the images.

Digital images are normally printed at an output resolution of at least 240dpi (dots per inch), so the maximum print size you can achieve is based largely on how many pixels its sensor contains. A 16x12in print made to a resolution of 240dpi will contain around 11 million pixels – 16x240 x 12x240 = 11059200 – which means that an 11Mp will be capable of producing high quality prints up to 16x12in. As the biggest inkjet printer used by the majority of enthusiast photographers is A3+, with a maximum print size of 13x19in, a digital SLR with 10–12Mp will be more than adequate. It is possible to print to sizes much bigger than the 'maximum' output size of the images from your DSLR, so a 10Mp camera would still work, even printing to 16x20in or more.

It is tempting to buy the most expensive DSLR you can afford, but in reality you're better off sticking to a 10–12Mp model and using the remaining budget to buy top quality lenses as they will help you to make the most of your DSLR's pixel resolution.

② **Exposure modes** When you take a photograph, there are two variables at your disposal that allow you to precisely control how much light reaches the camera's sensor to ensure a correctly exposed image is recorded – the aperture and shutter speed.

We'll look at these more closely in the chapter on metering and exposure (see page 74), but the way in which the aperture and shutter speed are set, and the amount of control you have over them, is governed by the exposure mode your camera is set to.

Program mode is a fully automatic mode where the camera sets both the aperture and shutter speed automatically. The choice is made at random, without taking into account the subject or lighting, so it won't always be suitable – the camera may set a wide aperture when you want a small one, for example, or a slow shutter speed when you need a fast one.

To override this, change the aperture and shutter speed combination set to suit each situation. Program is a quick and easy mode to use, but for night and low-light photography, where you need a greater degree of control over the camera's exposure setting, it's too automated.

Aperture Priority (Av) is, I think, the most versatile exposure mode for night and low-light photography as you decide which lens aperture (f/number) to select and the camera automatically sets the shutter speed/exposure time to give correct exposure.

By choosing the lens aperture you have control over depth-of-field. If you need lots of it to ensure that a scene is recorded in sharp focus from front-to-back, you set the lens to a small aperture such as f/16 or f/22, while if you want to reduce depth-of-field so only a limited area comes out sharply focused you can set the lens to a wide aperture such as f/4 or f/2.8.

As you do this the camera automatically adjusts the shutter speed to correspond with the aperture you've selected, so if you switch from a wide aperture to a small aperture, the camera will select a slower shutter speed, and vice-versa. This is convenient because if you need to use the slowest shutter speed possible in any situation, all you have to do is set your lens to its smallest aperture – a tip you will

encounter throughout this book.

Equally, if light levels change unexpectedly the camera will adjust the shutter speed automatically to maintain 'correct' exposure – providing the required speed doesn't fall outside the range offered by the camera, which can happen in low-light. Aperture Priority is also an ideal mode to use with electronic flash for techniques such as slow-sync or fill-in. That's because it's the lens aperture which governs correct flash exposure, not the shutter speed, so being able to control the aperture your lens is set to is important (see the chapter on low-light action).

Shutter Priority (Tv) is a semi-automatic mode like Aperture Priority, but in this mode you decide which shutter speed to set and the camera automatically selects a suitable lens aperture to maintain correct exposure. It tends to be favoured in situations where you need to control subject movement by setting a specific shutter speed – be it a fast shutter speed to freeze fast-moving action, or a slow shutter speed to record movement.

For night and low-light photography Shutter Priority has its uses – you could set an exposure of 30 seconds when photographing traffic trails, for example and let the camera decide which aperture to select. However, generally it's more useful if you have control over which aperture is set and the camera is left to sort out the required shutter speed.

Metered manual requires you to set both the aperture and shutter speed using the control wheels/dials on your camera. An indicator in the viewfinder tells you when the combination you have chosen will give correct exposure and if not, how far

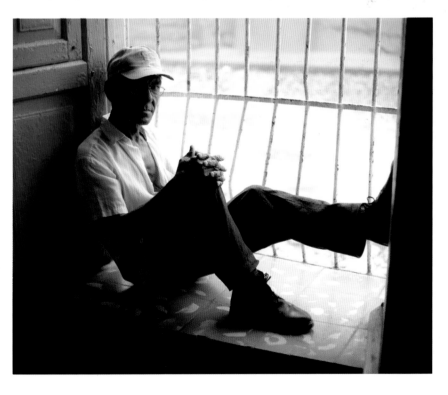

Trinidad, Cuba ▷
The exposure compensation facility is one of the most useful features found on digital cameras as it allows you to override the integral metering system to prevent exposure error. In this shot the man would have been badly underexposed due to the brightness of the background, but I predicted this, set exposure compensation to +1 1/3 stops and a perfect exposure resulted.
CANON EOS 1DS MKIII, 50MM F/1.8 PRIME LENS,
1/320SEC AT F/2.0, ISO400

over or under you are. Although slower to use than all the other exposure modes, Manual does have its uses. Once the aperture and shutter speed are set, for example, neither will change unless you change them, so the exposure remains the same even if light levels fluctuate or you change the camera's position. This is useful for some low-light subjects, such as traffic trails or fairground rides, where the bright lights moving in the scene could fool automatic exposure modes and give a false meter reading.

Subject-based modes In addition to the selection of exposure modes outlined above, it's also common for DSLRs to offer a range of specialist subject-based modes. When selected, they set certain camera features, in addition to the aperture and shutter speed, to suit specific subjects such as landscapes, portraits, sport and so on. For low-light and night photography the only one of these modes that's likely to be of use is Night Portrait, where the camera combines a burst of flash from the built-in flashgun with a slow shutter speed so you can photograph a person at night in front of a floodlit building. However, this is an easy enough job to do without the aid of a special exposure mode!

In summary, the two most useful exposure modes for low-light and night photography are Aperture Priority and, on the odd occasion, Manual when you need the exposure to remain fixed.

◢ Bar El Floridita, Havana, Cuba
The stunning high ISO performance of the latest generation of digital SLRs makes it possible to take high quality photographs in situations where it would have been impossible a few years ago. This image required me to take everything to the limit – lens aperture, ISO and handheld shutter speed. A tripod was out of the question, and had I been shooting film I probably wouldn't have even bothered to get my camera out.
CANON EOS 1DS MKIII, 50MM F/1.8 PRIME LENS, 1/25SEC AT F/1.8, ISO3200

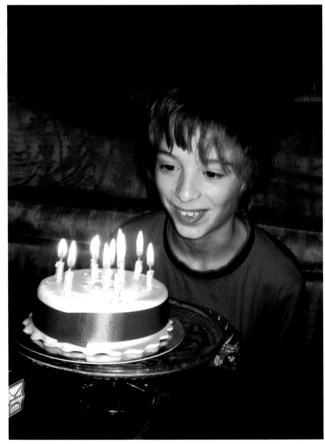

I always keep a digital compact camera handy ▷ to capture special family events such as birthdays. A candlelit shot like this would have involved a lot of effort had I been shooting film, but for a modern digital compact it's child's play – point, focus, shoot. Now who's for cake?
SONY CYBERSHOT 6MP COMPACT, 1/30SEC AT F/2.8, ISO400

THE DIGITAL COMPACT

Although a digital SLR is the ultimate camera for low-light photography, thanks to the level of control it puts in your hands, don't dismiss compact cameras altogether. The latest breed of digital compacts are fantastic and come armed with lots of useful features for low-light shooting incluing a wide shutter speed range, excellent high ISO performance, image stabilization, a powerful zoom, large, bright LCD monitor, the ability to shoot in RAW format in some cases and a choice of exposure modes. Compact cameras are no longer designed just to point-and-shoot – they boast all the latest technology and are capable of amazing results. Plus they offer the added benefit of being small, light and discreet so you can carry one everywhere you go and use it to take shots in situation where an SLR would be unsuitable.

The pixel resolution of digital compacts seems to be going up and up – some models boast 14Mp today and 10–12Mp is common. What you need to remember is that the sensor in a digital compact is far smaller than the sensor in an SLR so the pixels in a compact are smaller. Image quality, therefore, will never be as good in a compact as an SLR with the same pixel count. That said, you'll still be amazed by the quality a 10–12Mp compact camera is capable of.

If you're thinking of buying a compact camera for low-light photography, check to make sure it has...

• A tripod socket on the base so you can attach it to a tripod as and when required.
• A facility to plug in an electronic remote release or use an infrared remote release to trip the shutter without touching the camera (see page 50).
• A B (bulb) setting. Not many compacts have this, but it makes them much more versatile in low light.

I've compromised on size a little and my choice of 'small' digital camera is the fantastic Panasonic Lumix GF1. Instead of being a compact, it's a Micro 4/3rds camera with a sensor half the size of a digital SLR. This means it's not quite as pocketable as a true compact camera, but it satisfies all the criteria mentioned above, takes interchangeable lenses including a super-fast 20mm f/1.7 (equivalent to 40mm in full-frame terms) and produces stunning images.

The LCD monitor is the heart of any digital camera, not only displaying menus and settings but also allowing you to preview the images you've taken to check exposure and composition.

The Canon Powershot SX 210IS is one of the latest generation of digital compacts and comes with every handy feature you could ever want from a small camera – including a zoom with an effective focal length of 28–392mm!

Though not as small as a true digital compact, Micro 4/3rds cameras like the Panasonic Lumix DMC GF1 offer the versatility of an SLR in a much smaller package.

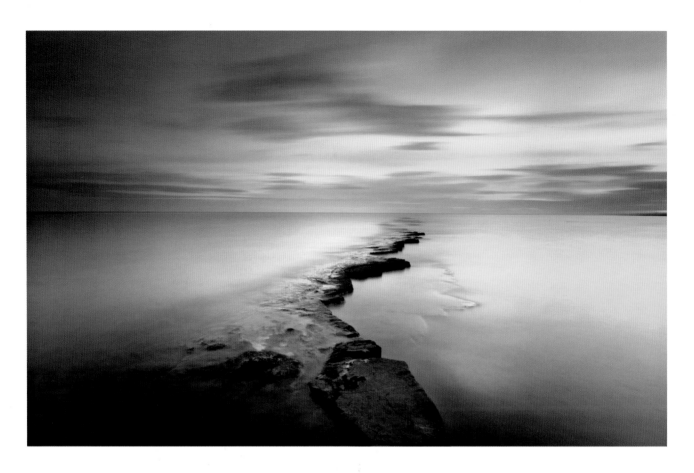

◤ Kimmeridge Bay, Dorset, England

When light levels drop beyond a certain point you'll have no choice but to use your camera's bulb facility to make exposures beyond the range offered by your camera – usually a maximum of 30 seconds. For this dusk scene I needed to make an exposure of two minutes, so the camera's shutter was locked open using a remote release and I timed the exposure using the count-up timer on my camera's top plate LCD.

CANON EOS 1DS MKIII, 17–40MM ZOOM, TRIPOD, 0.6ND HARD GRAD, 2 MINUTES AT F/8, ISO100

③ **Metering patterns** Metering patterns control the way in which light levels are measured to determine correct exposure. There are three main metering patterns – multi-zone/multi-pattern metering, which is the most sophisticated pattern found in DSLRs; centre-weighted, which is a traditional pattern; and spot metering, which is a specialist option that allows you to take a meter reading from a very specific part of a scene. For the benefit of camera choice, however, it's worth saying that multi-zone metering is by far the best pattern for general use – that, Aperture Priority and exposure compensation (see below) will guarantee perfectly exposed images in any situation.

④ **Shutter speed range** By its very nature, night and low-light photography involves working with lengthy exposures, so when looking at the shutter speed range a camera offers it's the slower

end that counts rather than the top end. It's unlikely that you'll ever take a low-light shot in available light at a shutter speed faster than 1/30 or 1/15sec, and more commonly you'll be using exposures of a second or more. Digital SLRs offer a shutter speed range down to 30 seconds or more. This will be adequate most of the time, but as your low-light shoots become more ambitious you'll find yourself using exposures that go into minutes, even hours, in which case you will definitely need a…

⑤ **Bulb (B) facility** With your camera set to B (bulb), you can hold the shutter open for as long as you need to and as soon as you release the shutter the exposure ends. The beauty of the B setting is it opens up a whole new world of long exposure photography. For subjects such as aerial firework displays and traffic trails it's invaluable. The same applies with creative techniques such as painting with light or open flash, which we'll explore in later chapters, and for photographing the sky at night, where exposures of several hours are usually required to capture star trails.

If you scroll through the shutter speed range you'll usually see a letter B at the very end. Failing that, B will be marked on the exposure mode dial or accessed via the camera's mode buttons.

⑥ **Cable release socket** When you're using long exposures (especially via the bulb setting) a remote release allows you to

trigger the camera's shutter without having to touch it. This is useful because, no matter how steady you think your hand is, even the act of pressing a finger down on the camera's shutter release button when the camera is on a tripod can be enough to cause vibrations that lead to unsharp pictures – especially if you're shooting on bulb and need to keep the shutter release depressed for the entire exposure. I'm not aware of any DSLRs that lack a remote release socket, but you may need to hunt around to find it; its often hiding behind a rubber cover on the side of the camera body.

⑦ **ISO range** A great benefit of digital SLRs is that you can adjust the ISO setting of the sensor as and when you like, so that pictures can be taken in a wide range of lighting. One minute you can be outdoors shooting with the camera on a tripod at ISO 100 for optimum image quality, the next inside a dimly lit room shooting handheld with the ISO set to 1600, 3200 or above to maintain a decent shutter speed. It's common for DSLRs to have a maximum ISO of 3200 these days, but some go as high as ISO 12800 and the Nikon D3s has a staggering ISO range from 100–102400!

The higher you set the ISO, the 'grainier' the images appear and the more image quality tails off. The grain effect in digital images is caused by a phenomenon known as 'noise', which is basically electrical interference in the sensor. Fortunately, noise control at high ISOs is one area where the latest DSLRs have improved, so while shooting at ISO 400 or above was to be avoided a few years ago, today you can shoot at ISO 1600 or 3200 and image quality will still be very high. Higher ISOs should be used sparingly – a tripod is a better solution than increasing the ISO in low light – but if you have no choice except to hike up the ISO, then do it – digital SLRs now make it possible to take successful photographs

in situations where film photographers would have been forced to pack-up and call in a day.

⑧ **Exposure compensation facility** All DSLRs have an exposure compensation facility. It allows you to override the metering system when shooting in Program, Aperture Priority or Shutter Priority modes to correct exposure error or bias the exposure to suit a particular situation. The extent to which you can do this depends on your camera, though it's usually +/-3 stops in 1/3 stop increments. The way the exposure is adjusted depends on the exposure mode set. In Aperture Priority mode, it's the shutter speed that's increased or reduced so the aperture remains constant, whereas in shutter priority mode the aperture setting is adjusted so the shutter speed doesn't change.

I use exposure compensation all the time when shooting in low-light. My usual approach is to set up a shot, make an exposure in Aperture Priority mode using multi-pattern metering (Evaluative on Canon cameras), check the preview image and the histogram (see page 84), then use the exposure compensation facility to increase or reduce the exposure if required. It's an invaluable but often under-used camera feature.

⑨ **Mirror Lock** All SLRs have a reflex mirror inside the body which is angled to bounced light entering the lens up to the pentaprism and on to the optical viewfinder so you can see can see your subject, compose the shot and focus. When you trip the shutter release, the mirror flips up to a vertical position so the light it had been reflecting can reach the sensor to expose the image.

When the camera's mounted on a tripod and you're using slow shutter speeds – normal practise in low light – the 'slap' of the

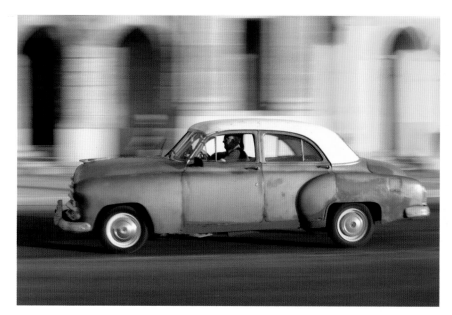

◀ **The Malecon, Havana, Cuba**
The autofocusing systems in digital SLRs are fantastic. I'm no action photographer, but for shots like this I simply set my camera to Servo AF and I know that, providing I keep the AF target over the subject, the autofocusing will continually adjust to keep it in sharp focus so all I have to do is fire away.
CANON EOS 1DS MKIII, 70–200MM ZOOM, 1/30SEC AT F/11, ISO100

ON THE PHONE

Though it may sound ridiculous, the digital camera inside your mobile phone can be used to take surprisingly good photographs. It's not something you're likely to use on a regular basis for serious photography, but on the odd occasion when a photo opportunity presents itself and you're without your camera, don't hesitate to use it. Though the sensor inside your phone camera is tiny, even by compact camera standards, resolution will probably be quite high – up to 10Mp – and the images captured will be better than you expected. Phone camera images also have a unique look that can add to their appeal, so you may decide to use it for this reason. Try more creative shots – low-light portraits in bars and clubs, blurred abstracts on the streets at night, reflections in puddles and cars after rain – you could even work on a whole series of low-light shots with your phone camera.

As I always carry my iPhone with me, its camera is often used to take photographs, and though image quality isn't great, it's better than nothing!

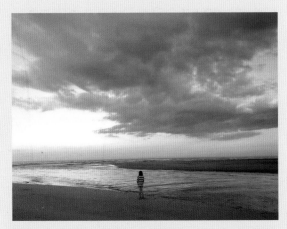

▲ **Alnmouth, Northumberland, England**
Mobile phone cameras are surprisingly good these days. I took this low-light shot during a walk on the beach with my daughter and it's now displayed in a frame in my home. The image size is only around 5x7in @ 300dpi, but that's big enough to print.

mirror as it flips up can cause vibrations that lead to camera shake. SLRs have a mirror lock facility to avoid this problem. Once you're ready to take the shot you can activate the mirror lock so the reflex mirror flips up, wait a few seconds for any vibrations to dissipate, then trip then shutter to take the picture.

On traditional film SLRs, the mirror lock was usually activated by pressing a button or moving a lever on the camera body. In digital SLRs it's an electronic feature that's usually buried deep in the menus, making it more of a hassle to access and use. Once selected, the first press of the shutter release causes the mirror to flip up, the second press takes the photograph.

In most cases you have to cancel the mirror lock, otherwise it kicks in every time you take a shot – annoying when you take the camera off the tripod to shoot handheld, press the shutter release to take a photograph, only to find that the mirror locks up instead and the viewfinder goes black! I've been caught out many times!

Setting the mirror lock as a custom function is your best bet, so it's easier to access without wading through the camera's menus. It's worth doing this and getting into the habit of using the mirror lock as it will help you achieve optimum image sharpness.

⑩ **Self timer** All SLRs have one, and though it's mainly used to delay the tripping of the shutter so you can include yourself in a photograph, it also comes in handy if you forget, lose or break your remote release. By setting the self timer, the delay between pressing the shutter release to take a shot and the shutter opening to make the exposure is long enough for any vibrations to settle down so camera shake is eliminated.

⑪ **White Balance** One of the great benefits of shooting low-light images with a digital camera is that the white balance (colour temperature) of the sensor can be adjusted to correct the colour cast created by different types of lighting. If you're shooting in tungsten light, for example, you can set white balance to Tungsten and the warm yellow/orange cast you'd expect to get on every image is remarkably absent, because the camera corrects it. All digital cameras also have a Fluorescent preset in the white balance menu, to get rid of the ugly green cast you normally get when shooting in fluorescent light.

In the days of film, special filters had to be used to balance these colour casts – a blue 80-series for tungsten and an FLD for fluorescent. Tungsten-balanced film is still available to produce natural results in tungsten light without the need for filters.

⑫ **LCD monitor** The heart of any digital SLR is the LCD preview screen because it not only allows you to check an image seconds after capturing it, but also to analyze the histogram and access

menus to change the camera setting and custom functions. Generally, the bigger the screen the better – especially when it comes to previewing images. The latest digital SLRs usually boast a 3-inch screen, which is ideal. Don't rely on the screen too much to assess correct exposure – the histogram is a more reliable guide.

⑬ **Live view** An increasing number of digital SLRs now have a live view feature where, at the press of a button, you get a real-time view of your subject on the rear LCD monitor. This is exactly how digital compact cameras work, but because SLRs have an optical viewfinder with through-the-lens viewing, they don't necessarily need live view.

Though it was first dismissed as gimmicky by some, more photographers are realizing the benefits of live view. It's handy for checking composition and critical focus, and the accurate alignment of ND grad filters. In low light, live view may also give you a better view of your subject than the camera's viewfinder as it's very sensitive – in some cases sensitive enough to produce an image on the LCD monitor even when you have a neutral density filter on the lens that's so dense you can't actually see through it with the naked eye (see page 35).

⑭ **Focusing** Modern autofocusing is amazing – not only quick and accurate, but able to operate reliably in almost pitch darkness so no matter how low the light levels are, you can be sure of a sharply focused image. This is made possible by infrared focus aids, which shine a beam of invisible light on the target subject so that the lens can see it and focus on it. Digital SLRs also have very sophisticated focusing systems that are far more sensitive than earlier cameras and have an array of sensors across the frame that help to ensure sharp focus is achieved – though I find that working with a single, central AF target is just as effective and makes me feel I'm more in control of what the camera's focusing on.

If the AF struggles at all, you can switch to manual focus. This was always a reluctant alternative in the early days of autofocus because lenses tended to have very sloppy manual focus rings. However, they're much better now and I actually use manual focus more often than autofocus, simply because it's what I'm used to.

⑮ **Image stabilization** A more recent innovation in digital camera design is the provision of a stabilization system in the camera, or certain lenses that allow you to handhold the camera at much slower shutter speeds without having to worry about camera shake. This, combined with improved high ISO performance and fast lenses, means that you can shoot handheld in more extreme lighting conditions than ever before and produce high quality images.

Canon was the first to introduce image stabilization for SLR users – specific lenses with 'IS' in the title use a system of motors to reduce the effects of camera shake and provide a shutter speed benefit of several stops. I use a Canon 70–200mm f/4 IS USM zoom and can say from personal experience that it works. Nikon have a similar system known as VR (Vibration Reduction).

⑯ **Integral flash** Many digital SLRs aimed at the consumer market have a small flash unit built into the pentaprism, which works in conjunction with the metering system to give perfectly exposed results. They're handy for snapshots or for fill-in flash outdoors, but the power output is quite low so they only work on subjects that are relatively close to the camera. This is a useful feature to have but it is not essential.

⑰ **File formats** The most common file formats for digital images are RAW and JPEG. RAW is favoured because it is a pure, uncompressed format that contains all data recorded by the sensor – rather like a film negative. JPEG is a compressed format so the file sizes are smaller and you can record more images on a memory card but some data is lost in compression. All digital SLRs allow you to use either file format, and an increasing number let you record each image in both RAW and JPEG.

⑱ **Integral sensor cleaning** The latest trend in digital SLR design is for cameras to have a vibrating sensor so that dust can be shaken off. Opinions vary on how well these systems work though, and even the best will at some point require a proper sensor clean using anti-static brushes or swabs (see page 53).

⑲ **Batteries** Digital cameras are far more battery-dependent than film cameras ever were and although the capacity of modern batteries is good, allowing you to shoot hundreds of images between charges, it's important to carry at least one spare when shooting in low-light. Long exposures, especially bulb exposures, drain batteries faster than normal shooting, while low temperatures, which are often encountered at night, only add to the problem, so, you can find that a fully charged battery is soon dead.

⑳ **Handling** One important factor that tends to be overlooked in favour of fancy features is the way a camera handles – how it feels in your hands, how accessible the controls are and how easy it is to use. Remember, once you buy a new camera you are likely to own it for years, so don't forget to pick it up and try it out before making a commitment. This is especially important with the more expensive pro-spec digital SLRs, which can be surprisingly big and heavy. You're also going to have to carry it, as well as hold it!

LENSES FOR LOW-LIGHT

The lenses you use for night and low-light photography will depend very much on the subject you're photographing or the effect you're trying to achieve, but suffice to say there are no specialist requirements. The range of lenses you already possess will probably be more than adequate – all but a few of the images in this book were shot with focal lengths between 17mm and 200mm. These lenses are also a mixture of primes and zooms, camera maker's own and independent, which illustrates, if nothing else, that in capable hands any make or type of lens can be used to produce great low-light photographs. This chapter explores the available options.

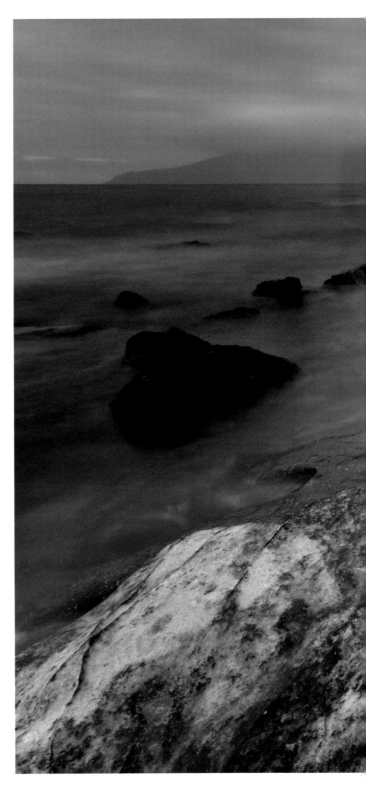

PRIME OR ZOOM?

The debate about whether prime (fixed focal length) lenses are better than zooms has raged for years, and will no doubt continue to do so. In reality, optical technology has reached such levels today that you can rarely see an obvious difference in quality between the two, unless you compare a bargain-basement zoom lens with a top-of-the-range prime lens, and even then the difference is unlikely to be staggering unless you make huge prints from the images and conduct a critical assessment, which is not the way to enjoy a photograph.

So, the decision to use one or the other should be based on your own needs and preferences, and the budget at your disposal, rather than the opinions of a bunch of stubborn photographers who refuse to move with the times.

In the last decade, many professional photographers have made the switch to zoom lenses after years working exclusively with prime lenses, and few have anything to complain about.

Until 2008, when I made the switch from film to digital capture, I used mainly prime Nikkor lenses – 20mm, 28mm, 50mm, 105mm macro – and possessed only one zoom, an 80–200mm. These days, I favour zooms and use 17–40mm, 24–70mm and 70–200mm, all from Canon, on my full-frame EOS 1DS MKIII, plus a Sigma 10–20mm zoom on a non full-frame Canon EOS 20D that has been modified for infrared.

Laig Bay, Isle of Eigg, Scotland
Although I carry lenses covering focal lengths from 17–200mm, the majority of the photographs I take are shot at wide-angle focal lengths of 28mm or less. I've always been a big fan of the wide-angle view – big, bold and dramatic. Being able to capture foreground interest gives the composition a strong sense of depth and perspective. Wide-angle lenses exaggerate this effect more than any other lens type.
CANON EOS 1DS MKIII, 16-35MM ZOOM, 0.6ND HARD GRAD, TRIPOD, 15 SECONDS AT F/22, ISO 100

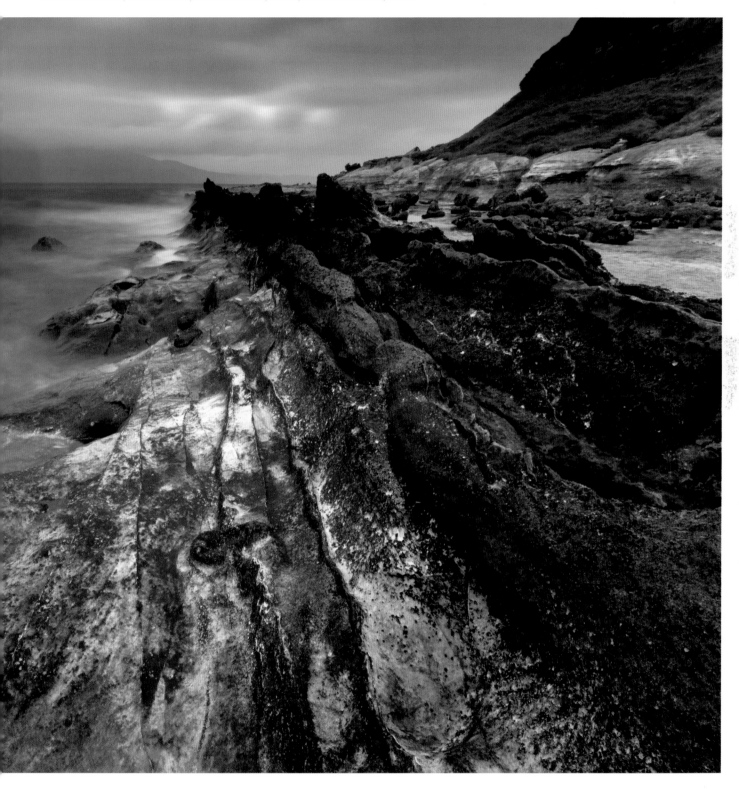

These are the three zooms that form the basis of my lens collection – a Canon EF 17–40mm f/4 L USM, Canon EF 24–70mm f/2.8 L USM and Canon EF 70–200mm f/4 L IS USM. Being zooms they are not without their flaws, especially the 17–40mm, which suffers from vignetting and loss of sharpness in the image corners when stopped right down. But these are minor niggles that can be dealt with and overall I'm more than happy with the image quality.

I still use prime lenses in some situations – a 50mm f/1.8, for reasons outlined below, and a Zeiss 21mm f/2.8 Distagon, which is the sharpest lens I have ever owned and has become my 'standard' for landscape photography. However, I'm more than happy with the zooms and use them for perhaps 95 per cent of my photographs.

If you look at things from a point-of-view of convenience, zooms win hands down because one zoom does the job of several prime lenses, which means less equipment to carry, less frequent lens changes and less chance of dust getting on the camera's sensor (see page 53). Zooms also allow you to make tiny adjustments to focal length so you can crop out unwanted detail and fine-tune your compositions.

The downside of zooms is that they're usually bigger and heavier than prime lenses, particularly at the wider end of the focal length range. A 28mm wide-angle is going to be smaller and lighter than a 28–80mm zoom, for example, so it will be easier to handhold at slow shutter speeds without the risk of camera shake.

Prime lenses also tend to be 'faster' than zooms. The average maximum aperture for a 28mm wide-angle lens is f/2.8, whereas it's going to be f/3.5–f/4.5 for a 28–80mm zoom, unless you pay

more for a faster zoom. Most of the time this isn't an issue, but when taking handheld shots in low light, a faster lens will allow you to use faster shutter speeds and provide a brighter viewfinder image to make composition easier.

In terms of sharpness, prime lenses do tend to have the edge over zooms simply because less glass is used in their construction. The reason why Zeiss has launched a new range of manual focus prime lenses aimed directly at users of high-end digital SLRs is in recognition of the fact that many zooms show their weaknesses when used on such cameras. However, when you compare cost and quality with convenience, the scales still tip in favour of zooms, which is why the majority of photographers use them so much – myself included.

QUALITY COUNTS

Whether you invest in prime lenses or zooms, an important fact to be aware of is that in this digital age, lens quality is more important than ever. The high-resolution sensors in the latest generation of digital SLRs are so good that they can easily out-resolve the lenses you fit to them, so any flaws in optical design will be highlighted.

These problems are at their worst in ultra wide-angle zooms, where chromatic aberration, diffraction, vignetting, barrel distortion and loss of sharpness at the image corners are all common problems – and the less you pay for the lens, the more it's likely to suffer; though not in all cases. Telezoom lenses tend to suffer less from all of the above because their optical design isn't as extreme, but they don't escape completely and the more pixels your camera has, the more your images will highlight any problems.

Barrel or pincushion distortion is easy to correct using the Lens Correction filter in Adobe Photoshop – a simple slider lets you eliminate it, with the aid of a grid to check that the straight lines are indeed straight. I often use this tool on images shot at extreme wide-angle as distortion is a common problem.

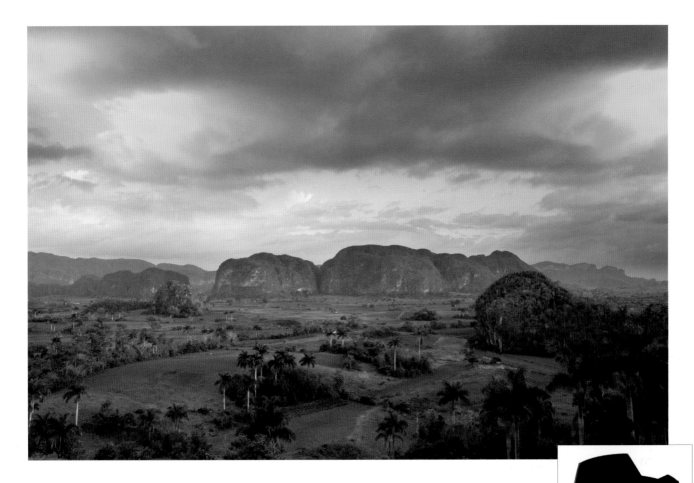

Optical flaws can be corrected, to an extent, in Photoshop – chromatic aberration and vignetting during RAW file processing using the Lens Correction tool in Adobe Camera Raw and distortion, whether barrel or pincushion, using the Lens Correction option under the Filter menu (Filters>Distort>Lens Correction). There are also third-party applications available that are designed specifically to correct lens flaws, though I've found the Photoshop options to be adequate.

Of course, it's preferable if these flaws don't exist in the first place, or are at least minimized, and the only way to ensure that is by buying the best lenses you can afford. So, if you have a budget available to equip yourself with a camera kit, don't blow most of it on the camera then settle for cheapest lenses in the range. It's a known fact that top quality lenses on a modest DSLR is preferable to cheap lenses on a top-flight body.

Don't necessarily take the price tag of a lens as the only indicator of quality as certain lenses from certain manufacturers have reputations, both good and bad. Instead, read reviews in photography magazines and online, ask the opinion of other photographers and test the lenses before buying – take your DSLR along to the dealer, put the lens on it and take some test shots. It's even worth testing two or three identical lenses and noting the serial numbers because when you check the test shots you may

◤ **Vinales Valley, Pinar Del Rio, Cuba**
If you want the ultimate in image quality, you have to pay for it! Prime lenses will always have the optical edge over zooms and the latest range of Zeiss manual focus prime lenses are the best in the world. Not only are they razor sharp, but colours just seem to leap out at you. The Zeiss 21mm f/2.8 Distagon used to shoot this scene is the sharpest lens I have ever used and even when printed to 20x30in, the images taken with it look stunning.
CANON EOS 1DS MKIII, ZEISS 21MM F/2.8 DISTAGON, 0.6 ND HARD GRAD, TRIPOD, 1/8SEC AT F/9, ISO100

find that one is better than the others. Despite advances in optical technology, it's a well known fact that with some zoom lenses, image quality can vary by quite a margin – get a good one and you'll love it, get a bad one and you'll be chewing your pillow. I've been there.

Finally, if you want to get the best optical performance out of any lens, a mid-range aperture of f/8 or f/11 is your best bet. Image quality is at its lowest at the widest and smallest apertures, especially with wide-angle zooms.

◀ Lenses like this Sigma 10–20mm zoom allow users of non full-frame digital SLRs to enjoy proper wide-angle photography. Its effective focal length range on the Canon EOS 20D shown is 16–32mm.

Magnification factors

The vast majority of lenses available for use on your digital SLR were designed for 35mm film SLRs or full-frame digital SLRs that have a sensor the same size as a 35mm film frame (24×36mm). However, only a handful of digital SLRs at present actually have a full-frame sensor (Canon EOS 1DS MKIII and 5D MKII, Nikon D3× and D700, Sony A900 and A850).

The majority of digital SLRs use a sensor that's smaller than full-frame 35mm. This means that the focal length of the lens you use on those cameras is effectively increased. The amount of increase can be calculated using a magnification factor (MF) and this is governed by the size of the sensor in the camera. Most digital SLRs have an MF of 1.5×, though for Canon DSLRs it's 1.6×.

A conversion chart (right) shows the effective focal length when lenses are used on digital SLRs with sensors smaller than full-frame.

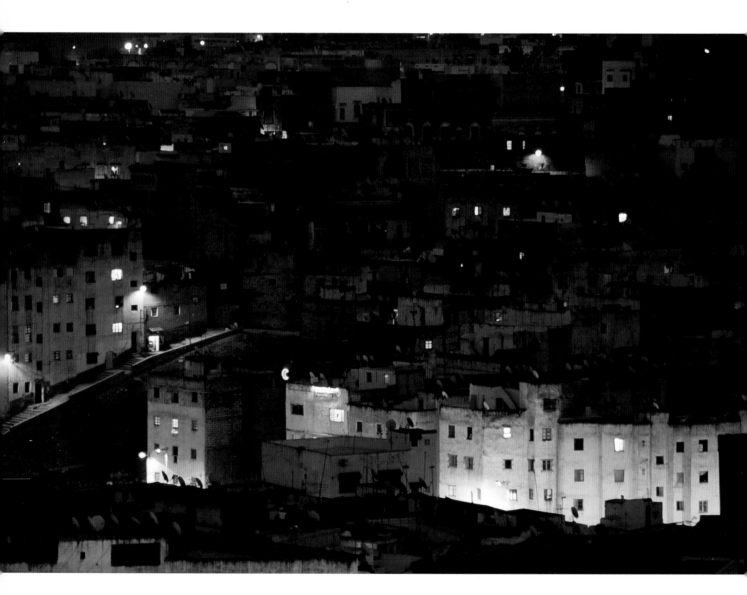

Full frame	MF 1.5x	MF1.6x
10mm	15mm	16mm
12mm	18mm	19mm
17mm	25mm	27mm
20mm	30mm	32mm
24mm	36mm	38mm
28mm	42mm	45mm
35mm	52mm	56mm
50mm	75mm	80mm
70mm	105mm	112mm
100mm	150mm	160mm
135mm	200mm	216mm
200mm	300mm	320mm
300mm	450mm	480mm
400mm	600mm	640mm
500mm	750mm	800mm
600mm	900mm	960mm

Depending on the subjects you shoot, these magnification factors can be a blessing or a curse!

For landscape photographers they're not so welcome because the MF increases focal length, so even wider lenses are required. Therefore the lenses you perhaps already owned when you switched from film to digital may not be wide enough. For example, an ultra-wide 17–40mm zoom will effectively work like a 25–60mm standard zoom on a digital SLR with a MF of 1.5x. To get the same effect as a 17–40mm zoom you would therefore need something like a 10–20mm or 12–24mm zoom.

For sport, nature and other subjects requiring telephoto lenses, the focal length increase is more beneficial because it makes modest lenses more powerful. A 70–300mm zoom effectively becomes a 105–450mm zoom on a digital SLR with a MF of 1.5x, for example.

Another factor to consider is that lenses are at their sharpest in the centre and at their softest towards the edges. Cameras with non full-frame sensors therefore get the best from full-frame lenses as they use the sharper central area of its image circle and don't see the outer limits of the image circle where image quality is lower.

The Medina, Fez, Morocco

Telezoom lenses are ideal for homing-in on part of a low-light scene and filling the frame with details and colour. This approach works well when shooting from a high viewpoint and looking down on a town or city. There's an amazing amount of interest concentrated in this single frame, but in a wider view it would have been lost. The way telephoto lenses compress perspective also adds to the drama. CANON EOS 1DS MKIII, 70–200MM ZOOM, TRIPOD, 10 SECONDS AT F/8, ISO100

LENSES FOR DIGITAL SLRS

An increasing number of lenses are now being manufactured specifically for digital SLRs, using a telecentric design, which allows light to hit the sensor inside the camera at an angle very close to 90°. In doing so it gives optimum image quality.

Some ultra wide-angle lenses and ultra wide-angle zooms are also designed specifically for digital SLRs that don't have a full-frame sensor. They utilize a smaller 'image circle', which is not big enough to cover the full area of a 24×36mm sensor so if you use them on a full-frame digital SLR, vignetting will occur. It isn't always obvious that a lens is designed for smaller sensors, you should always check before buying. Also, the focal length will still be stated in full-frame/35mm terms so a MF still has to be applied. The Sigma 10–20mm zoom I use on my infrared-modified Canon EOS 20D, for example, has an effective focal length range of 16–32mm as Canon DSLRs have a MF of 1.6. It's also not compatible with full-frame DSLRs, so if I fit it to my Canon EOS 1DS MKIII I see a circular image through the viewfinder.

LENS SPEED – IS IT IMPORTANT?

Lenses are often referred to not only in terms of their focal length, but also their speed. You may come across the phrase 'fast' telephoto, or 'slow' zoom. This refers to the maximum aperture of the lens in relation to its focal length – if it's wide, then the lens is 'fast' because it has greater light-gathering power than a lens of the same focal length with a smaller maximum aperture. A 'slow' lens has a smaller-than-average maximum aperture for its focal length.

To give you a few examples, a 50mm standard lens normally has a maximum aperture of f/1.8 or f/2, which itself is fast, but an f/1.4 or f/1.2 model is considered to be a fast standard lens. A 70–200mm f/2.8 zoom is also fast compared to a 70–200mm f/4, and so on.

The main benefit a fast lens offers is that you get a brighter viewfinder image, which aids composition and focusing in low light. More importantly, it allows you to use a faster shutter speed to freeze movement or prevent camera shake when handholding, or a smaller aperture to increase depth-of-field.

The drawback is that you pay a higher price for fast lenses. A 70–200mm f/2.8 zoom will cost more than double that of a 70–200mm f/4, and also be twice the size and weight, so you have to decide how important that extra stop of speed is. In the days of film, lens speed had more significance for low-light photography because if you were shooting handheld, with your lens at its maximum aperture and the shutter speed dropped below a safe

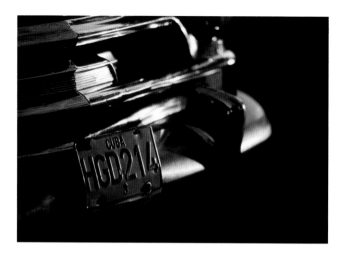

Havana, Cuba
The telezoom can also be used to isolate smaller details and create simple but striking images. I'd been busy shooting a row of old American cars at dawn in the Cuban capital when the sun rose and caught the bumper and number plate of this car. Zooming my lens up to 200mm allowed me to exclude everything else and concentrate on this telling detail.
CANON EOS 1DS MKIII, 70–200MM ZOOM, TRIPOD, 1/4SEC AT F4, ISO200

level, your only option was to load up with faster film. Today, all you do is increase the ISO on your camera and, as digital cameras produce much better images at high ISO than film ever did, you don't have to worry about the quality dropping. I often use my digital SLR at ISO 1600 or 3200 and the image quality is amazing compared to what I would have achieved using film of that speed.

This, combined with image stabilization technology, makes lens speed less important. In fact, when I switched from film to digital, I ditched my big, heavy Nikkor 80–200mm f/2.8 zoom in favour of a smaller, lighter and less costly Canon 70–200mm f/4 IS USM. It's much easier to handhold at slower shutter speeds due to its reduced size and weight, while the image stabilization provides an additional benefit of several stops.

Faster lenses don't always mean better image quality. The higher price tag is for the wider maximum aperture, but your photographs won't necessarily be any sharper. My 'slow' Canon telezoom is razor sharp and every bit as good as its faster f/2.8 stablemate – but cost about third less.

WHICH FOCAL LENGTH?

For most night and low-light situations, a range of lenses covering effective focal lengths from 20mm–200mm will be more than adequate, and it's only specialist applications, such as photographing the moon, where something longer or wider becomes necessary. I use a set of three zooms that cover 17–

200mm, though I don't shoot as wide as 17mm on a regular basis.

Wide-angle zooms are likely to prove the most useful of all. They allow you to include more in a picture, and they also exaggerate perspective, allowing you to produce dynamic compositions. Wide lenses also give extensive depth-of-field at small apertures such as f/16 or f/22 so you can record everything in sharp focus from immediate foreground to infinity – the wider the lens is, the more depth-of-field you get for any given aperture.

Telezooms are a better choice if you want to isolate small details in a scene, such as a distant building that's floodlit, the setting sun or a neon sign. The longer the focal length, the greater the magnification. Tele lenses are also invaluable for candids and portraits in low-light, and interior details. Obviously, they're bigger and heavier than wide-angle lenses, so the need to use a tripod in low-light increases if you want to avoid camera shake. Depth-of-field is also reduced so less of the scene will be recorded in sharp focus. Stopping right down to minimum aperture – often f/32 with telephoto lenses – will help to overcome this. Alternatively, shoot at a wide aperture such as f/4 or f/5.6, so only your main subject is recorded in sharp focus and the background is blurred. Doing this will also allow you to use a faster shutter speed.

Telephoto lenses compress perspective so the elements in a scene appear closer together. This characteristic, known as 'foreshortening', is ideal for shots of busy streets at night, rows of houses, transmission towers at sunset and so on, as it makes the elements in a scene seem crowded together to produce powerful pictures.

CARING FOR YOUR LENSES

The bright lights that often appear in low-light and night scenes can cause flare, which reduces image contrast, washes out colours and often creates ghostly light patches on your pictures.

Using a lens hood to shield the front element of your lens from stray light will help to reduce the risk of flare, but it's also important that you keep your lenses, and any filters used on them, as clean as possible. Dust and greasy fingerprints or smears can increase the likelihood of flare, as can scratches on your lenses and filters.

For this reason, it's a good idea to keep a protective caps on the front of your lenses when they're not in use, and even better to place a clear Skylight or UV filter on each lens so the front element is protected – it's far safer to clean a dirty filter than a dirty lens, and far cheaper to replace a scratched filter than a scratched lens.

If you need to clean your lenses, do so very carefully. Use a blast of air or an anti-static brush to remove dust and dirt particles, before wiping away any smears with a microfibre cloth that won't scratch the delicate multi-coating on the lens's front element.

THE 50MM STANDARD LENS

One of the most useful lenses for low-light photography is the vastly underrated 50mm standard prime lens. Back in my formative days of photography it was normal practice to buy a 35mm SLR body complete with a 50mm 'standard' lens – so named because it sees the world similarly to the naked eye. Unfortunately, once zoom lenses became popular, the 50mm fell out of favour and was considered boring by many because it lacked the drama of a wide-angle lens or the power of a telephoto.

For handheld photography in low-light, however, the 50mm prime lens is hard to beat and I urge you all to go out and buy one now! Not only is it small and light – my Canon 50mm f/1.8 weighs 130g (0.3lb) while my Canon 24–70mm zoom tips the scales at a whopping 950g (2.1lb) – but it also has the fastest maximum aperture of any lens you're likely to own, which provides a bright, crisp viewfinder image, gives shallow depth-of-field so you can throw backgrounds out of focus and allows you to maintain a decent shutter speed to prevent camera shake. Saying that, the risk of camera shake is dramatically reduced by the lightness of the lens anyway and I confidently handhold with my 50mm down to 1/15sec. That, combined with the high ISO capability of modern DSLRs means that you can shoot handheld in situations where with any other lens you'd be reaching for a tripod, and my 50mm

standard has saved my life on many occasions.

Far from boring, the angle of view of a 50mm lens on a full-frame DSLR makes it ideal for general use – I use it for landscapes, portraits, still-life, architecture… And remember, if you use it on a non full-frame DLR the effective focal length is 75mm, making it a perfect portrait lens.

You'd think that all these benefits would come at a price, but amazingly, the 50mm lens is cheap compared to even budget zooms and if you buy secondhand you'll pick one up for next to nothing. The cheaper models have a maximum aperture of f/1.8, while spending more will get you an f/1.4 model and if you're a lottery winner you could treat yourself to a 50mm f/1.2. However, I find the 50mm f/1.8 to be more than fast enough.

Image quality isn't compromised by the low price tag either – a 50mm f/1.8 prime lens will reward you with pin sharp, contrasty images and give the best zooms a run for their money.

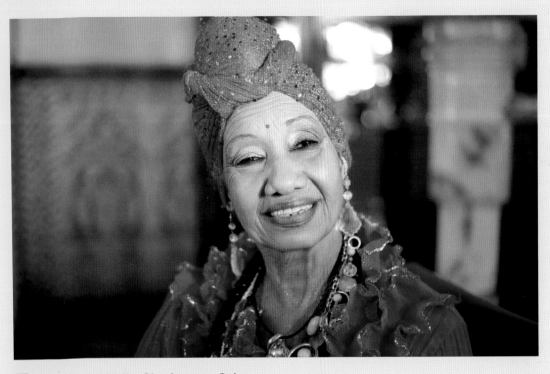

▲ Palacio Del Valle, Cienfuegos, Cuba

My Canon 50mm f/1.8 standard lens has saved my bacon on many occasions when shooting indoors – the combination of low weight, compact size and super-fast maximum aperture allows me to take photographs handheld that would be impossible with any other lens. The excellent high ISO performance of my DSLR also helps enormously.
CANON EOS 1DS MKIII, 50MM F/1.8 LENS, 1/40SEC AT F/1.8, ISO800

CONTROLLING DEPTH-OF-FIELD

Whenever you take a photograph, an area extending in front of and behind the point the lens focuses on will record in sharp focus. This zone is known as the 'depth-of-field' and three factors affect how big or small it is:

• Lens aperture – the wider the aperture (smaller the f/number) the smaller the depth-of-field – and vice versa.
• Lens focal length – the wider the lens (smaller the focal length) the greater the depth-of-field – and vice versa.
• Focusing distance – the closer the focusing distance is to the camera the smaller depth-of-field – and vice versa.

The first two factors are the most important – if you use a wide-angle focal length such as 24mm set to a small aperture such as f/16, depth-of-field will be great; if you use a telephoto focal length such as 200mm and a wide aperture such as f/4, depth-of-field will be very small.

Being able to assess and control depth-of-field is important, especially when you want to record the whole scene in sharp focus from front-to-back. What doesn't help is that when you look through your SLR's viewfinder you're seeing the depth-of-field you would get if you took a shot with the lens at its widest aperture. SLR lenses use the widest aperture as the default setting in order to make the viewfinder image bright, and only stop down to the aperture you've selected when you trip the shutter release to take a photograph – so you never get to see the depth-of-field that you will achieve. Here are three ways to overcome that.

The LCD monitors are now of a high enough quality to make critical assessment of your images possible. I use mine regularly to check the front-to-back sharpness.

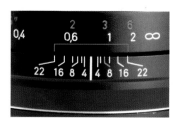

This is what a depth-of-field scale looks like. You'll find one on prime lenses, but it would be impossible to include an accurate scale on zoom lenses due to the variable focal length.

1 Depth-of-field preview

One way around this is to use the camera's stopdown preview, which is activated by a button on the camera or lens. It manually closes the lens aperture down to the f/number set. By looking through the viewfinder you can then get a fair indication of what will and won't be in focus, although at small apertures such as f/16 and f/22 the viewfinder image goes quite dark and you need to keep your eye to the viewfinder for maybe 20 seconds until it adapts to the dark image. This is not a particularly effective way of assessing depth of field.

2 Using the depth-of-field scale

Fixed focal length (prime) lenses have a depth-of-field scale on the lens barrel so having focused on your subject, or a specific distance into the scene, you can check the scale to see what the nearest and furthest points of sharp focus will be at different apertures and set the f/number you need to achieve sufficient depth-of-field. This is a useful way of assessing depth-of-field, but zoom lenses lack reliable depth-of-field scales so you can only use the method if you shoot with prime lenses – which these days rules out 99 per cent of photographers.

3 Using your camera's LCD monitor

The latest generation of digital SLRs have bright, sharp and big LCD monitors that are good enough to analyze your images on. Even though I'm experienced at controlling depth-of-field, I still tend to make sure by zooming into the preview image on my camera's monitor and scrolling from top to bottom to check everything is sharply focused.

Maximizing depth-of-field

Having worked out how to assess depth-of-field, you now need to learn how to maximize it at the aperture your lens is set to – especially if you want everything in the scene to come out sharp from foreground to infinity.

There is an old theory that depth of field extends roughly twice as far behind the point you focus on as it does in front, so if your lens is set to a small aperture, such as f/16, and you focus one-third of the way into the scene you should be okay. Similarly, with wide-angle lenses that give extensive depth of field, if you stop the aperture down to f/22 and focus on infinity, the chances are everything in the scene will record in sharp focus. Unfortunately, neither method is foolproof so if you want to be sure of achieving front-to-back sharpness, a technique known as 'hyperfocal focusing' can be employed.

Hyperfocal focusing works on the basis that there is a specific distance from the camera for any lens focal length and aperture setting where depth-of-field is maximized. To find that distance

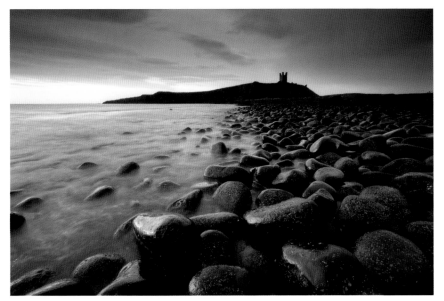

Dunstanburgh Castle, Embleton Bay, Northumberland, England
Being able to control and maximize depth-of-field when shooting scenes with a wide-angle lens or zoom is essential if you want to ensure front-to-back sharpness. Stopping down to f/22 and focusing on infinity often works – but not always – and there's nothing worse than a potentially fantastic photograph being ruined because the foreground is out of focus.
CANON EOS 1DS MKIII, 17–40MM ZOOM, TRIPOD, 0.9ND HARD GRAD, 15 SECONDS AT F/16, ISO100

Aperture (f/stop)	Lens focal length (mm)								
	17mm	20mm	24mm	28mm	35mm	50mm	70mm	100mm	200mm
f/8	1.0m	1.4m	2.0m	2.8m	4.2m	8.5m	17m	35m	140m
f/11	0.75m	1.0m	1.5m	2.0m	3.0m	6.3m	12.3m	25m	100m
f/16	0.5m	0.75m	1.0m	1.4m	2.1m	4.3m	8.5m	17.5m	70m
f/22	0.35m	0.5m	0.7m	1.0m	1.5m	3.1m	6.2m	12.5m	50m
f/32	0.25m	0.35m	0.5m	0.7m	1.0m	2.2m	4.2m	8.5m	35m

you can use your lens's depth-of-field scale, but as we've already established, autofocus zoom lenses lack reliable scales. A simple formula can also be used to calculate hyperfocal distance, but that's time-consuming. To save you the hassle, here's a table of hyperfocal distances for a range of popular effective focal lengths.

Note I say 'effective' focal length. If you're using a full-frame digital SLR, the focal lengths in the chart are as per the focal lengths of your lenses/zooms. For non full-frame digital SLRs, apply the magnification factor (MF) that applies to your camera first – either 1.5× or 1.6× – to find the effective focal length, then look for that length on the chart. For example, if you're shooting at 12mm, the effective focal length for an SLR with a MF of 1.5 is 18mm, so use the hyperfocal distances for 17mm, above.

Having found the correct focal length, read down to find the hyperfocal distances for different apertures. For example, if the effective focal length is 28mm and the aperture f/16, the hyperfocal distance is 1.4m. By focusing the lens on the hyperfocal distance, depth-of-field will extend from half the hyperfocal distance (approximately 0.7m in this case) to infinity, so providing everything in the shot you're about to take is less than, say, 80cm away, front-to-back sharpness will be achieved.

TELECONVERTERS

A teleconverter is a handy accessory that fits between the camera body and lens and multiplies the focal length of that lens. The most popular type is a 2× teleconverter, which doubles focal length – turning a 200mm lens into a 400mm, or a 75–300mm zoom into a 150–600mm. You can also buy 1.4× teleconverters, which increase focal length by 40 per cent. In both cases, the minimum focusing distance of the lens remains unchanged.

The main drawback with a teleconverter is it loses light – two stops for a 2× and one stop for a 1.4×, which means that you have to use slower shutter speeds or increase the ISO. They also reduce image quality slightly, especially budget-priced models. However, if you're using your camera on a tripod, as you almost certainly will for telephoto shots in low-light, this light loss needn't limit you in any way. The loss of image quality can also be minimized by choosing a high quality teleconverter and shooting at an aperture of f/8 or f/11, which tends to give the sharpest results. One factor to be aware of is that the autofocusing will usually only work if the maximum aperture of the lens is wider than f/5.6.

ESSENTIAL FILTERS

Like any subject, low-light and night photography can benefit from the use of certain filters. However, now that we're well and truly in the digital age, the number of different filters you really need has fallen dramatically. Colour balancing filters are redundant for users of digital cameras because the job they did on film can be replicated using your camera's white balance settings (see page 72), the colour temperature control during RAW file processing (see page 73) or the colour adjustment controls in Adobe Photoshop and other editing software.

Fancy effects filters seem to have died a death too, not so much because they've been superseded by digital technology – though some, such as soft focus, undoubtedly have – but more because we've grown out of them. Compared to the sophisticated effects you can now create using imaging software, Starburst and Diffraction filters seem rather tacky and old-fashioned. I used to own and use these filters myself when shooting low-light images, and had great fun it has to be said, but they were discarded long before I switched to digital capture and I

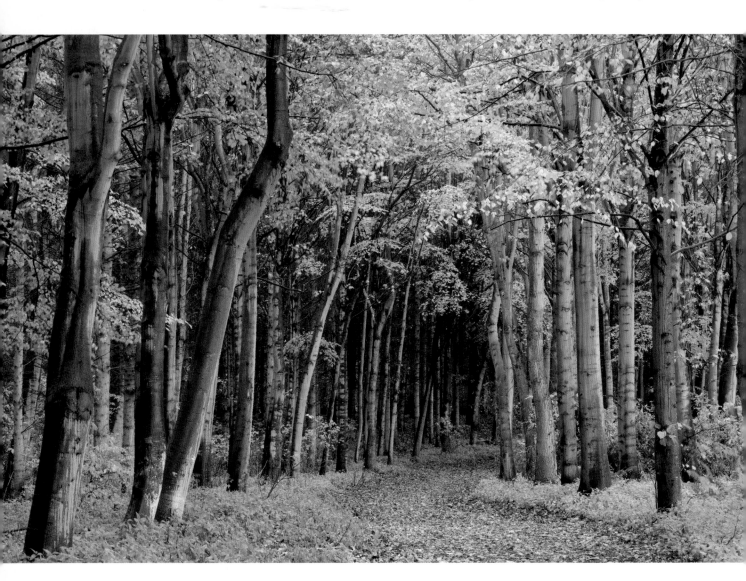

don't know any photographer who uses them.

The filters that remain are the essentials, designed to help you help your camera record images of the highest quality. Some photographers have abandoned them altogether, on the basis that digital technology has replaced them all. But while this is true to an extent, avoiding the use of filters at the taking stage just means more time at the computer at the finishing stage, and I for one would rather be 'out' shooting than 'in' processing. Also, having spent over two decades shooting film and having to get my shots right in-camera, it's a case of old habits die hard, and that is the approach I still adopt today with a digital camera. The use of the following filters helps a great deal, not only in low-light situations but all situations.

THE POLARIZER

The polarizer is perhaps the most versatile filter of all and does more jobs than any other filter type. It works by blocking out polarized light and in doing so performs three invaluable tasks – blue sky is deepened and clouds emphasized, glare is reduced on non-metallic surfaces such as foliage so colour saturation is increased and reflections are reduced or eliminated in water, glass and other surfaces.

The best part about using a polarizer is that you can see exactly what it's doing and therefore control the effect. All you do is place it on your lens then rotate it slowly while looking through the camera's viewfinder. You'll see the sky darken then lighten as you rotate, glare disappear then reappear, and when you're happy with the effect you stop rotating and start shooting.

For the strongest effect when deepening blue sky, the sun should be at a right-angle to the lens axis, so you're looking towards the area of sky where maximum polarization occurs. The sky also comes out deeper when the sun is low in the sky, so the first hour after sunrise and the last hour before sunset are prime times.

Take care when using lenses wider than 28mm as polarization is uneven across the sky so you can end up with a picture where the sky is a darker blue on one side than the other – especially if you are shooting with the sun just out of shot. Also, if the front end of your lens rotates as focus changes, focus first then adjust the polarizer, or hold the polarizer in place as you focus so its position doesn't change.

FILTERS AND EXPOSURE

Polarizer and ND filters reduce the light entering the camera lens and so cause the exposure to increase. The amount by which they do this is referred to as a 'filter factor'. A polarizer has a factor of ×4 which means it loses two stops of light. With ND filters the factor varies with density (see page 33). ND grads have no filter factor because they only affect part of the image and if you increased the exposure when using one you would defeat the object.

These filter factors can be pretty much ignored. Digital SLRs have fantastic metering systems (see page 74) and if you take an exposure reading with a filter on the lens, any factor will be accounted for automatically by the TTL (through-the-lens) metering, so you don't need to adjust anything. Just fit the filters you want to, use compose the shot and fire away.

The only exception is when using extreme ND filters that are so dense they will make your camera's metering go nuts! The exposures required are also often way beyond the automated range of your camera anyway, so you'll need to calculate the exposure and shoot on bulb (see page 84).

◄ Alnwick, Northumberland, England
Although a polarizer is mainly used in sunny weather, it also has its uses on grey, dull and wet days, too, cutting through glare to increase colour saturation. This works particularly well on woodland scenes after rain as the wet foliage creates a lot of glare that the polarizer eliminates.
CANON EOS 1DS MKIII, 70–200MM ZOOM, CIRCULAR POLARIZER, TRIPOD, 2.5 SECONDS AT F/16, ISO100

The reduction of glare can be clearly seen when shooting landscapes – the colour of grass and foliage suddenly seem much richer as your rotate the filter on your lens and maximum polarization is achieved. If you're trying to reduce glare and enhance the sky, a compromise may be necessary because achieving the best effect on the sky may not completely eliminate glare – and vice versa.

To reduce or eliminate reflections with a polarizer, the angle between the reflective surface and your lens axis should be around 30°, though you needn't be too precise about this.

The main thing you need to watch when using a polarizer is that its two-stop light reduction doesn't make shutter speeds too slow for handholding – ISO 100 effectively becomes ISO 25 when you have a polarizer on your lens, so even in bright sunlight exposures are going to be down to 1/30sec at f/11.

There are two types of polarizing filter – circular and linear. Both do exactly the same job and give exactly the same effect, but if you use an autofocus camera you ideally need a circular polarizer. If you use a linear polarizer instead, underexposure is likely because the metering system will be fooled. A circular polarizer overcomes this problem due to the way it's constructed.

You're not going to use a polarizer a great deal when shooting low-light scenes, but at either end of the day it will prove invaluable for landscape and architectural photography. The two-stop light loss can also be useful when you need to extend the exposure, so it's well worth carrying one.

Alnmouth, Northumberland, England ▷
A polarizing filter is handy at either end of the day, soon after sunrise and just before sunset, when the sun is low in the sky. On this scene, it not only deepened the blue evening sky, but also boosted colour saturation in the boats and sand and emphasized the ripples in the foreground.
SONY A900, 24–70MM ZOOM, CIRCULAR POLARIZER, TRIPOD, 1/8SEC AT F/11. ISO100

USING FILTERS TOGETHER

As well as using filters individually, you can combine them where necessary to benefit from the different jobs they do. It's common to use a polarizer and an ND grad together, for example, while a plain ND filter can be used with an ND grad or a polarizer, or all three can work together.

Just remember that the more filters you use, the more image quality will be reduced, so keep numbers to a minimum, and keep your filters clean. If you normally use a skylight or UV filter on your lens to protect the front element, it's also a good idea to remove it if you intend to use more than one technical filter.

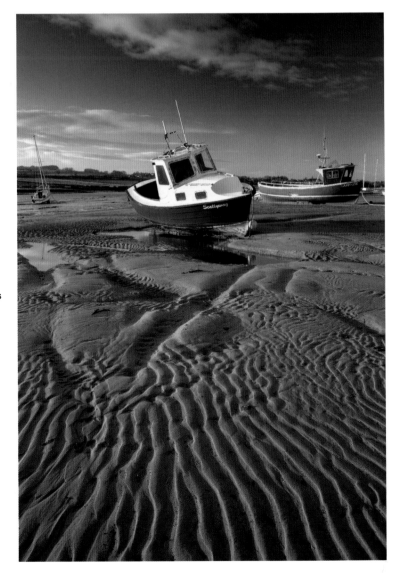

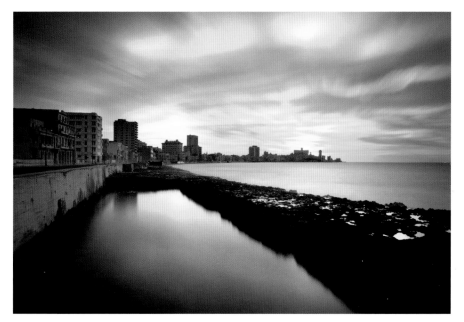

◁ **Plokton, Highland, Scotland**
Neutral density (ND) grads are essential for
scenic photography, allowing you to retain
the natural colour and detail in the sky
while correctly exposing the foreground.
No photographer should be without at
least a couple of ND grads – I use them
more than any other filter type. This pair of
images shows the difference they make. In
the unfiltered shot (left) the sky is washed
out and the foreground overexposed. For
the main shot I used a 0.6ND hard grad,
which not only balanced the sky but also
allowed me to give a little more exposure to
the foreground to achieve a perfect result
in-camera.
CANON EOS 1DS MKIII, 17–40MM ZOOM, 0.6ND
HARD GRAD, TRIPOD, 1/20SEC AT F/11, ISO100

NEUTRAL DENSITY (ND) GRADS

ND grads are clear on the bottom half and grey (that's the neutral density bit) on the top half, with the ND feathering down towards the centre of the filter to meet the clear section. They perform a similar job to solid ND filters (see page 34), but instead of darkening the whole image, they allow you to tone down just part of it – usually the sky. Being 'neutral' they don't change the natural colour of the area affected either. This is usually necessary when shooting scenics because the sky is much brighter than the landscape, so if you set an exposure that's correct for the landscape, the sky will be overexposed and 'burn out'.

In low-light situations this problem is a common one. If you're shooting landscapes before sunrise or after sunset, for example, the only light striking the landscape is reflected from the sky overhead, which is always darker than the sky over the eastern or western horizon – just as a window is always going to be brighter than the floor beneath it.

To redress this difference in brightness, ND grad filters are used to darken down the sky so it's a similar brightness to the rest of the scene. That way, the photographs you take will capture the scene as it appears to the naked eye.

Many digital photographers have abandoned ND grads and instead choose to darken the sky later when the images are downloaded to a computer. In some cases this is possible, but if the sky burns out in the original image there won't be any detail or colour to darken down.

Another option is to take two shots of the same scene – one correct for the sky and another correct for the landscape – then combine them using layers in Photoshop. This works much better than simply trying to darken the sky, but means more time spent at the computer and less time behind a camera. I know where I'd rather be, so I continue to use ND grads to control the sky, as I always did when shooting film.

ND grads come in different densities so you can darken the sky by a precise amount. A 0.3ND grad will darken the sky by one stop, a 0.6ND by two stops, a 0.9 by three stops. Intermediate densities are also available from some manufacturers such as 0.45 (1.5 stops) and 0.75 (2.5 stops). In most situations during the daytime a 0.6ND grad will be adequate, but when the sky is very bright (at dawn and dusk) a 0.9, say, will be required.

Some filter manufacturers make both 'hard' and 'soft' ND grads. A hard ND grad means the neutral density remains constant over much of the top half of the filter and merges more abruptly with the clear section. With soft grads the density starts to drop quite a way up the filter and feathers gently into clear. I prefer hard ND grads because they give a more defined effect, and though many photographers assume they are more difficult to use than soft grads, that's not the case at all – I find them easier to align so there's less chance of pushing the grad too far down in the holder.

With experience you'll know which ND graduate is required just by looking at the scene. If in doubt, take a shot with one or the other and check the image on your camera's preview screen. It's easy to over-grad the sky when using a digital camera, so be careful, otherwise you'll spend longer at the computer than you need to. It's rare to need an ND grad stronger than a 0.9 – if you do, you could be overdoing it.

To align an ND grad, slide the filter down into its holder while

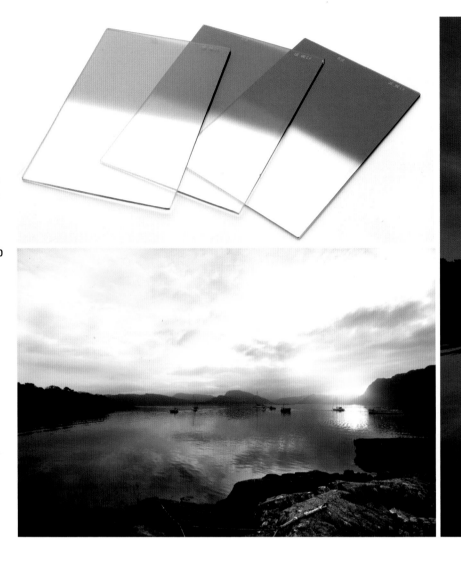

Plokton, Highland, Scotland
Neutral density (ND) grads are essential for
scenic photography, allowing you to retain
the natural colour and detail in the sky
while correctly exposing the foreground. No
photographer should be without at least a
couple of ND grads – I use them more than
any other filter type. This pair of images shows
the difference they make. In the unfiltered shot
(left) the sky is washed out and the foreground
overexposed. For the main shot I used a 0.6ND
hard grad, which not only balanced the sky but
also allowed me to give a little more exposure
to the foreground to achieve a perfect result
in-camera.
CANON EOS 1DS MKIII, 17–40MM ZOOM, 0.6ND HARD
GRAD, TRIPOD, 1/20SEC AT F/11, ISO100

looking through the camera's viewfinder. You should see the
top half of the image become darker. When that dark band goes
down to the horizon, stop. Pressing the depth-of-field preview
button on the camera or lens so it stops down to the aperture set
can help with alignment as it darkens the viewfinder image and
lets you see more clearly the effect the grad is having on the sky.
However, if you're shooting digitally it's easy enough to align the
grad. Take a shot and check it on the camera's LCD monitor – if the
sky towards the horizon is obviously lighter than the rest of the sky,
you probably haven't pushed the grad far enough down, and if the
landscape just below the horizon looks too dark, there's a chance
you've pushed it too far.

Finally, a word about exposure. In pre-digital days I always
advised photographers to take a meter reading before the ND
grad was fitted as the dark ND section of the filter tended to upset
the integral metering system and cause overexposure. These
days, however, metering systems are far more sophisticated and
ND grads pose no problem whatsoever. In fact by reducing the
brightness of the sky they make it easier for multi-pattern metering

systems to give an accurate exposure reading. So, if you're new to
ND grads, use it like any other filter – compose the scene, align
the grad and let the camera do the rest. You can always check the
preview image and histogram and adjust the exposure, but more
often than not you won't need to.

NEUTRAL DENSITY (ND)

The aim of neutral density filters is to reduce the amount of light
passing through the lens so that an exposure increase is required for
the whole image, without affecting the colour balance of the subject
or scene. Given that this book is all about taking photographs in
situations where light is already in short supply, you'd be forgiven
for thinking that ND filters are the last thing you need. However, the
definition of low-light is far-reaching, and with some subjects you
may find that even when light levels are relatively low, you could
actually do with them being even lower to make an effect possible.

Rivers and waterfalls are a common example. To achieve the
attractive blurred effect in moving water, an exposure of a second

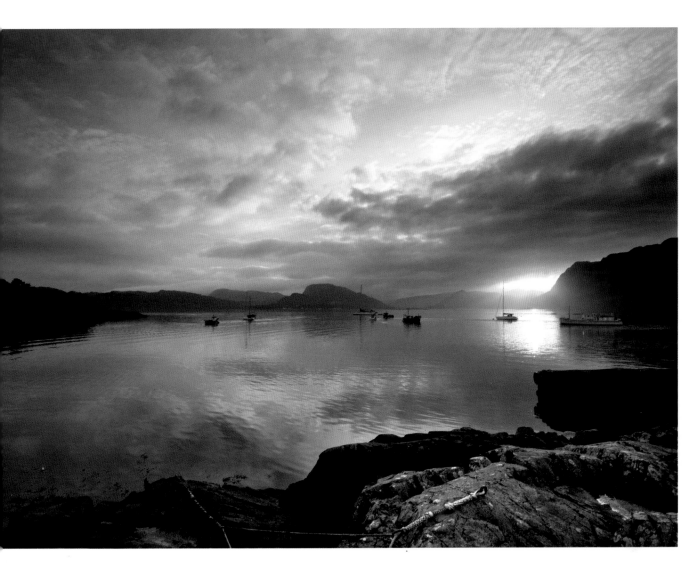

or longer is required. However, even if you are in dense woodland, where little daylight is getting through, using a low ISO setting and the smallest aperture your lens can offer, you may still find that the longest exposure you can use is only ½ or one second. By attaching an ND filter to your lens, you can use a longer exposure to achieve the desired effect.

The same applies when shooting coastal scenes. If you want to capture the sea as a mysterious mist, exposures of 30 seconds or longer will be required. At twilight this is usually possible using a small aperture and low ISO as light levels are naturally low. However, around sunrise and sunset you'd struggle to achieve an exposure longer than a second or two, which is fine if you want to record an impression of movement in the waves, but not fast enough to reduce them to a misty veil.

ND filters come in different densities. A 0.3ND increases the exposure by one stop, a 0.6ND by two, a 0.9ND by three and a 1.2ND by four stops. These four are the most common densities and can be used individually or together – 0.6 and 0.9 densities together would give a combined density of 1.5, or five stops.

EXTREME ND FILTERS

More recently, the use of extreme ND filters has become popular. I'm not sure where this trend started, but I was quick to embrace it and the technique now forms an integral part of my work.

Several extreme ND filters are available. Lee Filters now offer the Big Stopper, which has a density of 3.0 and increases the exposure by 1000x, or 10 stops. B+W also make a 10-stop screw-in filter in all popular thread sizes, and a 1.8 density (6 stop) ND. Heliopan offers a 3.0 and even a 4.0 ND filter, which increases the exposure by 13 stops while Hoya manufactures a 9-stop ND filter. There's even a variable ND from Singh Ray – rotate it like a polarizer and the density can be adjusted between two and eight stops.

I use both the Lee Filters Big Stopper and the B+W 3.0. Both give a 10-stop exposure increase, though while the Lee filter is quite cool in its colour rendition, the B+W is very warm and adds an attractive cast to images made with it. The fact that ND filters are supposed to be neutral can be ignored when it comes to these extreme options.

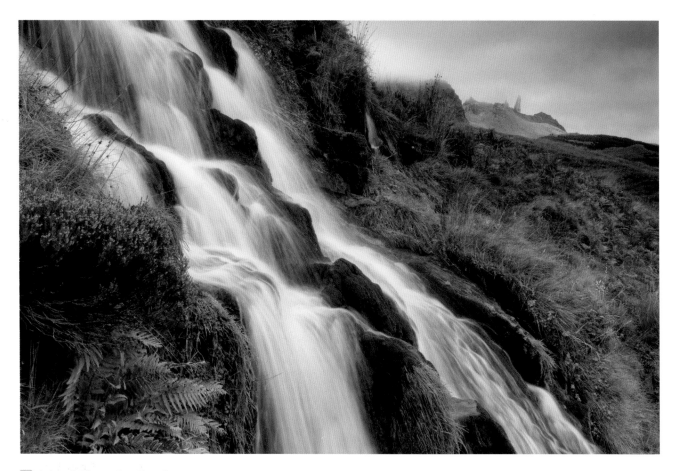

▲ **Isle of Skye, Scotland**
If you want to capture motion in moving water, neutral density (ND) filters come in handy, increasing the exposure so you can use a longer shutter speed. The ND filter shown is a 1.2 density, which increases the exposure by four stops. A polarizing filter loses two stops of light and so can double-up as an ND filter.
CANON EOS 1DS MKIII, 27–70MM ZOOM, 0.6ND, TRIPOD, 2 SECONDS AT F/16, ISO50

The whole point of such strong ND filters is that they allow you to use exposures of several minutes. To put things into perspective, if the metered exposure is one second, with a 10-stop ND on the lens it increases to 1,000 seconds, or almost 17 minutes! This means that instead of freezing time, which is what photography normally does, you're recording the passing of time and the resulting images look amazing.

Basically, anything in the scene that's moving will blur. Water turns to mist, drifting clouds create wonderful streaks and smudges across the sky and wind-blown grass record like delicate brush strokes of colour. If you use extreme ND filters on urban views you can also create images that depict them in a way you'll probably never experience with the naked eye – deserted streets devoid of people and traffic. That's because anything moving through the scene while the exposure is being made won't register on the image. People, cars, buses, taxis – they simply disappear.

Using these strong NDs is trickier than most filters, mainly because they're so dense you can't see through them and your

lenses won't be able to focus through them, which means you have to compose the image first, with your camera on a tripod, and set focus manually. If you own one of the latest digital SLRs you may find that the live view facility is sensitive enough to see through a 10-stop ND filter. My Canon EOS 1DS MKIII can just about do it, though the EOS 5D MKII, which is a couple of years newer than the 1DS MKIII has much better live view. A benefit of being able to use live view with extreme ND filters is that if you decide to move the camera, you can set-up the next shot without taking the ND filter off the lens – not a problem with the Lee Big Stopper as you simply lift it from the holder, but a hassle with the other brands as they screw onto the lens. Live view will also help you align an ND grad if you're using one, while the strong ND filter is still on the lens.

Calculating correct exposure also requires care. One option is to take a meter reading before you fit the filter then work back from there. For example, if the meter says 1/30sec unfiltered, with a 10-stop ND on the lens it will be 32 seconds (one-stop = 1/15sec,

two stops = 1/8sec, three stops = 1/4sec, four stops = 1/2sec, five stops = 1sec, six stops = 2secs, seven stops = 4secs, eight stops = 8 secs, nine stops = 16secs, ten stops = 32secs).

To save you the hassle of working this out, take a photo of the chart below then print it out and keep it in your camera bag. Alternatively, use a calculator to work it out – 1/30sec × 1000 = 33.3333 seconds – or purchase the ND Calc App for your iPhone!

I tend to do a guesstimated test shot based on experience. So, with the camera on a tripod, the scene composed, the lens focused, the ND filter in place and the shutter set to bulb, I'll make, say, a two minute exposure at f/8 and ISO 100, check the image and the histogram and increase/reduce the exposure accordingly. Canon digital SLRs have a count-up timer on the top plate so I don't have to worry about keeping an eye on my watch or counting elephants. If yours doesn't, a stopwatch will come in really handy – most mobile phones have one built in.

I generally shoot at ISO 100 and stick to apertures of f/8 or f/11 for optimum image quality, using the exposure duration as my main variable. However, when ambient light levels are quite low, such as at dawn and dusk, I may increase the ISO to 200 or even 400 occasionally so the exposure with the ND filter in place isn't too excessive – I try to keep them within five or six minutes. If I don't need lots of depth-of-field – say when shooting from a high viewpoint – I may open up the lens to f/5.6 or f/4 instead.

Unfiltered Exposure	Exposure with 10 stop ND
1/500sec	2secs
1/250sec	4secs
1/125sec	8secs
1/60sec	16sec
1/30sec	32secs
1/15sec	1min
1/8sec	2mins
1/4sec	4mins
1/2sec	8mins
1sec	16mins
2secs	32mins
3secs	48mins
4sec	1hr

▶ Vik I Myrdal, Iceland
This is the surreal effect you can create using an extreme ND filter to force exposures of minutes. The sky has turned to pastel streaks and the sea a milky mist, contrasting with the black volcanic sand. I used the Lee Filters Big Stopper ND filter, increasing the exposure by ten stops.
CANON EOS 1DS MKIII, 17–40MM ZOOM, 10-STOP ND, 0.9 ND HARD GRAD, TRIPOD, TWO MINUTES AT F/16, ISO100

Noise is more of an issue when using such long exposures, especially hot pixels, which glow like pin pricks of light. Digital cameras have Long Exposure Noise Reduction (NR) to combat this, but it works by making a second exposure the same duration as the first with the shutter closed, so if you make a five minute exposure you'll have to wait another five minutes before the image appears on the preview screen. I'm far too impatient for that, so I make sure my camera's NR is turned off and I clone out any hot pixels in Photoshop, which takes about a minute.

Batteries obviously drain faster too when you're making exposures several minutes long, so be sure to carry a fully charged spare, just in case.

FILTER SYSTEMS

Okay, now you know which filters you're going to need. But which brands should you buy, and how are you going to fit them to your lenses? There are two main types of filter to consider here: round screw-in filters, or square and rectangular filters that fit into a multi-slot holder.

Round filters are convenient in that you simply screw them onto the front of your lens. Their main drawback, however, is that they're made to fit a specific thread size, be it 49mm, 52mm, 67mm or whatever, so if you have lenses with different thread sizes, which is highly likely, you will need to do one of two things.

One is to buy the same range of filters in all relevant thread sizes so they will fit your full lens system; a potentially expensive move if you have four or five different thread sizes. The sheer number of filters you will need to carry also becomes prohibitive. The other option is to buy one set of filters in the biggest thread

size you need, or are likely to need, then invest in stepping rings which will adapt these filters to smaller thread sized so they can be used on your other lenses.

The latter option is more practical than adapting smaller filters for use on lenses with bigger thread sizes because if you do this, there's a strong chance of vignetting, especially with wide-angle lenses. Another drawback with screw-in filters is that if you want to use two or three together, the combined depth of the mounts – perhaps 3 or 4mm per filter – may extend too far and creep into the field-of-view, again causing vignetting.

Taking these factors into account, screw-in filters are ideal if you only want to use them individually, and your lenses have the same or very similar thread sizes, but beyond that they become inconvenient and a holder-based filter system is a better bet.

The immediate advantage of buying a slot-in system is that you can use the same filters on lenses with widely-different thread sizes simply by investing in a set of inexpensive adaptor rings, which means you only need ever buy one set of filters. You can also use two or three filters together without having to worry about vignetting.

Saying that, vignetting can't be ruled out altogether, because if the filter holder is too small it will encroach on the lens's field-of-view just like a screw-in filter would. The key to avoiding this is to buy a bigger 'pro' size filter system. It will be more expensive at the outset, because the holders, adaptors and filters cost more, but long term you will benefit because you should never need to upgrade the system.

The main slot-in systems available today are from Cokin, Lee Filters and Hi-Tech (Formatt).

Cokin is the world's best-known brand and comes in two sizes, P-series based on filters that are 84mm wide and Z-Pro Series based on filters that are 100mm wide. There used to be an even bigger X-Pro series using 130mm-wide filters but this has been discontinued – it was simply too big!

The Cokin P-series is the most cost-effective system around. Adaptor rings are available from 49mm to 82mm and the standard filter holder, which will accept up to three filters (two plus polarizer or three resin filters) can be used on lenses as wide as 20–24mm (full-frame DSLR) and 14mm (non full-frame) without causing vignetting. If you have a lens wider than this, it is possible to butcher a standard holder with a hacksaw and remove the front slot so the holder is shallower – the holders are inexpensive so this isn't as radical as it may seem. Alternatively, there's a Wide Angle P-Series holder available with a single slot that can be used safely on lenses as wide as 18–20mm (full-frame) and 12mm (non full-frame).

If you plan to go even wider, take a look at the 100mm–wide Cokin Z-Pro series, which is more expensive but will cope with lenses as wide a 17mm (full-frame) or 10–11mm (non full-frame).

Cokin filters are made from CR39 optical resin and offer excellent image quality for the money. One novel feature is the polarizer, which fits behind all other filters in the holder in a narrow slot and has a notched circular mount so you can rotate it in the holder to achieve the desired effect without moving the holder itself.

Elgol, Isle of Skye, Scotland
The B+W 3.0 ND increases the exposure by ten stops, but in addition it adds an attractive warm cast that can make a huge difference to images shot at dawn and dusk, when the light is supposed to be warm – but due to weather conditions isn't always. On this occasion, what I'd hoped would be a vivid sunset ended up being rather feeble, but by using my B+W 3.0ND, not only was I able to record motion in the sea and sky, but the warmth of the filter also added atmosphere.
CANON EOS 1DS MKIII, 17–40MM ZOOM, 3.0ND, 0.6ND HARD GRAD, TRIPOD, TWO MINUTES AT F/11, ISO200

▲ I use a filter system from Lee Filters based around a modular holder that takes 100mm wide slot-in filters and a 105mm screw-in polarizer. The holder is shown here, and also on my camera complete with an ND grad and a 105mm polarizer screwed onto the threaded front ring.

Lee Filters is considered by many to be the crème de la crème of filter systems and is favoured by the world's leading photographers. I've been a devotee of Lee Filters myself for many years (nothing to do with the name) and can't ever imagine changing brands.

At the heart of the system is a versatile 100mm-wide holder that comes supplied as a pile of bits of plastic and screws and can be constructed to suit your needs. If you use all the parts you'll end-up with a holder with four slots, but equally, you can construct one with three slots, two slots or even a single slot. The fewer slots, the less chance of vignetting with wide-angle lenses. Slot depth can also be varied from 2mm to 4mm so you can use filters from different manufacturers such as Hitech and Cokin in the holder and an optional 105mm threaded aluminium ring is available which attaches to the front of the holder so you can fit a 105mm diameter polarizing filter. For super-wide lenses there's even a push-on holder that sits level with the front of the lens, while adaptor rings are available in all sizes from 49mm to 82mm, including wide-angle adaptors that sit back on the lens a few mm to further reduce the risk of vignetting.

I have a couple of Lee holders set up with two slots and the 105mm threaded ring. I can use them on my widest lenses in conjunction with wide-angle adaptor rings – a 17–40mm zoom for full-frame and 10–20mm zoom for non full-frame – with a polarizer fitted, without vignetting. Lee Filters makes its own 105mm polarizer, but the mount is deep, around 10mm, so I use a Heliopan slim circular polarizer instead, which has a much shallower mount.

Graduated filters in the Lee range are 100x150mm while other filters are 100x100mm. The system is far from cheap, but filter quality is superb and if you invest in top quality lenses, it makes sense to put top quality filters on them.

More recently, Lee Filters has launched the RF75 system, which is designed for use with rangefinder film cameras, as well as high-end digital compacts and digital micro-4/3rds cameras such as the Lumix G range (I own and use the fantastic Lumix GF1). Adaptor rings from 39mm to 67mm are available, so if you have a smaller camera with a filter thread on the lens, the system is immediately compatible. If there's no thread, you may be able to get an adaptor – Lee Filters currently make them for the Panasonic Lumix TZ series of compacts and the Leica D-Lux 5. Others will no doubt follow.

Using this system on digital compacts is easy because you've got the live view facility on the camera's LCD monitor to aid alignment of ND grads and polarizers.

Hitech (Formatt) filters, though lesser-known than Cokin and Lee, are worth considering as well. Two systems are available – 85mm like the Cokin P-Series and 100mm like Cokin Z-Pro and Lee. These filters will fit in both Cokin and Lee Filters filter holders, though the Hitech holders are well made and a complete range of adaptor rings are available up to 82mm. Hitech also pioneered the use of a threaded polarizer ring on the front of the filter holder. Price-wise they fall between Cokin and Lee Filters and the optical quality is very high.

Some photographers buy a Cokin P-Series filter holder and adaptor rings, as they are inexpensive, then use Hitech 85mm filters in the holder. Even though Cokin P filters are 84mm, the 85mm-wide Hitech filters will fit the holder.

SKYLIGHT AND ULTRA-VIOLET (UV) FILTERS

Both these filters reduce atmospheric haze and cut out the blueness found in the light at high altitudes. However, because the effect they have on a photograph in normal shooting conditions is negligible, they tend to be used mainly to protect a lens's delicate front element. When you buy a new lens, it is worth spending a little extra on a screw-in skylight or UV filter as it is far cheaper to replace a damaged scratched or broken filter than a damaged lens.

UNDERSTAND YOUR FLASHGUN

The electronic flashgun is a much-underrated piece of equipment. For many photographers it's regarded merely as a last resort; something that provides extra light in situations where available light levels are insufficient, which is why it tends to be used mainly for snapshots at parties and special events, but little else. However, in creative hands, even the simplest flashgun can produce breathtaking results and be used as the basis of many specialist low-light techniques both indoors and out.

As with most things photographic, flashgun design and technology has come a long way in recent years. The vast majority now made are known as 'dedicated' guns because they're designed to work in conjunction with the metering system and other features of your camera to ensure accurately exposed images result. When I wrote the original version of this book, flashguns were mainly manual or automatic and dedicated models were an expensive rarity. Now it's the other way round – dedicated flashguns are the norm while manual and automatic guns have faded into near obscurity.

The reason for this is simple – with a dedicated flashgun you can slip it onto your camera's hotshoe, flick the power switch and literally start firing away. Through-the-lens (TTL) flash metering ensures that the gun delivers just the right amount of light to give a perfect exposure, the camera is set to the correct 'flash sync speed' (see right) and all you have to worry about is pressing the shutter button.

This is flash photography at its most automated and simple, but the latest generation of flashguns have much more to offer than that.

▽ Venice Carnival, Italy

Thanks to the ease of use and sophisticated features of modern flashguns, they allow you to produce perfect results with little or no prior experience of using flash. I wish it had been like that 15 years ago! For this shot, taken at sunrise, I combined a slow shutter speed to record colour in the sky, with a burst of flash to light my subject – a technique known, funnily enough, as slow-sync flash!

CANON EOS 1DS MKIII, 50MM LENS, CANON SPEEDLITE 580EXD II FLASH, 1/4SEC AT F/4

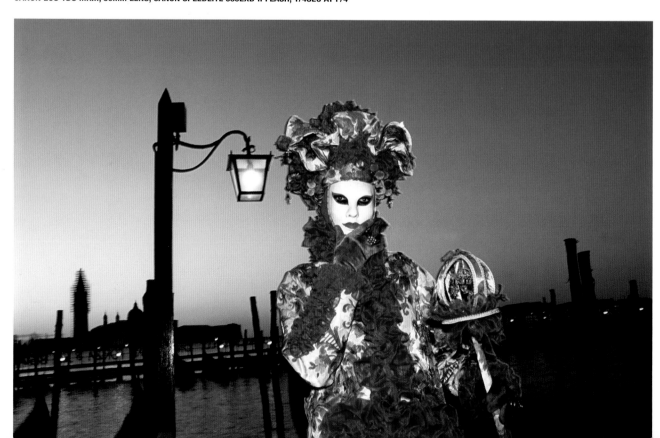

Power output A flashgun's power is expressed as a guide number (GN) in metres at ISO 100 – the bigger the number the greater the power. Small, low-powered models and built-in flashguns have a GN around 10 or 12, but a high-powered model will have a GN of 45, 50 or more.

More power means that you can use smaller lens apertures and photograph subjects that are further away. The GN increases when you use telephoto lenses as the flash coverage is reduced so it's effective over a greater distance. If you're going to use flash on a regular basis it pays to buy the most powerful gun you can afford – a GN from 36 up will be ideal in most low-light situations, and for general use.

Variable power output Being able to control the power output of your flashgun means that you have full control over its effect on a picture. When using fill-in-flash, variable power allows you to alter the flash-to-daylight light ratio to suit the subject and the effect you want to achieve. A ratio of 1:4 is normally used, so the flash doesn't overpower the image – this is achieved by setting the output to ¼. For a ratio of 1:2 set ½ and so on. You can usually vary the output from 1/1 (full, power) down to 1/64 or even 1/128 so you can have total control over the flash effect.

Flash exposure compensation Another way to effectively reduce the output of your flashgun is by adjusting the flash exposure compensation, which may be done on the flashgun or the camera, depending on the models in use. If you set –1 stop, for example, you'll underexpose the flash by one stop which is the same as firing on ½ power; if you set -2 stops you'll underexpose the flash by two stops, which is the same as firing on ¼ power. For techniques such as fill-in or slow-sync flash, where you generally don't want the flash to fire on full power, this feature can be used instead of variable output.

Exposure confirmation If this light comes on or changes colour when the flash fires, it indicates that the correct exposure is achieved. An indicator usually shows in the camera's viewfinder too, so you know if correct exposure has been achieved when a picture is taken.

Strobe/multiple flash mode Although found on only a few of the more highly-specified flashguns, a strobe mode will fire the flash many times per second – you choose the number of flashes and the power output for each then, when you trip the camera's shutter, the series of flashes occur automatically. This allows you to create amazing multiple flash effects in low light by capturing a moving subject several times on the same frame of film, such as a person swinging a golf club or jumping through the air, or a hammer falling towards a nail.

The Canon Speedlite 580EX II is one of the world's most sophisticated dedicated flashguns. It's powerful, packed with useful features and is weather sealed to match the robustness of the EOS 1DS MKIII digital SLR – though it can be used with any digital SLR in the Canon range.

LCD illuminator/Custom Function Press this button to light-up the LCD monitor on the gun so you can see it clearly in low light or darkness. Press and hold to access the gun's Custom Functions menu.

Test button In many cases, the ready light also acts as the test button so you can fire the flash without using the camera, which comes in handy if you're painting with light and need to fire the flash numerous times while at distance from the camera.

Mode button Modern flashguns have a range of modes, such as dedicated operation with TTL flash control, manual with variable output, multiple flash and so on. This button allows you to select a specific mode while the dial below lets you change the settings within that mode.

Flash ready light This light glows to tell you when the flash has charged up and is ready for use. In many cases, the ready light also acts as the test button so you can fire the flash without using the camera, which comes in handy if you're painting with light and need to fire the gun numerous times while a distance from the camera.

Power switch Turns the flash on and off. When you first turn the power button to 'On' there will be a delay of a few seconds while the flash charges up.

Recycling time This is the time it takes for a flash to charge after being fired. Modern dedicated flashguns use thyristor circuitry, which stores unused power from the last flash to reduce the length of time it takes to recharge the gun for the next flash. Because dedicated guns quench the flash when enough light has been delivered, they are also economical with power, whereas manual guns fire on full power all the time and take longer to recharge. With fresh batteries, recharging time is kept to a minimum – just a second or two. Some bigger guns also use powerpacks instead of batteries to provide more power and shorter recycling times.

Bounce/swivel head This feature allows you to adjust the position of the flash so it can be bounced off a convenient surface such as a wall, ceiling or reflector to produce more attractive illumination and soften shadows. Bouncing is a handy technique to use when photographing people indoors or using a flashgun to light a dark interior, because the light from a direct flashgun is very harsh and unflattering.

A bounce head isn't essential because you can achieve the same ends by taking the flashgun off the camera's hotshoe and pointing it towards a convenient surface.

Bouncing is easier to do with automatic and dedicated flashguns because any light loss incurred is accounted for automatically to ensure correct exposure. With manual guns you need to open up the lens aperture by one or two stops.

Zoom head This handy feature allows you to adjust the angle-of-coverage of the flash to suit lenses with different focal lengths. The range usually covers lenses from 24/28mm to 85/105mm, and when used with longer focal lengths effectively increases the guide number of the flashgun by narrowing down the angle-of-coverage so the flash travels further. Modern guns usually have a zoom button on the rear so you can match the flash angle to the lens focal length, though some of the more sophisticated models will automatically adjust the zoom setting as you change focal length.

Some models also have a pull-out diffuser that can be placed over the main flash to spread the light and give coverage for much wider lens focal lengths.

Wireless remote TTL flash control A growing number of flashguns can be used off-camera and allow full dedicated TTL exposure control without the need for sync leads. Alternatively, accessories are available such as the Pocket Wizard that allow wireless TTL flash control, so you can set up one or more flashguns in different positions around your subject and fire them all remotely when the camera's shutter is triggered – up to a range of several hundred metres outdoors. This makes for all kinds of creative possibilities.

AF Illuminator Works in conjunction with the AF system of your digital SLR and projects a beam of infrared light on your subject so that the lens can focus accurately in low light – even total darkness.

PC sync socket If you want to use a flashgun off the camera, but still connect the two together so that the flash fires when you trip the camera's shutter release, the flashgun must have a socket into which you can plug a flash sync lead. Most flashguns have this facility. If your flashgun doesn't, you will need to buy an off-camera shoe adaptor, which slips onto the gun's base and provides a socket for a sync lead.

FLASH SYNC SPEED

The vast majority of digital SLRs have a maximum shutter speed at which flash can be used. This is known as the 'flash sync speed'. You can use flash at that shutter speed or any slower shutter speed, but not at faster shutter speeds.

This is because of the way the camera's focal plane shutter works. When you press the shutter release to take a picture, the shutter's first 'curtain' opens to allow light through to the sensor, then to close the shutter again, a second 'curtain' follows it. Imagine a curtain being opened to let light in through a window, then a second curtain being drawn over it again soon after. Obviously, the faster the shutter speed you're using is, the sooner this second curtain begins its travel across the shutter gate to end the exposure. The flash sync speed is the fastest shutter speed at which the whole shutter gate is open when the flash fires. You can use slower shutter speeds than the flash sync speed, but if you use a faster shutter speed with flash, part of the picture will be blacked out because when the flash fires, the shutter's second curtain has already begun its travel across the shutter gate so it's blocking part of the image area.

This used to be a problem because film SLRs tended to have a flash sync speed of just 1/60sec or 1/125sec, so using fill-in flash in bright sunlight was tricky unless you stopped the lens down to a small aperture, which isn't normal practice for portraiture. However, with digital SLRs the norm is to have a flash sync speed around 1/250sec. In one or two cases, flash can also be used at any shutter speed up to the maximum of 1/4000sec.

REAR CURTAIN FLASH SYNC

If you're using a flashgun in combination with a slow shutter speed to produce slow-sync flash images, it's important to know whether the flash is going to fire at the start of the exposure (first curtain sync) or the end (rear/second curtain sync).

You're probably thinking it doesn't matter either way, but when you see the images you'll realise it actually makes a big difference. If the flash fires at the start of the exposure, it freezes the subject and then any subject blur recorded by the slow shutter speed will appear in front of the frozen image. If the flash fires at the end of the exposure, any subject blur recorded by the slow shutter speed will appear behind the frozen flash-lit image of your subject.

This latter effect looks more natural with moving subjects, so if you're using slow-sync flash, set your flash/camera to rear/second curtain sync. Most camera and flash combinations allow this.

RED-EYE REDUCTION

The most common problem encountered when taking flash pictures of people, particularly in low-light situations with the flashgun on your camera's hotshoe, is red-eye. This is caused by light from the flashgun bouncing back of the retinas in your subject's eye, causing them to glow bright red.

Some flashguns have a red-eye reduction mode which is designed to eliminate the problem. This is achieved by either firing a series of weak pre-flashes or shining a light in your subject's eyes before the main flash fires – the aim being to reduce the size of the pupils. Whether or not they work depends on the flashgun being used, and the situation you are using it in. Low-light increases the risk of red-eye because our pupils dilate considerably to enable us see properly, and a red-eye reduction feature may not reduce their size sufficiently.

There are ways to avoid red-eye in low light (see page 176) or, as a last resort, it can be corrected on your computer using a simple Photoshop technique.

Chillingham Castle, Northumberland, England
I had driven past this statue on numerous occasions and was convinced it would make an interesting subject but needed unusual treatment. In the end I decided that a low-light shot taken at dusk was the answer, but with a burst of flash to illuminate the statue against the darkening background. It was a straightforward shot to take, using a single burst of flash to provide the additional light.
CANON EOS 1DS MKIII, 24–70MM ZOOM, TRIPOD, CANON SPEEDLITE 580EX FLASHGUN, 30 SECONDS AT F/11, ISO200

USEFUL ACCESSORIES

Sync lead

If you want to use an electronic flashgun off the camera, and it doesn't have a wireless flash option, it must be connected to the camera to provide synchronization when the shutter release is pressed to take a picture.

The easiest way to do this is with a sync lead, which simply links the camera and flash together via their sync sockets and maintains full TTL control.

It's a good idea to buy a long rather than short lead, so you can use the flash quite a distance from the camera – for closer range, excess lead can be gathered up and secured with a piece of sticky tape or wire tie.

Slave unit

If you want to use more than one flashgun to take a picture in low-light, you need to ensure that they all fire at the same time when the camera's shutter release is pressed. One way of doing this is to buy a multiple sync adaptor into which two, three or four flashguns can all be plugged using a sync lead on each. However, a much more convenient method is to fit one flashgun to your camera's hotshoe, or connect it to the camera with a single sync lead, then fit a slave unit to each of the remaining flashguns that are being used.

A slave unit is basically an electronic 'eye' that fits to the foot of a flashgun or plugs into its sync socket and automatically fires the flash when it picks up light from the flashgun connected to your camera – or the integral flash, which can also be used to trigger 'slaved' guns.

Wireless flash triggers

If you want to use flash off-camera on a regular basis, or maybe work with more than one remote flashgun, a wireless trigger system is worth considering if your own camera/flash combination doesn't allow for remote wireless operation. Pocket Wizard is the best-known name, though there are others. The beauty of these systems is that as well as offering both TTL and manual flash exposure control and the ability to fire numerous flashguns

simultaneously, they operate using radio waves as well as infrared so they can even fire flashguns that are out of view. This means you can set up flashguns to selectively light specific areas and not worry about being able to see the gun itself, which would be the case with a conventional slave unit.

Ring flash

These flash units are circular in shape and have a hole in the centre for the camera lens to fit into so the flash tube actually surrounds the lens. Ring flash was initially designed for close-up and macro photography, to provide even illumination of small subjects that are just inches from the camera. However, portrait and fashion photographers also began to use it on shoots as it creates an unusual shadowless 3D effect that's impossible to achieve with conventional flashguns.

Ring flash units intended for close-up photography tend to have a small guide number as the subjects are usually close – which means their effective range for non-close-up work isn't huge. Professional photographers use powerful studio ring flash units, which are bulky and expensive. Fortunately, for users of Canon and Nikon's most powerful flashguns there's a ring flash adaptor available from Rayflash that adapts the light to emulate a studio ring flash.

Power pack

If you use flash a lot for low-light photography, especially multiple flash techniques that require several bursts in quick succession, it's worth investing in an independent power pack for your flashgun.

The best known brand available is Quantum, and there's a range of different battery packs to fit just about any make and model of flashgun. These packs will recharge your flashgun much faster than normal AA alkaline batteries, provide hundreds more flashes between charges and can also be used to power your camera as well if you buy a suitable module/lead.

Noah and Kitty on Santorini
Although the integral flashgun in your digital compact or SLR has a relatively low output, don't dismiss it altogether – for close range subjects it's ideal, and in low-light can be use in combination with the camera's Night Portrait mode to create interesting slow-sync flash shots of both static and moving subjects.
SONY CYBERSHOT 6MP COMPACT WITH FIXED ZOOM AND INTEGRAL FLASH, 1/2SEC AT F/6.3, ISO80

Flash modifiers

The light from a hotshoe-mounted flash is very harsh and unflattering, creating bright highlights and dark, ugly shadows. If you regularly take pictures with flash, particularly of people, you should consider fitting an attachment to the gun that will diffuse the light and produce a more flattering form of illumination.

There are many different flash diffusers available, from simple translucent plastic covers, such as the Sto-fen Omnibounce that clip over the tube and are favoured by press photographers, to mini softboxes or brollies that soften and spread the light to give results similar to studio flash heads.

Flash brackets

Using your flashgun on the camera's hotshoe or a small side bracket is fine if you're using slow-sync flash for action shots or to illuminate static subjects in front of floodlit scenes at night. However, for more conventional indoor portraiture, the light produced will be harsh and unflattering, casting ugly black shadows behind your subject and potentially causing the dreaded red-eye.

The only way to avoid these problems is to get the flash high above the lens so the shadows are cast down and out of view and red-eye is eliminated, and the easiest way to do that is by attaching the flashgun to an adjustable bracket. There are various designs available that allow you to vary the height of the flashgun above the camera and also have a rotating arm so that you can position the flash as required, whether shooting in landscape or portrait format.

Getting the flash away from the camera like this also makes it easier to use attachments, such as mini softboxes, to improve quality of light.

SUPPORTING YOUR CAMERA

By its very nature, low-light and night photography usually involves working at relatively long exposures compared with most other subjects. Instead of using shutter speeds measured in hundredths or thousandths of a second, exposure times often run into many seconds, even minutes or hours. Consequently, if you want to produce pin-sharp images and have full control over your choice of ISO to maintain high image quality and lens aperture to maximize depth-of-field, your camera will need to be supported in some way to prevent it moving while an exposure is being made.

This is no great revelation, and many photographers do it as a matter of course, it's just that with low-light photography it becomes essential rather than optional.

CHOOSING A TRIPOD

Of all the camera supports available, nothing beats a solid, sturdy tripod. With your camera fixed to a tripod, exposure times become irrelevant – seconds, minutes, hours; it doesn't matter how long you need to keep your camera's shutter open because if it's perfectly still you will create a pin-sharp image.

The biggest mistake photographers tend to make when buying a tripod is choosing a model that tries too hard to compromise between weight and stability. Lightweight tripods may be convenient to carry around, but they can be surprisingly unstable, especially in windy weather or when using telephoto or zoom lenses. Equally, there's little point in going to the other extreme and buying a tripod that's so big and heavy you just can't be bothered to carry it.

▼ Edinburgh, Scotland
A sturdy, solid tripod is the most useful accessory you can buy, allowing you to produce pin-sharp pictures no matter how low the light is and how long the exposure. Test the models first, buy the best you can afford and most important of all – use it!
CANON EOS 1DS MKIII, 70–200MM ZOOM, 0.6ND HARD GRAD, TRIPOD, 25 SECONDS AT F/8, ISO100

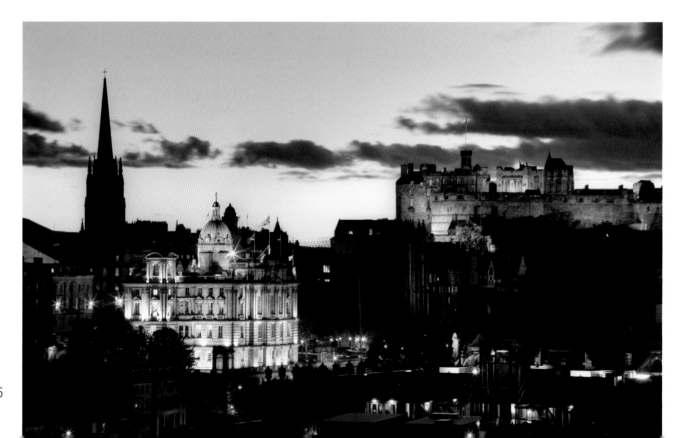

Extend your tripod to eye-level so you don't have to stretch or bend to see through the camera's viewfinder, make sure the head is level and fire the shutter using a remote release. Your images will be pin-sharp whether you expose for half a second or half an hour.

A good tripod head will not only keep the camera steady when it's in landscape format, but also when you turn it on its side to shoot images in portrait format.

The first step in achieving the compromise is to stick with reputable brand names, especially those that tend to be chosen by professional photographers, such as Manfrotto, Gitzo and Benbo. You may pay more but you will end up with a tripod that should last a lifetime and be reliable in all situations.

You can also put the odds of making a successful purchase in your favour by considering a few important factors:

• The tripod legs should have strong locks on them so the leg sections are solid when they are extended.
• The tripod should be able to extend to eye-level without needing to use the centre column, which is one of the weakest parts.
• Centre-bracing for the legs increases stability but can be restrictive because on uneven ground you need to be able to adjust each leg independently.
• Some manufacturers, including Gitzo and Manfrotto, produce carbon-fibre tripods,- which are considerably lighter than their alloy counterparts but match them for stability. They also cost at least double the price, but if weight is an issue they are well worth considering – I personally use a Gitzo carbon fibre tripod.
• Check the head for wobbles, which could lead to camera shake. Big, weighty tripod heads are much better than smaller, lightweight ones because they provide a more stable platform for the camera.
• You don't have to use a head from the same manufacturer as the tripod – even though my tripod of a Gitzo model I use a Manfrotto 410 Junior Geared Head on it.

• Many photographers prefer heavy-duty ball and socket heads to pan-and-tilt heads because they have less areas of weakness, are quick to use and are much more compact. Ball heads from manufacturer Really Right Stuff are among the best available. Arca Swiss is another well-known brand.

USING YOUR TRIPOD

Once you've found a tripod that suits your needs and budget, the battle is almost won. However, you won't get the best performance from your tripod if you don't use it properly, so here are a few tips:

• Always make sure the tripod is perfectly upright – a leaning tripod is an unstable tripod.
• Erect the tripod on solid ground if you can. Spongy surfaces such as bog or grass are unsuitable as they can easily lead to vibrations. Pushing the tripod legs down to solid ground can overcome this if you're working in undergrowth that creates a tangled barrier.
• Always extend the fattest leg sections first as they are the strongest, and make sure all leg locks are secure.
• If your telezoom lens has its own tripod socket, use it and fix the lens to the tripod head rather than the camera body. This will spread the weight of the camera and lens more evenly to reduce the risk of shake, and take the strain off the camera's lens mounting, which could be damaged by the weight of the lens. If you use long lenses that don't have their own tripod sockets, accessories are available that fit to the tripod and help to support the lens.
• Never extend the tripod's centre column unless you need to as it's the least stable part of the tripod. Achieve the desired height by extending the legs first.

I've been using the same tripod and head for a number of years – Gitzo GT3540LS carbon fibre legs, a Gitzo Leveling Base which helps when shooting images to stitch into panoramas (see page 180) and a Manfrotto 410 Junior Geared Head. It's quite a heavy combination, but it's rock solid and totally reliable.

- Don't extend the tripod higher than you need to, and don't splay the legs too wide to reduce height as this can lead to instability.
- In windy weather, increase the stability of your tripod by hanging your backpack over to lower its centre of gravity. Alternatively, carry a mesh or canvas bag that you can hang from the tripod and fill with stones to do the same job. Some tripods have a hook on the base of the centre column for this purpose.
- Always trip the camera's shutter with a cable release when it's tripod-mounted. This prevents you having to touch the camera and risk causing vibrations, which lead to unsharp pictures.
- Give your tripod a regular service to ensure everything is working properly. Fixings can wear loose and cause wobbles so they should be checked and tightened periodically, while controls on the trip head should be lubricated so they work smoothly and freely.
- If you use your tripod on a beach, rinse the leg locks with fresh water afterwards, not only to get rid of the sand but also to wash salt away as it's highly corrosive.
- Get into the habit of using a tripod at all times so it becomes a natural part of the picture-taking process rather than a hassle – your pictures will improve dramatically.

ALTERNATIVE SUPPORTS

Although a sturdy tripod provides the best form of support for your camera, sometimes it won't be convenient or possible to use one and a different type of support will be required. Here are the most common ones.

Compact tripod

As a back-up to your main tripod, a smaller table-top model is well worth considering for use in those situations where the size and bulk or anything bigger would be inconvenient. If you're shooting with a compact camera and want to travel really light, a pocket tripod will also be fine.

If you're shooting indoors you can set up the tripod on any available platform such as a wall, banister or table top. Outdoors, a pocket-tripod could also be placed on a convenient wall or post, or even the roof or bonnet of your car.

Small tripods obviously don't offer the flexibility of a full-sized model, but if you use them properly it's surprising just how

effective they can be, making it possible to take pictures in low-light situations where handholding is out of the question.

Monopod

Sport and action photographers favour monopods because they provide lots of support for long telephoto lenses but offer considerably more freedom of movement than a tripod. However, this one-legged accessory can also be invaluable for low-light photography, especially in situations where you don't need the kind of support a tripod can offer, or are unable to carry one, but light levels are too low to handhold the camera.

This includes taking pictures inside buildings or outdoors at dawn or dusk, photographing indoor sporting events, or concerts and plays. On the one hand, a monopod will allow you to use long lenses at shutter speeds slower than you could get away with handholding (see below). On the other, it can provide enough stability for you to take pictures with short focal length lenses at exposures down to 1/8, 1/4 even 1/2sec.

This can be invaluable for landscape photography in bad weather or low light, freeing you from the need to carry a heavy tripod but providing sufficient support so that you can still set small lens apertures to control depth-of-field, without worrying about slow shutter speeds causing camera shake. A monopod is also ideal for capturing street life, allowing you to move around much quicker than you could with your camera on a tripod.

HANDHOLDING YOUR CAMERA

Although there's no substitute for a sturdy tripod if you want to be sure of keeping your camera completely steady, in some low-light situations the use of one may be neither convenient or possible, and the only option is to take pictures handheld.

The rule-of-thumb when handholding is to use a shutter speed that at least matches the focal length of the lens – 1/30sec with a 28mm or 35mm lens, 1/60sec with a 50mm, 1/250sec with a 200mm, 1/500sec with a 500mm and so on. This is not only because longer focal length lenses are generally more difficult to hold steady due to their increased size and weight, but also because the longer the focal length is, the more camera-shake is magnified.

Saying that, providing you hold the camera properly, with practise it's possible to take pin-sharp pictures at much slower shutter speeds than these – down to 1/15sec or 1/8sec with short focal length lenses, especially if they have image stabilization (see page 26).

The first step is to make sure tha the camera is held firmly in your hands. The easiest way to do this is by gripping the right side

MAKESHIFT SUPPORTS

If you don't have a purpose-made support at your disposal, it's usually possible to find something else that can be pressed into service whether you're indoors or out. Walls, gates, posts, fence, the frame of an open car window, the back of a chair, your car bonnet and many other things are ideal, so if you're in a situation where you need more support than your hands can provide, have a quick look around and something is bound to turn up.

To increase the stability of a makeshift support you should ideally place something on it that will cushion your camera or lens. Many photographers carry a purpose-made or home-made 'beanbag' for this very task, which is usually just a fabric bag filled with dried peas or polystyrene balls. Alternatively, use a rolled-up sweater or jacket to cushion the lens.

Here a small beanbag was placed on the top of a steel frame and used to cushion and support the lens.

Back straight, feet apart, elbows tucked in, hold tight, deep breath, exhale… Squeeze the shutter. That's the key to successful handholding!

your left or right wrist so it pulls the camera into your hands. The best time to actually take a photograph when handholding is just after breathing out, so your body is relaxed, and you should do this by gently squeezing the shutter release button rather than stabbing at it with your index finger.

If you find that this technique still doesn't solve the problem, there are various other methods you can use:

- With telephoto or zoom lenses, try crouching down so your left knee is resting on the ground and your right knee is upright. You can then rest your right elbow on your right knee.

- Look for a convenient post, pillar or tree trunk and jam the camera against it. This can provide an extremely stable support and with short focal length lenses allow you to shoot at shutter speeds down to 1/4 or even 1/2sec.

- Lying flat out with both elbows resting on the ground to support the camera and lens can also work well, though the low viewpoint may not be suitable.

of the camera body with your right hand, so the right index finger falls naturally on the shutter release button. Meanwhile, the left hand should be cupped under the lens so you can support and – in the case of manual focus cameras – focus at the same time. If you're using a long lens, the left hand should support it at the middle or towards the front end, depending which you find the most comfortable. Avoid cupping the lens at the rear as the weight towards the front will put a strain on your wrist and increase the risk of camera shake.

Adopting a stable stance is important. Do this first by tucking your elbows into your sides so your arms form the two sides of a triangle and your chest the base. Next, stand with your back straight and your legs slightly apart – so your feet are as far apart as your shoulders. Don't lean backwards or forwards as this will reduce stability and increase the risk of camera shake. If your camera has a shoulder strap it can help if you wrap this around

HANDY ACCESSORIES

In addition to cameras, lenses, filters, flashguns, tripods and any other hardware you'll need to explore the mysterious world of low-light, there are various accessories and gadgets worth considering to make your life a little easier and hopefully help you take better photographs…

REMOTE RELEASE

As mentioned earlier in the section on camera supports, if you're shooting with your camera mounted on a tripod – as you will in probably 95 per cent of low-light situations – the shutter release should be triggered remotely rather than with your finger in order to reduce the risk of camera shake.

The likelihood of this happening is increased significantly when you're using the camera's bulb (B) setting, and the shutter release has to remain depressed for the duration of the exposure. Trying to do this with your finger without vibrating the camera is like trying to stop a hand grenade going off after removing the pin – the longer you do it for, the harder it gets!

There are two main types of remote release available for digital cameras. The most popular is an electronic cable release, which plugs into the camera body at one end and is activated by pressing a button at the other. Basic releases have just a button and a locking mechanism so you don't have to keep the button pressed during long bulb exposures. More sophisticated versions can be set to time a specific exposure, make delayed exposures after a preset period, make multiple exposures and so on.

I've always used the more basic type of electronic release as they're cheaper and I have a habit of losing or break-ing them! Instead of buying the camera maker's own releases I also buy cheap Chinese models from Ebay – they cost about five times less but look identical and work fine.

The other option is an infrared remote release, which allows you fire the camera wirelessly – handy if you want to include yourself in the shot. Not all cameras have this facility and on the occasions I've seen photographers using infrared releases on my workshops, they seem rather fiddly.

SPIRIT LEVEL

Judging whether or not you camera is perfectly square when taking pictures in low-light can be tricky, usually because there's no obvious reference point in the scene which you can rely on.

To overcome this, buy a small spirit level, which slips on the camera's accessory shoe on top of the pentaprism and provides an instant check for level. Wonky horizons can be corrected during image processing by rotating the image then cropping it, but it's better to get it right in-camera.

I find a hotshoe level especially useful when shooting with wide-angle lenses as judging whether or not the horizon is level is then trickier.

TORCH/HEAD TORCH

As well as being invaluable for painting with light techniques (see page 146), it's worth carrying a small torch so you can see what you're doing when taking pictures outdoors at night. There's nothing worse than trying to find some small accessory at the bottom of your backpack in darkness, or wanting to check camera settings and not being able to see them.

A pocket-sized torch will overcome both these problems. I also keep a head torch in my backpack so I can find my way to/from locations when light levels are low – reaching a location for pre-dawn involves setting out in darkness, and when you're out in the countryside where there is little or no light pollution, it does get really dark!

SPARE BATTERIES

There's nothing worse than the batteries in your camera or flashgun dying on you just as you're in the middle of taking a great photograph. To prevent this, always carry at least one spare set of batteries so you can swap them over if necessary. Batteries tend to drain faster in low temperatures, and when using long exposures.

LENS HOODS

If you're photographing night scenes or interiors where there are bright lights, there's risk of flare being created by light glancing across the front of your lens. This results in patches or streaks of light appearing on your images, or creates an overall haze, which reduces contrast and makes colours look washed-out.

If the lights causing the flare are visible through the viewfinder, there may be little you can do to avoid flare. However, if it's caused by lights that are just out of shot, you may be able to prevent it by fitting a hood on your lens.

Many zoom lenses come with a hood attached or supplied, but if not, collapsible rubber hoods are ideal as they cost little and take up minimal bag space.

To be honest, I rarely bother with lens hoods simply because I have a filter holder on my lenses most of the time, so the hoods that came with the lenses won't fit. I could purchase a hood that clips to the filter holder, but instead I tend to use either a piece of card or my hand to shield the lens if flare is a problem.

PIECE OF CARD

For some low-light techniques involving the use of your camera's B setting, it may be necessary to interrupt the exposure if a lull in the action occurs – while waiting for more traffic to appear if you are capturing traffic trails, or while more fireworks are launched if you're photographing an aerial firework display, for example. The easiest way to do this is by carrying a piece of black card – it needn't be any bigger than 10x8in – so you can hold it in front of the lens while the shutter is open, then remove it when you want to resume the exposure. The card also makes a handy lens shade to avoid flare.

BRUSH AND CLOTHS

It's important to keep your cameras, lenses and filters clean – especially optical surfaces that determine image quality. To do this, I carry a stiff brush that's used to remove dust, dirt and sand from the camera body and lens barrels, an anti-static brush with fine bristles for use on the lens elements and filters and several microfibre cloths which I use to remove finger marks, condensation and raindrops from the front element of my lenses or any filters on the lenses. The cloths are stored in polythene bags to keep them clean and free of debris, which could scratch delicate optical surfaces.

PHOTO BACKPACKS

All this equipment has to be carried somehow and protected from the elements. Shoulder bags tended to be used by photographers, with brands such as Bellingham being favoured for their good looks and robust build quality. The main downside with shoulder bags is that they're not very comfortable to carry when packed with heavy equipment – all the weight goes on one shoulder, which naturally throws you off balance and usually leads to aches and pains.

To overcome this, manufacturers started to design photographic backpacks and in the last 15 years they have completely taken over, with Lowepro being the world's most popular brand.

Backpacks are more suited to regular and sustained use because they distribute the weight evenly across your back and shoulders and allow hands-free operation. Removable padded dividers also allow you customize the interior to suit your needs, there are pockets for bits and bobs and the fabric used is at least showerproof – usually with a pull-over waterproof cover tucked away somewhere for rainy days.

I would never go back to using a shoulder bag as backpacks are much more versatile and comfortable. My current choice is a Lowepro Vertex 200, which comfortably carries my full digital kit.

Here's a selection of the 4Gb and 8Gb Compact Flash cards I use in my Canon DSLR. The 8Gb are a much cheaper brand than the 4Gb cards, but I've found them to be just as reliable, so don't assume you need to buy the most expensive cards.

MEMORY CARDS

The small plastic cards you slot into your digital camera are the modern equivalent of film – storage devices that are used to record captured images. When the card is full, you simply remove it and replace it with an empty card, in the same way that you would load a new roll of film.

The main difference between memory cards and film is that you can copy the images from a memory card onto a computer or alternative storage device, erase the images from the card by re-formatting it and use it over and over again. While the most shots you could take on a roll of film was 36, memory cards also have a much greater capacity and, depending on the card type, the pixel resolution of the camera and whether you're shooting in RAW format, JPEG, or both, you can take hundreds, perhaps thousands of images before the card is full.

There are numerous card formats available. Digital SLRs and many compacts use either Compact Flash (CF) or Secure Digital (SD) cards, although others are available such as Memory Stick and Memory Stick Pro Duo.

All types of cards come with different levels of storage capacity. A few years ago you could buy 256Mb or 500Mb cards and a 1Gb card was seen as an expensive luxury. But, as with all things digital, capability has gone up and price has gone down, so 4Gb is now considered about the norm for a memory card and 16Gb and 32Gb cards are now available.

The important thing to remember is that memory cards are not 100 per cent reliable and until the images on the card are copied onto a more permanent storage device they are vulnerable. If you use a 16Gb card in a digital SLR with a 10mp sensor and you shoot in JPEG format, you will literally be able to shoot thousands of images before the card is full. This may seem like a bonus, but if the card malfunctions when it's almost full, you could lose all the images on it forever. Therefore, it makes sense to stick with smaller capacity cards or make sure you download and back-up the images on a bigger card at least once each day, just in case.

I mainly use 4Gb CF cards in my DSLR. They only give me around 150 frames when shooting in RAW, but for me that's more than enough. I carry cards with a total capacity of around 90Gb when away on location. I always download the images from full cards to a laptop computer on a daily basis and back-up on to a 160Gb external drive. As an additional safety measure I also avoid re-formatting memory cards while I'm away unless I have to, though with the images from those cards downloaded onto two separate hard drives, it would be safe to do so.

PORTABLE STORAGE DEVICES

If you don't fancy the idea of taking a laptop computer on location or away on trips, consider buying a smaller portable storage device instead so you can back-up image files.

There are many different devices on the market today, with prices to suit all budgets and storage capacities from 20–160Gb. All are similar in that they allow you to insert a memory card and copy the data from it. Many also have a preview screen so you can check the images as well, and they have high capacity batteries so that you can use them on location for hours on end.

The Epson P–7000 is one of the latest generation of portable storage devices that allows you to download and view your digital images while on location.

SENSOR CLEANING

One disadvantage of digital SLRs is that try as you might, it's almost impossible to keep the sensor free of dust. Even models with integral sensor cleaning, like my Canon EOS 1DS MKIII, still suffer, so periodically you'll have no choice but to clean the sensor – or spend ages cloning out dust spots from your images.

I'll be honest – cleaning my camera's sensor scares the life out of me. I've heard too many horror stories about ham-fisted photographers doing more harm than good, and until recently I used to send my camera body away twice a year for a professional sensor clean. Unfortunately, during a trip to Iceland in 2010, during which I photographed the Eyjafjallajokull eruption, I had no choice but to clean my DSLR's sensor simply because it was in such a mess. Having done it, and realized that it's a straightforward procedure if you have the right tools, I now enjoy the prospect of a good sensor clean – knowing it will save me hours of computer time.

To check if your camera's sensor needs a clean, take a shot of a plain area such as the sky using a wide-angle lens stopped down to f/16 or f/22 then examine the image on the camera's preview screen or even better, download it to your computer. By zooming into the image and scrolling around it, you'll see if there are black blemishes caused by dust or hairs. If there are, you need to remove them.

This enlargement of a RAW file shows you what sensor dust looks like. Cloning it out is fairly easy and in a strange way quite therapeutic, but keeping the sensor dust-free is preferable.

I use items from the Visible Dust range, and the way I clean the sensor depends on how bad it is. The first step is to set the camera up for a sensor clean – check your owner's manual to find out how – then remove the lens. I always do this with the camera body facing down to reduce the risk of more dust getting inside the camera.

Next, I give the sensor a few gentle blasts using a Zeeion air blower, which blows oppositely-charged air at the sensor to prevent the dust being re-attracted to it and also has a one-way valve so the dust can't get inside the blower – only to be blasted back out again. This removes most of the dust.

Here are the Visible Dust items I use to clean my camera's sensor – Zeeion blower, sensor loupe, Arctic Butterfly sensor brush and wet swabs. Cleaning is only done when absolutely necessary.

Step three is to reach for my sensor loupe, which is a magnifier with LEDs. By placing it against the camera body I can peer inside and get a great view of the sensor and see where the stubborn dust spots are.

More targeted blows with the Zeeion often get rid of these specs, but if not, I use my Arctic Butterfly brush. Vibrating the microfibre bristles for a few seconds using the internal motor put a negative charge on them, then when the brush is carefully drawn across the sensor it attracts the dust like a magnet. These brushes need to be used with care – only do one or two passes and avoid the edges of the sensor otherwise you may pick up lubricant from the mirror box and smear it on the sensor, making cleaning even more difficult.

If the worst comes to the worst, special swabs can be used to wet clean the sensor. They come in different sizes to suit different sensors and are designed to remove oil, saliva and other nasties.

I always carry a pack of swabs with me when I'm away from home, but so far have never needed to use them – and hope I never do!

Of course, the easiest way to avoid sensor cleaning is to prevent dust and muck getting on the sensor in the first place. Never change lenses in windy conditions – go inside a building or your car to do it – change lenses as infrequently as possible, and always turn your camera off before removing a lens so the sensor isn't powered and there's no static electricity to draw dust towards. Prevention, as always, is better than cure!

THE DIGITAL WORKSTATION

Remember the days when photography involved shooting rolls of film, sending them off to a commercial lab for a processing and waiting a few days for the postman to deliver a pile of prints or a box of colour slides? If you do, then like me you'll still be coming to terms with the changes the digital revolution has brought about. If you don't, well, what you never had you'll never miss.

Photography today is very much an in-house affair – you take the photographs, download them to a computer, 'process' the image files, enhance and manipulate them, save them and back them up and, if the feeling takes you, you might even runs off a few prints, or publish a photo book or create a website…

Taking on these extra tasks definitely makes the photographic learning curve steeper and longer because, as well as mastering your camera, you also need to become adept with a computer and sophisticated software. But long term, the DIY approach digital imaging requires will definitely add to your enjoyment and make photography an even more exciting and rewarding pastime than it ever was.

This chapter looks at the equipment you need to set-up a digital workstation, so you can transform your image files from millions of coloured dots to amazing photographs.

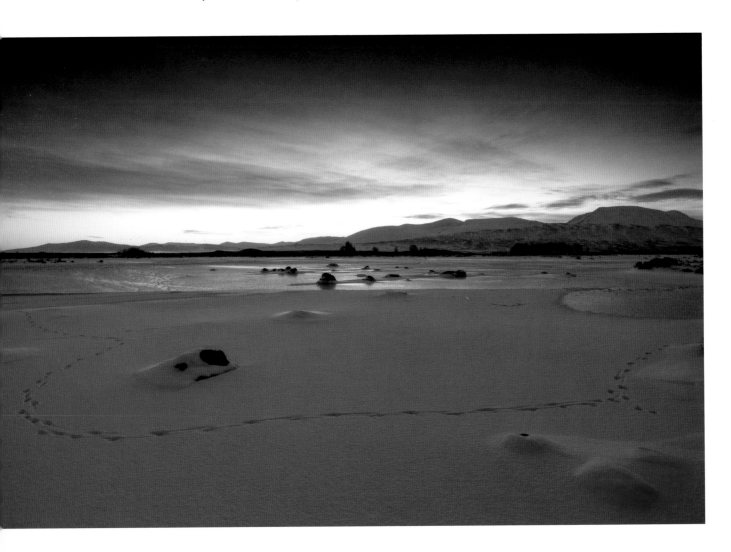

COMPUTER

The computer forms the heart of any digital workstation, not only providing a relatively safe place to store your image collection, but also to 'process' RAW files, enhance and manipulate them, create presentations, upload images to websites, email them to friends and maybe output your favourites as prints.

There are two main options when it comes to computer choice – a Windows-based PC or Apple Mac. PCs are far more widespread and popular than Mac, but in recent years, thanks to other Apple innovations such as the iPod, iPhone and iPad, the brand has received much greater recognition and Macs are finding their way into many more homes. They are also industry standard in the worlds of design and publishing.

Whichever type you choose, you need to accept that before long it will seem slow and outdated compared to the latest model, which annoyingly costs less than what you paid for yours. That said, if you buy the best you can afford at the outset, it will sustain your for years, simply because advances in computer hardware are slowing down and we are reaching the stage where more memory and greater operating speed simply isn't necessary.

Here are the main features you need to consider when shopping for a computer:

• Processor

The speed at which the computer operates is governed by the processor it uses. Intel is the best-known brand, being widely used in both PCs and the latest Macs. They're getting faster all the time, but the norm these days seems to be a dual-core or quad-core processor with an operating speed of 2.8–3.0Ghz. Top-level machines have 8–core, 3Ghz processors, but such performance is only required by professionals.

• Random Access Memory (RAM)

RAM is used by the computer to process applications and actions, so when you launch an application such as Photoshop, open and work on images and perform other tasks, the computer's RAM is used. Basically, the more you have, the better – especially if you

◁ Loch Ba', Rannoch Moor, Scotland
The editing, processing, enhancement, cataloguing and printing of digital images is an integral part of modern photography, and if you want your own photographs to realize their full potential you really have no choice but to embrace new technology. It's not nearly as difficult as it appears though, and once you master the basics you will never look back – since switching to digital capture I can honestly say my photography has improved and I'm enjoying it more than ever.
CANON EOS 1DS MKIII, 16–35MM ZOOM, 0.9ND HARD GRAD, TRIPOD, 1/3SEC AT F/16, ISO100

◁ I've been a dedicated Apple Mac user for almost 20 years now and wouldn't consider changing. As well as being stylish and intuitive, they're also reliable – Macs don't suffer from viruses like PCs do. My first Mac had 4Mb of RAM and a 40Mb hard drive. My latest machine is a Quad-Core Intel Mac Pro with 4000Mb of RAM (4GB) and almost two million Mb (2TB) of hard drive space – a sign of how technology has advanced!

work with large image files. You can manage with 2GB of RAM but the more you have the better – 4Gb or more ideally.

• Hard drive

All data is stored on the computer's hard drive (HD) so the bigger it is the better. Today's Macs and PCs may offer up to 1Tb (1000Gb) of storage on a single internal drive with the option to add more internal drives. This may seem like a phenomenal amount, but given that digital image files are getting bigger, software packages are taking up more memory and computers are also used for home entertainment, it is surprising how quickly your HD will fill up.

• Interfaces

Any accessories you buy for your computer, such as scanners, printers, card readers and external drives will connect to it via an interface. The most common is USB2 (Universal Serial Bus) but the other main interface is Firewire, which is faster than USB2 and the preferred choice of photographers.

• DVD reader/writer

An easy, practical and inexpensive way to back up digital images is by copying the files to writeable DVD – DVD/R. Each disc will hold 4.7GB of data and yet takes up very little space, so you could back up your whole archive and store the discs at a different location from your computer. That way, if your computer suffers a catastrophic crash, is destroyed by fire or flood or stolen, you'll have a copy of all your images elsewhere. DVDs aren't totally stable though, so don't rely on them completely and always back-up images onto external hard drives as well.

MONITORS

While the computer handles storage and runs applications, it's the monitor that brings your images to life and allows you to see exactly what they look like and what happens when you perform certain actions – be it adjusting colour and contrast, cropping, or creating special effects. To do the job efficiently and effectively you therefore need to make sure the monitor you choose is suited to the job and gives an accurate rendition of what the image is really like.

Modern monitors tend to be LCD rather than the older CRT (Cathode Ray Tube) design. They're sleek and slim, occupy little desk space and are available in sizes from 15–30 inches. If you need more screen space, it may be less costly to buy two smaller monitors and run them side-by-side. A pair of 21-inch monitors will cost less than a single 30-inch one, for example, and you can use one to view images and the other for tools and dialogue boxes. In all cases, make sure the monitor can display millions of colours and that screen resolution is a minimum of 1024x768 pixels.

Deciding between one monitor and another is tricky. If you buy a PC and it comes bundled with a monitor, chances are that monitor won't be the best model going so consider using that as your second 'toolbox' monitor and buy a better quality one on which to view images. If you're a Mac user, the Apple Cinema Screens are high quality but the majority of photographers who use Mac machines go with non-Apple monitors that have more controls for calibration. The monitors for the latest iMacs are superb, but they have a shiny surface that you may find problematic for viewing photographs on. Ultimately, it's about preference and taste, but just as lenses control the quality of your images more than the camera they're fitted to, the monitor you use to view those images plays a more important role than the computer it's connected to.

There's a vast range of applications available today to help you get the most from your digital images, with Adobe Photoshop being the most popular and sophisticated.

SOFTWARE

In order to work on digital images you will need suitable software, and by far the most popular package used by photographers worldwide is Adobe Photoshop. It has been the industry standard ever since digital imaging became accessible to the masses and with each new version (the latest is CS5) it becomes more intuitive, more user-friendly and more sophisticated, allowing you not only to make technical adjustments and corrections to an image, but also to create a vast range of creative and special effects, combine whole images or elements from many different images, stitch images to create panoramas and so on. It is amazing!

The full version of Photoshop is expensive and contains many features you will never use, so initially you could work with the more basic Photoshop Elements, which contains all the main features you're likely to need but costs a fraction of the price and is often bundled with digital cameras and scanners. If you ask around among your photography friends there may even be someone with a spare licensed copy of Elements that they don't need.

In addition to Photoshop there are many other graphics packages and plug-ins available that let you to perform specific

The importance of investing in a good quality monitor can't be underestimated – it's the one item you'll rely on more than any other to judge your images. I've used a number of monitors over the years, but my current model is probably the best one so far, a Mitsubishi NEC SpectraView 2690 with a 25in screen. It was expensive, but has paid for itself several times over already.

tasks such as adding borders, mimicking the effects of certain films, converting to black and white, creating HDR images and so on.

Image management software such as Adobe Lightroom or Apple Aperture (see page 59) will also do most of the things that Photoshop can do for a fraction of the price, as well as allowing you to manage your growing image collection.

PERIPHERALS

• Card readers

Though it is possible to connect a digital camera direct to your computer via a USB or Firewire port to download images from the memory cards, it is much easier to remove the card from the camera and insert it into a card reader, which is basically like a small disc drive. Some readers are made to handle one type of memory card, such as Compact Flash or Secure Digital, but there are also multi-slot readers available that will handle all card types.

◄ Card readers are relatively inexpensive but allow you to download your images quickly and easily.

• Graphics tablets

If you do a lot of intricate work on digital images, such as selecting detailed areas so you can work on them independently, a graphics tablet will make life much easier. They consist of a flat tablet like a mouse mat and a pen-like stylus, which you can use to work on an image with far greater precision than a conventional mouse.

• External hard drives

External hard drives provide an inexpensive and practical way of making back-ups of your digital images and also easing the pressure on your computer's internal hard drive. They simply plug into the computer via a USB or Firewire port and appear on the computer's desktop as a separate icon so you can drag and drop individual files or folders from the main computer.

I have a number of external drives. One, with a capacity of 1Tb (Terra Byte = 1000Gb) is used as a 'Time Machine' on my Mac and automatically backs up the system every hour, then condenses those hourly back-ups into daily back-ups and so on. If my main computer hard drive, containing all the applications and documents, should crash, everything on it is backed-up on the Time Machine. If I accidentally delete a file or document I can also go back in time on the Time Machine and retrieve it. Clever stuff.

In addition to this drive, I have two 750Gb external drives onto which I back-up all my processed image files, plus two 500Gb external drives onto which I back up all RAW files. This means I have two copies of processed images and RAW files outside my

◄ Use external hard drives to back-up your processed images and RAW files/JPEGS. The three drives here provide a total of 2.5Tb of storage. That's a lot of images!

main computer hard drives. Once the drives are full, I disconnect them, store them in a safe place and connect up new drives.

Finally, I have another 1Tb drive onto which I make a copy of all processed image files. This is kept by friends in their home as extra security and periodically I retrieve it, back-up new images and return it to my friends.

• Mutli-port hubs

All computers have USB ports while most have both USB and Firewire. There are rarely enough, though, so you will almost certainly need to purchase multi-port hubs that allow you to connect several peripherals to the computer via just one port.

PRINTERS

Having recorded an image with your digital camera, downloaded it onto a computer, processed the file, enhanced and manipulated it, the final stage is usually to create a photo-quality print.

Until a few years ago, the only way to do this and achieve a high-quality result was by sending the image away to a printing studio, but thanks to huge advances in inkjet printer and ink technology it is now possible to produce your own prints for a relatively small investment – and they are every bit as good as those from a professional lab.

Canon, Epson and Hewlett Packard are the main names in inkjet printing and all produce a range of models to suit every budget and need, from compact and inexpensive A4 colour printers to A3 and A3+ models. A range of professional large-format printers are also available with paper widths of 17-inch, 24-inch, 36-inch, 48-inch and even 64-inch!

For the majority of photography enthusiasts, A3+ is more than big enough, allowing you to produce prints up to 13x19 inch and in some cases load paper rolls so you can print panoramas up to 13-inch deep and as long as you like! Beyond A3+ the printers are big, heavy, expensive to buy and expensive to run, so unless you need to produce prints bigger than 13x19 inch on a regular basis, they're unnecessary.

The latest pigment inks used in inkjet printers are much more stable and consistent than earlier inks and, combined with a huge range of inkjet papers in different weights and surface finishes, they allow you to produce prints that have the same quality and archival permanence as traditional silver-based prints.

◁ A good quality inkjet printer will allow you to produce photo quality prints from your favourite digital images. I started out with an A3+, upgraded to a 17in (A2) model and now use a 24in Epson 7880 wide-format printer. It's superb!

COLOUR MANAGEMENT

If you want to produce the best possible results when working digitally, your computer monitor and printer must both be set up so that the prints look like the images you see on the screen and vice versa. If you ignore this, you'll waste a lot of time, paper and ink trying to adjust images on-screen so that the prints from them are acceptable to you, but never quite knowing if the monitor is at fault, the printer or both. Believe me, I know better than most, having spent a long time filling bins with rejected, defective prints.

◁ Monitor calibration units like the ColourView Spyder II shown, are essential for accurate colour management while printer/paper specific profiles (below) help to ensure your inkjet printer delivers optimum print quality.

Fortunately, it doesn't have to be that way because if you calibrate your monitor on a regular basis so the contrast, brightness and colour balance are correct, what you see on the screen will accurately reflect what the image really looks like.

Similarly, if you use ICC profiles for your printer to optimize its settings when using specific inks and papers, your prints will not only look exactly the same as the image on the screen but print quality will also be at its highest.

The easiest way to calibrate your monitor is by investing in a hardware-based calibration unit that hangs in front of the monitor so a sensor in the unit can assess the colour output. Software then adjusts the colour channels and a custom profile is created which is embedded in the monitor preferences so that every time you

turn the computer on, the monitor settings are controlled by the profile to ensure consistency. When you re-calibrate, the new profile automatically becomes the default profile used by the computer.

Similarly, with printers you can use custom profiles to colour manage when outputting on certain papers using certain printers. The paper manufacturers put these profiles on their websites so you can download then for free and install them onto your computer. Alternatively, you can have profiles written for you for use with specific ink and paper combinations. Either way, when you go to print an image, you can choose the specific profile for your printer model and the paper being used.

By calibrating your monitor and profiling your printer, you should be able to edit images on-screen with confidence and output top-quality prints every time.

IMAGE MANAGEMENT

In the good old days of film, managing your photo collection was relatively straightforward. Colour slides were usually mounted on individual card or plastic mounts, then stored in transparent sheets that could be hung on suspension bars in filing cabinets or clipped into ring binder folders. Negatives were placed in strips in paper sleeves then filed in a similar way, while prints could be placed in portfolio cases, presentation boxes or empty printing paper boxes.

With digital photography it's not quite so straightforward because the images exists in a virtual world – cyberspace – so unless you formulate some kind of logical computerizes system of organizing and filing batches of images as you shoot them, being able to locate specific images from the many thousands you end up with could take forever.

Software packages such as Adobe Lightroom and Apple Aperture can make image management much easier because they allow you to organize your collections and access them based on key wording each image. For example, a photograph of the Taj Mahal in India could have the following keywords: Asia, India, Agra, Taj Mahal, Architecture, Ancient, White, Domes, Ornate, Atmosphere and so on. If you were searching for images in the future and you entered any one of those keywords, the image would be called up, along with any others that matched the same keyword. The metadata recorded by the camera can be used as a basis of a search – so you can call-up all images shot at a certain shutter speed, f/number, ISO or focal length. Images can also be organized by subject, or you can have folders for favourites, or give images a star rating and so on.

In addition to file management, these software packages also have powerful RAW conversion tools, so that when you download images into the application you can convert the RAW files, enhance the images by adjusting colour balance, exposure and contrast, convert to black and white, tone images, crop them and organize them, all in the same place. Even better, the changes made to each image are saved as a series of actions so they are non-destructive, the original image file remains unchanged and consequently, far less computer memory is used.

It is much easier to use a system like this if you start it when your image collection is quite small. Wait until you have hundreds or thousands of images and it will take an age to input them into the system.

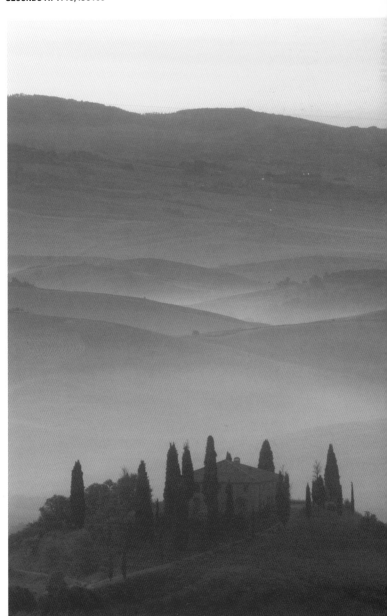

▽ **Val D'Orcia, San Guárico D'Arcy, Tuscany, Italy**
Colour management ensures your computer monitor gives an accurate rendition of your images and your printer matches that.
CANON EOS 1DS MKIII, 70–200MM ZOOM , 0.6ND HARD GRAD, TRIPOD, 10 SECONDS AT F/16, ISO100

FUNDAMENTALS

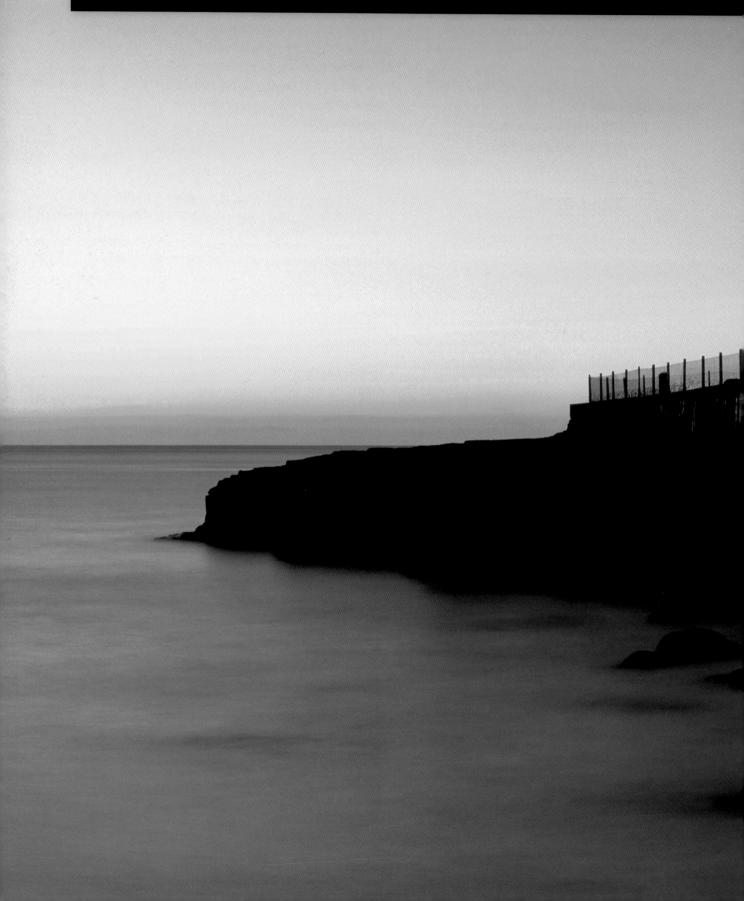

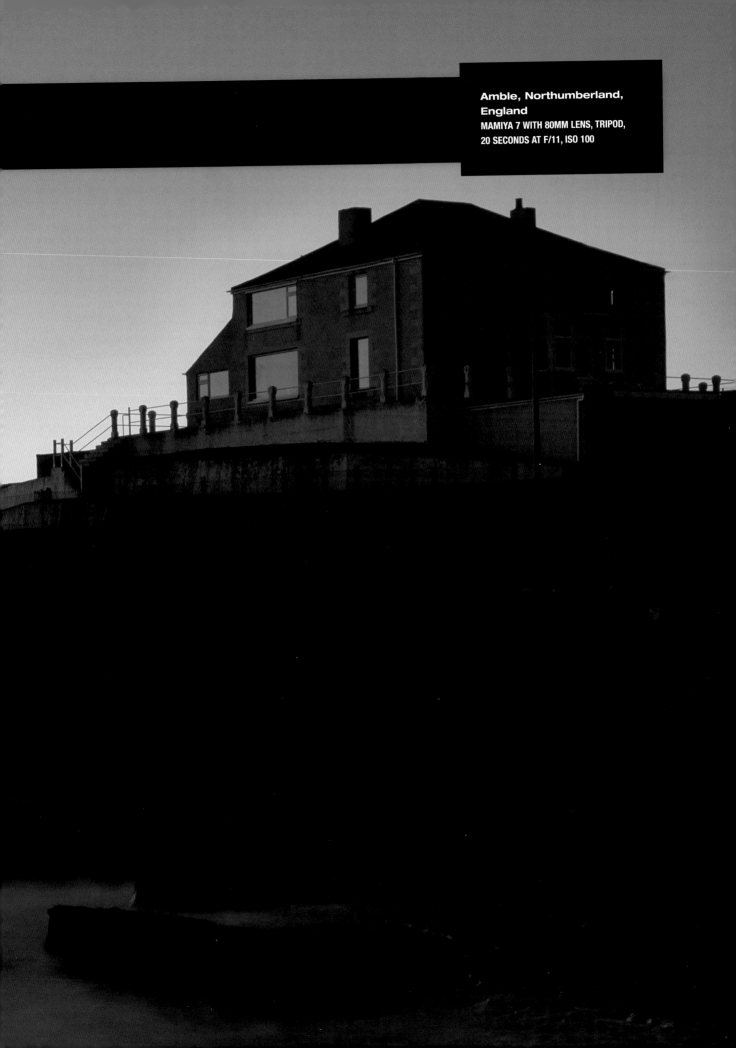

Amble, Northumberland, England
MAMIYA 7 WITH 80MM LENS, TRIPOD,
20 SECONDS AT F/11, ISO 100

UNDERSTANDING LIGHT

Think of any night or low-light subject, and the one factor more than any other that determines the success of a photograph is the quality of light. From the warm glow of a flickering candle flame or traffic trails on a busy road, to a floodlit building against the twilight sky or colourful illuminations strung along a seaside pier, night and low-light photography is concerned more with harnessing and exploiting unusual lighting situations than anything else. An understanding of the different types of illumination you're likely to encounter, both natural and artificial, and the factors that influence the quality of light, is therefore vitally important if you're to make the most of each situation.

▽ Edinburgh, Scotland

Extremes of daylight can produce breathtaking conditions for outdoor photography. The ideal time to shoot urban scenes is during the 'crossover' period after sunset, when daylight levels fade and artificial lighting adds vibrant splashes of colour. Find a good view in any town or city and you can't fail to produce great images – but act fast because the prime shooting period doesn't last for long.
CANON EOS 1DS MKIII, 70–200MM ZOOM, TRIPOD, 15 SECONDS AT F/16, ISO200

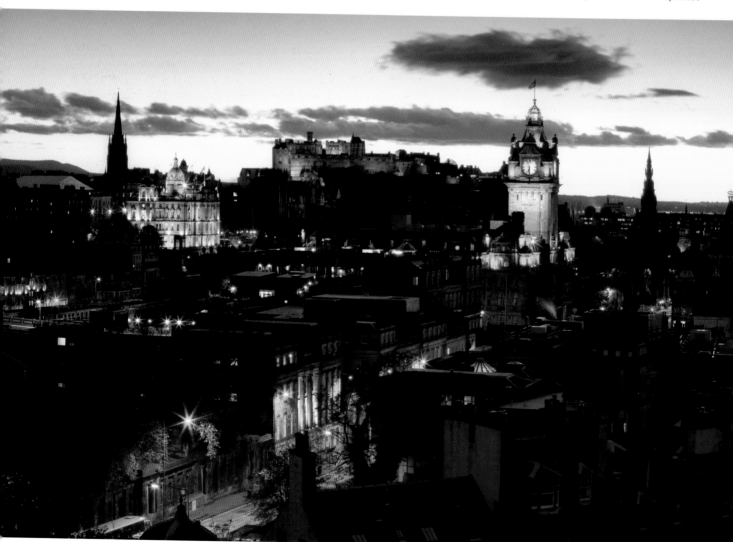

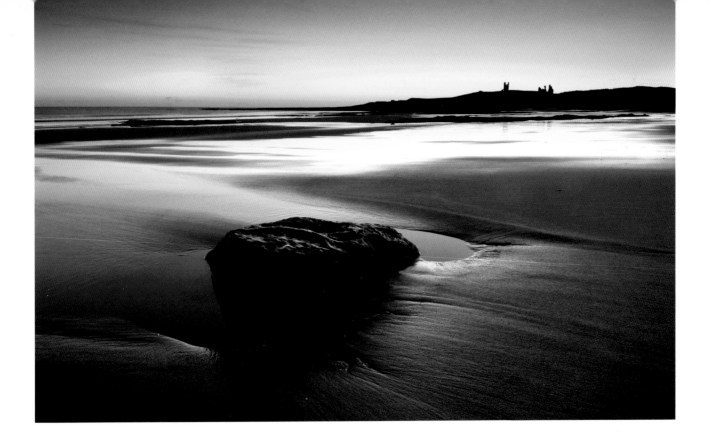

NATURAL DAYLIGHT

Daylight is an ever-changing force. From the moment the sun rises every morning to the time it sets every evening, the colour, harshness and intensity of the light is forever changing. And although low-light photography only involves working in extremes of daylight, it's surprising just how different that light can be from one minute, one hour, one day or one month to the next.

PRE-DAWN

Before the sun rises, any light striking a scene is reflected from the sky, which acts like an enormous diffuser. The light is soft and shadows are weak to the point of being non-existent. The colour of the sky also influences the colour of the light. Well before sunrise the sky overhead will either be blue in clear weather or grey in cloudy weather so the light takes on a cool-blue cast that can be very atmospheric. During the last 30–40 minutes before the sun is due to rise, the sky will hopefully begin to 'colour-up' with warmer hues of reds and oranges. As it does, the mood of the scene changes completely. Areas of the scene still illuminated by reflected light from the sky overhead will retain a steely-blue cast while the eastern sky glows red and orange to create a stunning colour contrast. If the warm colour in the sky spreads far enough, the coolness in the foreground will then fade until the whole scenes basks in a wonderful warm glow.

Pre-dawn is an ideal time to shoot low-light landscapes. Scenes

▲ Embleton Bay, Northumberland, England
When you're shooting low-light images outdoors, knowing where to head to make the most of different types of light helps enormously. This pre-dawn shot was taken at a location I had visited many times before. From experience I knew that if the tide had been receding through the night and the weather was clear, conditions would be perfect. My hunch paid off and the early start was well rewarded. The cold/warm contrast is typical of pre-dawn, with the foreground taking on the cool colour of the overhead sky.
NIKON D3X, 24–70MM ZOOM, 0.9ND HARD GRAD,12 SECONDS AT F/16, ISO100

containing water can be particularly enchanting, especially in calm weather when the surface is mirror-like, or wintry scenes covered in snow, mist or thick frost. The coastline is another great hunting ground before sun-up. Low light levels allow you to use long exposures to record motion in the sea, while rock pools reflect the colour in the sky and provide bold splashes of foreground interest.

City streets have a completely different mood before sun-up too. The roads are empty of both traffic and people, and an eerie stillness pervades. Street lighting also looks effective in the cold, blue light, adding welcome splashes of warmth.

The pre-dawn period begins at different times of day depending on the season. In high summer, first light may occur as early as 2–3am, whereas in winter you needn't venture outdoors until 7am. Above the Arctic Circle, this pre-dawn period persists all day during winter, because the sun never rises, while in summer, when the sun never really sets, you can shoot all night long in the atmospheric twilight glow.

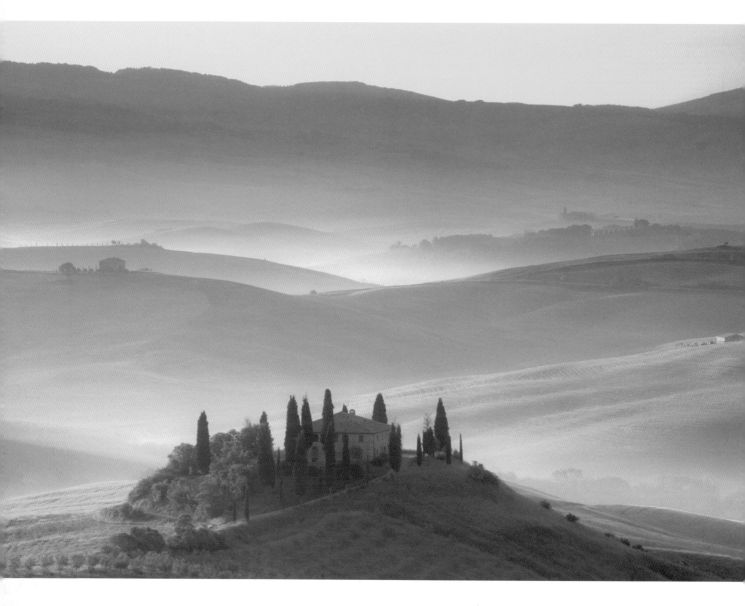

SUNRISE

As the sun rises, the quality of light changes dramatically in a very short space of time. Often the rich pre-dawn colour in the sky fades in the moments before sun-up which is why you should be on location at least an hour before the sun's due to rise.

Once the sun breaks the horizon in clear weather, golden rays of light burst across the landscape. If you've been shooting into-the-sun until now, this is time to start checking out the landscape from other angles, not only because the intensity of the sun will almost certainly cause flare on your images, but also because the light will be performing its magic elsewhere. The low sun has an amazing warmth in the first few minutes after sunrise and coming from such a low angle it rakes across the landscape, casting long shadows that reveal texture and form. The shadows also have a cool cast blue because they're lit mainly by skylight overhead,

which is usually still blue, and this contrasts beautifully with the warm sunlight.

Occasionally, when there is broken cloud in the sky and the rising sun illuminates it from underneath, the light can be magnificent, but in temperate regions it's usually a more subdued affair, and on cloudy days you may only have a minute or two to capture light breaking over the horizon before the sun rises and is obscured by cloud. On cold, misty mornings, the sun may also appear much bigger than normal because its light rays are scattered by the atmosphere. This scattering also reduces the sun's intensity, so you can shoot it without your photographs suffering from flare.

Sunrise is again an ideal time to shoot low-light landscapes, buildings bathed in the first light of the day, or warm sunlight burning through mist in woodland. The warm glow of first light can also be used for outdoor portraiture.

◁ Val d'Orcia, Tuscany, Italy

I've photographed this scene many times and it never fails to inspire. A 5am start is necessary to catch it at its best, when the valleys are filled with delicate mist and the undulating landscape folds away into the distance. Stumble upon it in the middle of the day and it hardly warrants a second glance, but at dawn it has to be one of the most beautiful views in the world.

CANON EOS 1DS MKIII, 70–200MM LENS, 0.6ND HARD GRAD, TRIPOD, 1/8SEC AT F/16, ISO100

Havana, Cuba ▷

Sunrise is a magical time of day, though the type of images you produce will depend not only on the weather conditions but also where you are. In urban or industrial locations smoke, haze and pollution scatter the light to give a more pronounced warm glow whereas out in the countryside or on the coast where the atmosphere is cleaner, the colours are often more subdued.

CANON EOS 1DS MKIII, 70–200MM ZOOM, 6ND HARD GRAD,1/500SEC AT F/6.3, ISO400

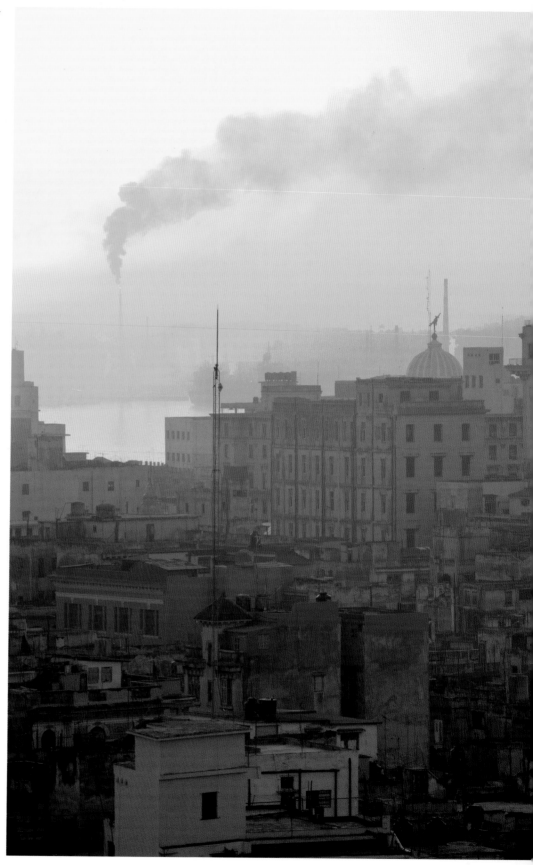

THE GOLDEN HOUR

Once the sun has risen, light levels climb quickly and low-light photography is no longer possible, outdoors at least, until later in the day. The best time to begin work again is about an hour before sunset, during a period fondly known as 'The Golden Hour'.

This name is given, as you might have guessed, because the light is warm – the closer to the horizon the sun is, the warmer the light gets. This assumes clear weather, of course; in cloudy conditions the colour and quality of the light will show little change at all.

Sunlight tends to be warmer at the end of the day than the beginning because the atmosphere is denser and in urban or industrial areas where pollution is more likely, the light is scattered, much of its blue wavelengths are absorbed, and the redder wavelengths are left to perform their magic.

Everything the light strikes takes on a beautiful golden glow, whether it's a person's face, a building or a mountain, and it's hard not to take successful pictures at this time of day. The colour temperature of the light is also much lower than around midday, so your pictures will come out even warmer than you expected (see page 72). Shadows are also long again, and rake across the landscape revealing texture in the flattest of scenes. Shadows cast by trees, people and lamp posts seem to stretch for miles, creating fascinating patterns and lines, while the low sun reveals gentle ripples on sandy beaches and the rough texture of surfaces such as stone walls or tree bark.

▽ Nkob, Morocco

The last hour before sunset isn't called the 'Golden Hour' for nothing. In clear conditions, rich, sumptuous light adds a Midas Touch to the landscape while long, raking shadows reveal texture and form. The light has more 'body' in the evening due to haze and pollution acting as a filter, blocking the cooler wavelengths and letting the warmer light perform its magic.
HASSELBLAD XPAN, 90MM LENS, 0.6 ND HARD GRAD, TRIPOD, 1/4SEC AT F/16, ISO50

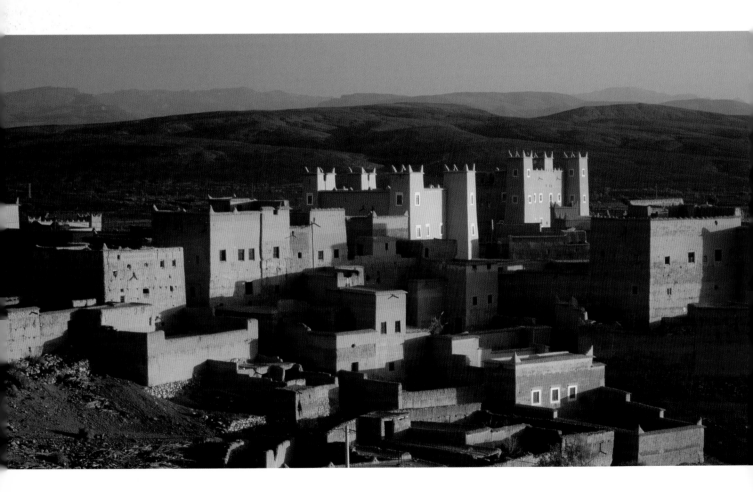

SUNSET

Although sunrise and sunset are pretty much the same thing in reverse, you can often tell one from the other when looking at photographs. This is mainly because the warmth of the light is usually greater at sunset than at sunrise due to the effects of atmospheric haze scattering the light, and the fact that the sun sets on a warm earth whereas it rises over a cold earth, so you don't get the same warm/cold contrast at sunset.

The beauty of a setting sun is hard to beat, though its impact is influenced by prevailing weather conditions, and in many parts of the world – especially temperate regions – no two sunsets are the same and it can be impossible to predict what it's going to be like from one day to the next. Visiting a location specifically to photograph the sunset can therefore be disappointing, but this disappointment is more than made up for by the occasions when everything falls perfectly into place.

What makes sunset so appealing for photographers is its versatility. You can use the sun's fiery orb and golden sky as a backdrop to silhouettes one minute, then turn your back and capture the golden glow of its light on buildings, people and scenery the next. Often the sun's orb is too intense to include

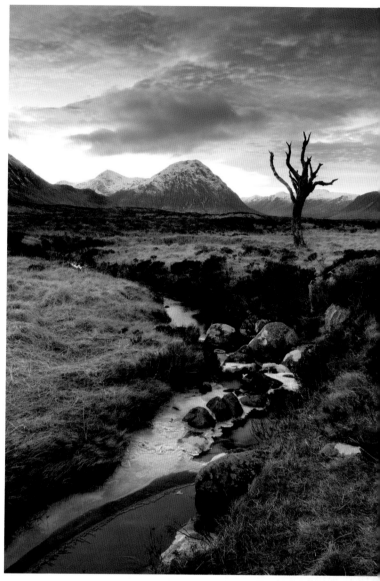

Rannoch Moor, Scotland
One benefit of shooting sunset over sunrise is that you can anticipate whether or not a stunning sunset is likely to materialize by observing the light and weather through the afternoon – then make sure you get to a suitable location. With sunrise it's a case of setting your alarm clock early and hoping for the best. I had visited this location earlier in the day but the light was rather bland and didn't do the dramatic scene justice. Later in the day, however, I sensed that a great sunset was likely so I headed back over the moors and waited for nature to take its course. This is one of many shots taken that evening – I couldn't have wished for a better sunset.
CANON EOS 1DS MKIII, 24–70MM ZOOM, 0.9ND HARD GRAD, 2½SECS AT F/16, ISO100

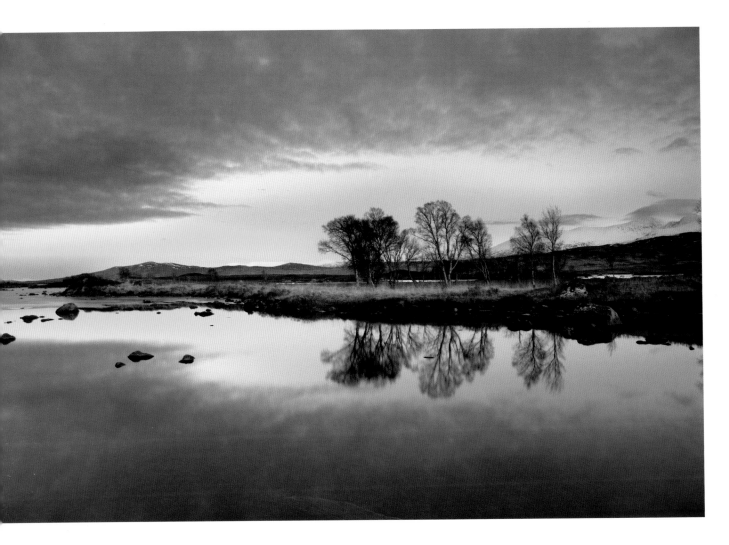

in your pictures, but in urban areas, where pollution clogs the atmosphere, this is less common and you can often capture it sinking towards the horizon. The light also looks much warmer in photographs than it did to the naked eye because its colour temperature is very low.

In clear weather sunset tends to be a rather subdued affair. There's no fiery fanfare, it just sinks below the horizon and any warm afterglow quickly fades. The light striking the landscape retains a fair degree of intensity until the moment the sun disappears, however, so although you may have made the effort to stay out in order to capture a magnificent sunset sky, it's worth changing tack and instead capture the effects the dying embers of daylight have on the landscape – the resulting photographs can be just as magnificent.

To get that magnificent sky we tend to associate with sunset, you need cloud; not so much cloud that it totally snuffs out the sun, but just enough so that as the sun sinks below the horizon it uplights any cloud above it. Ideally the cloud also needs to be fairly close to the horizon; if it's too high in the sky you may not be able to include them without compromising the composition.

Loch Ba, Rannoch Moor, Scotland

Once the sun has set, twilight approaches and the warm colours in the sky gradually fade to purples and blues – a great time to shoot landscapes, and if you can include water to mirror the soft colours, so much the better. On clear evenings, Alpenglow can often be seen in the sky opposite to where the sun actually set. It appears as a red band and is caused by back scattering of the light when the sun is below the horizon. This view of Loch Ba shows Alpenglow. You'd be forgiven for thinking the glow in the sky is where the sun had just set, but in actual fact it had gone down behind my back.

CANON EOS 1DS MKIII, 24–70MM ZOOM, 0.45ND HARD GRAD, TRIPOD, 0.5SECS AT F/11, ISO100

Cienfuegos, Cuba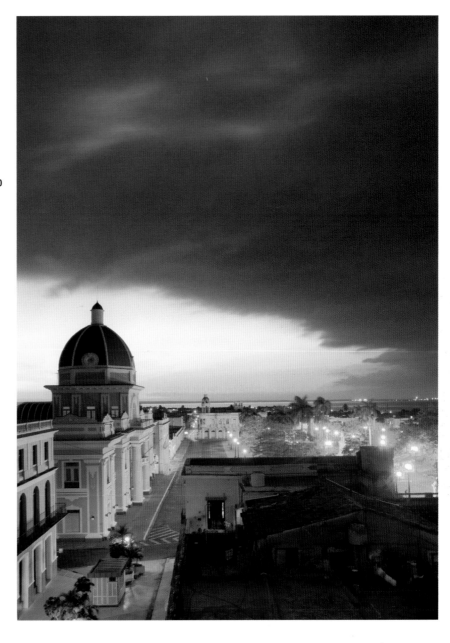

The period between sunset and nightfall is the ideal time to shoot urban scenes. Natural and artificial lighting are at similar levels, so you can record colour in the sky without overexposing manmade illumination and there's enough light coming from the sky overhead to 'fill-in' the areas that aren't being artificially lit. The colour contrast between the cool sky and warm street lighting adds impact.

CANON EOS 1DS MKIII, 17–40MM ZOOM, 0.6ND HARD GRAD, TRIPOD, 30 SECONDS AT F/8, ISO200

TWILIGHT AND BEYOND

With sunset over, light levels begin to drop and the most active period of the day for low-light photography begins.

As during pre-dawn, the light after sunset is reflected solely from the sky, but it tends to be more photogenic because the sky itself often contains a myriad of colours, starting off as a warm glow and gradually fading to pastel shades of blue, pink and purple. This is an ideal time for low-light landscapes or coastal views and, again, scenes containing water are worth pursuing as the colours in the sky are reflected to incredible effect. Light levels are also low enough to necessitate the use of long exposures so you can record the movement of people, traffic, water or trees swaying in the breeze.

The first 30 minutes or so after sunset are the best in this respect, but there's more to come, because as the twilight colours in the sky begin to fade back to blue, a period known as 'after-light' begins.

This is the perfect time to photograph scenes containing artificial lighting, be it floodlighting on buildings, traffic moving along busy roads, or urban street scenes containing everything from neon signs and street lamps to illuminated shop and office windows. That's because the natural and artificial light levels are more or less in balance, so both require the same amount of exposure. If you begin shooting too soon, the artificial lighting won't be obvious enough because ambient light levels are too high, but if you leave it for too long, there won't be enough ambient light around so shadow areas and the sky come out black

when you expose for the brighter artificial lighting.

This afterlight or 'crossover' period occurs at different times depending on the season of the year. During summer it begins 30–40 minutes after sunset and may continue for upwards of an hour, but during winter it lasts no longer than 20–30 minutes. Therefore, you can take more pictures and visit more locations in an evening during the summer than you can during the winter, but during winter you don't have to wait so long for afterlight to arrive. During the winter months the sun sets around 4pm, afterlight begins at 4.30pm and by 4.50pm it's all over. In the height or summer the sun doesn't set until after 10pm and there can still be colour in the sky well after 11pm.

Once light levels fade to a point where the sky appears black in your images, you should stop photographing urban scenes as the difference between ambient and artificial lighting is too great and contrast too high. Digital cameras are actually better at capturing the last traces of colour in the sky than film, and you may find when shooting with a digital SLR that your images show colour even when the sky appears black to the naked eye.

Once the sky is truly black, concentrate on details instead, such as shop windows, people captured in the glow of a street lamp, reflections in puddles or car bodywork or neon signs outside clubs and bars. Alternatively, leave the big city behind and head for the countryside. Landscapes shot at night have a surreal quality because they show us something we've never seen before. The light is soft, shadows weak, and the long exposures – 30 minutes or more – that you'll need to use will also record movement in everything from clouds drifting across the sky to water flowing and trees swaying. Digital images usually record with an obvious blue colour cast. This can look effective, but converting the images to black and white is also worth trying.

If the full moon is out, light levels will be much higher, relatively speaking, and the eerie glow it casts can be very effective, especially on scenes containing water where a shimmering silver band of light breaks up the inky black. Exposures of several minutes will still be required, however, and the moon should be excluded from your pictures because as well as being grossly overexposed it's also moving and therefore records as an ugly white smudge. A much better idea is to superimpose an image of the moon on night scenes (see page 134).

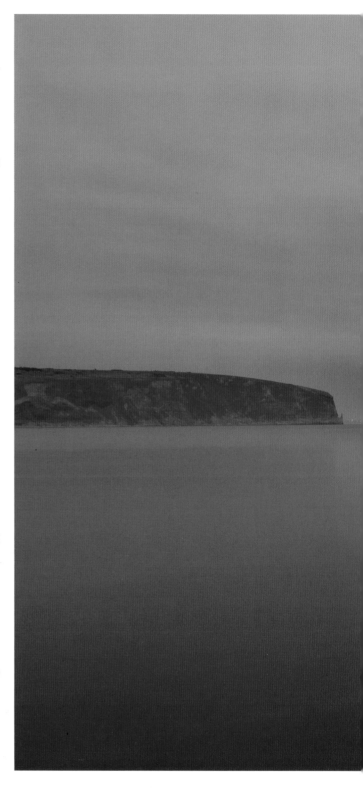

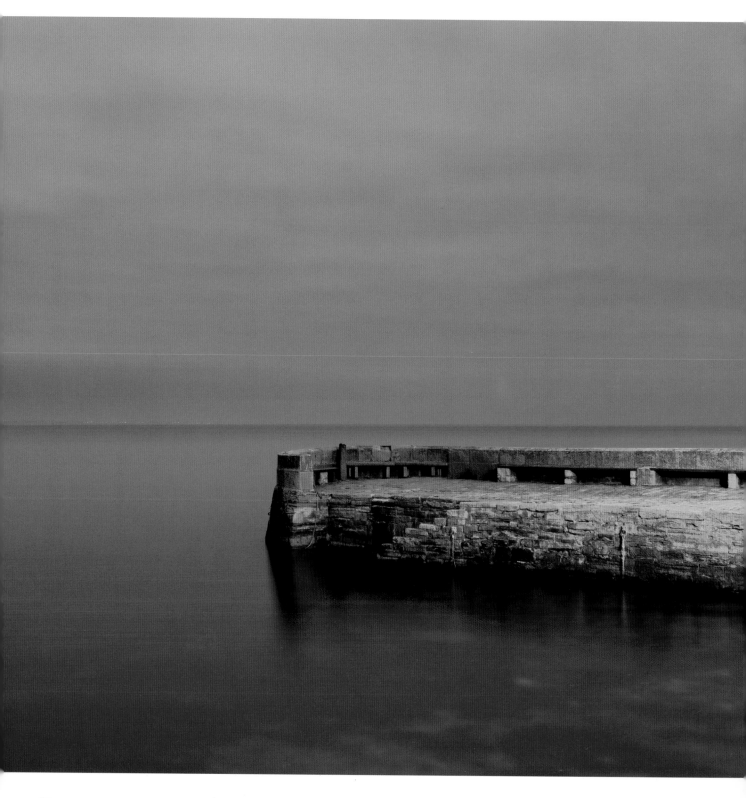

◤ Swanage, Dorset, England

Where scenes contain mixed light sources, using a white balance preset on your camera will cancel one colour cast but add another. For that reason I tend to leave my camera set to AWB (Auto White Balance) when shooting in mixed lighting. More often than not it works perfectly well, and if not, I can always make changes to the image during RAW file processing, or afterwards in Photoshop.

CANON EOS 1DS MKIII, 24–70MM ZOOM, 0.6ND HARD GRAD, TRIPOD, 82 SECONDS AT F/16, ISO100

COLOUR TEMPERATURE AND WHITE BALANCE

Variations in the colour of light are referred to by their colour temperature using a unit known the Kelvin scale. Temperature is used as a form of measurement simply because the way the colour of daylight changes is exactly the same as if you heat a substance. Heat an iron bar and it will eventually glow red, then orange, then yellow until it's white hot. Beyond that, the bar would melt, but if it didn't, and its temperature continued to rise, it would eventually appear blue. The cooler the light is, therefore, the higher its colour temperature, and the warmer it is the lower its colour temperature.

If you were a keen film photographer before digital imaging took over, you may remember that normal daylight-balanced film is intended to give natural-looking results in light that has a colour temperature of 5500k. This is typically found around noon or early afternoon in clear, sunny weather and is known as 'average noon daylight'. Electronic flash also has a colour temperature of 5500k. Early or late in the day the colour temperature of daylight is much lower – down to 3000k – so photographs taken on normal colour film at these times look warmer than the scene really was.

Similarly, if you took photographs under artificial forms of lighting such as tungsten, fluorescent or sodium vapour, they would come out with a colour cast – yellow/orange in the case of tungsten lighting and green in the case of fluorescent. You aren't aware of these colour casts because your eye naturally adapts to

different colour temperatures so everything looks more or less normal, but film can't. To balance these colour casts, special filters were used – a blue colour conversion filter would reverse the effects of tungsten lighting, for example. With digital cameras, colour correction filters are unnecessary, though, because instead you have an adjustable white balance facility that allows you to adjust the sensor so it produces natural-looking images in different types of lighting.

The usual white balance presets on a digital SLR or compact are:

- AWB - Auto White Balance
- Daylight (Approx. 5200K)
- Shade (Approx. 7200K)
- Cloudy (Approx. 6000K)
- Tungsten Light (Approx. 3200K)
- Fluorescent
- Flash (5500K)
- In addition there may also be a Colour Temperature scale that allows you to set any colour temperature between 2500-10000K in 100K increments.

For normal lowlight shooting, AWB will do a perfectly good job. At sunrise and sunset the images are rich and warm while in cloudy or stormy weather a cool blue cast is often evident, which helps to capture the mood of a scene. I also tend to stick with AWB when shooting with flash, even though my SLR has a Flash setting

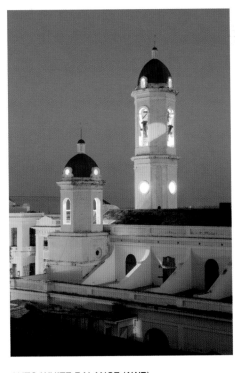

AUTO WHITE BALANCE (AWB)

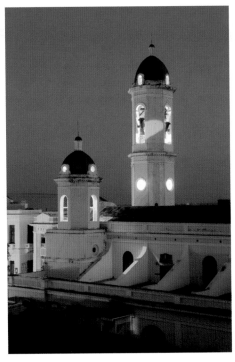

DAYLIGHT

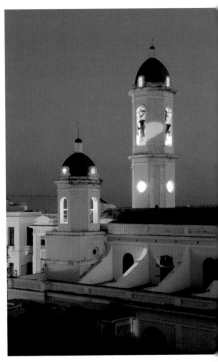

CLOUDY

in the white balance menu.

The presets mainly come into play if you find yourself shooting under a specific type of lighting such as fluorescent or tungsten and you want to get rid of the colour cast produced. Alternatively, you can use them creatively to intentionally add a colour cast – if you set white balance to Cloudy or Shade when shooting at sunrise or sunset the images will come out even warmer; if you set white balance to tungsten when shooting on a cloudy day the images will come out much cooler.

Where light sources are mixed, as is always the case when shooting urban scenes at night, there isn't much you can do to correct the colour casts they create, because by using a white balance setting to deal with one cast, you will introduce others in areas lit by daylight or other artificial sources of illumination. Sometimes this can work in your favour. If tungsten and daylight are mixed and you set white balance to Tungsten the areas lit by tungsten will look natural while the areas lit by daylight will come out much bluer. But in the same situation, if you set white balance to Daylight, the areas lit by daylight will look natural while the areas lit by tungsten will look very warm. Ultimately, it depends what kind of effect you're trying to achieve.

For me, much of the appeal of night scenes comes from the fact that they contain different light sources, which all produce their own vivid colour casts, so I tend to stick with AWB and let nature take its course!

SHOOTING IN RAW FORMAT

Using white balance presets or setting a specific colour temperature on your camera when shooting in artificial lighting is useful, but if you shoot in RAW format rather than JPEG it becomes unnecessary because you have the option to change the colour temperature of your images when you process the RAW files. All RAW conversion software has this option, usually in the form of a simple slider that increases or reduces the Kelvin level. Some also have presets similar to those found on digital cameras – for Tungsten, Fluorescent, Cloudy, Shade and so on.

The benefit of adjusting colour temperature at the image processing stage is that you can experiment with different presets or temperatures to see which you prefer, always with the option to revert back to the original colour temperature if you end-up preferring that one. A single RAW file can also be processed several times, using a different colour temperature for each, to give you variations of the same images.

▽ Cienfuegos, Cuba
This set of images shows the effect of using different white balance presets on your camera to adjust the colour temperature. If you shoot in RAW format, you can experiment with colour temperature while processing your files, but if you shoot in JPEG, you will need to use the white balance presets or colour temperature control in-camera. My favourite image in this sequence is the one shot using Tungsten white balance as it has added a rich blue cast to the sky.
CANON EOS 1DS MKIII, 24–70MM ZOOM, TRIPOD, 25 SECONDS AT F/8, ISO100

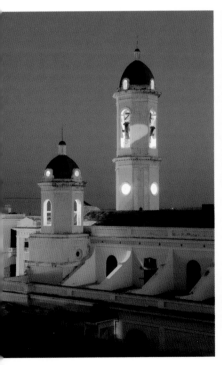

SHADE

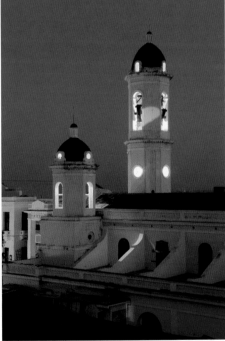

TUNGSTEN

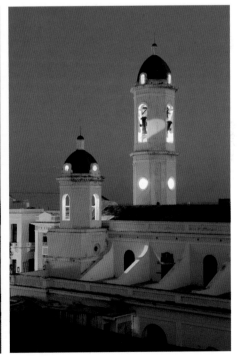

FLUORESCENT

METERING AND EXPOSURE

The most difficult aspect of night and low-light photography is not so much dealing with the limited light levels, but making sure your get enough of that light to the sensor in your camera to capture a correctly exposed image.

In normal conditions this isn't usually a problem, because as well as being more abundant, the light is also more evenly distributed so contrast is manageable and accurate metering straightforward. Alas, the same can't be said of most night and low-light subjects, and a more common scenario is to find yourself photographing a scene that contains bright highlights against a sea of dark shadow, or a well-lit subject against a dark background. Whether it's a cityscape at night, Christmas illuminations on a busy high street or a person lit by candlelight, the same ingredients are there, and unless you know how to handle them, there's a high chance that exposure error will result.

That said, the situation isn't as grim as it might seem. For a start, the same problems tend to crop up time after time, so once you know how to take correctly exposed shots of one low-light subject, you should be able to handle others with the same degree of success.

Modern digital SLRs and compacts also have fantastic integral metering systems that are designed to recognize and deal with tricky lighting, plus you get to see your images seconds after taking them, so if exposure error has occurred you will be alerted and can make any corrections immediately using your camera's exposure compensation facility. In other words, combined with the advice you'll find in this chapter and the accuracy of your camera's metering, there's no reason why you should ever take a badly exposed low light photograph.

HOW YOUR CAMERA'S METERING WORKS

The first step in avoiding exposure error is to understand a little about how your camera's metering system works, so that when you use it to take an exposure reading you'll have a better idea of how it interprets what appears in the viewfinder.

Firstly, all in-camera metering systems measure reflected light – the light bouncing back off a subject or scene – so the reading they give is influenced by how reflective a particular surface is.

If you take a meter reading from a landscape scene at twilight, for example, the exposure the camera sets will be far different if that scene is covered in snow than if it isn't, because snow reflects a much higher percentage of the light falling on it than green grass does. Similarly, if you photograph a person spotlit on stage at a theatre performance, the exposure your camera sets will be far different if the background is also well lit than if it's in deep shadow – because dark colours and shadow areas reflect far less of the light falling on them than lighter colours do.

Your camera's metering system is actually designed to correctly expose subjects or scenes that reflect around 18 per cent of the light falling on them. Visually, this can be represented by a mid-grey colour, known as 18% grey.

What happens if your subject reflects more than 18 per cent of the light falling on it? Well, give or take reasonable margins, you'll get an incorrect exposure reading because your camera can't differentiate. So, going back to the above examples, a landscape scene covered in snow will be underexposed because your camera assumes it's much brighter than the typical scene it is designed to deal with so it doesn't give enough exposure, while a small spotlit subject against a sea of darkness will be overexposed because the background is much darker than the average scene so the camera gives too much exposure to compensate.

In both cases, your camera sets an exposure that will record the predominant tone as mid-grey, which is why a snow scene is underexposed to make it darker, and a dark background is overexposed to make it lighter.

The thing to remember, also, is that your camera's metering system will base its exposure reading on the most dominant tone. So if you photograph a night scene containing really bright lights, chances are you'll get an underexposed shot, even if those lights are against a dark background. This is quite a common situation at night, which is why underexposure is far more common than overexposure. The main exception is when the dark background dominates the scene, and the best example of this is when photographing the moon. Even though the moon is bright, if you take a picture of it sitting in the black night sky, your shots will be overexposed because the dark sky influences the exposure. Try this for yourself by taking a meter reading from the night sky, with a full moon included, using a 100mm or 200mm lens. The exposure suggested will be many seconds in duration, yet a full moon requires an exposure of just 1/250sec at f/5.6 and ISO 100.

This is obviously an extreme example, but if you think of it when photographing any brightly-lit subject that's small in the

◀ **Charles Bridge, Prague, Czech Republic**
Where do you start with a scene like this? Bright street lamps, pools of subdued light, a brooding sky and dark shadows – all the ingredients of an exposure nightmare. But as your experience of night and low-light photography grows, scenes like this will pose no problems – especially now you have the benefit of instant feedback from your digital camera and a histogram to help you determine if you've captured a well-exposed image. When I photographed this scene a few years ago I wasn't so fortunate; I was using a film camera with no integral metering and had instead to rely on my trusty handheld meter to determine 'correct' exposure. Situations like this used to send me into a mild panic and I always exposed too much film, but not anymore – digital imaging is a dream for low-light and night photography.
FUJI GX617, 90MM LENS, TRIPOD, 60 SECONDS AT F/22, ISO50

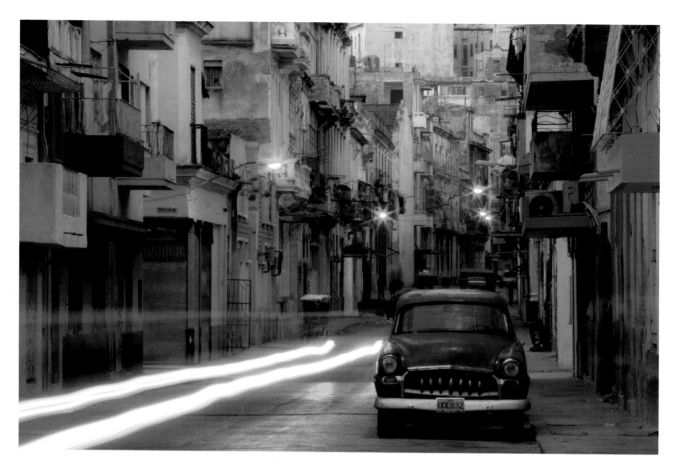

Havana Centro, Cuba

Although most low light scenes are far from 'average' in terms of their tonal balance and reflectance, modern multi-zone metering is surprising good at recognizing unusual situations and dealing with it to produce well exposed images. I was busy shooting this scene when a car suddenly started heading towards the camera. I fully expected the brightness of the headlamps to fool the camera's meter into giving too little exposure, but it didn't falter.

CANON EOS 1DS MKIII, 70–200MM ZOOM, TRIPOD, 10 SECONDS AT F/32, ISO100

Devil's Garden, Utah, USA

If you want to produce well-exposed images in changing low-light situations you need to think about what you're doing. I arrived at this amazing location in darkness and as soon as it was light enough to see I started shooting. Initially, the scene was illuminated solely by reflected sky light as the sun had yet to rise, so contrast was low and metering straightforward. But within minutes the sun rose, the hoodoos, perched on higher ground, were hit by the golden light and suddenly it was a totally different proposition. Using a handheld spot meter I took a reading from the weathered tree branch in the foreground, set that on the camera, then took a second spot reading from one of the sunlit hoodoos to work out which density of ND grad would be needed to tone it down and avoid overexposure. A little bracketing of exposures was required to be sure I got it right and I had to wait a fortnight to find out. These days, with a digital camera, I know if I've got the shot seconds after taking it – that makes a big difference!

MAMIYA 7II, 43MM LENS, 0.9ND GRAD (FOR LATER IMAGE), TRIPOD, 4 SECONDS AT F/16 AND 1 SECOND AT F/16, ISO50

frame against a dark background, it will hopefully help you to avoid exposure error.

It's also worth adding at this stage that I am talking worse case scenario. The multi-zone metering systems founds in all digital SLRs is surprisingly accurate and can usually produce well-exposed images in all but the most extreme conditions – so having read this, you may head out expecting most of your low-light and night shots to be badly exposed, only to find that the majority are perfect and wonder what all the fuss was about. I hope that's the case – but you need to be aware that it may not be!

METERING PATTERNS

Digital SLRs come armed with different metering patterns that are used to measure light levels and determine correct exposure.

Centre-weighted average

This used to be the standard metering pattern found in cameras with TTL metering – there was a time when it was state of the art!

It works by measuring light levels across the whole viewfinder area, but biases the exposure towards the central 60 per cent. As a result, it's particularly susceptible to error in situations where there's a predominance of light or dark tones, such as a small, spotlit subject against the night sky or a person captured against a white wall. Although it's still found on just about all digital SLRs, I don't know of anyone who uses it as the other metering patterns available are more accurate and reliable.

Multi-pattern metering

Different brands of SLR have different systems – Canon cameras have Evaluative metering, Nikon cameras have Matrix metering – but all work in the same way by measuring light levels in different

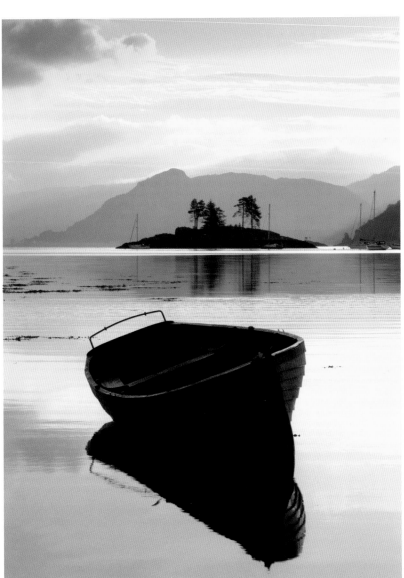

◀ **Plokton, Scotland**
Careful metering is necessary when shooting backlit scenes. The difference in brightness between the brightest areas of sky and the inside of the boat is huge – beyond the range the sensor in a digital camera can cope with – and though the multi-zone metering in digital SLRs would give a fairly accurate exposure reading, it's vital to check the histogram and assess the distribution of tones to see if it's possible to give more exposure to increase shadow detail, without blowing-out the highlights. Even a 1/3rd stop shift in exposure can make a big difference when contrast is so high.
CANON EOS 1DS MKIII, 70–200MM ZOOM, 0.6ND HARD GRAD, 1/10SEC AT F/32, ISO100.

'zones' of the viewfinder to try and build up a picture of the type of scene being photographed and hopefully prevent exposure error. The number of zones varies from a few to dozens – in theory the more zones the more accurate the metering, though all multi-zone systems are good these days and can be relied on in all but the most extreme lighting.

The key is to try your own system out in different low-light situations and see how well it copes. You may get a surprisingly high rate of success, but equally you might not, and the best way to ensure correct exposure at night or in low-light is usually by applying experience and instinct rather than relying completely on modern technology.

Spot metering

There are variations on this pattern, including 'partial' and 'selective' but the basic idea is that it allows you to meter from a very specific part of a scene so light and dark tones don't influence the exposure reading obtained.

True spot metering is the most versatile of all, as the metering zone usually covers just 1° or 2°, whereas other comparable systems may cover anything from 6° to 15°, depending on the make and model of camera you own, so obviously you can't meter from such a small area.

Any form of spot or selective metering is welcome, however, and in experienced hands can provide the most accurate means of overcoming exposure error in tricky light. If your main subject is surrounded by a large area of darkness, for example, you can simply meter directly from that subject so the exposure reading isn't influenced by the dark areas.

The main thing to remember is that this type of metering pattern still measures reflected light, so you must meter from a tone that has a similar density to mid-grey and is well-lit if you want to get an accurate reading. Meter from something that's lighter than a mid-tone and underexposure will result; meter from something darker and overexposure will result.

Outdoors there are lots of things that equate to a mid-tone – most building materials such as brick, stone, weathered concrete and roof slates; grass and foliage, and so on. If you were photographing a floodlit building such as an old castle or church, therefore, you could take a spot reading from an area that's lit by the artificial illumination – avoiding areas that are too close to the actual light source as they will be much brighter than the rest of the building and cause underexposure.

When photographing night scenes that contain a mixture of artificial lighting and ambient (natural) light, blue sky around 30 minutes after sunset will also give an accurate exposure if you take a spot reading from it. This is well worth remembering as it can provide a quick and easy way of determining correct exposure in situations that may at first appear confusing.

USING A HANDHELD METER

Although integral metering systems are accurate and reliable, some photographers prefer to use a handheld meter instead. This is mainly because traditional handheld meters not only allow you to measure reflected light, like your camera does, but also incident light as well – the light falling on to a subject or scene.

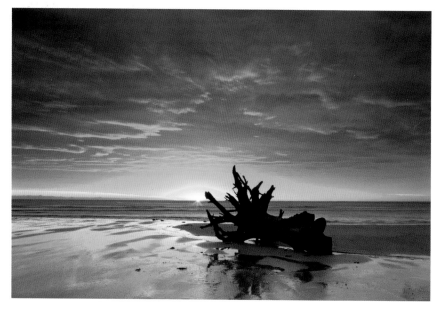

Alnmouth, Northumberland, England
Controlling the contrast of a low-light scene prior to photographing it can help to ensure correct and effective exposure. When shooting landscapes, the most useful accessory to help you do that is the trusty ND grad filter (see page 33), which allows you to reduce the brightness of the sky so it's closer to that of the foreground and avoids overexposed highlights or blocked-up shadows.
CANON EOS 1DS MKIII, 24–70MM ZOOM, TRIPOD. 0.6ND HARD GRAD, 1.3 SECONDS AT F/11, ISO100

The main benefit of measuring incident light is that the exposure reading you get isn't influenced by how light or dark the tones are in a scene, so there's less chance of exposure error occurring. If you photograph a person lit by candlelight against a dark, shady background, for example, your camera's metering system is likely to cause overexposure. This is because it's measuring reflected light and will therefore be influenced by the dark background, which has low reflectance and fools the camera into giving more exposure than you need. By measuring the light from the candle flame that's actually falling on to your subject, however, the reading won't be affected by the dark background, so the exposure you get should be very accurate.

To take an incident light reading, all you have to do is hold the meter in the same light that's falling onto your subject, with the white dome or 'invercone' pointing back towards the camera. With subjects such as portraits and still-lifes you can hold the meter very

close to be sure of an accurate reading, whereas with landscapes and other large-scale subjects, all you need to do is hold the meter in the same light that's falling on the scene.

Once light levels have been measured, you will then be presented with a range of aperture and shutter speed combinations, any of which can be used to give correct exposure. The one you choose will depend whether you need a small lens aperture to give extensive depth-of-field and a longer exposure time, or a short exposure and a wider lens aperture. Either way, the aperture and shutter speed are set on your camera in manual exposure mode.

▽ Cienfuegos, Cuba
Another way of overcoming high contrast is to shoot a series of frames at different exposures then merge them together. There was no way I could retain so much detail in this scene using a single exposure so I shot three in quick succession at -1 stop, correct and +1 stop then combined them using the Exposure Blend option in Photomatix Pro 3.0 software (see page 187). Doing so has retained the golden glow in the sky but also revealed lots of detail in the street.
CANON EOS 1DS MKIII WITH 70–200MM ZOOM, TRIPOD, 1/30, 1/60 AND 1/125SEC AT F/8 AND ISO100

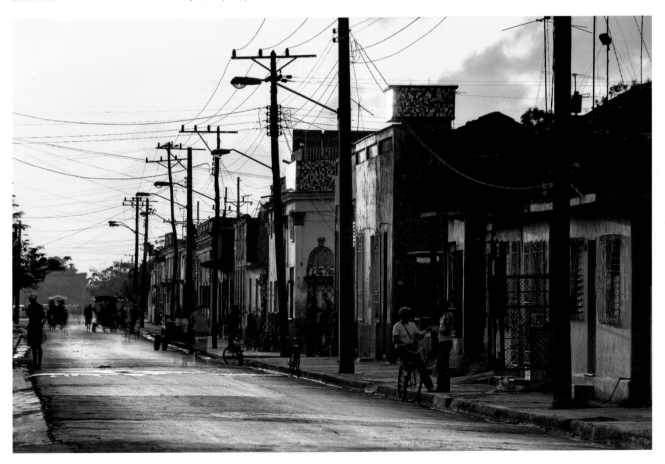

EXPOSURE BRACKETING

No matter how bad things get, and no matter how confused a particular lighting situation leaves you, there's always bracketing to fall back on.

This handy technique involves taking a series of photographs of the same subject or scene at exposures over and under the one deemed to be 'correct', thus providing a safety net and ensuring that at least one shot from the set will be acceptable. You might think this is unnecessary with a digital camera, because exposure error can be corrected later during RAW file processing or using Photoshop, but as we've already established earlier in this chapter, if you want to achieve optimum image quality, it's vital that you get the exposure just right in-camera for any given subject or scene, otherwise vital highlight or shadow detail can be lost when it doesn't need to be.

The easiest way to bracket is by using your camera's exposure compensation facility (see page 17). All you have to do is take your first shot at the metered exposure, then further shots with the exposure compensation set to give more or less exposure. If you're working in aperture priority mode, the shutter speed will be adjusted when you use the exposure compensation facility and the aperture you have set the lens to will remain unchanged. Similarly, in shutter priority mode the lens aperture setting will be adjusted when you dial in exposure compensation and the shutter speed will remain constant.

The extent to which you need to bracket depends on the situation you're in. If you are confident of your metering technique and have taken photographs successfully in similar situations before, then you may only need to bracket one shot over and one shot under the metered exposure. Where you're not completely sure, however, it's worth bracketing more widely just to be on the safe side.

Alternatively, use your camera's Auto Exposure Bracketing (AEB) mode. This allows you to set bracketing parameters such as -1 stop, Correct and +1 stop, then, when you trip the shutter, the camera automatically takes three shots, varying the exposure for each.

Fans of bracketing argue that in this digital age it doesn't cost anything to take a photograph, so why not take lots? The downside of bracketing exposures all the time is that you fill memory cards much faster and you have many more images to work through once home so you spend more time at the computer.

I bracket exposures all the time when shooting in low-light situations, but rather than keep every image, I scroll through the sequence just shot and delete any that are obviously under- or over-exposed on the spot – making sure I keep the ones where I have exposed 'to the right' as they are likely to be the ones I work on.

EXPOSURE WITH DIGITAL CAMERAS

The way I tend to work these days when shooting night and low-light subjects with a digital SLR is as follows:

① First I set the camera to aperture priority (Av) exposure mode so that I choose the lens aperture to control depth-of-field and the camera sets the required shutter speed to achieve correct exposure. The longest automated exposure is 30 seconds; if I need an exposure longer than that, to cope with the light levels or for creative effect, I use the camera's bulb (B) setting (see page 84).

② I always leave the ISO set to 100, for optimum image quality. If I'm handholding the camera and need to increase the ISO in order to use a faster shutter speed – to freeze movement and/or avoid camera shake – then I will, but where possible I stick to ISO 100.

③ I always use the camera's multi-zone metering pattern to determine correct exposure. My digital SLR also gives me the option of centre-weighted and spot metering but I've never used them simply because Canon's Evaluative metering is so accurate – most of the time!

④ The scene is composed as I want to shoot it, any filters that I decide are necessary, such as ND grads, are fitted to the lens and the lens is stopped down to the required aperture (f/number). I also tend to keep my lenses set to manual focus. Modern autofocusing is quick and accurate, but I like to know exactly where the lens is focused to maximize depth-of-field, so I prefer to do that job myself. The main exception to this rule is if I'm shooting handheld portraits, when I use autofocus instead.

⑤ A 'test' shot is taken of the scene or subject. It's rare that I find myself in a situation where it's crucial that the first shot has to be perfect – most night and low-light subjects are static and there's usually time to take a number of shots, so no need to rush. Seconds after taking this initial shot I can see the image on the bright, crisp 3in LCD monitor and make a quick assessment – not only of the composition, depth-of-field and to check the filtration is right, but also the exposure.

⑥ If the exposure needs adjusting, I do so using the camera's exposure compensation facility, which allows me to increase or reduce the exposure by up to +/-3 stops in 1/3 stops increments. As I'm shooting in aperture priority (Av) mode, the lens aperture I've set remains unchanged and the camera adjusts the exposure by increasing or reducing the shutter speed.

If an image is badly over- or underexposed, that will be obvious when you look at it on the camera's LCD monitor. However, smaller degrees of error are harder to see on the screen image, especially when shooting in low light, so you shouldn't just rely on that alone.

READING THE HISTOGRAM

Although the preview image on your camera's LCD monitor will give you a reasonable indication of exposure accuracy, a far more accurate and useful facility is the histogram, which you can call-up by pressing the camera's 'Info' button and either view a small histogram and the image at the same time, or a larger version of the histogram with no preview image.

The histogram is a graph that shows the distribution of tones in a digital image from the shadows (the darkest tones) to the highlights (the lightest tones). The sensor in your camera is capable of recording a brightness range of roughly five stops, so think of the histogram as representing that five-stop brightness range.

The graph goes from the darkest shadows on the left, through mid-tones, to the brightest highlights on the right, while the vertical axis shows how many pixels exists for each of those brightness levels. For example, if the graph peaks roughly in the middle that tells you there image has a high mid-tone content.

Although most 'normal' scenes and subjects shot in daylight have a tonal range that falls within five stops, night and low-light scenes are often far from normal and the brightness range can be much higher, reaching 8, 9, even 10 stops, so careful exposure is necessary in order to record the maximum amount of detail in the image – and the best exposure may not necessarily be the 'correct' exposure.

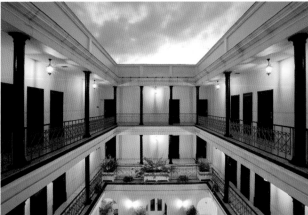

◸ Hotel La Union, Cienfuegos, Cuba

These images show how adjusting the exposure makes a big difference to the image and the shape of the histogram. The initial shot I took looked fine on the camera's preview screen, but a quick look at the histogram told a different story – you can see that the tones are bunched towards the left and the shadows have been clipped. This is a clear sign of underexposure. Using my camera's exposure compensation facility, I dialed in +2/3 stop extra exposure and re-shot the scene. Not only did the preview image look brighter and crisper, but you can see from the histogram that there's a much better distribution of tones. The highlights are clipped, but that's caused by the lamps hanging in the corridors – it would be impossible to prevent them from overexposing. The deeper shadows in the doorways are also clipped, but this doesn't have an adverse effect on the image.

CANON EOS 1DS MKIII, 17–40MM ZOOM, TRIPOD, 30 SECONDS AT F/20 (FINAL IMAGE) AT ISO100

The shape of a histogram is determined by the tones within the scene, and how much exposure you have given the image. There's no such thing as a 'perfect' histogram, but analyzing it will help you decide if the exposure you used was the best one for that particular scene or subject.

For example, if the tones in a scene are predominantly light, the histogram will be bunched over to the right side of the graph and if the tones are predominantly dark the histogram will be bunched over to the left side.

Whatever the shape of the histogram, the key is to try and ensure that all the tones are contained within its boundaries. If any tones touch the left-hand edge of the histogram that means some of the shadow areas have been 'clipped' and will come out black.

HANDY EXPOSURE TRICKS

If you find yourself in a situation where light levels are so low your camera's metering system appears unable to register a reading, there are various tricks you can employ:

• First of all, try setting your lens to its widest aperture to give the metering more light-gathering power. If this gives an exposure reading you can then backtrack to the aperture you want to use, doubling the exposure each time you move to the next smallest f/number. For example, let's say you get a reading of 20 seconds at f/2.8, but you want to take a picture at f/11. The exposure you need at f/11 is 5 minutes 20 seconds – 20secs at f/2.8, 40secs at f/4, 80secs at f/5.6, 160secs at f/8, 320secs at f/11.

• An alternative is to try increasing the ISO setting instead of the aperture – your camera may not give a reading at ISO 100, but chances are it will at ISO 3200. The same technique of backtracking is then applied, with the exposure being doubled each time you halve the ISO. So, if your camera meter gives an exposure reading of 15 seconds at f/4 on ISO 3200, at ISO 100 the correct exposure will be eight minutes at f/4 (15sec at ISO 3200, 30secs at ISO 1600, 60secs at ISO 800, 120secs at ISO 400, 240secs at ISO 200, 480secs at ISO 100).

• In extreme cases you can use a combination of both – setting your lens to its widest aperture first, then if that doesn't work, also increasing the ISO. Thankfully, you would need to be in a pretty black hole to make this necessary.

The more the tones are stacked to the left, the darker the image will be – a sign of probable underexposure.

Increasing the exposure using your camera's exposure compensation facility will rectify this – the more exposure you give, the more the tones will shift to the right. Keep adjusting the exposure in +1/3 stops until no tones are touching the left edge of the histogram, but also keep an eye on the right edge as well because if you give too much exposure you'll 'clip' the highlights and some areas of the image will record as white, with no discernible detail.

Overexposure is the opposite of the scenario outlined above. Tones touching the right hand extreme of the histogram mean the highlights have been clipped, so you need to reduce the exposure in small increments until the tones have shifted away to the left of the histogram – but watch that it's not so far that the shadows are then clipped.

In contrasty light, it may not be possible to avoid clipping the highlights or the shadows so you have to decide which end of the tonal range is the most important and expose accordingly – save the highlights and let the shadows block-up or record detail in the shadows and let the highlights blow out. I usually give priority to the highlights, as I always did when shooting colour slide film, unless I intentionally wish to create a high-key image in which case I don't mind if the highlights blow out. There are steps you can take to lighten shadows areas that are too dark, but there's nothing much you can do about blown highlights because if no detail records, there's nothing to try and retrieve.

The alternative is to find a way of overcoming the problem of high contrast. Using an ND grad on the sky (see page 33) can often greatly help as it brings the brightness of the sky down to a level that's closer to the rest of the scene and within that magic five-stop range.

Another option is to take two identical shots with your camera on a tripod – one making sure the highlights aren't clipped and one making sure the shadows aren't clipped – then combine them in Photoshop or shoot a sequence of identical images at different exposures then combine them using HDR software (see page 186).

EXPOSING TO THE RIGHT

Allied to using the histogram as a guide to exposure is a technique known as 'exposing to the right', a relatively recent idea that allows you to maximize the amount of detail recorded in a digital image.

To use this technique you must shoot in RAW format rather than JPEG – but you should ideally be shooting in RAW anyway as it offers numerous benefits (see page 91). This is because a RAW file records data in 16-bits whereas JPEGS only record data in 8 bits, so RAW files contain far more tonal information for you to work with.

What few photographers realise is that the sensor in their digital camera is a linear device, so the tonal information it's capable of recording isn't distributed evenly across the brightness range shown by the histogram. Instead, half of all the tonal levels available are recorded in the brightest f/stop of the range (the highlights) half as much by the 2nd f/stop, half as much again by the 3rd f/stop and so on. In other words, the brightest tones in the image contain 16x more levels than the darkest tones, so if the tonal distribution is biased towards the left side of the histogram, the image will only contain a fraction of the levels the sensor is capable of recording. Exposing 'to the right' is designed to overcome this.

The basic idea is that you give an image as much exposure as you can, to shift the tones as far to the right of the histogram as you can, without actually clipping the highlights. By doing so you're recording the maximum number of tonal levels possible because they're concentrated on the right side of the histogram. This is done by taking a shot at the exposure you or the camera thinks is correct, checking the histogram, then using the camera's exposure compensation to increase the exposure in 1/3rd stop increments and taking further shots until the highlight warning on the histogram starts to flash. Once you get flashing highlights, stop increasing the exposure and scroll back through the sequence of images – the first one you get to with no highlight warning is the best of the bunch.

When you open that RAW file on your computer it will appear overexposed and washed-out. However, you can rectify that quite easily using the exposure controls in the RAW processor – I use Adobe Camera RAW in Photoshop CS3.

By working in this way you not only record maximum tonal levels in the image, but issues with noise (see below) in the shadow areas are minimized. As low-light and night scenes often include a lot of shadows, this can only be a good thing.

DEALING WITH NOISE

Grain in photographs taken using film is caused by the silver halides in the film's emulsion clumping together to make it more sensitive to light. Therefore, as film speed (ISO) increases, grain becomes courser and more obvious.

Noise is basically the digital equivalent of film grain, and as with film, the higher you set your camera's ISO, the more noise you will see in the images – especially in plain areas such as the sky. This is because digital cameras make the sensor more sensitive to light by amplifying the image signal settings, and the more you do this, the more interference you get, which shows as noise.

Earlier digital cameras produced terrible results at high ISO (over ISO 400), but camera manufacturers have worked hard to combat

USING EXPOSURE CREATIVELY

If reading through this chapter has filled you with dread, don't worry – things aren't as grim as they seem. There's no denying that taking perfectly exposed pictures at night or in low-light is trickier than in bright sunlight, but it's surprising how quickly you will learn to recognize situations that are likely to cause exposure error, and be able to take steps to overcome them. Your digital camera will help enormously thanks to the feedback you get from the preview image and the histogram.

The key is to be liberal in your interpretation of the word 'correct'. Exposure is highly subjective, and what's correct technically may not necessarily be the best creative solution to a particular situation. Many night and low-light subjects can also tolerate quite a variation in exposures, so don't be afraid to experiment and take creative risks – you can always delete the images if they don't work.

The biggest mistake newcomers to night and low-light photography tend to make is not giving their pictures enough exposure. It seems amazing that a scene may need to be exposed for 30 seconds or a minute when you're used to working in hundredths or thousandths of a second, but long exposures are part and parcel of night and low-light photography – and often a scene will need much more exposure than you think it does to record a wide range of detail.

noise over the last few years and the latest generation of digital SLRs produce amazing results no matter how high you set the ISO – 3200, 6400… I have no qualms about using my own DSLR at ISO 1600 or ISO 3200 when handholding in low light and it's only when you start to really enlarge the image that noise/grain becomes obvious. This is a huge advantage when working in low-light because it means shots can be taken in situations where, armed only with film, you would probably have packed up and walked away.

A second cause of noise in digital images is underexposure – if you lighten an image that's too dark, noise is emphasized, especially in the shadow areas. This is why I advocate the technique of 'exposing to the right' discussed above, because it helps to combat noise by maximizing shadow detail without blowing the highlights – better to darken down an image that's a little overexposed rather than lighten an image that's underexposed.

A third cause of noise is the use of long exposures, which are obviously unavoidable when shooting in low-light. If exposures are

THE BULB SETTING

Digital SLRs tend to have an automated shutter speed range up to 30 seconds. This is long enough to cope with most low-light subjects, but occasionally you'll find that light levels force you to use exposures beyond that – or you choose to for creative effect, such as when using 10-stop ND filters (see page 35). In those situations, your camera's bulb (B) setting must be used, so you can hold the shutter open for as long as you like – minutes, hours... I regularly make exposure of several minutes – the longest to date is around two hours, used to record star trails in the night sky (see pages 136–137).

The bulb setting will either be marked on the mode dial on your camera's top plate or accessed via the Mode menu. When I'm using my camera's bulb setting, I trip the shutter with a remote release then hold it open using the lock on the remote release's control panel.

My camera has a count-up timer on the top plate, so I don't have to worry about timing the exposure, I just keep an eye on the timer and release the shutter when the required time has elapsed. Not all cameras have an integral timer, but you can use a small stopwatch, or your wristwatch – or simply count the exposure in your head. When using exposures of many seconds, you don't have to be too accurate with your timing. Exposing a scene for 22 seconds instead of 25 seconds will have no noticeable effect. More expensive remote releases can be programmed to make a specific exposure, so once you trip the shutter you can leave the camera alone and the shutter will close automatically at the end of the preset time. You can also program the release to make a series of exposures one after the other. This is handy for subjects such as star trails – you could set-up the camera and go to bed, leaving the remote release to make exposures through the night!

The main thing you need to be aware of when making long bulb exposures is that camera batteries drain rather quickly, and if the battery runs out of juice halfway through a two hour exposure the shutter will close – and you'll kick yourself! So, to avoid disappointment (and self harm!), make sure your battery is fully charged and you have at least one spare with full charge if a long night of shooting lies ahead.

▶ The Malecon, Havana, Cuba
The bulb facility is invaluable as it allows you to experiment with long exposures outside the automated range offered by your camera – either to cope with low light or for creative effect. In this case it was the latter reason. Using a 10-stop ND filter at dusk allowed me to use an exposure of two minutes, which recorded motion in the sea and sky to add an unexpected twist to the image.
CANON EOS 1DS MKIII, 17–40MM ZOOM, LEE BIG STOPPER ND FILTER AND 0.6ND HARD GRAD, 120 SECONDS AT F/11, ISO100

just a second or two you're unlikely to see any increases in noise if you're using a relatively new digital SLR, but once exposures extend into tens of seconds or minutes, the pixels in your camera's sensor start to get warm and some may even glow as bright pinpricks of colour – known as 'hot pixels'. They're easy enough to remove later using the Clone Stamp tool or Healing Brush tool in Photoshop.

The first step in minimizing noise is to shoot in RAW format rather than JPEG – JPEG is a compressed 8-bits/channel format whereas your camera will probably be 12 bits/channel uncompressed and shooting in RAW will allow you to take full advantage of that, producing images with a much greater range of tonal values.

The second step is to watch your exposure, as already explained.

The third step is to keep the ISO setting as low as possible. If your camera's mounted on a tripod it doesn't matter how long the exposure is, within reason, so set your camera's default low ISO – usually ISO 100 or ISO 200 – for optimum image quality and minimal noise and only increase the ISO if you need to.

The fourth step is to consider using your camera's Long Exposure Noise Reduction facility (NR). To my knowledge all digital SLRs have NR now – scrolling through the menus will take you to it. NR works by making a second 'dark frame' exposure with the camera's shutter closed that's of the same duration as the exposure you just made. The camera is then able to identify where the hot or stuck pixels are on the dark frame image and remove them from the photograph you've taken. The downside of using NR is that you can't use the camera while the dark frame image is being exposed – not such a problem if the exposure is only a few seconds, but if you make a three minute exposure, you then have to wait an additional three minutes before you can take another shot, which could waste valuable time. For this reason, I never use my camera's NR facility.

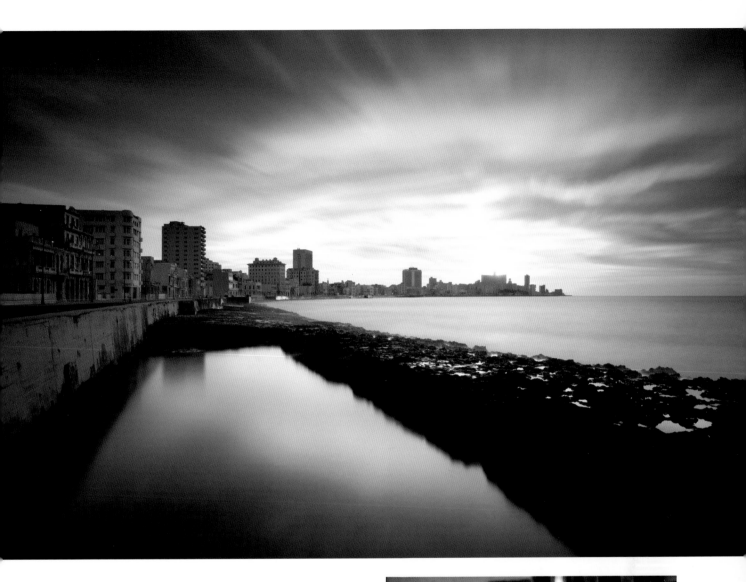

If you find that an image suffers from noise when you view it on your computer monitor, try using the Reduce Noise facility in Photoshop (Elements 3 and CS2 onwards). Go to Filter>Noise>Reduce Noise and enlarge a part of the image where noise is obvious so you can see the effect of using different settings. As noise tends to be more evident in some areas more than others, it's also a good idea to select those areas worst affected and apply the Reduce Noise filter, rather than applying it to the whole image. Noise reduction software such as Noise Ninja (www.picturecode.com) is also available and can help.

El Floridita, Havana, Cuba ▶

When light levels are low and you have no choice but to shoot handheld, increasing your camera's ISO setting will help to maintain a decent shutter speed and avoid camera shake. I shot this image at ISO 1600 and image quality is still fantastic – certainly better than it would have been had I shot with ISO 1600 film.
CANON EOS 1DS MKIII, 50MM F/1.8 LENS, 1/25SEC AT F/1.8, ISO1600

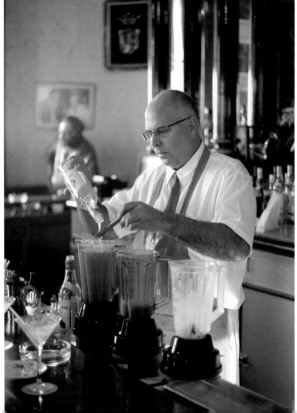

ISO 50

ISO 100

ISO 3200

This set of images shows how increasing the ISO setting on your camera leads to an increase in noise, which appears like grain in the images. A small part of the original scene was enlarged in each case to emphasize the effect.
CANON EOS 1DS MKIII, 17–40MM ZOOM, TRIPOD, 0.9ND HARD GRAD, 6 SECS AT F/5.6, ISO50

To be honest, noise is far less of a problem than it was a few years ago, so if your digital SLR is a fairly recent model you'll probably find that it copes remarkably well whether at high ISO or when subjected to long exposures – or both.

From a creative point of view, noise can be beneficial as it adds a film-like feel to digital images. I often used to shoot high-speed black and white film specifically for the coarse grain because I liked the effect, so when I shoot images to convert them to black and white, I really don't mind if they exhibit noise. In fact, sometimes I edit them to intentionally increase the noise as it adds a stark, gritty feel. As the old saying goes: 'One man's meat is another man's poison'.

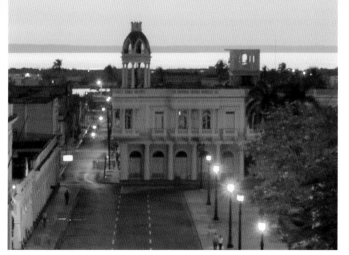

ISO 400

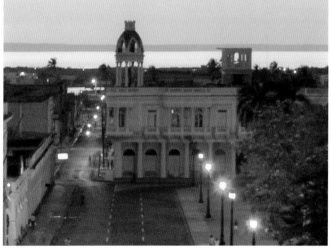

ISO 1600

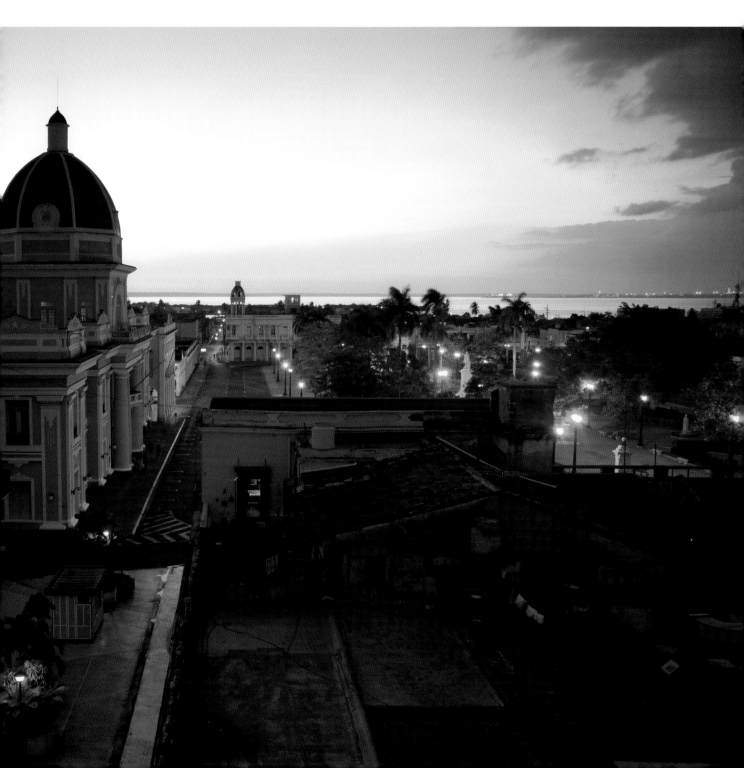

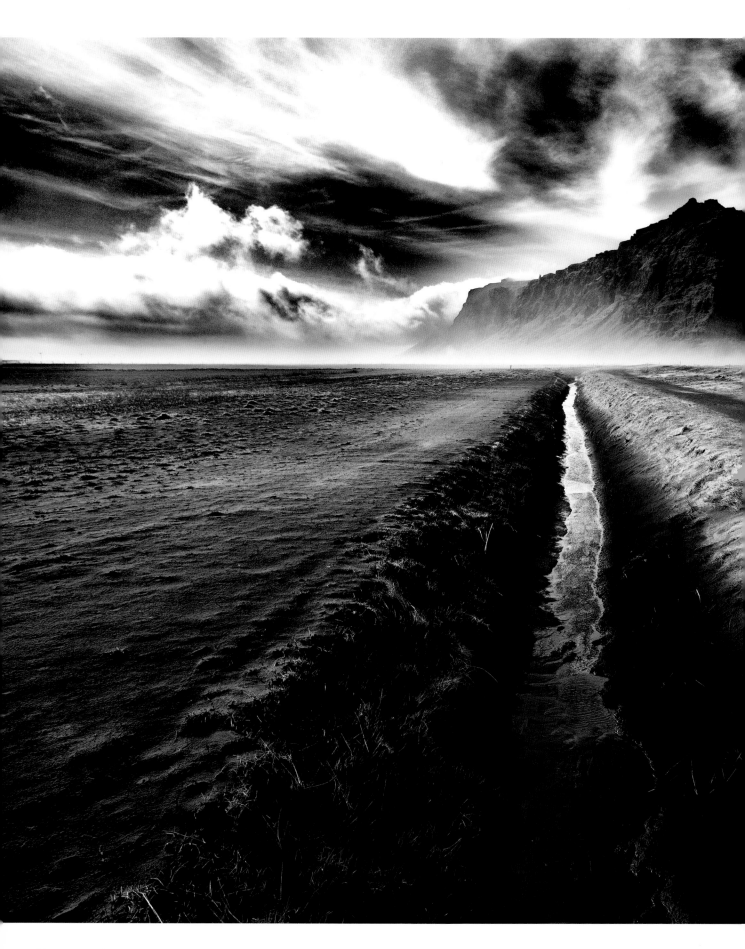

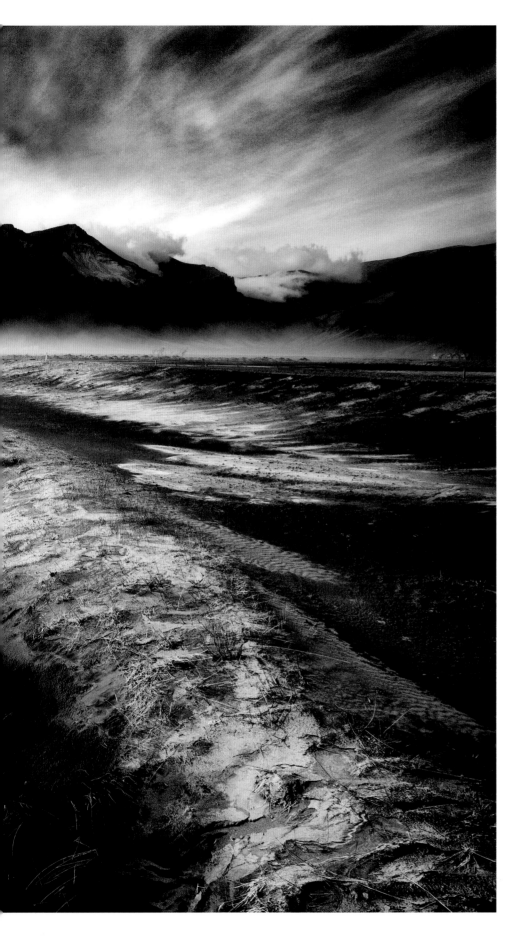

◀ **Near Skogar, Iceland**
Although many photographers go
to great length to avoid noise, given
the right subject it can actually be
a bonus, adding a gritty, film-like
texture to the image. It's particularly
evident in the sky in this scene
and was caused more by over-
manipulation to achieve the desired
look than because I shot at a high
ISO. But as far as I'm concerned,
it doesn't matter how you get what
you want, so long as you get it!
**CANON EOS 1DS MKIII, 17–40MM ZOOM,
0.6ND HARD GRAD, 1/200SEC AT F/11,
ISO200**

DIGITAL IMAGE PROCESSING

Although you probably don't realise it yet, producing perfect low-light images is easier now than at any stage in the entire history of photography – and it's all thanks to digital technology. Chances are many of you will have come into photography since the digital revolution began, in which case you'll have little or no experience of what life was like pre-pixels. Well take it from me, it's a walk in the park compared to shooting film.

Being able to see your shots seconds after taking them is a fast-track to success because you can learn as you go, correcting mistakes and making changes so that you need never miss a great shot. This immediacy, and the fact that every press of the camera's shutter button doesn't cost money, also encourages you to take creative risks, which is by far the best way to master new techniques and fine-tune your low-light skills.

Of course, these days, pressing the shutter release is just the first stage in the creative process because once home your images are then downloaded to a computer where you can turn those millions of coloured dots into amazing photographs with the aid of the latest editing software. Successful low-light and night photography therefore requires a combination of solid camera work with sympathetic 'processing'.

Throughout this chapter I will discuss the most important factors you need to consider when processing your images. It's by no means comprehensive, as digital imaging is a subject that can fill a book in its own right, but it will at least point you in the right direction.

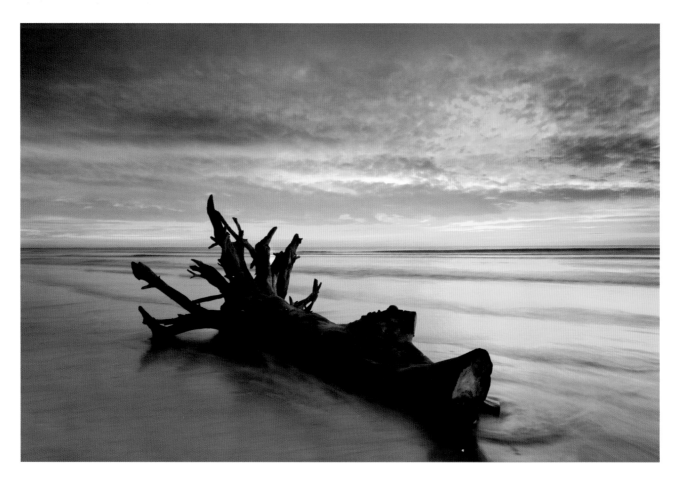

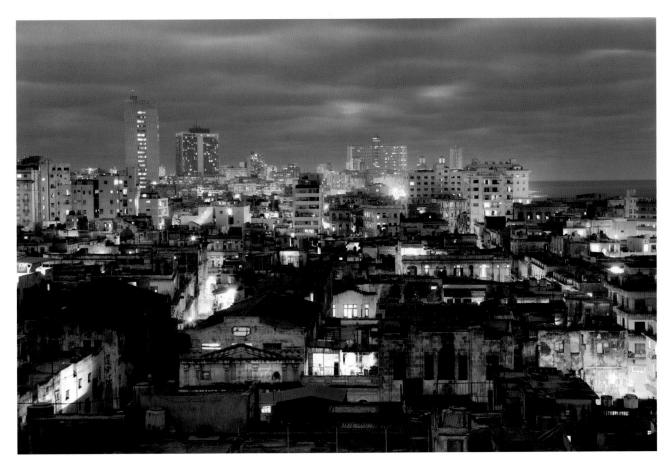

RAW VS JPEG

The debate about whether RAW is a better image format than JPEG is on-going and there are passionate advocates on both sides of the fence. Newcomers to digital photography tend to start out shooting in JPEG because it's easier and the images look better when they're downloaded from the memory card. However, more experienced photographers tend to swear by RAW format – and I'm one of them – because the images are more versatile.

The major difference between a RAW file and a JPEG is that when you shoot in RAW format, the images recorded on your camera's memory card consist of the RAW data from the sensor – nothing is added, taken away or changed. If you shoot in JPEG,

◁ **Alnmouth Beach, Northumberland, England**
Perhaps the biggest advantage of digital technology is that it allows you to take control of the whole picture-taking process from start to finish. There's a lot more to learn, but the sense of satisfaction you'll get from producing successful images makes the effort worthwhile. I shot this amazing sunrise just metres from my home. Within half an hour of tripping the shutter I'd returned home, downloaded the images to my computer, processed the RAW files and had images ready to print – all before breakfast!
CANON EOS 1DS MKIII, 16–35MM ZOOM, 0.6ND HARD GRAD, 3.2 SECONDS AT F/16, ISO100

△ **Havana, Cuba**
RAW files are like digital negatives – they provide you with all the raw ingredients of the image then let you decide what to do with them. For night and low-light scenes, having this control is a great benefit because you can make subtle changes and optimize image quality. JPEGs are already 'part-baked' by the time you get your hands on them and therefore less versatile.
CANON EOS 1DS MKIII, 24–70MM, 30 SECONDS AT F/6.3, ISO200

the camera first records all the RAW data, but then it develops the RAW file in-camera, applies pre-set parameters to white balance, sharpening, any camera styles you have set and so on, deletes data it doesn't feel is necessary then erases the RAW file as well.

In film terms, a RAW file is rather like a negative, whereas a JPEG is like a colour slide. Slides are convenient because when they come back from the processing lab they're finished and ready to view. Similarly, JPEGs are supposedly ready to print straight from the camera. However, this convenience means that you need to get everything right in-camera, so there's less room for error – and for creative manipulation.

Negatives are more time-consuming than slides because to appreciate the images you must print them first, but they're also much more versatile, suited to individual interpretation in the darkroom and have more latitude for error. RAW files are the same.

RAW PROCESSING SOFTWARE

To process RAW files you need special software. When you purchase a digital SLR it usually comes with a CD containing the camera maker's own RAW processor – Canon has its own system, so does Nikon. However, the majority of photographers prefer to use a third-party RAW processor. The most popular is probably Adobe Camera Raw, found in all versions of Adobe Photoshop from CS2 onwards, Photoshop Elements since version 3.0 and all versions of Adobe Lightroom. Apple Aperture also has its own RAW convertor, while Capture One from Phase One is popular with some photographers. SilkyPix is less known but worth trying the free trial download. I personally use Adobe Camera Raw in Photoshop CS3.

I use Adobe Camera Raw (ACR) in Photoshop CS3 to process my RAW files. It's quick, intuitive and effective.

They always require 'processing' using suitable software before they're considered finished, but this allows you to correct mistakes and make changes to enhance the images and correct mistakes:

① Colour temperature can be adjusted to get rid of unwanted colour casts or add them to change the mood of the image. This can also be done with JPEGs in Photoshop, but not with the same precision.

② Colour strength can be increased or reduced, but much more subtly than using the Hue/Saturation control in Photoshop – you can adjust Vibrancy as well as saturation.

③ If the exposure isn't quite right you can increase it or reduce it while processing the RAW file, or intentionally adjust the exposure to change the mood of the image without compromising image quality. You can make a JPEG lighter or darker but image quality will be affected.

④ It's possible to expose RAW files in-camera so that image quality is optimized – by giving as much exposure as you can without blowing the highlights, shadow detail is increased and the effects of noise reduced (see page 83). The exposure can then be 'pulled back' during RAW file processing. This is only possible because the RAW file contains more data than you need so it has wide exposure latitude, whereas a JPEG is already compressed and 'spare' data has been deleted so you don't have the same room for manoeuvre without compromising image quality.

⑤ If you do accidentally overexpose a RAW file so the highlights 'blow out', you can recover them to a certain extent during image processing. This isn't possible with JPEGs so blown highlights appear white and if you try to darken them they simply go grey.

⑥ Sharpening can be applied to a RAW file using whichever method you prefer – either relying on the sharpening tools in the RAW file processing software or cancelling that and using third-party applications. JPEGs are already sharpened so additional sharpening must be done carefully otherwise you can spoil the image.

⑦ You can correct optical problems such as chromatic aberration and vignetting when processing a RAW file. Both are quite common when shooting with ultra wide-angle lenses or zooms.

⑧ Any changes you make to a RAW file are non-destructive because you then make an editable copy – ideally as a 16-bitt Tiff file – and the original RAW file remains unchanged. This means you can return to the same RAW file and process it again and again.

⑨ Because RAW files contain so much data they can be processed several times then combined, either to address exposure and contrast problems or used as the basis for creative techniques such as HDR (High Dynamic Range – see page 186).

⑩ RAW files support 16-bits of data per colour channel whereas JPEGs only support 8 bits, so RAW files give superior image quality.

This won't be obvious initially, but heavy editing reduces image quality and 8-bit files will show this more readily than 16-bit, with problems such as posterization.

Many photographers are put off shooting RAW because they assume it's more complicated and requires more experience. However, RAW file processing software is very intuitive to use and any changes you make to a RAW files can easily be reversed or cancelled. Also, although JPEG is seen as a more convenient format for beginners because you don't need to do so much to the images afterwards, RAW is actually better because it gives you more room for error – and you're more likely to make mistakes as a beginner.

What are the downsides to shooing in RAW?

Well, one is that you inevitably need to spend more time at your computer because RAW files need to be processed before they're ready for use. But if you get as much right in camera as you can, a RAW file can be processed in a matter of seconds. Also, you can batch process RAW files, which saves time if you shoot a lot of very similar images that require the same changes.

Another downside is that RAW files are approximately four times bigger in terms of megabytes than JPEGs so take up more storage space. However, memory cards and external computer hard drives are cheap these days, so if you've spent a fortune on your DSLR it would be false economy to choose an image format purely on the basis of how much storage space the image files require.

Bigger image files also mean that your DSLR's buffer will fill-up faster if you shoot RAW. However, low-light and night photography is rarely rapid-fire, so this is unlikely to be a problem. I don't ever remember having to wait for my camera's buffer to empty while shooting low-light subjects.

If you decide to shoot in RAW format you won't notice any difference to shooting in JPEG, just change the image format, under the Quality setting in your DSLRs menu.

In terms of how you use your camera and its controls, that remains pretty much the same. The only difference is that when shooting RAW you give the image as much exposure as you can without 'clipping' or overexposing the highlights (see page 82). By doing this you'll record as much shadow detail as possible and better image quality result. It does mean that the images in their RAW state appear overexposed, but this is easily resolved during RAW file processing – as shown below.

If you're uneasy about shooting RAW initially, why not set your camera to record every image in both RAW and JPEG formats? That way, while you get used to processing RAW files, you know you've also got JPEGs of the same images, for reassurance.

IMAGE QUALITY WITH JPEG

One big difference between JPEG and Tiff formats is that JPEG is a 'lossy' format and Tiff is 'lossless'. What this means is that you can make as many copies as you like from a Tiff file and image quality will remain exactly the same, but every time you copy a JPEG, data is lost and image quality will decline.

In reality, this isn't nearly as bad as it seems. If you shoot in JPEG rather than RAW format, providing your camera is set to its highest JPEG quality and when you open and save the image in Photoshop you choose the highest quality JPEG setting, 12, there will be no noticeable difference in quality between that image and an image of the identical scene that was shot in RAW then opened and saved as a 16-bit Tiff file. You could argue that there must be a difference when a JPEG is 8-bit and a Tiff is 16-bit, but you'd need to subject the JPEG to some heavy Levels and Curves adjustments before you saw that difference. Also, having done tests myself, I can tell you that you would need to copy a JPEG dozens of times before any loss of image quality became noticeable, and in practice you're unlikely to ever do that. Also, even if the quality loss was more rapid, you can halt it simply by opening your JPEGs when you download them to your computer and saving them as Tiff files before you make any adjustments.

You can choose RAW, JPEG or RAW+JPEG from the Quality setting in your camera's menu.

RAW FILE PROCESSING

Processing RAW files is a straightforward task, though how long it takes and how many adjustments you need to make to the image will depend how close you get it to finished in-camera. Photographers who spent years shooting film before switching to digital tend to do more work on their images at the time they're taken because that's what they had to do with film, and old habits die hard – not a bad thing in this case. If you've only ever used a digital camera in anger there's a greater chance you'll rely more on software to sort out your mistakes, which means spending far longer at a computer than you need to.

This step-by-step guide shows you how to process RAW files using Adobe Camera Raw in Photoshop and what the different tools do to the image. I've intentionally chosen a RAW file that needed plenty of work in order to show what you can achieve, but ideally it shouldn't take longer than a minute or two to open a RAW file, process it and turn it into a high quality 16-bit Tiff file.

① When you open your RAW files you may be disappointed because they often look rather flat and washed out. This is because you're seeing the image in an unadulterated state, whereas the

preview image you see on your camera's LCD is a small JPEG of the RAW file and so tends to look better.

② RAW files produce the best image when the tones are weighted to the right side of the histogram, but if they touch the right side the highlights will be 'clipped', which means some areas

of the image have no recorded detail. Clicking on the red triangle above the histogram shows the areas that are overexposed as red.

③ The clipped highlights are mainly in the sky – quite common when shooting landscapes at dawn and dusk. Overexposed highlights can be recovered, to an extent, using the Recovery slider

in Adobe Camera Raw. In this case, applying it to a level of 30 sorts the sky out. Recovery flattens contrast so use it sparingly.

④ The next job is to tackle the exposure as the image is still looking wishy-washy. Pulling the Exposure slider to the left to -0.50 makes a noticeable difference by darkening the whole image,

though it still looks a little flat and lifeless. Again, this is common when you shoot in RAW format, but can be easily solved.

⑤ Clicking on the Tone Curve icon in the toolbar brings up a Curves window with sliders for Highlights, Lights, Darks and Shadows. In this case, reducing the values for Darks and increasing

Lights a little boosts contrast and brings the image to life. The sky will need a little attention in Photoshop though.

⑥ Next the Colour Temperature is checked. The shot was taken with the camera set to Auto White Balance (AWB) and has a slight cool cast as it was shot at dawn on a cloudy day. Various colour

temperature presets are tried to see if the effect they give is any better, but it seems the As Shot setting is the most effective here.

⑦ Now it's time to boost the colours. There are two sliders you can use in Adobe Camera Raw , Vibrance and Saturation. Vibrance is more subtle because it affects lower-saturated colours and leaves those that are already deeply saturated alone though a

small increase in Saturation is acceptable too. The key is always not to go OTT!

⑧ Another handy slider in ACR is Clarity, which adds depth to an image by increasing local contrast. Zoom in to 100% when using it, increase the level until halos appear near the edge details then

reduce it slightly. Or simply apply in a low level – in this case +20 – to give the image an additional boost.

⑨ RAW files always need sharpening to optimize image quality. There are lots of ways to do this and photographers have their own favourites, but if you want to keep life simple you could do a

lot worse than stick with the default sharpening settings in Adobe Camera Raw, as I did here.

⑩ Images shot with ultra-wide zooms often exhibit vignetting (darkening of the image corners), which can be corrected in ACR

using the Lens Vignetting slider in the Lens Correction window. Chromatic Aberration can also be corrected. This is a telephoto shot so it didn't suffer from either problem.

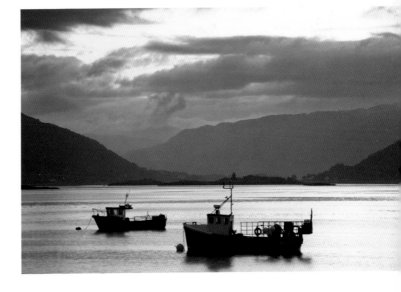

△ Plokton, Scotland
And here's the finished image – an atmospheric dawn shot that captures the moody character of the original scene, ready for printing or publication.
CANON EOS 1DS MKIII, 70–200MM ZOOM, 0.6ND HARD GRAD, 0.8SEC AT F/11, ISO100

ADJUSTMENTS IN PHOTOSHOP

You can get an image close to completion during RAW file processing, but it may still be necessary to perform additional tasks once that image is saved as a Tiff file. If you shoot in JPEG format, all adjustments are made in Photoshop or using other applications.

CROPPING

This can be done during RAW file processing, but I tend to wait until the image is saved as a Tiff file and opened in Photoshop.

Ideally, you should aim to compose your photographs in-camera but sometimes you may decide later that a shot can be improved if you crop it, either to remove unwanted elements or to change its format, to a square or panoramic shape, for example.

Obviously, the more you crop an image, the smaller its optimum output size will be, but if you're shooting with a 10+ megapixel digital SLR, you can afford to lose a little of the image area. Also, if you decide to make a print from a cropped image and the print size you want is bigger than the output size of the cropped image, you can increase its size using Photoshop by a fair degree without a noticeable loss of image quality.

CORRECTING WONKY HORIZONS

This task can also be carried out during RAW File processing, but I prefer to do it in Photoshop, it's a matter of personal preference. Go to Select>All then View>Show>Grid and a grid will appear over the image. Next, go to Image>Rotate Canvas>Arbitrary, enter a value you think is sufficient to correct the problem, such as 0.5°, choose clockwise or anti-clockwise rotation then hit OK. The image will be rotated by the amount entered and you can use the grid lines to check the horizon is level. All you have to do then is crop the image edges by dragging the Crop tool over the image. When you're done go to Show>Grid and uncheck the Grid box to get rid of the grid. Simple.

LEVELS ADJUSTMENT

Although recent versions of Photoshop have sophisticated (complicated?) tools that allow you to adjust the brightness and contrast of an image, I still prefer the more basic Levels, which does a perfectly good job when used with care.

Levels is ideal for giving an image more 'kick' by boosting contrast, as shown in this example of an image that looks rather flat and underexposed. Because I shoot in RAW format, the exposure/contrast would normally be adjusted during RAW processing, but if you shoot in JPEG you'll need to do it in Photoshop – and even after processing a RAW file, I often still end up adjusting Levels or Curves to get it just right.

① Go to Image>Adjustments> Levels and a dialogue box appears containing a histogram of the image with tabs for shadows (far left), midtones (middle) and highlight (far right).

② By moving the highlight tab to the left, so it's closer to the edge of the main histogram, the image is brightened up and contrast increased, as you can see here.

③ If you move the highlight tab too far, so it ends-up under the histogram rather than on the right-hand edge of it, the highlights will be blown out, so take care.

④ Similarly, if the shadow tab is moved too far to the right so it falls under the histogram rather than being on the left-hand edge of it, the shadows will block-up.

⑤ With scenic images, I find it much better to select the sky with the Polygonal Lasso tool, here using a feathering of 50 pixels, and apply Levels to the sky alone.

⑥ Once the sky is sorted I select the foreground and apply Levels again, moving the highlight tab up to the edge of the histogram as shown, to brighten the sea and rocks.

USING CURVES

The Curves adjustment in Photoshop – Image>Adjustments> Curves – has the same effect as Levels in that you can selectively stretch or compress the tones in an image. However, whereas Levels is easier and more intuitive, Curves is more versatile and can be adjusted with greater precision.

More experienced photographers tend to prefer Curves over Levels, but as far as I'm concerned, if you shoot in RAW, expose an image properly at the taking stage and make the necessary correction during RAW processing, you shouldn't need to rely on complicated Curves adjustment anyway.

Where I do find Curves useful is if I want to boost the contrast of an image. When you open the Curves dialogue box for an image you'll see that the Curve is actually a straight diagonal line. To boost contrast, all you do is click on this line approximately ¼ along its length from the bottom end and pull it down to the right a little so the bottom half of the line bows. Next, click on the line ¼ along its length from the top and pull it up so the top half bows the other way and the Curve looks like a shallow 'S' shape. Contrast will be boosted and your image will have more punch.

USING LAYERS

One of the great benefits of Photoshop is that it allows you to make duplicate layers from the main image and apply changes or effects to that layer so the main image is unaffected. Working with layers, mistakes can easily be rectified – if you don't like an effect or something goes horribly wrong, you can delete the layer and start again. You can also choose different blending modes and opacity levels to control the way the effect you have created actually works on the main image, and combine more than one image then hide or reveal selected areas in the different layer – as explained in Maximising Detail (page 98).

To create an adjustment layer, open your main image in Photoshop then go to Layer>Adjustment Layer and choose the type of layer you want from the options. Alternatively, if you simply want to make a duplicate layer go to Layer>Duplicate Layer and give it a name.

You can view your layers using Window>Layers. Always make sure the duplicate or adjustment layer is at the top of the layers palette, and when you have completed the effect on the layer, try different blending modes and opacity levels to see which gives the best effect.

Once the image is finished you can go to Layer>Flatten Image to combine the layers and make the effect permanent. However, by leaving the layers as they are, you always have the option to make changes at a later date or delete the layers altogether, so it is probably best not to flatten the image.

REMOVONG SENSOR BLEMISHES

Dust and dirt on your camera's sensor will show up as black marks on the images. An increasing number of digital SLRs have integral sensor cleaning that reduces problems with sensor 'muck' and if you avoid changing lenses in dusty environments – as well as making sure the camera's On/Off switch is set to Off before changing lenses – you can reduce it further. But even with the best will in the world, keeping the sensor spotless is almost impossible, so you will find that spots on the images need to be removed.

Fortunately, getting rid of them in Photoshop is easy. All you do is enlarge the image on your computer monitor to 100% so the offending marks are clearly visible, then click on the Clone Stamp tool. You can change the size, shape, strength and opacity of the tool and use it to copy pixels close to the offending blemish then paste those pixels over the blemish to get rid of it. The Healing Brush tool also does the same job and is quicker and more automated. I tend to use both tools.

Bigger blemishes caused by things like hairs on the sensor require more work. It's tempting to increase the brush size to speed things up, but if you're too hasty you will leave evidence of your actions on the image – so stick with a small brush and take your time.

CONVERTING TO BLACK AND WHITE

Although the majority of low-light and night images you shoot will remain as colour – because the colour actually creates the impact – there will be situations where you decide that the final image works better in black and white. I shoot a lot of images using 10-stop neutral density filter for example (see page 35) and most end-up as black and white as I find that they're more effective. But general low-light shots can also work well without colour.

There are lots of ways to convert a colour digital image to monochrome. These days I do most black and white conversion using a third party application, Nik Software Silver Efex Pro (www.niksoftware.com), which is accessed from the Filters dropdown menu in Photoshop. It's not cheap, but it's quick and easy to use, has lots of really good presets (High Structure is fantastic), allows you to mimic the characteristics of different black and white films, make localized changes to the image, tone it and much more.

MAXIMISING DETAIL

One of the most useful properties of a RAW file is that it contains far more information and detail than you actually need to create a successful image. You can't see this detail, of course, because it's beyond the dynamic range of a single Tiff, PSD file or JPEG, but what it does mean is that in images where the contrast is too great to hold detail in the lightest and darkest tones (shadows), you can process a single RAW file twice – once with the exposure correct for the darker tones and once with the exposure correct for the lighter tones – then merge the two in Photoshop to create a singe image with extended brightness range. Here's a step-by-step guide to how it's done.

① Open the original RAW file in Adobe Camera Raw (ACR) then adjust the exposure of the image until the sky looks correct. This will make the foreground really dark but don't worry. The Exposure slider in ACR can be used, and/or the sliders in the Tone Curve window. Once you're happy, save the image as a 16-bit Tiff file.

② The RAW file will remain open in ACR and the first version of it will be saved to your computer's desktop. Now you need to make a second version of the original RAW file, this time adjusting the exposure until the foreground looks correct. Doing this will burn out the sky, as you can see. Save this image as a 16-bit Tiff file.

③ Close ACR then open the two Tiff files you've just made in Photoshop. Click on the darker image, go to Select>All then Edit>Copy and the image will be copied. Close the darker image, click on the lighter image to make it active then go to Edit>Paste and the darker image will be combined with it as a layer.

④ With the darker image layer active, click on the Polygonal Lasso Tool, set feathering to 50 pixels, select the dark foreground from just below the skyline then go to Edit>Cut and the dark foreground will disappear to reveal the correctly exposed one underneath. The image is looking good already.

⑤ To get rid of any more areas of the dark foreground, select the Eraser Tool from the Photoshop toolbar, choose a medium-sized soft-edged brush and with the Opacity set to 40–50%, start 'rubbing' out the last unwanted bits of the darker image layer to reveal the correctly exposed foreground areas in the layer beneath.

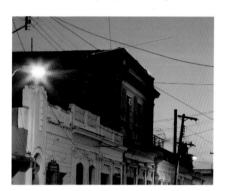

⑥ With the sky and foreground now looking great, it's just a case of fine-tuning the image to complete it. In this case I select small areas of the image using the Polygonal Lasso tool and adjust Levels to lighten or darken those areas as required until I'm happy with the overall look.

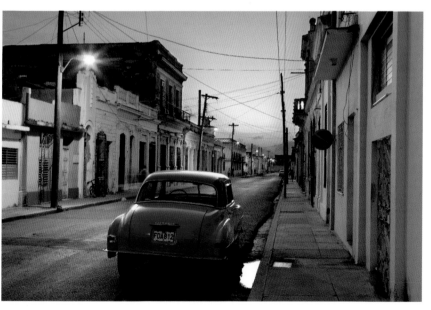

▶ **Cienfuegos, Cuba**
Here's the final image, created by combining two versions of a single RAW file where the exposure was first adjusted so the sky was correct and then again so the rest of the scene was correct. For scenes like this, where the skyline is broken, combining two images is more effective than using an ND grad to tone down the sky.
CANON EOS 1DS MKIII, 24–70MM ZOOM, 1 SEC AT F/11, ISO100

SUBJECTS AND TECHNIQUES

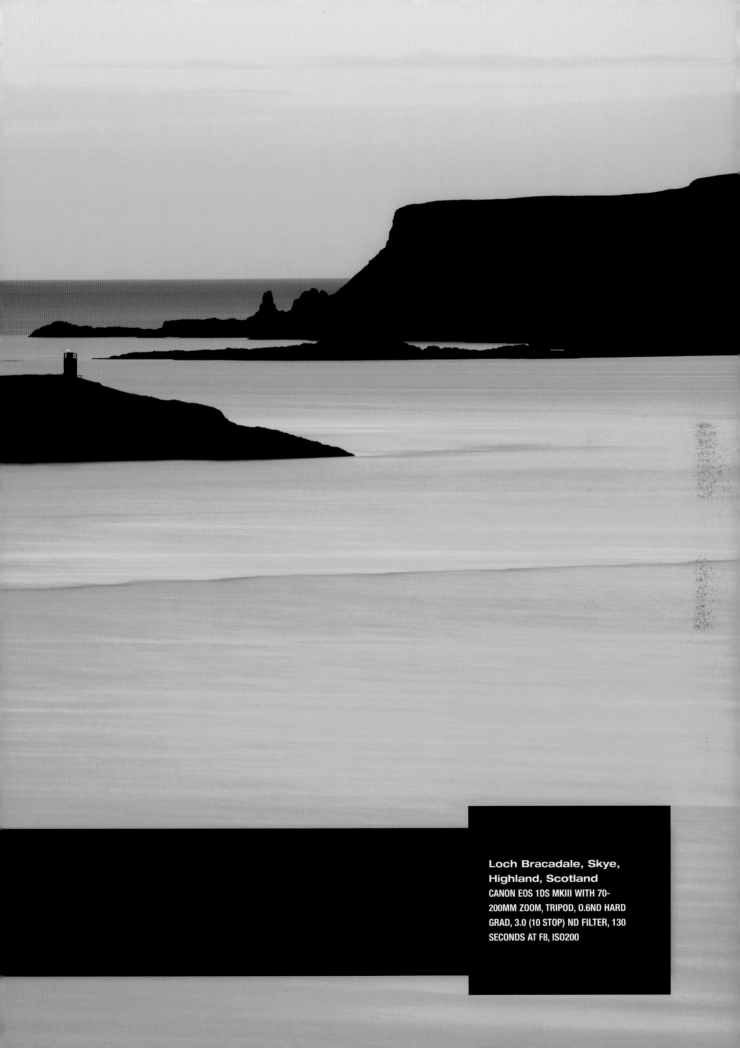

Loch Bracadale, Skye,
Highland, Scotland
CANON EOS 1DS MKIII WITH 70-
200MM ZOOM, TRIPOD, 0.6ND HARD
GRAD, 3.0 (10 STOP) ND FILTER, 130
SECONDS AT F8, ISO200

TOWNS AND CITIES

There are few sights more impressive than a town or city at night shimmering under the colourful glow of artificial illumination, or towering office blocks reflecting the vibrant colours of the twilight sky. London, New York, Hong Kong, Sydney, Dubai – wherever you go in the world there are amazing cityscapes to be captured. Don't feel you have to visit faraway locations to capture fantastic night shots though – any town will be transformed as day turns into night.

Getting high enough so you have a clear view is often the main problem, but if you look around and ask around you may find a solution. Office blocks in big cities tend to provide breathtaking views, but bridges are worth checking out too and in most big cities there's usually some vantage point that visitors have access to – look at the postcard stands for clues. There are many buildings along the banks of the River Thames in London, for example, that offer amazing views, including restaurants with public viewing galleries. Apartments with balconies are also worth seeking out. If you can find one that's for sale, an estate agent may give you access for an evening, perhaps in return for a couple of photos that can be used for publicity.

GENERAL TECHNIQUES

If you're forced to work more or less from ground level, the other option is to get well away from the location so you can view it from a distance. Towns and cities on the coast, by a lake or on the banks of a river tend to suit this approach, as you can usually get an uninterrupted view from over the water – with the possibility of reflections as well.

High-rise town and cityscapes are best photographed around sunset, when the glass facades of office blocks reflect the fiery colour in the sky, contrasting beautifully with the blue sky behind. Using the golden sky as a backdrop to floodlit buildings just after sunset can also produce breathtaking results. The 'afterlight' period when light levels are low but there's still colour in the sky is again a good time to shoot town and cityscapes, though once the sky had faded to black you will find that the scene loses its appeal, with brightly lit areas swimming in a sea of darkness. This is your cue to pack up and head home until the next evening.

When shooting from a high viewpoint, use a wide-angle lens to capture sweeping vistas, with roads and buildings stretching as far as the eye can see, then perhaps switch to a telephoto or telezoom lens to isolate parts of the scene.

Telephoto lenses are also invaluable for photographing distant cityscapes where buildings are lined-up on the horizon – the top end of a 70–200mm or 75–300mm telezoom will be powerful enough for frame-filling shots.

◄ Edinburgh, Scotland
When dusk and rush hour coincide you have the makings of great low-light urban landscapes. I took this shot in late October. I was actually heading back to my hotel after shooting the city from a higher viewpoint (Calton Hill). From there the light appeared to have faded beyond its best, but once down at street level and looking west towards where the sun had set, I realized there was still time to get more shots, so my camera came back out of its pack and my tripod was hastily set-up by the side of the road. Although light levels were fading fast I was amazed how much colour my digital camera was still managing to pick up in the sky – far more than film ever would. And I got to see the shot seconds after taking it so I knew it was a success – a benefit of digital imaging that I never take for granted.
CANON EOS 1DS MKIII, 70–200MM ZOOM, TRIPOD, 20 SECONDS AT F/29, ISO200

TIMING IS EVERYTHING

If you're unfamiliar with the location, it's well worth doing a recce earlier in the day to discover potential subjects and establish viewpoints. In big cities, check the postcards stands to find out which buildings or monuments are floodlit at night, and which scenes tend to look the best so you have a better idea where to head for when you return later.

The best time to take 'night' pictures in towns and cities isn't actually at night at all, but during the period after sunset when there's still colour in the sky to provide an attractive backdrop to the artificial illumination and enough residual daylight to partially fill-in the shadows so they don't block up. The optimum time is in fact when daylight has faded to a point where the ambient and artificial lighting in a scene is at a similar level so both require an equal amount of exposure – often referred to as 'cross-over' lighting. This point is usually reached around 30 minutes after sunset, depending on the time of year. In summer it lasts much longer and the colour in the sky may linger for an hour or more, whereas in winter the twilight is short and darkness creeps up very quickly – giving you only 20–30 minutes of prime cross-over light.

If you shoot too soon, daylight levels will be too high and the artificial lighting won't stand out enough. But leave it too late and contrast will be far too high, with bright lights against deep shadows and black sky. That said, digital cameras are much better at drawing the last drops of colour from the sky than film, so even if all colour appears to have faded from the sky, you may find that your camera's sensor, being more sensitive than your eyes, continues to record colour for another 10 minutes or more.

Even with this extra time, you'll still find that darkness comes all too soon, so it's worth scouting your location earlier in the day for suitable viewpoints. If you're visiting a location for just one night, you also need to decide well in advance which scenes you want to photograph and get to the first one around sunset so you don't waste any time. If, on the other hand, you're in the area for several nights or can visit on a regular basis, the pressure is off and you can always go back the next night too.

FLOODLIT BUILDINGS

The majority of towns and cities contain a variety of floodlit buildings, from churches, cathedrals and castles, to town halls, museums and art galleries. All make effective low-light subjects, and all can be approached in exactly the same way.

The main factor that makes one floodlit building different from another tends to be the light source used to provide the illumination, as this dictates what colour the building will record. Buildings lit by tungsten or sodium vapour come out yellow/orange, for example, while mercury vapour lighting creates a blue/green cast. You can use the custom white balance settings on your digital camera to balance the colour casts produced by certain

types of artificial lighting (see page 72). However, more often than not you'll find that there's more than one light source in the scene so a custom white balance setting won't be completely successful. More importantly, the strange colour casts created by artificial lighting usually look incredibly effective, so you'd be mad to try and filter the, out! I tend to leave my digital SLR set to AWB (Auto White Balance) and let nature take its course. By shooting in RAW format I know that I can adjust colour temperature later to change the appearance of different light sources, though it's rare that I bother to because the weird and wonderful colours are what make the shots so appealing.

Getting the exposure spot on when shooting floodlit buildings is child's play these days, thanks to the sophisticated metering

systems found in digital cameras. It's rare that they get it wrong, but if they do, the fact that you get to see the images immediately after taking them means that you can take steps to correct any exposure error there and then using your camera's exposure compensation facility or, if shooting with the B (bulb) setting you can simply increase or reduce the exposure time. Shooting in RAW format rather than JPEG also means that you can correct a fair amount of exposure error later, while processing the RAW files. That said, don't let the latitude of the RAW format turn you into a lazy photographer – I always strive to get exposure perfect in-camera as it means less time spent at the computer later and, more importantly, better image quality.

If in doubt, bracket exposures over and under the initial reading. If your first shot is taken at an exposure of 10 seconds at f/16, for example, take others at exposure of 5, 7, 15 and 20 seconds then choose the best frame later. You can use your camera's autobracketing feature (AEB) to save time as it will automatically make a series of exposures one after the other at the increments you have set. Alternatively, use your camera's bulb setting and simply change the exposure time for each shot.

Avoid including bright lights in the shot that are pointing towards the camera as they will create flare. Thankfully, most floodlighting is well concealed behind bushes or walls, so you can photograph the building from various angles without trying to avoid it. If you're shooting from across the street and traffic occasionally passes in front of the camera, it's also a good idea to shield your lens as it does so, to prevent light trails from the head and tail light recording – though the addition of light trails can improve the shot rather than spoil it.

Finally, don't worry if people are walking in and out of your shot. Moving objects won't record using such long exposures, so the worst that's likely to happen is that you get faint, ghost-like images on some shots where people have stood still for a few seconds before walking on – but again, this can improve rather than spoil a good night shot by adding an unusual and unexpected feature that will undoubtedly have people asking, 'So how did you do that?'

▼ Newcastle-upon-Tyne, England
The Quayside along the River Tyne in Newcastle is a fantastic location for night photography. Not only is there a series of bridges along the river, but fantastic buildings too, and on a clear evening you can't fail to take great shots – though I almost missed the light completely on this occasion after getting stuck in rush-hour traffic. I made it just in time, after running along the quayside to a spot where I knew I would get a clear view with a reflection of the floodlit Millennium Bridge. Note to self: cities are busy at rush-hour – allow more time to reach location in future!
CANON EOS 1DS MKIII, 17–40MM ZOOM, TRIPOD, 25 SECONDS AT F/16, ISO100

STREET SCENES

Busy streets full of traffic, people and buildings are packed with colourful low-light photo opportunities and, although big cities undoubtedly offer the greatest variety of subjects, even the smallest town can be a source of successful pictures – especially on Fridays and Saturdays when the shops stay open until later and there's more activity going on. Seaside towns and resorts are also ideal locations for low-light photography, particularly during the busy summer season when the streets are packed with people and restaurants, cafes and bars add colour to the lively scenes.

As with all urban low-light subjects, dusk is the ideal time to be exploring the streets with your camera, though an earlier recce is advised if you're unfamiliar with the location. This won't be necessary in your home town or city, but if you're on holiday or visiting somewhere purely to photograph it, the more you can familiarize yourself with the location during the day, the better equipped you'll be to photograph it when light levels begin to fade.

Busy shopping streets and squares tend to be where you'll find the greatest concentration of colour and action, especially if traffic has access as well – pedestrianized areas don't have the same impact, and remember that moving objects won't record during a long exposure so you may find that what appeared busy to the naked eye may look rather empty and lifeless in the final image.

Street level viewpoints can produce excellent shots, especially if you can find a spot to work from such as a traffic island in the middle of the road where you have a clear view. Busy pavements are less useful as there's a high risk of your camera being knocked as people try to pass you, and your view will be restricted by heads and bodies. Wherever you shoot from, put safety first. Avoid standing on the edge of a busy road, or setting your tripod up so it's half on and half off the road, otherwise you could end up being the victim of a road traffic accident – or causing one by obstructing the view of motorists.

Higher viewpoints get around all these problems, so look for cafés and bars with balconies overlooking busy streets, a

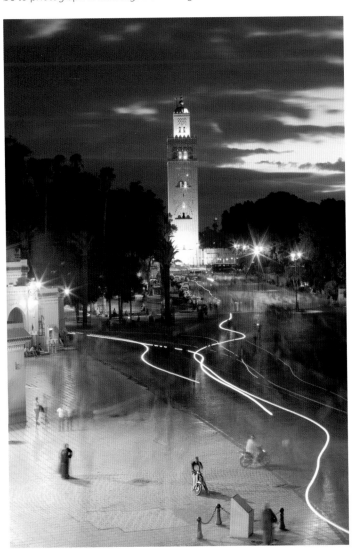

Siena, Italy ▷

While wandering around the streets of Siena, I stumbled upon the entrance to a restaurant where illuminated numbers on the roof were casting a vivid green glow over the walls. I've got no idea what those numbers relate to, but they certainly did a great job of turning a drab entrance into an eye-catching light show. It was still daylight behind me so I wasn't carrying a tripod. However, as my lens was at its widest focal length, 17mm, I knew I would have enough depth-of-field even if I shot at maximum aperture. That, combined with increasing the ISO, allowed me to shoot handheld and achieve a sharp image.
CANON EOS 1DS MKIII, 17–40MM ZOOM, 1/50SEC AT F/4, ISO400

◁ The Koutoubia, Marrakech, Morocco

One of the most fascinating things about low-light photography is that you can never predict with 100% accuracy how a scene will record, so the final images are often full of surprises. In this case, I was mainly interested in capturing the floodlit minaret against the dusk sky, but the pool of light in the foreground coming from a nearby street lamp was an unexpected bonus, as were the ghostly figures of people and the light trails created by mopeds speeding through the scene during exposure. These extra elements have turned a good shot into a great one.
CANON EOS 1DS MKIII, 70–200MM ZOOM, TRIPOD, 25 SECONDS AT F/16, ISO100

multi-storey carpark, or a convenient office window – if you ask politely you may be given permission to shoot from it. Getting on to the rooftop of a building is another option. It's unlikely this will be allowed in the UK, where health and safety regulations are strict, but overseas you may find authorities less forbidding.

If you have an unrestricted view, a 70–200mm or 75–300mm telezoom will produce dramatic shots of street scenes, compressing perspective so all the main elements – people, traffic, buildings – are crowded together in a single composition. Wide-angle lenses are a better choice when you can get close to interesting features and fill the foreground; I find a 17–40mm zoom to be invaluable when shooting urban landscapes at night. Wide-angle lenses also stretch perspective, which can help to add impact to your compositions.

Whichever lens you use to photograph street scenes, avoid including bright lights in the shot if they are causing flare or ghosting, otherwise your pictures will be ruined. Bright lights just out of shot can also cause flare. This won't be evident when you look through the camera's viewfinder, or even when you inspect images on the preview screen, but you'll see it clearly when you download those images and view them on a computer monitor. Subtle flare can often be removed using the Clone Stamp tool in

◤ The Sage, Newcastle-upon-Tyne, England
This amazing space-age building is a concert hall situated on the banks of the River Tyne in Newcastle. The prime shooting period was over and hardly any colour was visible in the sky to the naked eye, but as I wandered back to my car I decided to take a few more shots to see how they turned out. I was surprised by how much colour was still recording, and though the purple cast is rather unusual – probably caused by light pollution from the city – it suits the subject well. Second note to self: Even though you can't see colour in the sky, your camera may be able to.
CANON EOS 1DS MKIII, 70–200MM ZOOM, TRIPOD, 30 SECONDS AT F/11, ISO200

Photoshop to 'paste' pixels over the areas suffering from flare, but you need to work carefully to avoid tell-take marks. I find a soft brush and light opacity, around 30%, works.

Exposure-wise, there are no magic formulas here because every street scene differs depending on what's in it, how much lighting there is and so on. As is usually the case, I set my digital SLR (or compact if I'm using one) to aperture priority (Av) mode, select a smallish aperture such as f/11 or f/16, then leave the camera to determine the exposure time required. As most street scenes are reasonably well lit at dusk, this metering method is

usually accurate, and providing the exposure time required isn't longer than 30 seconds, it falls within the automated shutter speed range offered by my camera. The first shot is then quickly checked on the camera's preview screen along with the histogram and if I need to increase or reduce the exposure, I do so using the exposure compensation facility and reshoot. As contrast is high when shooting street scenes at dusk, it's common for the brighter areas, such as light sources, to overexpose and flash as highlight warnings. There isn't a lot you can do about this as getting rid of the blown highlights would involve reducing the exposure so much that the rest of the scene would be grossly underexposed. Therefore, I work on the basis that if most of the scene is well exposed, I can live with a few small areas of underexposure – and the 'Recovery' tool in Adobe Camera Raw can help to remedy them anyway during RAW file processing.

Before switching to digital capture, I tended to use a handheld spotmeter to take selective meter readings. However, the metering systems found in the latest digital SLRs is so accurate that you really don't need anything more – and the instant feedback you get provides such a fantastic safety net that you need never lose a great shot through exposure error.

▽ Cienfuegos, Cuba
Dusk isn't the only time of day to shoot successful low-light images in urban locations – dawn can be equally rewarding. I took this shot of the Palacio Del Valle from the balcony outside my hotel room. I had actually got up early to shoot the sunrise, not realizing that the Palacio would be floodlit in the morning, so before heading down to the waterfront I took a few shots of the building against the sea and dawn sky.
CANON EOS 1DS MKIII, 24–70MM ZOOM, 30 SECONDS AT F/14, ISO100

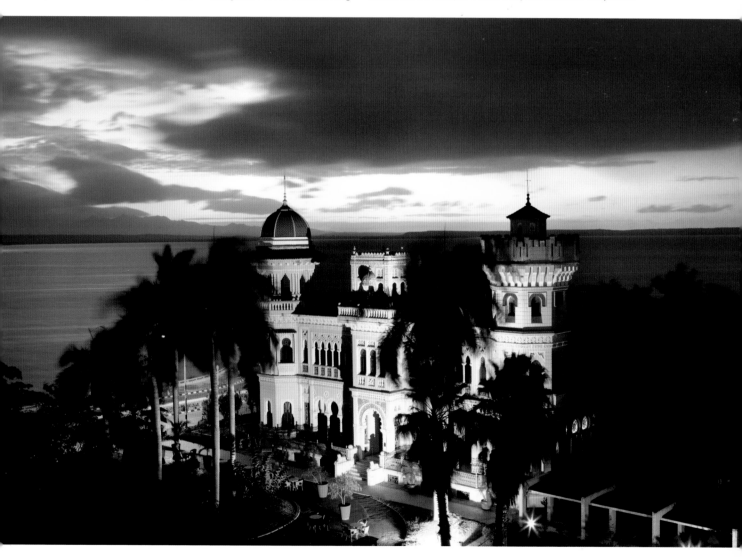

 Djemaa el Fna, Marrakech, Morocco
In countries that enjoy a warm climate, the streets and squares are often still busy well into the night, providing yet more exciting photo opportunities. I photographed this crowd from the terrace of a café and experimented with different exposure times to vary the blurred/sharp contrast between people standing still and those moving around.
CANON EOS 1DS MKIII, 70–200MM ZOOM, TRIPOD, 2 SECONDS AT F/4, ISO400

TRAFFIC TRAILS

Traffic trails are created by using an exposure of 20–30 seconds to capture traffic moving along a busy road at night – the vehicles themselves don't necessarily record because they're moving, but their head and tail light do, creating red and white light trails stretching off into the distance. The best time of year to shoot traffic trails is from late autumn through to early spring, as rush hour coincides with dusk so the roads are at their busiest during the optimum period when there's still colour in the sky and shadows are partially filled-in by daylight. That said, if you live in a big city, the roads tend to be busy even late at night, so you can shoot traffic trails all year round.

To make the most of traffic trails, an elevated viewpoint over a busy road, roundabout or motorway is required. Bridges, flyovers and multi-storey carparks are ideal for this, and although it's possible to take great shots of an average two-lane road or dual carriageway, big motorways or intersections with lots of lanes

and traffic merging from slip roads will provide more traffic and therefore more light trails.

To capture the traffic trails, mount your camera on a tripod, set the lens aperture to f/11 or f/16 at ISO 100 or ISO 200 and the shutter to B (bulb). All you have to do then is wait until the light levels have fallen sufficiently for the lights on passing traffic to stand out and start shooting. Do this by tripping your camera's shutter with a cable release and holding it open for 20–30 seconds so plenty of passing traffic will record. If there's a lull in the traffic flow, hold your hand or a piece of card in front of the lens to interrupt the exposure, wait for more traffic to appear, then

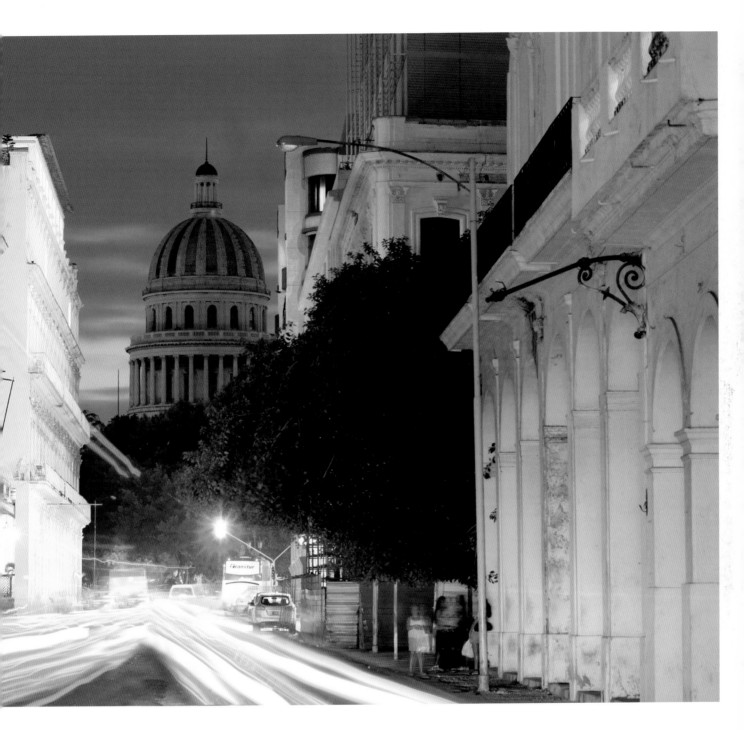

uncover the lens. Repeat this as often as necessary until the scene has been exposed for the required length of time.

If buildings are included in your picture, such as office blocks that are still lit inside, or floodlit buildings lit from the outside, you need to use an exposure that's correct for them. I shoot in aperture priority (Av) mode and let the camera work out the 'correct' exposure time, stopping the lens down to a small aperture and keeping the ISO low so the required exposure is long enough to record plenty of traffic trails. This limits to exposure to 30 seconds though, and makes it tricky to 'halt' the exposure with a piece of card while waiting for more traffic to appear. If I need to do this,

▲ Havana, Cuba

Any busy road at rush-hour can be the source of great traffic trail images and although the colourful light trails themselves make for interesting abstract images, I prefer to capture them as part of a wider street scene and so tend to look for locations where there are floodlit buildiings and other features to include in the composition.
CANON EOS 1DS MKIII, 70–200MM ZOOM, TRIPOD, 25SEC AT F/7.1, ISO200

I switch the camera to bulb mode and count the exposure in my head, having already taken a test shot to establish how long that exposure needs to be.

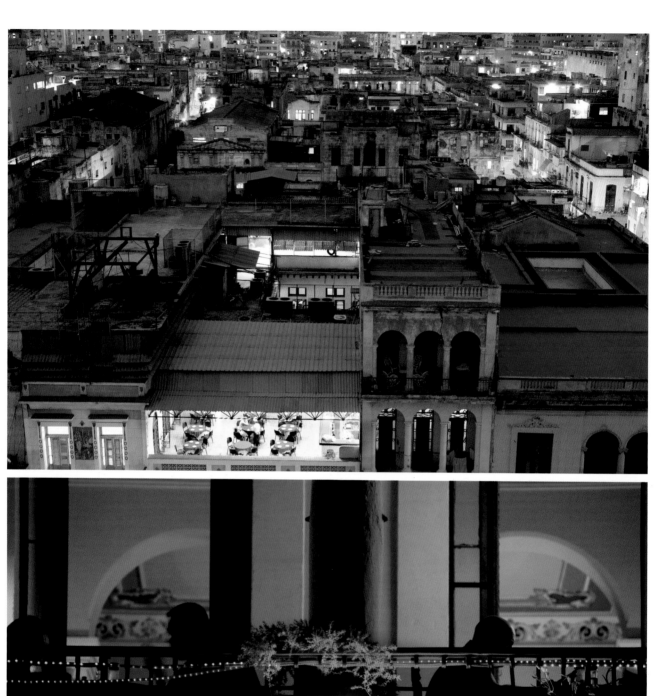

Havana, Cuba

You don't have to include sky when shooting town and cityscapes – sometimes a scene works better if you zoom in closer and fill the frame. I captured this view over the rooftops of Havana Centro from the window of my seventh floor hotel room. It's literally packed with detail, and once you start looking, it's hard to stop!
CANON EOS 1DS MKIII, 24–70MM ZOOM, TRIPOD, 30 SECONDS AT F/7.1, ISO200

Trinidad, Cuba

One of the most significant benefits of shooting night and low-light images with a digital camera rather than film is that it's now possible to produce successful images in situations where it would have been impossible a few years ago. This shot is a good example: by setting my camera to its maximum ISO and the lens to its widest aperture I was able to use a relatively fast shutter speed to capture life in the street despite the low light levels.
CANON EOS 1DS MKIII, 70–200MM ZOOM, TRIPOD, 1/20SEC AT F/4, ISO3200

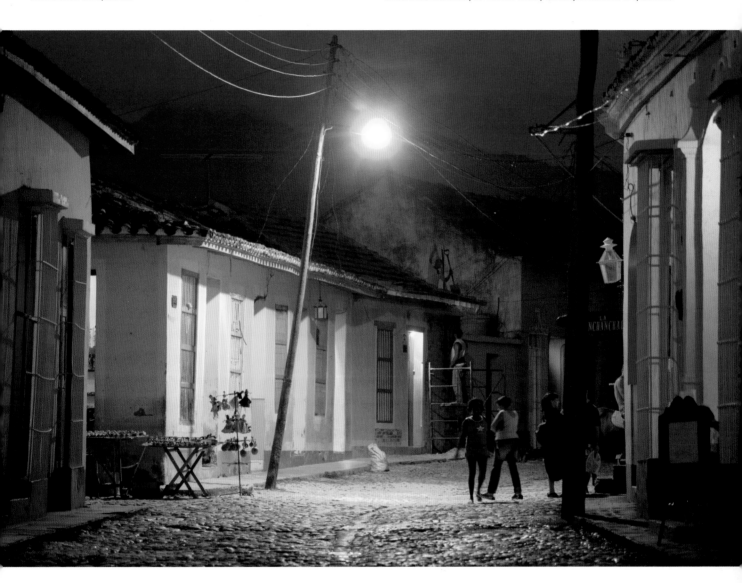

Havana, Cuba

Illuminated signs outside bars, clubs and restaurants make great low-light subjects and are relatively straightforward to photograph. The key is to shoot while there's still some residual daylight from the sky, or other forms of artificial illumination, otherwise contrast will be high and the illuminated tubes of the sign will burn out. I captured this sign as I wandered back to my hotel – the cooler colours inside the restaurant help to emphasize the sign itself.
CANON EOS 1DS MKIII, 70–200MM ZOOM, TRIPOD, 0.8SEC AT F/5.6, ISO100

SUNRISE AND SUNSET

Sunrise and sunset provide some of the most breathtaking conditions for outdoor low-light photography. The sun's golden orb sitting on the horizon is always a memorable sight, while the warm light it generates casts a magic spell over anything it touches.

You can often distinguish pictures taken at the start of the day to those taken at the end. At dawn the sun rises over a cold earth and into an atmosphere that has often been cleansed during the night, so in clear weather the clarity at sunrise can be incredible, with visibility stretching for miles. Shadows take on a cool cast because they're partially lit by reflected light from the sky overhead, mist can often be found veiling valley bottoms or floating gracefully over lakes, while the landscape is coated with dew.

Come sunset, things have changed dramatically. The atmosphere is no longer clean, but may be clogged by heat haze or pollution. Sunlight is scattered and much of the blue wavelengths are filtered out, so the light is much warmer than it was at sunrise, while the sun's orb may appear much bigger as it sets because of this scattering of light rays.

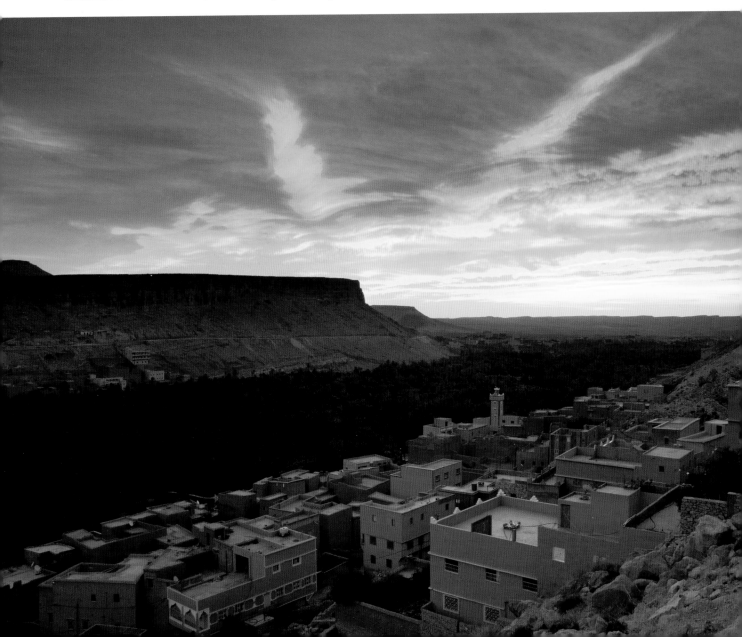

THE WEATHER

Weather conditions also determine how powerful or subdued sunrise and sunset are. In cloudy weather you may not see the sun at all between dawn and dusk, though when the weather is poor, there's usually a greater chance of seeing the sun at dawn than at dusk – if only for a minute or so.

Some parts of the world are more reliable than others for producing brilliant sunrises and sunsets because the weather is fairly predictable on a day to day basis – usually the further south you travel, the better it gets. One summer day in Australia or the Southern USA is pretty much like any other, for example, but in Western Europe and the UK, the weather can change dramatically in the space of a few hours, and one good sunrise or sunset is no indication of another one the following day.

Making the most of sunrise and sunset is therefore down to patience and perseverance. You need to make the effort to get out there and hope everything will go accordingly to plan, and if it doesn't, be prepared to do exactly the same thing the next day until you get what you want.

Fortunately, when everything does come good, the pictures you take will be so wonderful that it makes all the waiting and hoping worthwhile.

EQUIPMENT NEEDS

Exposure error used to be the ruin of many a good sunrise or sunset image, but these days it's almost a thing of the past and in all but the most extreme situations your digital SLR will usually come up with a well-exposed shot. You may need to give it a helping hand by dialing in a little exposure compensation, but it won't be far off.

◁ Tinerhir, Morocco
The only way to catch a great sunrise is to set your alarm clock nice and early and take a chance on the weather. I aim to be on location an hour before the sun's due to come up so I have time to get organized and also be ready to catch the pre-dawn colours at their most intense, which is often well before sunrise. On this occasion, the colours peaked for literally 30 seconds before fading very quickly, but as I had been watching and waiting for some time there was no danger of me missing them.
CANON EOS 1DS MKIII, 24–70MM ZOOM, 0.9ND HARD GRAD, TRIPOD, 1.3 SECONDS AT F/10, ISO100

▽ Alnmouth, Northumberland
No two sunsets are ever the same – one day the sun may drop behind dense cloud, the next it could set the sky on fire with vibrant reds, yellows and oranges and the next hang over the horizon like a ball of molten gold. It's all down to the weather, and in the UK, trying to predict that from one day to the next is like trying to pick the winning numbers in the Lotto. To help you make the most of great sunsets when they do occur, earmark some locations close to home that you can get to quickly and at short notice. Anywhere with water is always a good bet because it reflects the colours in the sky.
CANON EOS 1DS MKIII, 70–200MM ZOOM, 1/125SEC AT F/9.9, ISO100

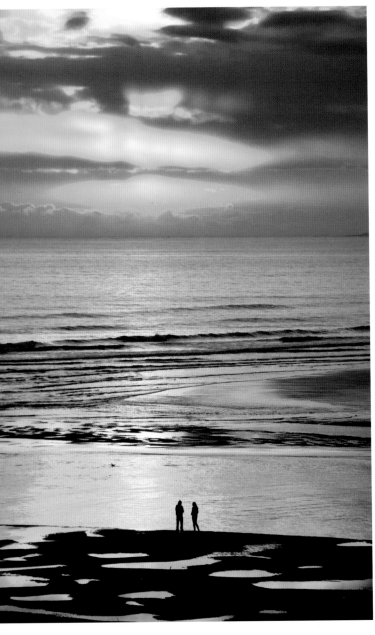

In terms of lenses, the focal length you use will depend on the scene or subject you're photographing. The main thing to remember is that the longer the lens is, the bigger the sun's orb will be. So, if you want to make a feature of it, use the longest lens you can lay your hands on – anything from 300mm up will do a great job. Wide-angle lenses make the sun's orb appear smaller than it does to the naked eye due to the way they exaggerate perspective, but don't let that put you off – for scenic pictures a 28mm or 24mm focal length will be perfect.

The only filters you need when shooting sunrise and sunset are a couple of ND grads (see page 35), to tone down the brightness of the sky and sun so you can record detail in the foreground without the sky being overexposed. You'll need quite strong ND grads at sunrise and sunset – I find a 0.9 (3 stop) the most useful and I prefer 'hard' grads to 'soft' grads as they're more effective on bright skies. At dawn and dusk the sky is brightest at the horizon, but that's where ND grads filters are at their weakest. A hard grad is less weak than a soft grad so there's less chance of the sky close to the horizon blowing out, though you have to accept that more often than not, there will be areas where no detail records and you get highlight warnings on the preview image. You can use the Recovery slider when processing the RAW files to reduce the size of blown-out areas, but contrast is so high when shooting at sunrise and sunset that sometimes you just have to accept that some areas will overexpose.

EXPOSURE ACCURACY

The way you photograph a sunrise or sunset will depend on the type of effect you are trying to achieve and prevailing weather conditions. You may want to shoot into-the-sun to create a powerful silhouette, or capture detail in the foreground of a scene without losing the drama of the sky. Then again, you may decide to turn your back to the sun and photograph scenery bathed in its golden light. Each approach can work well, but the metering technique you use will differ.

Let's begin with creating silhouettes, as this is the simplest technique to master. Silhouettes are essentially black shapes, devoid of detail but identifiable by their distinct outline, and were made popular by the French politician, Etienne Du Silhouette, in the 19th century. He created black profiles of people on white backgrounds as a form of portraiture – hence the name.

Photographically, the same effect is achieved by capturing any solid feature, be it a building, tree or person, against a bright background or light source. By exposing for the brightest parts of the scene, that feature is underexposed by several stops so it records as a solid black mass – a silhouette. Sunrise and sunset provide ideal

▲ Alnmouth, Northumberland, England
Sunrise over the sea is hard to beat in the mood stakes as you not only get colour in the sky, but also reflecting in the foreground. I shot this view from my son's bedroom window which looks out over Alnmouth Bay. Being mid-winter, the sun didn't actually rise until after 8am, by which time people were out strolling along the beach and enjoying the fresh air. This couple entered frame and stopped to admire the sunrise – providing a perfect focal point in my composition and adding a strong sense of scale.
CANON EOS 1DS MKIII, 70–200MM ZOOM, 1/1250SEC AT F/4.5, ISO200

opportunities to do this, with the bright sky and sun's orb making a perfect backdrop to whatever feature you decide to photograph.

Metering for silhouettes is simple, too. My usual approach is to set his camera to aperture priority mode, select a suitable aperture to provide sufficient depth-of-field, then leave my camera to automatically select the shutter speed required to give 'correct' exposure. If there is an area of excessive brightness in a scene, it tends to influence the exposure a camera's integral metering system sets, usually resulting in underexposure of the main subject matter. Under normal circumstances this is the opposite of what you want, but with silhouettes it gives perfect results – a solid black shape against a well exposed sky.

The main thing you need to be aware of is that if the sky or sun's orb is excessively bright, your camera may underexpose by too much, so the sky comes out too dark and the silhouette is hard to make out.

The biggest mistake photographers make when shooting silhouettes at sunrise or sunset is making the composition too cluttered, so that when all the features in a scene are reduced to black shapes, they end up as a confusing muddle. Avoid this by sticking to one or two key features, such as a lone tree on the horizon or a person gazing towards the setting sun. Boats on water, piers and jetties also make great subjects. Keep the foreground to a minimum too, otherwise you'll end up with a solid

black mass at the bottom of your shot – better to tilt the camera up to emphasize the sky than down. To get a better idea of how a scene will look when solid features in it are reduced to silhouettes, look at it with your eyes almost closed – technically known as 'the squinty eye test'!

The opposite approach to shooting silhouettes at sunrise or sunset is recording a scene as it appears to the naked eye, with a full range of detail in the sky and foreground. This is trickier because while our eyes can cope with an extreme brightness range, film and digital camera sensors can't and either give you a well exposed sky with an underexposed foreground, an overexposed sky and a well exposed foreground or both the sky and foreground badly exposed.

▽ Plokton, Scotland
Once the sun finally rises, providing it doesn't immediately disappear behind cloud, you can expect a few moments of amazing light. With the sun so close to the horizon, long, cool shadows rake across the landscape while the light itself has a beautiful golden glow that brings anything it touches to life. This warmth if created because the light has a very low colour temperature, though from the point the sun peeks over the horizon the colour temperature rises and within minutes the sumptuous glow will have faded – so make sure you're ready to capture it.
CANON EOS 1DS MKIII, 70–200MM ZOOM, 0.6ND HARD GRAD, TRIPOD, 1/13SEC AT F/25, ISO100

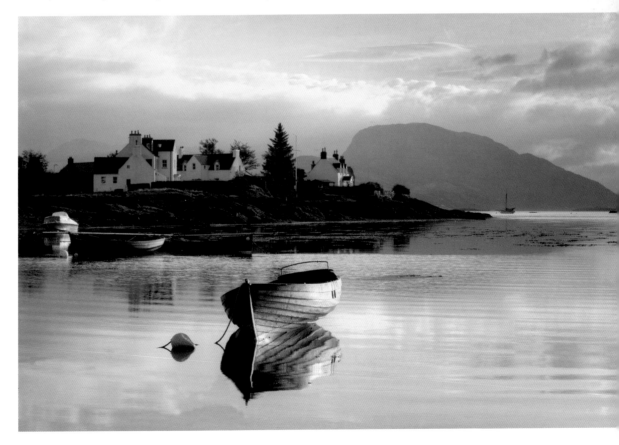

TIME AND PLACE

The time sunrise and sunset occur depends mainly on the season of the year and the location you're in, but knowing the positiont and the times is an important part of planning a dawn or dusk shoot so you know where the sun will rise and set and when you need to be there. Sunset is much easier to predict because you can observe the sun's path during the afternoon and you're on location in daylight. However, sunrise shooting often involves setting out in darkness, so you need to know that where you're heading for is the right place!

I always check sunrise and/or sunset times when I'm planning a shoot, mainly using the following website for the UK: http://www.canterburyweather.co.uk/sun/ukmap.php. All you have to do is input the date you need to know the times for and it displays them for that date throughout the UK.

A more sophisticated tool that's becoming more popular with photographers is known as the Photographer's Ephemeris (http://www.photoephermeris.com). This is available as a free download for both Mac and PC (plus as a paid-for App for the iPhone) and allows you to determine not only sunrise and sunset times for anywhere in the world, any day of the year, but also the angle of the sunrise/sunset so you can check if the sun's orb will be blocked by a range of hills, say. Moon rise and set times are also provided.

If you're heading overseas on a photo shoot, being able to access this kind of information is invaluable as it allows you to plan each day carefully and reduce the risk of bring in the wrong place at the right time!

In the UK the sun rises more than four hours earlier in summer than it does in winter, and sets six hours later. In practice this means rising very early and staying out late to photograph the summer sunrise and sunset, whereas in winter the sun is rising as most people head for work and has set before they make the return journey home.

If I'm planning a sunrise shoot, I aim to be on location an hour before the sun's due to rise as the richest colours in the sky often occur well before sunrise. Similarly, I aim to be where I need to be an hour before sunset to take advantage of the wonderful light during the 'Golden Hour' and also so I have plenty of time to decide on a viewpoint before the sun's orb disappears. Then it's just a case of waiting and hoping that the broken cloud above the horizon lights up the sky!

Sunrise and sunset times for the UK can be checked on www.canterburyweather.co.uk/sun/ukmap.php, while the Photographer's Ephemeris (www.photoephermeris.com) is a more sophisticated tool for Mac and PC.

GOLDEN SHOTS

Of course, there's no law saying you must shoot into-the-sun at sunrise or sunset, and while doing so can undoubtedly produce stunning photographs, remember that the golden light from the rising or setting sun could be doing magical things literally behind your back, so don't forget to peer over your shoulder every now and then.

Golden sunlight has the ability to transform even the most mundane scene, and this is never more so than when the sun is almost sitting on the horizon, casting long shadows and blessing everything it strikes with a wonderful warm glow.

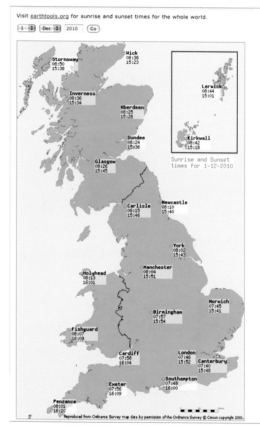

In normal conditions, scenes that are frontally lit tend to look rather flat because shadows fall away from the camera and out of view. But when that scene is lit by golden light the effect is far more dramatic, and because shadows cast by the low sun are so long, you can usually include some in the foreground to add a feeling of depth – though with wide-angle shots you will struggle to avoid including your own shadow, and may need to change viewpoint or switch to a longer lens. Alternatively, emphasize the long shadows by shooting with the sun at an angle to the camera rather than directly behind it.

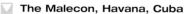 **Balanced Rock, Arches National Park, Utah, USA**
The last hour before sunset is often referred to by photographers as 'The Golden Hour' because, as the sun sinks ever-closer to the horizon, the light becomes warmer and richer. As there's more haze or pollution in the atmosphere at the end of the day, the light is redder than at dawn because more wavelengths at the blue end of the spectrum are filtered out.
MAMIYA 7II, 150MM LENS, POLARIZER, TRIPOD, 1/2SEC AT F/16, ISO50

The Malecon, Havana, Cuba
One advantage of sunset over sunrise is that you can monitor the light and weather through the afternoon and decide on a location that will allow you to make best use of the conditions you expect to encounter. In Cuba's capital city, the waterfront, known as The Malecon, is by far the best place to shoot sunset. On this occasion, huge waves were breaking over the sea wall so I timed my shots carefully to catch them at their peak.
CANON EOS 1DS MKIII, 17–40MM ZOOM, 1/250SEC AT F/4.0, ISO200

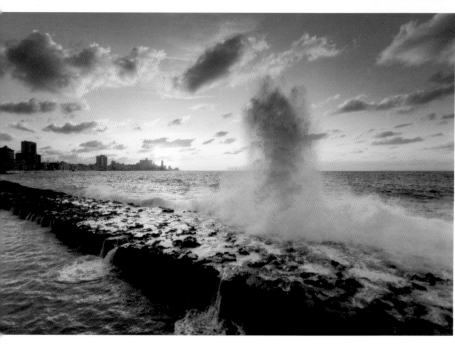

LOW-LIGHT LANDSCAPES

Although the vast majority of landscape pictures are taken in bright, sunny weather, the most dramatic conditions tend to be encountered in bad weather, at dawn and dusk, or even at night. Light levels are inevitably much lower, but the quality of light can be truly magical. It's for this reason that professional landscape photographers are at their most active at the beginning and end of the day, and reserve the middle hours, when the light is less attractive, as travelling time, or to recce new locations.

The importance of light, and the factors that control it, has already been discussed back on pages 62–73, while sunrise and sunset has been dealt with on pages 114–119. The aim of this chapter, therefore, is to look at some of the other low-light situations where stunning landscape pictures can be taken, and offer advice on how you can make the most of them.

▽ Upper Loch Torridon, Scotland

Dusk is a fantastic time to shoot landscapes – even if the weather doesn't play ball, great images are still possible. In this case I was hoping for warm evening light to rake across the foreground, but the sky clouded over and I didn't see the sun again that day. When I downloaded the images to my computer, however, I realized that I still had some pleasing results, with the overcast light helping to emphasize the rich colours in the scene and the bruised sky providing an attractive backdrop.

CANON EOS 1DS MKIII, ZEISS 21MM PRIME LENS, TRIPOD, 0.6 ND HARD GRAD, 0.8SEC AT F/16, ISO100

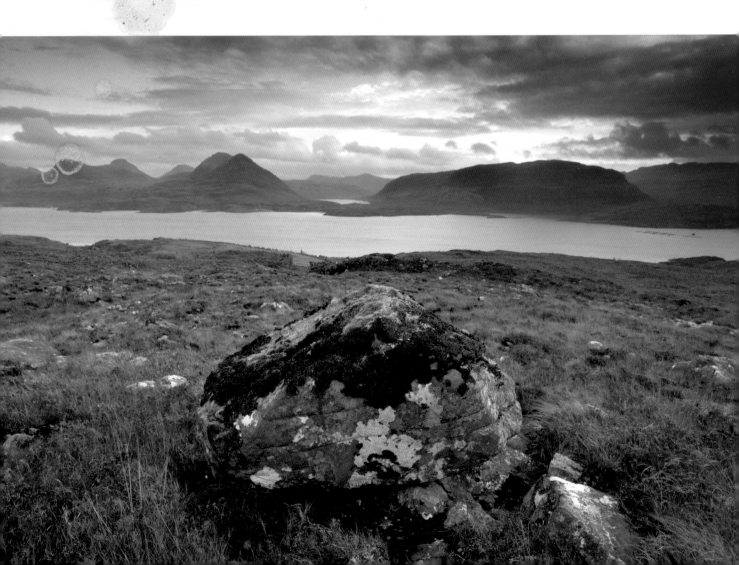

BAD WEATHER – GREAT IMAGES

Bad weather is a term used by the general public who tend to prefer warm sun on their back to freezing wind or driving rain, but photographically there's no such thing as bad weather, only 'weather', and the more extreme it gets, the more exciting the light tends to be.

Different types of extreme weather bring their own unique blend of characteristics to the landscape, allowing you to produce a wide range of images in a single location. What they all have in common, however, is the ability to reduce light levels considerably, to the point that exposures of many seconds may be required even in the middle of the day. This makes a careful and considered approach essential, especially when it comes to keeping your camera steady to avoid shaky pictures.

MIST AND FOG

Mist and fog reduces the landscape to a series of simple two-dimensional shapes and monochromatic colour. Fine detail is obscured, and all sense of depth lost other than the lightening of tone with distance; a phenomenon known as aerial perspective.

▲ Glen Torridon, Scotland
Early morning mist combined with subtle backlighting from the sun can transform an everyday scene into something very special. Colours merge into a harmonious palette while the mist adds mood and atmosphere. Here, I used a telezoom lens to fill the frame and exclude the sky. Moments later the heat of the sun had burned the mist away and the opportunity was gone.
CANON EOS 1DS MKIII, 70–200MM TELEZOOM, TRIPOD, 1/15SEC AT F/16, ISO200

Both mist and fog are created when warm, moist air hits the cold ground or clashes with pockets of cold air and condenses. That's why mist is common in the morning and can often be seen floating serenely above rivers and lakes or enveloping lowland areas and valley bottoms.

The best time of day to photograph mist is during early morning, before the air and ground temperature has a chance to rise and melt away the delicate veil, while the best times of year tend to be spring and autumn.

If you reach your location before sunrise, you may be lucky enough to witness the first rays of sunlight melting through the mist and washing the landscape in warm pastel hues, or exploding through trees in woodland to create an incredibly dramatic sight.

Loch Tollaidh, Torridon, Scotland

Landscape photography can be a frustrating business. You get out of bed at some silly hour to be on location nice and early, only to find that heavy cloud had descended and the chance of a decent sunrise is almost nil. This has happened to me many times, but having made the effort to get up and out, I always hang around just in case conditions improve. On this occasion they did – after about an hour of waiting, the sun momentarily broke through the cloud and illuminated the distant hills, doing just enough to make this shot a success.

CANON EOS 1DS MKIII, ZEISS 21MM PRIME LENS, TRIPOD, 0.6 ND HARD GRAD, 0.6SEC AT F/11, ISO100

Fog is far less subtle, reducing visibility to just a few metres at times and transforming the landscape into a monochromatic grey blanket where only the boldest features, such as trees and church spires, can be seen rising from the gloom. But don't let this put you off – the graphic simplicity of thick fog can make a refreshing change to the clarity and crispness of clear conditions and produce highly evocative images.

The key to success when photographing mist and fog is playing on its strengths and weaknesses. If you want to emphasize the receding effect created by aerial perspective, use a telephoto lens to photograph things like roads or rivers heading off into the distance, becoming less and less visible the further they are from the camera until everything appears to simply disappear. Long lenses exaggerate this by compressing perspective so the fall-off in tone seems to happen very rapidly.

Wide-angle lenses do the opposite, mainly because they allow you to include elements in a composition that are close to the camera, where the effects of mist and fog are minimal and everything appears pretty normal to the naked eye. Alternatively, when taking photographs in thick fog, try to include a splash of bright colour in your pictures to provide a focal point – such as a person wearing a red coat, or a red pillar box.

Both mist and fog can cause exposure error because the moisture particles in the atmosphere bounce the light around. To prevent this, you may need to increase the exposure your camera meter sets by ½–1 stop, though I usually take a test shot with no exposure adjustment, see how the camera copes then increase the exposure if necessary.

Shooting with a blue filter on the lens was common when photographing mist and fog on film, to add a cool, mysterious cast to the image. You no longer need filters to do this, simply changing the camera's white balance to Tungsten will have the same effect, though if you shoot in RAW format you don't need to worry about changing the white balance as you can do that when you're back home and processing your RAW files. Misty and foggy scenes also work well in black and white, so don't be afraid to experiment with monochrome conversion (see page 98).

STORM LIGHT

Stormy weather creates the most dramatic conditions for landscape photography, with shafts of sunlight illuminating small parts of a scene against the dark, threatening sky. Such conditions are usually difficult to predict, so you may have to spend time waiting at a location and hoping a break in the storm will occur, but it's worth the effort because when the clouds begin to part and the sun breaks through, the lighting will be truly magnificent.

Days when the sky is a mass of dark, wind-blown clouds tend to be the most promising because the weather is constantly changing and gaps in the sky regularly appear – you just have to hope that one of those gaps eventually passes over the sun.

If it does, the light may only break for a few seconds so you need to be prepared, with your camera already set up and the scene composed so you can start shooting immediately. Mount your camera on a tripod so you can keep it in position and fit an ND grad to lens to retain the drama in the sky – a 0.6ND grad should do the trick. Stop your lens down to f/11 or f/16 to give plenty of depth-of-field to record the whole scene in sharp focus, then, when the light breaks, take a quick test shot and check both the preview image and the histogram to make sure it's well

exposed. If not, adjust the exposure and reshoot, as quickly as you can! If you're lucky, the break in the storm will last long enough for you to bracket exposures and overcome any error, but there's no guarantee this will happen, so you really need to try and get it right the first time.

RAINBOWS

Rainbows are created when sun shines through falling rain and the light rays are refracted by the water droplets to form a band of light containing all the colours of the spectrum. To locate a rainbow in such conditions, simply turn your back to the sun and you should be able to see it arching across the sky.

To emphasize the colours of the bow, try to juxtapose it against a dark background – stormy sky is ideal, along with hills and mountains. Underexposing the shot by around ½ stop will also make the bow more prominent.

In terms of lens choice, use a wide-angle focal length if you want to capture the whole bow as part of a sweeping view, or use a telephoto lens to pick out just part of it – focusing on the bow itself if you use a telephoto or telezoom lens.

▽ Lower Antelope Canyon, Arizona, USA
Some landscape subjects are always in low light due to their location. Antelope Canyon is one such place. This amazing sandstone slot canyon has been created over thousands of years by the action of water, gradually eroding the bedrock into a sinuous, graceful crack in the earth. Even at midday it's still pretty dim down there, but the shades of orange, red, yellow and magenta created by daylight being bounced around the canyon make it a true photographer's paradise.
MAMIYA 7II, 43MM LENS, TRIPOD, 30 SECONDS AT F/16, ISO50.

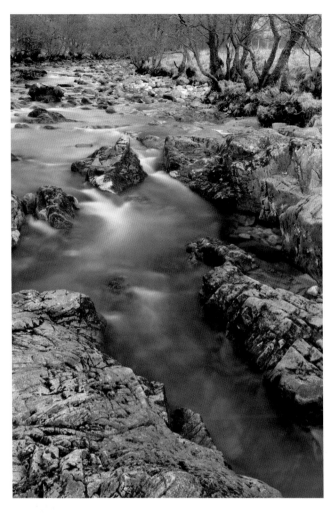

River Nevis, Glen Nevis, Scotland

Rivers and waterfalls benefit from low light because it forces you to use a slow shutter speed, which in turn records the moving water as a graceful blur. Though this technique has become something of a cliché, I feel it's by far the best way to capture the sense of movement in water, and the contrast it creates against stationary elements in the scene undoubtedly makes for successful photographs.

CANON EOS 1DS MKIII, 24–70MM ZOOM, TRIPOD, 10 SECONDS AT F/22, ISO100

LIGHTNING

Electric storms are undoubtedly the most dramatic example of 'bad' weather, and can produce amazing images if you are fortunate enough to capture them.

The ease of doing this depends very much on which part of the world you live in. Here in the UK, lightning tends to be very brief and unpredictable, with no warning of its arrival. Photographers have been known to take successful shots over here, but it tends to be a result of luck rather than judgment because the lightning flashes are often over before you even realize what has happened, and there may be a delay of several minutes before the next one appears – usually in a completely different part of the sky.

In more tropical regions, including much of Australia and certain parts of the USA, however, electrical storms usually occur on a much bigger scale, are more predictable, and last for much longer, making it much easier to capture them on film.

The technique you use to do this is the same as if you were photographing an aerial firework display. Mount your camera on a tripod, note where the lightning bolts are striking, then aim your camera in that direction and lock the shutter open on bulb (B) at an aperture of f/11 or f/16. Lightning is more common at night, and this makes it easier to photograph because you can leave the shutter locked open for a minute or two without having to worry about overexposure.

If there's a lengthy delay between strikes, hold a piece of card in front of the lens to halt the exposure, then take it away when you expect the next strike. By repeating this process several times you can capture lots of lightning strikes on the same frame to produce really dramatic images.

RIVERS AND WATERFALLS

Moving water is an ideal low-light subject, as a long exposure will record it as a graceful blur, capturing its energy and motion far better than a fast shutter speed ever could.

How long does the exposure need to be? Well, that really depend on how fast the water is flowing and how much water there is. A one second exposure makes a useful starting point; anything slower than that is unlikely to give a strong effect. But don't be afraid to go much slower – 5, 10, 30 seconds; even longer.

Much will depend on the location your're working in and how low the light levels are. If you're in woodland or a shaded valley then exposure of a second or longer will be easy to obtain – stopping your lens down to f/11 or f/16 and using a low ISO will be enough. But if you're taking pictures in dull, cloudy conditions, or early or late in the day, much longer exposures can be expected.

Should you find yourself in a situation where the longest exposure you can obtain is too brief, even with your lens stopped right down to its smallest aperture, the easiest solution is to use a filter to reduce light levels and force and exposure increase. Neutral density filters are designed for this very job (see page 34), and cause a light loss without changing the colour balance of the image. Failing that, why not use your trusty polarizing filter? It, too, will cut the light by two stops, allowing you to quadruple the exposure time – from ¼ sec to 1 sec, for example.

For the best results, try to include static elements in the scene

to emphasize the movement of the water. Rocks or boulders mid-stream are ideal, as the water will naturally flow around them and create interesting patterns. With waterfalls, take a step back or use a wider lens to include the immediate surroundings.

WOODLAND

Light levels are almost always low in woodland, simply because the leafy canopy overhead acts as an effective screen to the sun, and even in bright, sunny conditions you will probably find that exposures of a second or more are required when using a low ISO and small lens apertures.

Autumn is the premium time to photograph woodland, when the leaves on the trees are beginning to turn from lush green to a palette of warm and rustic colours. Beech, sycamore, oak, maple; every type of deciduous tree responds differently to the ending of the summer, but all can produce beautiful results, especially where different species appear in the same scene, providing a rich palette of colour and tone. Carpets of fallen leaves on the ground also form fascinating patterns and are well worth photographing in close-up.

Overcast weather reveals woodland at its best, as the soft light keeps contrast low but enriches leaf colour – in sunny weather,

Near Kinlochewe, Highland, Scotland
Dull, grey days may not fill you with excitement, but they do create ideal conditions for certain subjects. Woodland is one – the soft, low contrast light of dull weather is ideal for capturing the rich colours of autumnal foliage. I took this shot in heavy rain. While sheltering and waiting for the rain to stop, I noticed how the beech trees were swaying in the wind so I experimented with different slow shutter speeds to emphasize the movement.
CANON EOS 1DS MKIII, 70–200MM ZOOM, TRIPOD, POLARIZER, 3.2SECONDS AT F/32, ISO50

pools of light filtering through the branches can take contrast well beyond the capabilities of your film, creating stark highlights against deep shadows. To make the most of these conditions, use a polarizing filter to cut through glare on the foliage and increase colour saturation. In windy weather you can also add interest to your images by experimenting with slow shutter speeds to blur the swaying branches.

AFTER DARK

Beyond twilight, light levels fade to a point where the landscape appears monochromatic and the sky goes from blue to black, but

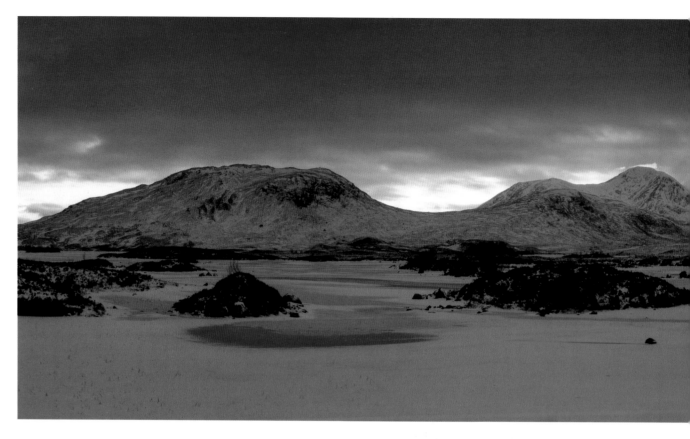

Rannoch Moor, Highland, Scotland
This panorama was created by 'stitching' six individual frames together (see page 180), which I shot as the last embers of daylight were fading beyond the mountains at the end of the freezing cold day. Dawn and dusk are ideal times to shoot winter landscapes as low light levels and cool colour casts add an air of mystery and drama. You can almost feel the cold just by looking at this image!
CANON EOS 1DS MKIII, 24–70MM ZOOM, TRIPOD, 0.6ND HARD GRAD, 1/20SEC AT F/11, ISO100

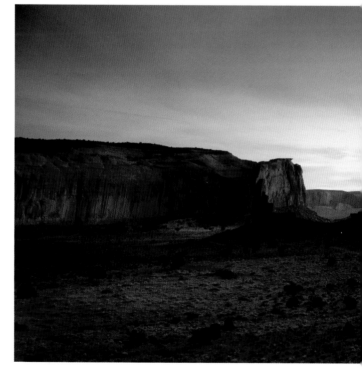

in reality, the sky is still blue and the landscape full of colour, it's just that our eyes aren't sensitive enough to see it. Digital cameras can, however, and when exposed for long enough will record the landscape in a way you will never see it with the naked eye, producing surreal images that are lit by the feint glow of skylight.

The time it takes to do this will depend on prevailing weather conditions. On a clear night, light levels will be higher than in cloudy conditions, just like they would be in the middle of the day, and if the full moon is out, there will be even more light in the same way there is if the sun is shining. In fact, the only major difference between night and day is light intensity, and if you give a picture taken in the middle of the night enough exposure, you might struggle to tell it from one taken 12 hours earlier – the only clues being movement in things like trees, and the appearance of feint star trails in the sky due to the long exposure.

Getting the exposure right is fairly hit and miss, because it's unlikely your camera's lightmeter will be able to register any reading at all, even when set to the highest ISO and widest aperture. Fortunately, there is a certain degree of exposure latitude here, especially towards underexposure, because you wouldn't expect pictures taken at night to look like they were shot at midday. Set your camera to bulb (B) and try an exposure of

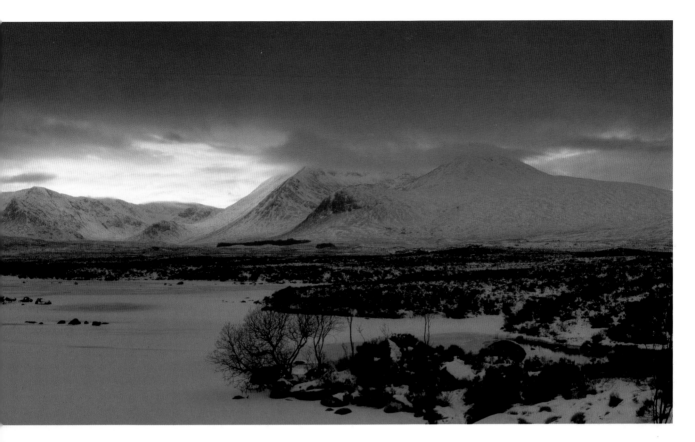

◢ Monument Valley, Utah, USA

This twilight panorama has a totally different feel to the Scottish winter scene. Thanks to the sandstone scenery and the afterglow in the evening sky, the colours are warm rather than cold. It was a tricky scene to capture as the contrast between the sky and landscape is huge but the main butte in the centre of the composition breaks into the sky, making the use of a strong ND grad less straightforward. In the end, I took a range of shots and this one proved to be the best. A little post-production on the scanned transparency also revealed more detail in the scene.

FUJI GX617 PANORAMIC CAMERA, 90MM LENS, 0.45 CENTRE-ND FILTER, 0.6 ND HARD GRAD, TRIPOD, 15 SECONDS AT F/16, ISO50

Seljalandsfoss Waterfall, near Hella, Iceland
The darkness of night is deceiving, because we assume that when light levels are so low, there's no point trying to shooting images in available light. However, even though our eyes aren't sensitive enough to see a great deal, it's surprising how much the sensor in your digital SLR can record if you keep the shutter open for long enough. It was so dark when I shot this Icelandic scene that I could barely see the waterfall. However, my camera did a fantastic job of recording it and the soft, surreal light from the night sky adds a wonderful air of mystery.
CANON EOS 1DS MKIII, 17–40MM ZOOM, TRIPOD, 0.9ND HARD GRAD, 3 MINUTES AT F/8, ISO200

60 minutes at f/8 and ISO 100. If the full moon is out, light levels will be a stop or two higher, so try 60 minutes at f/11 or f/16. These times are merely guides, however, so don't expect perfect results on the first attempt and be prepared to try more than once – or stay out all night so you can bracket exposures. Any type of landscape can be photographed by night, though scenes containing water are ideal as the long exposure will record lots of movement. Trees or grass swaying in the breeze can also add an extra element to low-light landscapes.

For the best results, arrive at the location while there's still enough daylight present for you to see what you're doing. That way, you can compose the shot accurately, making sure the camera is square, and set focus to ensure everything will come out sharp. It's a good idea to carry a small torch for use later, when you need to check the camera controls – and to find your way back to wherever you came from.

COASTAL VIEWS

Coastal views tend to look their best at the beginning and end of the day for a number of reasons.

Firstly, the mood of the sea is influenced to a great extent by prevailing weather conditions and the quality of the light, and the light tends to be at its most attractive during these periods. In the cool, blue light of pre-dawn the sea has the colour of gunmetal, whereas at sunset it can appear like liquid gold, turning the reflection of the sun's orb into a shimmering highlight on its ever-changing surface.

Secondly, the coastline, like the landscape, is revealed at its best at dawn or dusk, when golden light from the low sun rakes across it, revealing texture and form to give your pictures a strong sense of depth.

Thirdly, light levels are low early and late in the day, so you can use long exposures to record the motion of the sea as it crashes against the rocky coastline or washes over rocky shelves and up deserted beaches. The longer the exposure is, the more blur you will get, to the point that the sea can appear more like mist than

water. Anything from a second will produce a good effect, but don't be afraid to experiment with exposures much longer than this – several minutes if necessary.

The time of day you photograph a coastal location will depend to a large extent on the direction it's facing. The east coast is generally best visited at dawn if you want to capture the sun's orb rising over the sea, and the coastline bathed in sunlight, while the west coast will be lit by the evening sun and give you good views of it setting over the sea.

▽ **Rhum from Laig Bay, Isle of Eigg, Scotland**
Once the sun has set, the mood of the landscape is transformed. Direct light no longer provides illumination and instead, the sky acts like a giant diffuser, creating soft, shadowless light. I arrived at this location while the sun was still up so I had plenty of time to explore the foreshore and find interesting foreground features – of which there are many on Laig Bay, from rock pools to erratics.
CANON EOS 1DS MKIII, 16–35MM ZOOM, TRIPOD, 0.6ND HARD GRAD, 22 SECONDS AT F/18, ISO100

That said, don't automatically assume that by going to the east coast you will see the sunrise, or the sunset on the west coast. The topography of the coastline could mean that you're facing due west on the east coast and due east on the west coast. Equally, you could be facing north or south on either coast. To avoid this, it's well worth checking a detailed map of the area before visiting, so you can pinpoint the location you want to photograph and determine which way it faces.

When you do reach the location, think carefully about the composition. Views from the coastline looking straight out to sea can easily look boring unless there's a stunning sunrise or sunset to liven the picture up. So look for vantage points where both land and sea can be included in your compositions, and where there's good foreground interest to lead the eye through the scene.

Alternatively, find a viewpoint above a gorge or inlet, so you can look down and capture the sea crashing against the rocks below.

Long, empty beaches are best photographed when the sun is low, so light rakes over the sand revealing the delicate ripples created by the wind and tide – these ripples make ideal foreground interest for wide-angle pictures, acting as lines that lead the eye through the scene. Pieces of driftwood can also be used to good effect as foreground interest if you move in close with a wide-angle lens.

Another way to photograph beaches is at sunset, when the sand is wet and reflects the fiery colours in the sky. Look for shallow pools left by the retreating tide that can be included in the foreground, or capture rocks on the beach in silhouette against the sky and reflective sands.

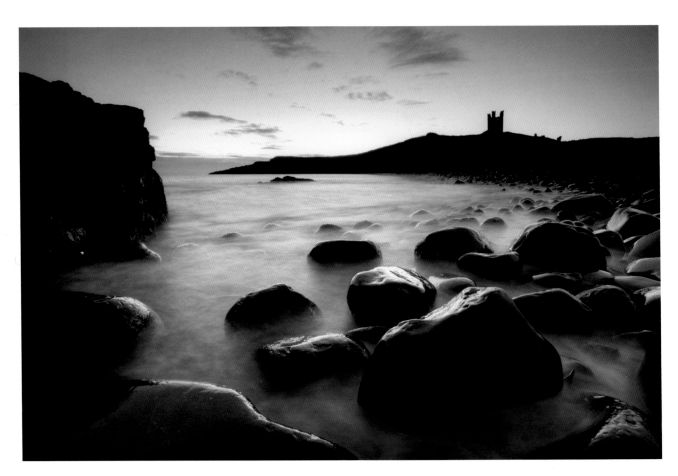

Dunstanburgh Castle from Embleton Bay, Northumberland, England
This is one of my favourite coastal locations in the world – and it's only a few miles from my home so I get to visit it numerous times through the year. It's best photographed at dawn – during spring and summer the sun rises north of east so the scene is sidelit by the rising sun while in the autumn and winter the sun rises further south of east so the scene is thrown into sharp silhouette by the dawn sky. No two mornings are ever the same, and whether the tide is high or low, there's always a great shot there for the taking.
CANON EOS 1DS MKIII, 17–40MM ZOOM, TRIPOD, 0.9ND HARD GRAD, 10 SECONDS AT F/22, ISO100

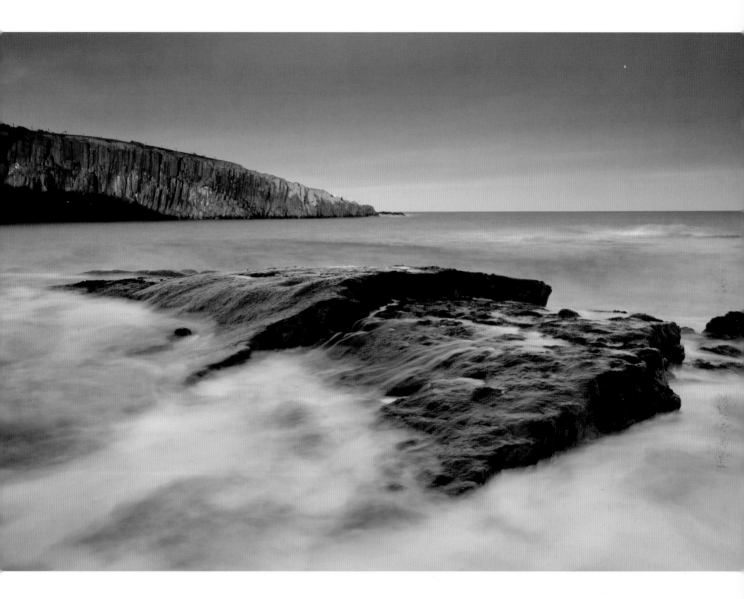

◤ Cullernose Point, Northumberland, England

The quality of light is the main factor that can make or break a landscape image, and though planning and perseverance undoubtedly put the odds of success in your favour, sometimes a little luck comes into play too. I had headed to this location knowing the tide would be just right to capture waves washing over large rock slabs on the foreshore, but as the sky was very cloudy I resigned myself to the fact that I probably wouldn't see sunlight again that day. Fortunately, after around half an hour, the sun did managed to peep through the clouds and bathe the distant cliffs in warm afternoon light, transforming the shot completely.
NIKON D3X, 24–70MM ZOOM, TRIPOD, 0.6 ND HARD GRAD, 2 SECONDS AT F/22

THE SKY
AT NIGHT

Although the best time to photograph most night scenes is during the period after sunset when there's still colour in the sky, once that colour has faded to blackness you don't have to pack away your camera and head for home. Why? Because if you take a look overhead you will see a whole new chapter of low-light photography opening up before you – namely, the moon and stars in the night sky.

Serious astro photographers use complicated tracking devices known as equatorial drives and powerful telescopes to take pictures of the galaxies, but you don't need them to produce interesting images. The aim of this chapter is to look at how you can take produce breathtaking results using the equipment you already own.

SHOOT THE MOON

Including the moon in a night scene, or photographing it in isolation, is relatively straightforward providing you're aware of two important facts. Firstly, it's very bright compared to the rest of the scene. Secondly, it moves – a distance equivalent to its own diameter every two minutes.

What this means in practice is that if you include the moon in a picture, it's going to be badly overexposed if you correctly expose the rest of the scene, and if you use an exposure longer than a few seconds, it will also record out of shape – the longer the exposure, the more 'sausage-like' it will become.

If you're using a wide-angle lens to record a scene in which the moon is included, this won't necessarily be a problem because the moon itself will be so small that it won't spoil the shot – even if it does record as a featureless white smudge! However, if you use a telephoto lens for the shot then you need to keep the exposure as brief as possible to minimize the degree of overexposure and movement recorded. Shooting when the moon first appears and ambient light levels are still quite high will help here, allowing you to use short exposures. Increasing your camera's ISO to 800 or 1600 can be a benefit too.

However, by far the best solution is to photograph the moon separately, so you can ensure it's pin sharp and perfectly exposed, then combine it with a separate night scene.

When I wrote the original version of this book back in 1999, the only way to superimpose the moon on a night scene was by exposing the same frame of film twice using the camera's multiple exposure facility, if it had one, or by running the same roll of film through the camera twice if it didn't. I managed to perfect this technique, but it was fiddly and time-consuming. Today, thanks to digital cameras and Adobe Photoshop, the task is a doddle. All you have to do is photograph the moon, download the image to your computer and within minutes it can be combined with any night shot of your choosing. Not only that, you can combine the images with great precision to achieve a perfect result that will have everyone fooled.

◀ Vík í Mýrdal, Iceland

Here's a good example of the kind of effect you can achieve by digitally adding a moon to a low-light or night scene. I liked the look of the original image, which I shot at twilight using a 10-stop ND filter (see page 35) to extend the exposure and record motion in the drifting clouds, but felt that it needed something extra. A five-minute Photoshop exercise solved that problem and added a surreal twist. Turn the page to find out exactly how I created it.

CANON EOS 1DS MKIII, 70–200MM ZOOM, 0.9ND HARD GRAD AND 3.0ND FILTER, 124 SECONDS AT F/20 AND ISO100

Overleaf is a step-by-step guide to adding the moon to a night shot, but before that, here are some general tips on photographing the moon.

① The best time to shoot is on a clear night when the sky is black so the moon is sharply defined, and also when the moon is quite high in the sky so you have a clear view of it with lots of empty sky around. The moon also looks its most impressive when it's full, so check your diary for the full moon dates. A few days either side of this will also produce good results.

② To get a perfect shot of a full moon surrounded by blackness, you need to be using an exposure of 1/250sec at f/8 and ISO 100; 1/125sec or 1/60sec for a crescent moon. There is a little leeway in this, but if you're photographing the moon in clear conditions against the black night sky, these exposures will give a good result. As always, check the image on your camera's preview screen and zoom into it to check that the moon is sharp and well exposed.

② In terms of lenses, for every 100mm increase in effective focal length, the diameter of the moon will increase by 1mm – 0.5mm with a 50mm standard lens; 1mm with a 100mm; 2mm with a 200mm; 4mm with a 400mm; 6mm with a 600mm and so on. Anything from 300mm will give you a good shot as you can always enlarge the moon itself – the resolution of digital SLRs these days is more than enough to allow quite dramatic enlargement of the moon with no noticeable loss of image quality. Whichever lens you use, it's a good idea to mount your camera on a tripod to keep it perfectly still, and trip the shutter with a cable release.

④ If you don't have a powerful telephoto or telezoom lens, take a shot of the moon with your longest lens then increase the image size of the shot in Photoshop. Open the image then go to Image/Image Size. In Document Size, double the width and height measurements then click on the bottom window where it says Bicubic (best for smooth gradients) and choose Bicubic Smoother (best for enlargement). Click OK and the image will double in size. This is more effective than scaling up the size of the moon once it has been added to your low-light scene.

⑤ If you don't manage to get any decent moon shots of your own, or you're just feeling lazy, it's possible to download free images of the moon at websites such as http://www.freeimages. co.uk/galleries/space/moon/index.htm. Using them to enhance your own images is perfectly legal, though if you intend to publish those images you need to credit the supplier of the moon pics.

ADDING THE MOON TO A LOW-LIGHT SCENE

This is a straightforward Photoshop technique that takes just a few minutes and requires very little knowledge of image manipulation.

Choose your moon image and also a low-light scene that you want to superimpose the moon onto. Ideally the sky should be quite dark in the main image, so the moon stands out, though there should also be some colour in the sky to create a more interesting backdrop for the moon. Clear sky also gives a more realistic effect than cloudy sky, as the moon would be partially obscured by cloud in real life.

① Open your main image and the moon image so they're both visible on the computer monitor then, using the Move tool in Photoshop, drag the moon image onto the main low-light scene and it will automatically be added as a layer.

② Don't worry if the black background to the moon image is visible in the new layered image – just go to the Layers palette and change the Blending mode for the layers from Normal to Screen. The black background will disappear and the moon will look like it's a natural part of the main image.

③ If the moon looks too big, make sure the layer containing the moon image is active then go to Edit>Transform>Scale and a box will appear around the moon. Hold the Shift key down on your keyboard then click on one of the corners of the bounding box around the moon and move it inwards to change its size.

④ If the moon is in the wrong place, click on the Move tool again then click on the moon and move it to where you want it in the sky. You may also want to reduce the Opacity of the moon layer a little so it doesn't stand out so much. You'll find the Opacity slider in the Layers palette. Reducing it to 70 or 80% should do the trick.

⑤ Make any changes to the main image you feel necessary by clicking on the main image layer in the Layers palette to make it active. In this case, I decided that the main image needed to be a little darker so I adjusted Curves (Image>Adjustment>Curves) until I was happy with the overall look.

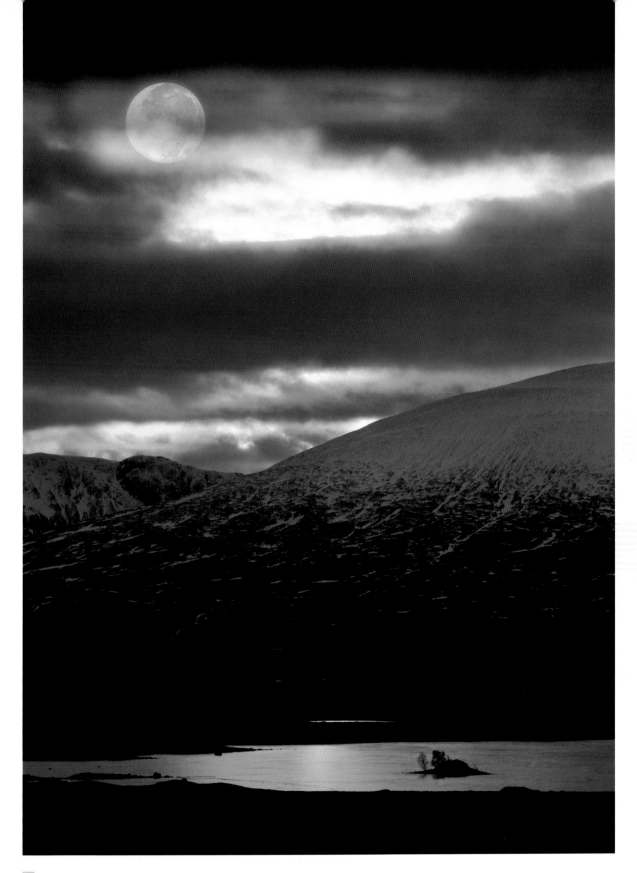

Rannoch Moor, Scotland
This dramatic scene was shot before on a bleak winter morning on desolate Rannoch Moor. The mysterious colour cast is natural – a result of the steely blue clouds acting as an enormous lightsource and bathing the scene in cool light. To enhance the mood of the scene further, I decided to add a full moon using the same technique outlined in the step-by-step guide. The only difference was that I also used the Clone Stamp tool in Photoshop to 'paint' some weak cloud over the moon to give the impression that it was partially obscured.
CANON EOS 1DS MKIII, 70–200MM ZOOM AND 0.6ND HARD GRAD, 1/60SEC AT F/8 AND ISO100

Northumberland, England

You don't always have to travel to take interesting moonlit photographs – I captured this scene literally outside my back door. I happened to peer through a window and noticed a neighbouring farmhouse in silhouette with the moon obscured by cloud lighting up the night sky. Grabbing my camera and tripod, I stepped outside to capture the scene. It was tempting to think, 'Oh, I'll do it tomorrow', but if you adopt that attitude, tomorrow never comes and opportunities are missed.

CANON EOS 1DS MKIII, 24–70MM ZOOM, TRIPOD, 15 SECONDS AT F/2.8, ISO400

Sahara Desert, Morocco

This is the kind of effect you can achieve by using a long exposure to record star trails in the night sky. There was absolutely no light pollution at the location so by 8pm it was pitch dark and the night sky was glistening with millions of stars. It's amazing to lie back and look up at such an amazing sky. The Milky Way was clearly visible, shooting stars, galaxies, satellites... I'm no stargazer, but it's hard not to be impressed and humbled by the immensity of it all. To record the scene, a compass was used to locate north then I wandered away from camp, set up my camera and tripod, composed the scene so a sand dune ridge was included in the bottom of the frame, focused the lens manually on infinity, opened the aperture to f/4, set ISO to 200 then locked the shutter open on bulb for one hour.

CANON EOS 1DS MKIII, 17–40MM ZOOM AT 17MM, TRIPOD, 60 MINUTES AT F/4, ISO200

Sahara Desert, Morocco

If you don't use your camera's Long Exposure Noise Reduction, expect your star trail shots to suffer from serious noise! I purposely took this shot with the NR turned off and you can see from the enlarged section of the image, below, that it suffers from terrible noise. The main star trail image, above, was taken using Long Exposure NR. As well as being almost free from noise it also appears sharper and more vibrant.
Canon EOS 1DS MKIII, 17-40mm zoom at 17mm, tripod, 60 minutes at f/4, ISO200

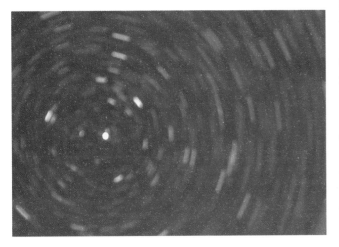

STAR TRAILS

If you look up at a clear night sky, you'll see that it's packed with thousands of tiny stars twinkling overhead. To the naked eye, these stars appear as small, fixed points of light, but if you photograph them using a longer exposure something surprising happens – those stars record as white light trails streaking across the sky.

This effect is produced because the earth is rotating on its axis, and if you keep your camera's shutter locked open for long enough this rotation will be recorded in the night sky. All you have to do to try the effect yourself is, literally, mount your camera on a tripod, point it up to the sky, and leave the shutter locked open on

B (bulb) for a while (see page 84). However, to get the best results you should follow a few simple guidelines.

① Wait for a clear night when there's no cloud obscuring the sky and the stars are clearly visible. Cold, clear nights are ideal so winter is a good time of year. Also, it gets darker much earlier in winter so you don't have to wait until the middle of the night for suitable conditions.

② Choose a location out in the countryside where there is no light pollution from urban areas to spoil the effect. You may not be aware of the light pollution yourself if you look at the night sky, but prolonged exposure will record it, either as weird colour casts, flare streaks or both. High altitude locations work well because the air is clearer the higher you get. Deserts are another good choice due to the lack of human habitation. If you can't climb a mountain or a sand dune, just get as far away from towns and cities as you can.

③ Try to include a feature in the composition such as a hill, electricity pylon or tower to provide a sense of scale and add interest. It might be small in the frame, but any feature will improve the shot. Sky alone doesn't work as well.

④ Use your widest lens – I favour the wide end of my 17–40mm zoom on a full-frame digital SLR. On a non full-frame camera you'll be looking at 10–12mm. The more sky you can include, the better.

⑤ Although you can capture star trails in any part of the sky, the area around the Pole Star (Polaris) is the best because the star trails will form a series of concentric circles around this star, which doesn't appear to move because it's in line with the earth's axis. To locate the Pole Star, use a compass to find north. Even if you can't see it, by pointing your camera in a northerly direction and shooting with a wide-angle lens you're pretty much guaranteed to include it in the shot.

⑥ The exposure duration you use will depend on your location. I have photographed star trails successfully in the Moroccan Sahara using exposures of 1–2 hours with my lens set to its widest aperture – f/2.8 or f/4 and the ISO at 100 or 200. Equally, I've seen fantastic images shot in places such as the Himalayas using exposures of 6–8 hours. If you're in a remote location with no light pollution, you could literally leave the shutter open all night long, but you don't need to – anything from an hour will work. If you're closer to civilization, try shorter exposures of 30–60 minutes. Any longer than that and light pollution may have an adverse effect on the images.

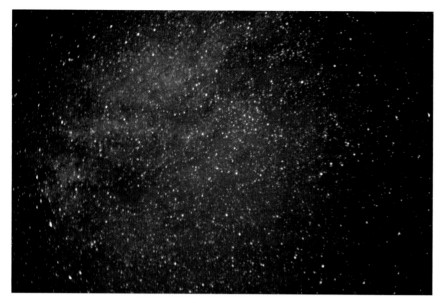

⑦ If you don't want to spend long periods sitting by your camera, electronic remote releases are available from some camera manufacturers that can be programmed to give a specific preset exposure then automatically close the camera's shutter. They can also be programmed to shoot a sequence of exposures, so you could leave the camera out all night long to do its job and go to bed! I use a more basic remote release so I simply set the alarm clock on my mobile phone and it alerts me when it's time to close the camera's shutter.

⑧ Long exposures and low temperatures drain batteries. You're going to encounter both when shooting star trails, so make sure the battery in your camera is fully charged and, if you're in a remote location, also make sure you have at least one other fully charged battery – not only so you can shoot more star trails, but also to ensure you have battery power the next day!

⑨ When you set up your camera you'll need a torch to see what you're doing. However, to check the composition, it's better to turn off your torch so your night vision improves. You will also need to keep your eye to the camera's viewfinder for maybe 20 seconds before you can see an image. By doing this you can ensure that you're included features in the bottom of the frame for scale.

⑩ Noise is a big problem when shooting star trails with a digital camera. Keeping the shutter open for hours causes the sensor to warm up and hot pixels will be visible in the final image as tiny colored dots – hundreds of them in some cases! The very latest digital SLRs seems to cope much better than older models. I recently led a photo tour in Morocco where one member of the group shot star trails using a Canon EOS 5D MKII. Hardly any noise was noticeable in his images, but my own shots, taken for the same duration using a Canon EOS 1DS MKIII (a much more expensive camera, but two years older) suffered badly from noise.

The only way around this is to set your camera's Long Exposure Noise Reduction. It makes a big difference to the quality of the final image. The downside is that when you use Long Exposure NR, the camera makes a second 'closed shutter' exposure the same duration as the exposure you used to record the star trails. This is necessary so that the hot pixels can be mapped and removed in-camera, so if you use an exposure of two hours, you then have to wait another two hours before you can see the image. I get around this by climbing into my sleeping bag and taking a nap while the closed shutter exposure is being made!

MAKING MULTIPLE EXPOSURES

An alternative but more complicated way to capture star trails is by using a remote release with an interval timer and setting-up the timer to take a series of, say, five minute exposures over a period of several hours – instead of a single long exposure. The individual images are then stacked together as layers in Photoshop to create the final composite. One benefit of doing this is that noise is less of a problem because the individual frames are given much shorter exposures. That said, remote releases with interval timers are much more expensive than basic electronic releases, so unless you're likely to use one on a regular basis it is probably not worth the investment.

Havana, Cuba

After a long day on location I was all set to head back to my hotel for a much-needed Mohito when I noticed this rather surreal scene. Everywhere else the sky was black-dark as the sun had long set, but here the full moon was backlighting the night sky and passing traffic illuminated the buildings with their headlights. Needless to say, the cocktail was put on hold – for a few minutes anyway!

CANON EOS 1DS MKIII, 17–40MM ZOOM, TRIPOD, 25 SECONDS AT F/4.5, ISO200

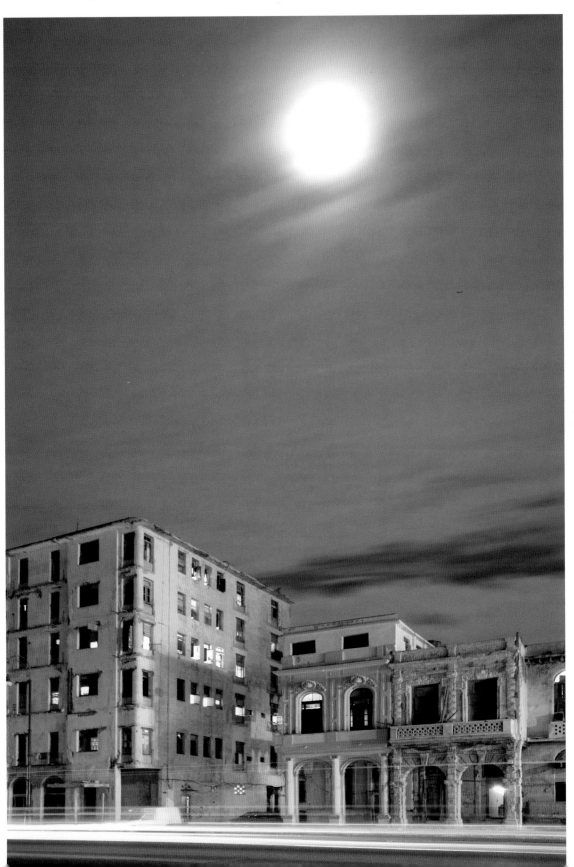

FUNFAIRS AND CARNIVALS

Funfairs and fairgrounds come to life in the evening, when the flashing lights and colourful rides make perfect subjects for low-light photography. Also, as most stay in town for several days, you will have the opportunity to take lots of different pictures and experiment with new techniques – such as slow sync flash.

If you're not familiar with the location, it's well worth having a look around during the day so you get a feel for the place and what it has to offer. See if you can find a good vantage point that overlooks the whole fairground, as this could produce some great shots, and check out the different rides so you can start thinking about the type of shots you might take and the techniques you'll need to use – and also how you can make best use of your time each evening.

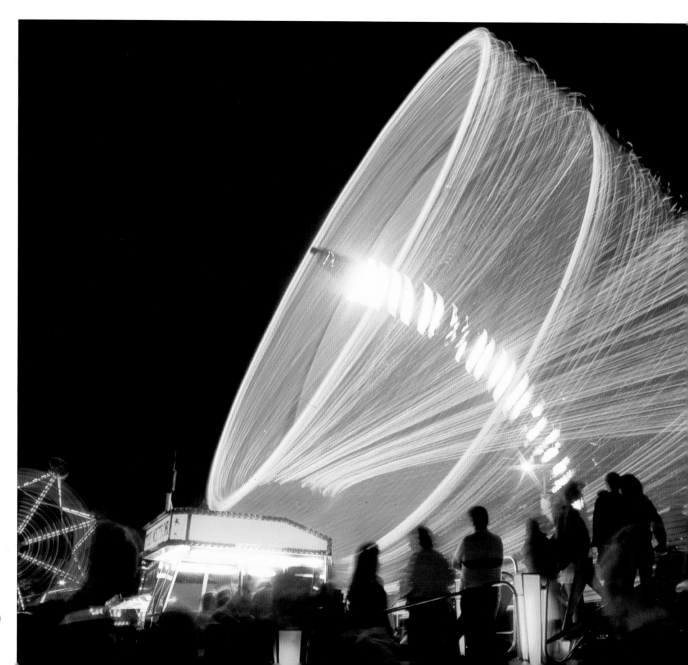

PERFECT TIMING

The best time to arrive at the funfair when you intend to take photographs is before sunset. If the location is suitable, with any luck you may be able to get some great shots of the fair against a fantastic sunset, but if not, it won't take long before light levels start to fade and the colourful lights of the fairground light up the sky to create a dazzling spectacle.

Your most successful shots will be taken while there's still some colour in the sky – usually a deep, rich blue – as

it provides an attractive backdrop against which to capture the vibrant light trails of moving rides such as the Big Wheel. During this 'crossover' period between day and night, natural and artificial light levels are in balance so you can record colour in the sky without overexposing the lights of the fairground. It lasts the longest during summer – around 45 minutes – and fortunately most funfairs take place during summer, so you should be able to take a wide variety of shots in a single evening. Digital technology helps here, as always, because by being able to preview your images immediately after taking them you'll know when you've got a perfect shot so you can move on to the next one. There was always a degree of uncertainty when shooting with film so I often found myself spending too much time concentrating on one scene or subject and before I knew it, the prime shooting period was over.

Once the sky begins to darken, contrast levels increase dramatically and the colour in the sky fades. Once you lose colour in the sky it's time to start looking for subjects that don't include it – such as candids of people on the rides and game stalls.

GOT THE GEAR?

In terms of equipment, a digital SLR with focal lengths from 24–200mm will allow you to take a range of different shots, though you could manage quite happily with just a single zoom lens such as a 24–70mm or 24–105mm (on a full-frame DSLR). Light levels will be low, so for most shots you'll be using exposures of several seconds. This makes a sturdy tripod essential to keep your camera steady and ensure sharp results. A remote release is also handy for tripping the camera's shutter.

Another essential item is an electronic flashgun. It needn't be particularly powerful, or boast lots of fancy features, but you'll find it invaluable for freezing movement when photographing things like the dodgem cars.

For long exposure shots of fairground rides and action shots taken with flash, stick to a low ISO for optimum image quality – ISO 100–200 is ideal. You only need to go higher than that if you decide to take some handheld candid shots of people enjoying the fun of the fair, in which case ISO 800–1600 should be high enough if you have a fast lens – such as the 50mm prime lens I've mentioned numerous times throughout this book and hopefully now convinced you you need!

The main thing to remember is that fairgrounds, like any busy venue or event, often attract some rather unsavoury characters who will be on the lookout for some easy pickings. Modern digital SLRs are expensive and desirable, so be on your guard. Never leave your backpack unattended while you're taking a photograph, otherwise it's likely to disappear as you're peering through the camera's viewfinder and concentrating on your shot. Instead, hang it from your tripod so you can see it or keep

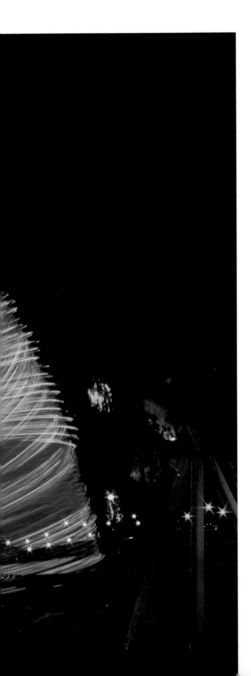

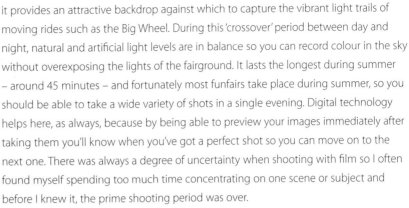

◄ Paignton Regatta, Devon, England
The most exciting photo opportunities at fairgrounds are created by moving rides. Because light levels are low and long exposures are required to photograph them, the many bright lights used to decorate the rides record as colourful streaks and swirls. For the best results, wait until the ride is spinning before tripping your camera's shutter release, and use an exposure of at least ten seconds to capture plenty of movement. In this case, the ride not only spun but also tilted up and over to create an amazing pattern of colourful light trails – rather like a giant 'slinky' toy!
OLYMPUS OM4-TI, 28MM LENS, TRIPOD, 20 SECONDS AT F/11, ISO100

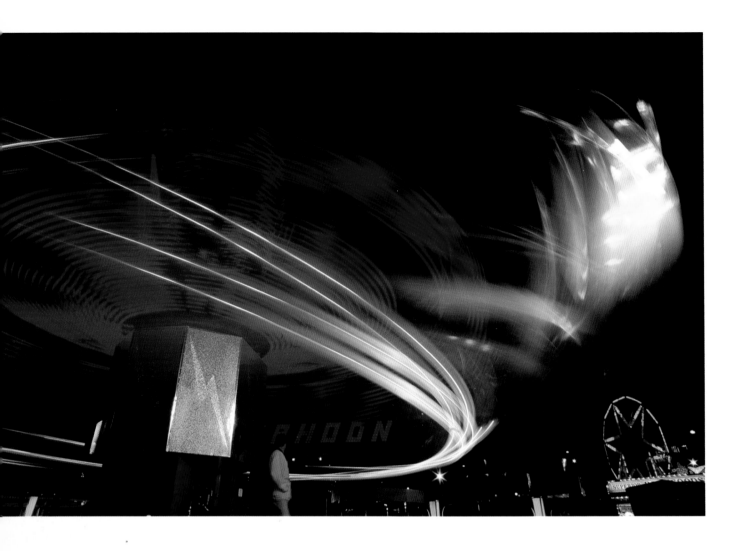

Peterborough funfair, Cambridgeshire, England
Once the colour in the night sky begins to fade, one option is to move in closer to your subject so it fills more of the frame – shooting from close range with a wide-angle lens also creates a dramatic perspective that adds impact to the composition. I was just a couple of metres from this ride and had no idea how it might record during the long exposure, but the combination of red and white light trails is highly effective and the fact that the sky is almost black is not too much of a worry.
OLYMPUS OM4-TI, 21MM PRIME LENS, TRIPOD, 30 SECONDS AT F/11, ISO50

it on your back. The chance of you experiencing any problem is very slim – I never have in all my 25 years as a photographer – but it's better to be safe than sorry.

EXPOSURE POSER

Back in the good old days (?) of film photography, taking perfectly exposed shots of fairgrounds, like most night and low-light subjects, could be rather hit and miss. Metering systems were much more basic – for many years all I had was basic centre-weighted metering – so the chance of exposure error was greater, especially when shooting slide film as all serious photographers did. Unfortunately, you didn't know mistakes had been made until after the event, by which time it was too late.

These days, this is no longer the case – not only are multi-pattern metering systems much more accurate and reliable, but as you can check the image and histogram on the spot, on the rare occasion your camera's meter does get it wrong, you can correct any error and reshoot. If you've become interested in photography since the digital revolution you will never realize just how lucky you are to have such amazing technology at your disposal!

So, when shooting at funfairs, my approach to metering and exposure is as it is with pretty much all low-light subjects: my camera is set to aperture priority so I can choose the aperture to control depth-of-field and the camera sets the required shutter speed to give correct exposure (hopefully!). I compose the shot as I want to take it, focus the lens manually rather than using autofocus, set the aperture to f/8 or f/11 in most cases – wider apertures are used when shooting handheld and smaller apertures if I need to increase the exposure time – and an exposure is made.

I then check the image on the camera's preview screen and also check the histogram to make sure the highlights haven't been 'clipped' (see page 84). Chances are some shadow clipping will have occurred because there are bound to be some small areas in the scene where no light has penetrated. I can live with that. If the shot needs more or less exposure, I then make the required adjustment using the camera's exposure compensation facility and re-take. It's a very quick and easy process and by sticking to the same system of working it becomes very instinctive. Often the camera gets the exposure spot on with no adjustment, but I will still take another one or two shots at the same exposure, just in case there's a problem later with file corruption – occasionally I find that one image on a memory card containing 150 images is totally frazzled for some reason, and I'd hate that image to be a particularly good one, with no back-up. Once I've shot that back-up, I pick up my tripod and move on to the next scene.

FAIRGROUND ACTION

The aim of funfairs is to give people a thrill as they spin around at high speed on the various rides, so when you've taken lots of long exposure pictures of those rides, why not look for some closer-range action opportunities? Rides like the waltzer and dodgem cars are ideal for this as the action takes place more or less at ground level.

Because light levels are low, action-stopping shutter speeds are out of the question no matter how high your camera's ISO will go or how fast your lenses are. Fortunately, this needn't be a problem because the action-stopping burst of light from an electronic flashgun will do the job for you.

This technique that can be used to photograph fairground action is known as slow-sync flash and involves combining a burst of flash with a slow shutter speed. The idea is that the flash freezes your subject while the slow shutter speed records ambient light and movement, so you get a frozen and blurred image on the same photograph.

Docklands, London, England
As well as shooting whole rides and wide views, look for opportunities to photograph some more abstract details. This is the centre of a fairground Big Wheel that I captured using a telephoto lens to fill the frame and capture the spinning lights as colourful concentric spheres.

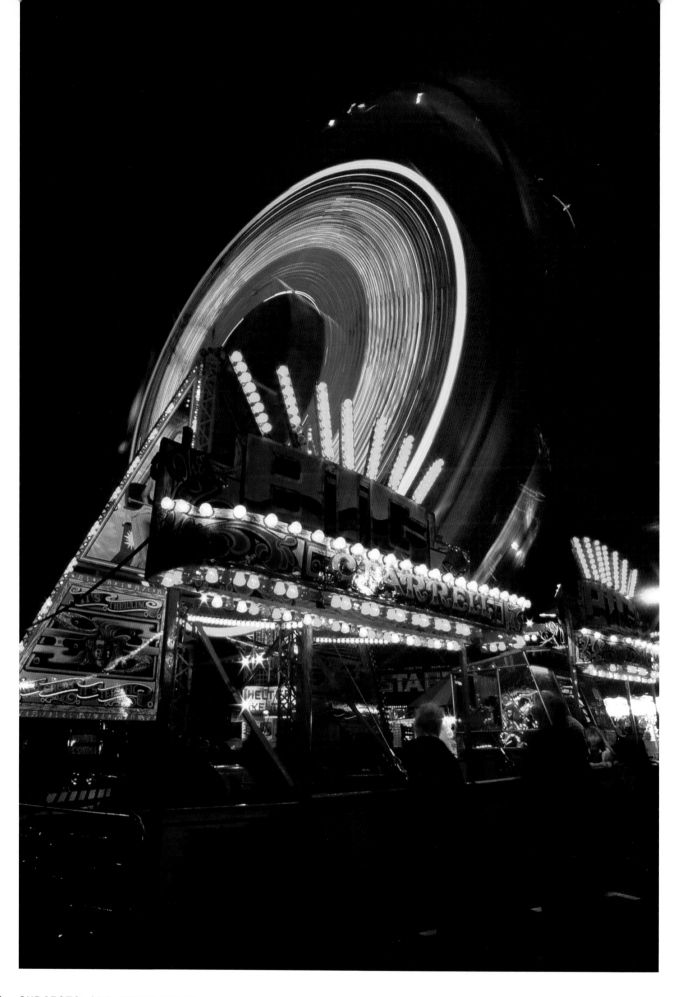

Peterborough funfair, Cambridgeshire, England

The ideal time to shoot funfairs is during the crossover period between day and night when there's still some colour in the sky to provide an attractive background to the colourful light trails of the rides. Light from the sky also helps to fill-in shadow areas so contrast remains at a manageable level. This period of prime shooting is brief though, so make the most of it!

OLYMPUS OM4-TI, 21MM LENS, TRIPOD, 20 SECONDS AT F/16, ISO100

Peterborough funfair, Cambridgeshire, England

The action-stopping burst of light from an electronic flashgun will freeze the fastest of movement, allowing you to capture people as they spin around on the hair-raising funfair rides. Combine the burst of flash with a slow shutter speed – 1/8sec or so is ideal – and pan the camera as you take the shot so any lights in the background record as streaks to heighten the sense of movement. Use a wide-angle lens so you can get close to your passing subjects – just don't get too close, otherwise you could end up hitching an unexpected lift!

NIKON F90X, 28MM PRIME LENS, VIVITAR 283 FLASHGUN, 1/8SEC AT F/11, ISO100

A dedicated flashgun mounted on your digital SLR's hotshoe will produce slow-sync flash effects automatically, while modern compact cameras have a slow-sync or 'night portrait' mode which does the same job.

The idea is that you combine a slow shutter speed which records subject blur in the low ambient light with a burst of flash that freezes your subject, so you have a sharp image overlaying a blurred one to create a strong sense of motion.

A flash: ambient light ratio of 1:2 or 1:4 tends to be the most effective as you don't want to flash to dominate the image. If you find that leaving everything to your camera and flashgun produces unsatisfactory results, set the flash output to ½ or ¼ power or the flash exposure compensation to -1 or -2 stops.

The amount of blur you get in the background depends on the shutter speed set by the camera. Initially, you'll find that 1/4 or 1/8 sec is more than slow enough, but once your confidence increases, try experimenting with speeds down to a second or more – you'll be surprised by the results.

PAINTING
WITH LIGHT

Although the majority of night and low-light scenes are photographed in available light, there's nothing to stop you adding your own light. This may be necessary to provide illumination in situations where little exists, to supplement the lighting already present, or to create unusual lighting effects.

A variety of different light sources can be used to do this, from a flashgun or torch to the headlights on your car. Fireworks could also be considered as an elaborate form of painting with light, filling the night sky with colourful patterns, while the sparklers children love on Bonfire Night can be used in a similar but more controlled way.

▽ **Derwentwater, Lake District, England**
I often carry a two million candlepower torch in my car – not only for use in emergencies should I be unfortunate enough to breakdown, but also so I can use it as a lightsource when suitable subjects are discovered. This lake scene is a classic example of one such subject. I'd been shooting the view of the jetty and the lake at sunset but eventually the jetty started to look very dark as light levels dropped at twilight. Normally this would be a cue to pack up and head home, but instead I decided to put my own light on the jetty using a torch. My camera's white balance was set to Daylight and I knew that this would result in an attractive colour contrast between the coolness of the fading daylight and the warmth of the torchlight.
CANON EOS 1DS MKIII, ZEISS 21MM PRIME LENS, TRIPOD, 30 SECONDS AT F/22, ISO100

△ Torchlit flowers, Alnmouth, England
A small penlight or keyring torch can be used to create interesting painting with light effects on small scale subjects. For this image I waited until nightfall, turned off the lights so the room was dark and used a torch to selectively illuminate the flowers, putting more light on the blooms themselves. It took several attempts to achieve an effect I was happy with, but that's the beauty of digital imaging – if at first you don't succeed, try again!
CANON EOS 1DS MKIII, 24–70MM ZOOM, TRIPOD, 2 MINUTES AT F/11, ISO200

TORCHLIGHT

The humble torch may be invaluable for helping you find your way around in the dark, but it can also be used to produce eye-catching lighting effects.

Indoors you can use a torch to illuminate still-lifes in a darkened room, selectively highlighting different areas with the narrow beam, and perhaps using coloured gels to introduce different colours to different areas. Outdoors, a powerful torch or lamp can be used to illuminate a feature in the foreground of a scene or a whole structure, in the same way that multiple flash bursts can. The benefit of using a torch on large-scale subjects is that you have a much better idea of where the light is going because it's a continuous source, whereas a burst of flash lasts for just a fraction of a second so your eye can't register its effect.

The type of torch you need will depend on the scale of the

subject. I use a range, from small keyring torches purchased from bargain basement stores to big, powerful, two million candlepower units. American Maglite torches are ideal for use at close range as the beam can be adjusted down to a narrow, concentrated spot so it only lights a small area.

Determining correct exposure is straightforward as the light from a torch is constant. All you have to do is shine it on your subject and take a meter reading from the brightest area. Once you know that when using a certain torch from a certain distance you will need a certain exposure, you can control the effect it has. If an exposure of four seconds at f/22 is required when you keep the narrow beam of your torch aimed at an object one metre away, for example, you can make some areas darker than others by shining the torch for just one, two or three seconds. Equally, if you want an area to come out really light, shine the torch on it for five or six seconds.

If you're using torchlight for still-life photography, set up your props, compose the picture then turn all the lights off so the room is in total darkness. That way, the only light recorded will be coming from the torch, so you can create exactly the effect you choose. Your camera's shutter can also be locked open on B for as long as it takes to build up the lighting on your still-life.

Outdoors, the same technique is employed, only on a bigger scale. With your camera's shutter locked open on B, you can leave the camera in position and move up closer to whatever you're lighting, so the torch doesn't have to be aimed at any one area for too long, and gradually build up the light.

PHYSIOGRAMS

A torch can also be used to create fascinating images known as physiograms. To do this you need a penlight torch with a small bulb on the end, a piece of string and somewhere to suspend the torch – a light fitting in the middle of a room is ideal.

Basically, all you do is tie the torch to one end of the string, then tie the other end to the light fitting so the torch is suspended. Ideally, use a piece of string 1m or so in length, and suspend it so you can set up your camera on a tripod about 1m directly under the torch.

Once you have got your camera in position, mounted on a tripod and with a cable release attached, set the shutter to bulb and stop the lens down to f/5.6 or f/8 at ISO 100. Now turn the torch on and focus the lens on it manually while looking through the camera's viewfinder.

With all preparations now complete you are ready to create your first physiogram. To do this, switch the torch on and the room lights off so you're in darkness, then pull the torch 40–50cm back from its static position over the camera and set is swinging in an

arc. Once you've done this, peer through the camera's viewfinder and at the point the swing of the torch is small enough to fit in the picture area, trip the shutter and lock it open on bulb.

Each swing of the torch will create a sphere of light so if you leave the shutter open for 30 seconds or so, you will end up with an amazing and unique light pattern. To add interest to your physiograms, place filters over the lens to colour the light trails – red, green, blue, orange and yellow are ideal. If you hold a piece of card over the lens to stop light from the torch recording, you can swap filters mid-exposure then take the card away and capture more light trails in a different colour. Repeat this three or four times until the torch has almost come to rest.

Physiogram, Alnmouth, England

I created my first physiograms many years ago using a film camera and they were a great success. However, it's much easier to achieve digitally because you can see the results immediately, so if you don't get it quite right you can correct your mistakes and try again. Saying that, it's hard not to produce interesting effects because of the random nature of the technique, so give it a try and see what you can come up with. I created this example in four stages, first spinning the torch with no filters on the lens, then with red, green and yellow filters. The torch was halted at the end of each stage then set spinning again on a different motion to create the intricate pattern of light trails.

CANON EOS 1DS MKIII, 24–70MM ZOOM, TRIPOD, 92 SECONDS AT F/11, ISO200

Alternatively, let the torch swing for 15 seconds or so, then cover the lens with card, stop the torch, set it swinging in a different way and take the card off the lens to record a different pattern over the first one. Do this three or four times, placing a different coloured filter over the lens each time you set the torch swinging again.

Physiograms are incredibly easy to create, but the effects can look amazing, with each image looking completely different to the last. So, the next time you're stuck at home with nothing to do, give it a try!

OPEN FLASH

This technique involves using an electronic flashgun in conjunction with a long exposure. In essence it's just like slow-sync flash (see page 143), but instead of using a shutter speed of 1/8 or 1/4sec, the camera's shutter is locked open on B for anything from a few seconds to several minutes, depending on the situation. Instead of the flash firing when you trip the camera's shutter release, it's also taken off the camera and fired manually using the test button. By working in this way, you have complete control over when the flash is fired, where it's fired from, which part of the scene you light with it, and how many times it's fired.

On a small scale, you could use a single burst of flash to illuminate a feature in the foreground of a low-light scene, such as a cross in a churchyard with a floodlit church behind it, or a swan on the edge of a lake at twilight. On a bigger scale, the flash can be fired many times during an exposure of several minutes to illuminate the exterior facade of a building, cliffs on the coastline, a monument or tree, or to light the interior of a building that has poor natural lighting.

Whatever the subject or scale of the picture, a powerful flashgun set to full power is the most effective as it delivers a consistent amount of light with each burst. If you have two flashguns, so much the better because while one is recharging after being fired you can fire the second one – if you're using flash to light a large area this will save a lot of time.

To determine which lens aperture you need to use to give correct flash exposure, divide the flashgun's guide number (GN) into the lens aperture you're using to find out how far away the flash needs to be from the area you're going to light with it. For example, if you have a flashgun with a GN of 32 and are using an aperture of f/16, the correct flash-to-subject distance is 32/16 = 2m. This is correct for ISO 100. If you're shooting at ISO 200, stop the lens down one f/stop – to f/22 in this example – or increase the flash-to-subject distance to 3m.

If the area you want to light with the flash is relatively small and accessible, then you should be able to provide sufficient illumination in a single flash burst. Usually you can trip the shutter and lock it open on B with a wired remote release – the camera must be on a tripod, of course – then walk up to the area you need to light, point the flashgun at it and fire the test button.

If this isn't possible, and you have to fire the flash from a distance that's outside its range at the aperture you want to use, there are two options. One is to set a wider aperture – by opening up the lens two stops you can double the flash-to-subject distance. This is the easiest option, but setting a wider lens aperture means you will lose depth-of-field. The other is to stay where you are and fire the flash more than once at the same area while the camera's shutter is open, to build-up the light on it. If the maximum flash-to-subject distance you can use for one flash is 2m, for instance, you will need to fire the flash twice if you are 3m away, four times if you are 4m away, six times if you are 5m away, eight times if you are 6m away and 16 times if you are 8m away.

In situations where the area you want to light is too great for a single flash burst due to the flashgun's limited coverage, such as the front of a building, then you have no choice but to use multiple flash bursts. Instead of doing this to build-up the light

Lochain Na h'Achlaise, Rannoch Moor, Scotland
Although conditions here were favourable, with a mirror-calm loch
and clear dusk sky, the colour I had hoped for at sunset failed to
materialise and the whole scene took on a sombre blue cast. To add
a splash of contrasting colour, I grabbed a torch from my car and
while the camera's shutter was open I painted the foreground boulder
with light, a quick and easy technique that transformed the image.
CANON EOS 1DS MKIII, 17–40MM ZOOM, 0.45ND HARD GRAD, TRIPOD, 1.3
SECONDS AT F/16, ISO50

levels in a single area, however, you walk around your subject and
fire the flash at different areas so you can gradually light the whole
subject, or parts of it that need lighting.

Large-scale subjects such as buildings are best photographed
with a wide-angle lens so you can set-up the camera at relatively
close range – this reduces the distance you have to walk to get up
to the building and light it with the flashgun, and the time it takes
to get there and back to the camera at the end of the exposure.

Ideally, get to your chosen location before dusk so you
have plenty of time to get organised. Set the camera to Manual
exposure mode, the shutter to B (bulb) and stop the lens down to
f/11 or f/16. Wait until light levels have dropped to a point where
you need to use an exposure of at least two minutes at f/11 or f/16

to record colour in the sky, then trip the camera's shutter and lock
it open on bulb with a remote release.

Next, head quickly towards the building and when you get
close enough, fire the flash at the first area, wait for the gun to
re-charge then light the second area. Repeat this as many times as
you think is necessary.

Providing you keep moving around, you won't register on the
shot. However, when firing the flash you need to make sure that
you're not between the flashgun and the camera, otherwise you'll
end-up with a nice silhouette or your own body in the picture
– not necessarily a bad thing, but not ideal either, especially if you
appear several times on the same shot!

Once you've lit the entire building, and any other features in
the scene that take your fancy, head back to the camera, close the
shutter and check your effort on the preview screen. It's difficult to
know how many flashes you will need to light an entire building,
but it's almost always more than you think, so be extravagant
rather than mean with your flashes and if the first shot doesn't
quite work – usually because you didn't give enough flash bursts
– try again. The benefit of digital is that you can check progress
and correct mistakes as you go.

SPARKLERS

As well as fireworks, sparklers are also associated with Bonfire Night and can be used to create eye-catching 'painting with light shots' where a person writes their name in the air with a lit sparkler, or traces circles in front of their face. The technique used to capture this involves locking your camera's shutter open on bulb while the sparkler is alight and being moved around, then adding a burst of flash towards the end of the exposure to illuminate your subject. Here's how it's done.

① Mount your camera on a tripod, attach a cable release and fit a standard zoom – 24–70mm will be ideal. Set the camera to manual exposure mode and the shutter speed setting to B (bulb).

② Position the tripod and camera in a dark, open space at night, well away from brightly lit areas. Avoid locations where there are lights in the background, such as a window – the middle of your garden would be ideal.

③ Position your subject, a person holding the unlit sparkler, between the camera and the background so that their head, shoulders and body fills the frame for a tight, upright composition.

④ Conduct a test to check the composition is okay by lighting the sparkler and asking your subject to spin it around in front of their body so a circle of light, is created around them. While they're doing this, check through the viewfinder that you're including the sparkler in the shot. If the movement is too wide, ask your subject to make smaller circles or set the zoom to a wider focal length.

⑤ Turn on your flashgun, open the camera's shutter on bulb using a remote release, manually fire the flash using the test button then close the shutter. Check the image on the camera's preview screen to make sure that the flash exposure is correct. If not, adjust the power output so the gun delivers more or less light and shoot another test. Once the flash exposure is correct, you're ready to go.

⑥ Ask your subject to light a sparkler. As soon as it's lit, lock your camera's shutter open on bulb and instruct your subject to start twirling the sparkler in front of them as before. Keep the shutter open for about 30 seconds, or as long as it takes for the sparkler to almost burn out.

⑦ Before the sparkler burns out completely, point the flashgun at your subject and press the test button to illuminate them. Make sure your subject's arm is in a downward position before firing the flash, so their face isn't obscured. The flashgun doesn't have to be attached to the camera; you can simply hold it in your hand. Once the flash has fired, end the exposure by closing the camera's shutter.

When you've mastered the basic technique, experiment with different variations. You could ask your subject to write their name in the air with the sparkler, for example.

Noah, Northumberland, England

My son has enjoyed playing with sparklers since he was very young – and still does! This shot was set up to demonstrate the type of effect you can achieve using a long bulb exposure to record the light trails from the sparkler followed by a burst of flash to illuminate the person holding the sparkler. My daughter acted as flashgun controller, standing just out of shot and pressing the test button on my command.
CANON EOS 1DS MKIII, 50MM PRIME LENS, TRIPOD, 20 SECONDS AT F/11, ISO400

◄ **Kitty, Northumberland, England**
Having assisted me in taking sparkler shots of her brother, my
daughter decided she wanted a slice of the action, only instead
of simply spinning the sparkler in front of her face she fancied
something more ambitious, leaving me to work out what and how!
This wacky image was created by tracing an outline around her body
then adding the swirly patterns, all during a single exposure and with
a single sparkler. When the sparkler finally expired, I dashed back to
the camera position, picked up the flashgun and fired it at Kitty to
provide the additional illumination. An interesting image and a fun
half an hour in the garden!
CANON EOS 1DS MKIII, 50MM PRIME LENS, TRIPOD, 41 SECONDS AT F/6.3,
ISO400

FIREWORK DISPLAYS

Grand firework displays are not only part of Bonfire Night
celebrations on November the 5th, but are used to mark all kinds
of special occasions, including music festivals and carnivals.

Whatever the venue or occasion, the technique used to
photograph firework displays is pretty much the same. Your best
bet is to ignore small-scale ground displays, which tend to produce
disappointing photographs, and concentrate your energies instead
on the much more impressive aerial displays, where powerful
rockets explode and fill the sky with a myriad of spectacular
colours. Arrive at the venue nice and early, before the crowds, and
establish where the fireworks will be launched from so you can
select a suitable viewpoint. Resist getting too close, otherwise
you'll end up being surrounded by people.

Once in position, set up your tripod and get your camera
ready. For shots of the whole display you'll need a moderate wide-
angle focal length such as a 24mm or 28mm. Alternatively, use
a telephoto or telezoom lens – anything from 100–300mm will
be ideal – and home-in on the 'eye' of the display so you fill the
camera's viewfinder with exploding fireworks. Whichever lens you
use, stop the aperture down to f/11 or f/16.

As with many night and low-light subjects, firework
photography requires you to use your camera's bulb setting so you
can hold the shutter open manually for as long as you like. This
makes a remote release essential, so you can hold the shutter open
without touching the camera. In windy weather it's also a good
idea to hang your backpack over the tripod to increase its stability
– and so you can see where it is while you're taking pictures.

If you're attending a firework display during the middle
months of the year, when the days are long, you may find that
there's still some colour in the sky when the display begins –
usually a beautiful velvety blue which makes a perfect backdrop to
the colourful fireworks. At either end of the year, however, the days
are much shorter so by the time the firework display begins the
sky will be completely black. This needn't be a problem, though
it's a good idea to try and fill the frame as much as possible so you
don't have lots of empty black sky in your pictures.

Once you're ready to shoot, all you have to do then is wait for
the first few fireworks to be launched so you can see where they
explode, adjust the position of your camera accordingly, then
prepare to take your first photograph. To do this, watch for the
telltale light trail shooting into the sky which indicates a firework
has been launched, then trip your camera's shutter and hold it
open with the remote release so the explosion is recorded.

With really lavish displays you may find that fireworks are
launched repeatedly, in which case all you need to do is keep
the shutter locked open for 30 seconds or so while four or five
explosions record. More commonly, however, there's a short delay
between fireworks during which nothing happens. If this is the
case, keep the camera's shutter locked open but hold a piece of
black card over the front of the lens. Then, wait for more fireworks
to be launched and move the card away so more explosions
record on the same frame. By doing this several times you'll
gradually build up the number of fireworks on the same shot.

Another option is to shoot a series of explosions on individual
frames then combine them in Photoshop using Layers. This gives
you more control over the look of the final composite image.

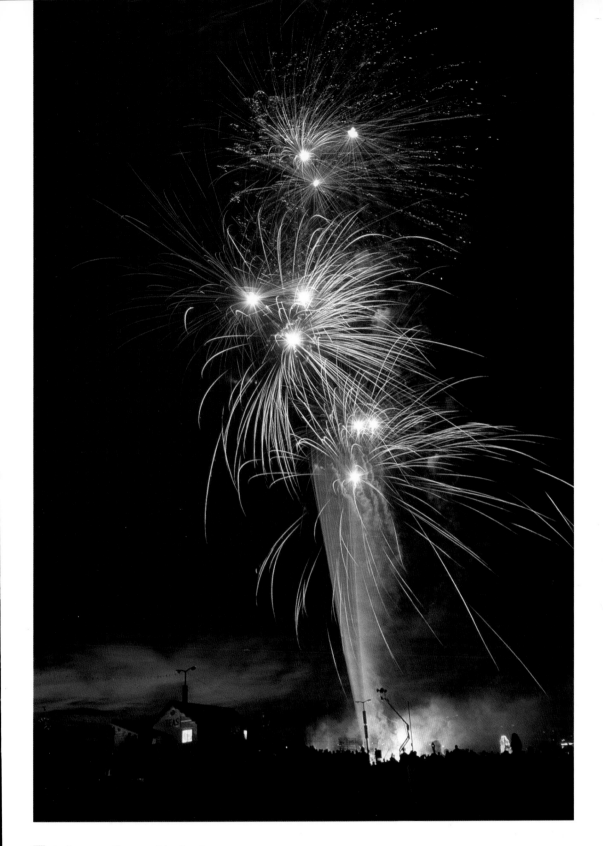

▲ Paignton, Devon, England

This firework shot was taken many years ago on my very first attempt at photographing an aerial firework display. It remains my favourite and illustrates two key points. First, that shooting great firework images is actually very easy – I captured this one on film using a simple, all-manual 35mm SLR – and second, that the results can look stunning. I was lucky here in that the firework display took place during the summer, so there was still colour in the sky quite late at night, which provides an attractive backdrop. On Bonfire Night in November, the days are short and the sky jet black by the time any fireworks are launched. So, if you can find a display taking place earlier in the year, it's well worth making the effort to pop along with your camera.

OLYMPUS OM1N, 28MM LENS, TRIPOD, 30 SECONDS AT F/16, ISO50

LOW-LIGHT ACTION

Photographing moving subjects in low light presents a different set of problems to other subjects because as well as coping with the lack of light, you also have to consider the movement itself and how you can best capture it. In normal conditions this isn't a problem, because abundant light allows you to pick and choose shutter speeds to match the rate at which your subject is moving, but in low light much of that control is taken away and you will often find yourself struggling to set a moderately fast shutter speed, even with your lens at its widest aperture and your camera's ISO at a high setting.

In this chapter we'll look at how these problems can be overcome, and explore techniques that can be used to both freeze and emphasize movement in a variety of low-light situations and produce fantastic, creative images.

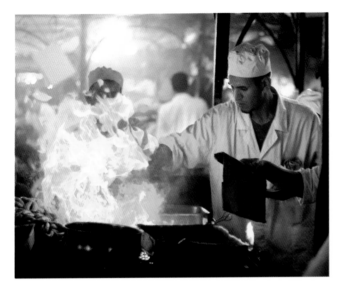

◁ **Djemaa el Fna, Marrakech, Morocco**
Every evening, dozens of food stalls are set up in the main square in Marrakech and food is cooked on open flames well into the night. It's an amazing spectacle to witness. Clouds of smoke swirl into the night sky, flames provide momentary flashes of colour and crowds of people gather for an al-fresco supper. Taking handheld photographs in this environment is tricky due to the low and fluctuating light levels and the fact that the cooks are continually on the move, but armed with a fast 50mm prime lens I was able to grab this candid as the flames rose.
CANON EOS 1DS MKIII, 50MM PRIME LENS, 1/500SEC AT F/1.8, ISO800

FREEZING MOVEMENT

The two main factors that you must consider above all else when resolving how to freeze a moving subject in low light are firstly, just how low the light is, and secondly, how fast your subject is moving. Obviously, the lower the light and the faster the movement, the more difficult the job becomes because it will push the capabilities of your equipment and skills as a photographer to the limit.

Working in available light is perhaps the most difficult approach to low-light action photography because you have no choice but to accept the conditions you are presented with and make the most of them. That said, by giving some thought to those conditions before you encounter them, steps can be taken to ensure you manage to take successful pictures. Forewarned is forearmed, as they say.

Conditions are less predictable outdoors because light levels can change significantly in a short space of time. If the weather takes a turn for the worse you will suddenly lose several stops of light and that can make all the difference between being able to freeze the action with a suitably fast shutter speed and having

to pack up and head for home. Similarly, if you're taking pictures outdoors at dusk, light levels will be far lower than they were earlier in the day so exposures will be longer.

In pre-digital days, it was necessary to carry two or three camera bodies, each loaded with a different film speed so if, say, ISO 100 was suddenly too slow, you could reach for the camera loaded with ISO 400 or ISO 1600 film. Fortunately, life with a digital camera is much easier because you can vary the ISO your camera is set to from shot to shot, the ISO range available on most digital SLRs is greater than the range of film speeds that used to be available and image quality at higher ISOs is far better with a digital camera than it was with film.

To give you an idea of the difference changing ISO can make, if you were limited to a shutter speed of 1/4sec at ISO100 and your lens set to its widest aperture, at ISO 200 you could shoot at 1/8sec, at ISO 400 1/15sec, at ISO 800 1/30sec at ISO 1600 1/60sec and at ISO 3200 1/125sec. That's the difference between an image where the subject is seriously blurred and one where it's sharp.

FOCUSING TECHNIQUE

Once you've overcome the difficulties imposed by low light, the next obstacle is actually taking a sharply focused photograph. There are two main techniques at your disposal here: pre-focusing and follow-focusing.

Pre-focusing involves focusing your lens on a pre-determined spot that you know your subject will pass then waiting for the right moment to shoot. This makes it ideal for sporting events that follow a recognized course, such as athletics, car and motorcycle racing, cycling and so on.

The key is to find a good viewpoint where you can get as close as possible to the action, then simply wait for it to come to you. At a motorcycle race you could position yourself close to a bend in the track then focus the lens on the bend and wait for the riders to approach, or at a horse race, get near one of the jumps and focus on the top of it so you're ready when the jockeys and their mounts become airborne.

◁ **The Malecon, Havana, Cuba**
Freezing fast-moving subjects outdoors at night is virtually impossible even with the fastest lenses and highest ISOs, but that needn't stop you producing dramatic images. This shot was taken well after sunset so light levels were extremely low, but by standing opposite a brightly lit building I was able to use a half-decent shutter speed and fill the background with vivid colour, while panning the camera enabled me to retain a reasonable level on sharpness in the passing car and capture a strong sense of motion as well.
CANON EOS 1DS MKIII, 17–40MM ZOOM, 1/8SEC AT F/4.0, ISO3200

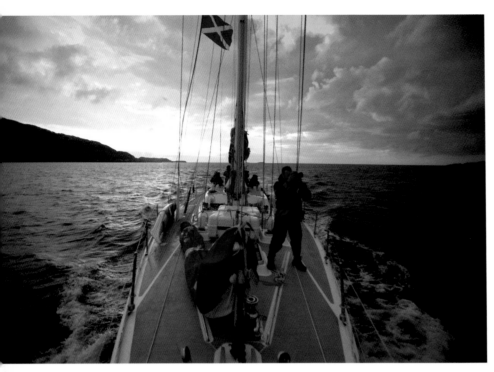

◁ **Off the Harris coast, Outer Hebrides, Scotland**
I took this photograph on the deck of a former round-the-world racing yacht that I had chartered for a group photo tour around the Outer Hebrides. It was our first evening and as we sailed away an amazing sunset filled the evening sky with colour. Seeing the potential for some great shots, I headed to the bow, balanced as best I could and started shooting. By using an ultra wide-zoom I was able to shoot at a wide aperture to maintain a fast shutter speed and still have enough depth-of-field to keep everything in sharp focus.
CANON EOS 1DS MKIII, 16–35MM ZOOM, 1/500SEC AT F/2.8, ISO400

The mistake most photographers make when pre-focusing is to trip the camera's shutter release when they see through the viewfinder that their subject has reached the pre-determined point and appears sharply focused. However, if you do this, there's a chance that you'll end up with a slightly out-of-focus subject because in the short time it takes for your brain to tell your finger to press the shutter release and the shutter to actually open, your subject will have passed beyond the point you focused the lens on. To avoid this, the shutter must be fired just before your subject snaps into focus. It takes experience to gauge this accurately, but practise makes perfect and the more you try it, the more your hit-rate will improve.

Setting your camera's motordrive to Continuous High so it fires several frames per second can help ensure you capture the perfect moment, but success isn't guaranteed and I prefer to shoot in Single Shot mode and time each frame carefully.

Where the action is more erratic and pre-focusing becomes unreliable, you need to use follow-focusing instead. As you might gather from its title, this involves tracking your subject with the camera while looking though the viewfinder and continually adjusting focus to keep it sharp, so that you can shoot when the action reaches its peak or your subject is positioned where you want it.

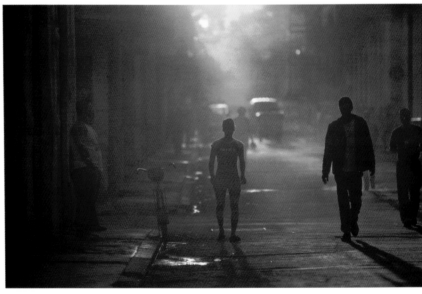

▷ **Havana, Cuba**
Even though light levels are low at sunrise and sunset, if you shoot into the sun it's still possible to maintain a relatively high shutter speed and freeze moderate movement without sending the ISO into treble figures. For a scene like this, 1/125-1/250sec will be more than fast enough to freeze people walking towards the camera; even cars.
NIKON F5, 80–200MM ZOOM, 1/125SEC AT F/4, ISO100

Science Museum, London
If there's no movement to emphasize, you can create your own – and some interesting images into the bargain – simply by moving the camera while making an exposure with a slow shutter speed. In this case, I tripped the camera's shutter and held it open on bulb for around a second while walking through the building. The result is an interesting, colourful, abstract image.
HOLGA 'TOY' CAMERA, FIXED 60MM LENS, 1 SEC AT F/11, ISO400

Modern autofocusing systems are fast, accurate and reliable, so it's no longer necessary to follow focus manually – just set your camera to Servo or Continuous AF and providing you keep an AF sensor over your subject while tracking it, the camera will automatically adjust focus to keep it sharp, even when light levels are very low.

USING FLASH

If you find it impossible to use shutter speeds fast enough to freeze your subject in available light, a simple solution in some situations is to use flash. Although you may have never realized, the brief pulse of light from even a basic gun lasts for only a tiny fraction of second – 1/20,000sec, often even less – so it can freeze the fastest movement. Because this is achieved using light rather than the camera's shutter, it also means that you can photograph subjects moving at high speed in the poorest of lighting conditions.

The only limitation when using flash in this way is that your subject must be within range. This rules out sporting events such as football in a floodlit sports stadium, because the action takes place too far away from the camera, but for close-range subjects such as motocross, car rallying, cycling and some athletics events, it's ideal. Flash can also be used in more everyday situations to freeze movement, such as when photographing people outdoors at night – paparazzi photographers almost always have a flashgun mounted on their camera's hotshoe when shooting celebrities outside nightclubs and restaurants because it makes life so much easier.

Producing well-exposed results is easy too. Dedicated flashguns can do it every time with no help from you. The only time they may struggle is if you're shooting outdoors at night, as the darkness in the scene may fool you flashgun into giving too much light, causing overexposure. This is easily rectified, though, just set the flash exposure compensation to -1 or -2 stops.

Another consideration is which shutter speed to use. Dedicated flashguns tend to automatically set your camera to its recognized flash sync speed, which is usually 1/125sec or 1/250sec, depending on the camera. You can also do this if you so wish, but if you do,

remember that in most low-light situations it will be too brief to record any ambient lighting so there's a danger of everything but your main subject coming out black because it's underexposed.

In some situations this can improve the shot by focusing all attention on your subject. Also, if your subject is photographed against a dark background – such as a martial arts expert caught in mid-air doing a side-kick – you wouldn't it any other way. But if you do want to record detail in the background, you must ensure the exposure time used is long enough.

The easiest way to do this is by setting your camera to aperture priority mode, so you select the lens aperture required to give correct flash exposure, while the camera automatically sets a shutter speed to record the ambient lighting. If you do this, remember to check just how long the exposure is going to be – a shutter speed of 1/4 or 1/2 a second will be fine, but there's little point in using flash to freeze a moving subject if the camera's shutter then remains open for several seconds.

EMPHASIZING MOVEMENT

Of course, there's no rule that says you must freeze all traces of action when photographing a moving subject in low-light, and in

▲ **Alnwick Garden, Alnwick, Northumberland, England**
This slow-sync flash image was taken using a very basic digital compact camera by today's
standards, but still proved to be a success. A slow shutter speed was used to record detail
in the background and the graceful movement of the dancer, while a burst of flash from the
camera's integral flashgun also recorded a frozen image. This combined effect creates a
strong sense of motion.
NIKON COOLPIX COMPACT, 1 SECOND AT F/4, ISO400

some cases doing so can actually reduce the impact of a picture by losing all sense of motion – which somehow defeats the object of shooting it in the first place.

The solution is to use a controlled amount of blur so your subject looks as though it's moving rather than being glued to the spot, and there are several ways in which you can do this.

Use a slow shutter speed

As well as controlling how long the light entering your camera lens is allowed to reach the sensor to ensure correct exposure, the shutter also serves another important role – it governs how subject movement is recorded. If you photograph a moving subject with a fast shutter speed, all movement will be frozen, whereas if you set a slow shutter speed your subject will blur.

The amount of blur recorded depends on two factors – how fast your subject is moving and which shutter speed you use. Therefore, the key to emphasizing movement is matching the right shutter speed to the right subject to create a convincing effect without the end result looking like a mistake. If you photograph a Formula One car at 1/125sec, for example, the car will come out blurred because it's moving so fast, especially on a straight. But if you use that same shutter speed to photograph a person walking past the camera, chances are they will be stopped dead and all traces of movement frozen.

As a guide, here are some suggested shutter speeds for different subjects:

Subject	Moderate Blur	Extensive Blur
Person walking	1/30sec	1/4sec
Person sprinting	1/60sec	1/15sec
Horse trotting	1/30sec	1/8sec
Horse galloping	1/125sec	1/30sec
Car travelling at 30mph	1/125sec	1/30sec
Car travelling at 70mph	1/250sec	1/60sec

These shutter speeds assume the subject is travelling towards the camera. For subjects moving across your path, more blur will record so consider using a slightly faster shutter speed – 1/60sec instead of 1/30sec, for example.

At the same time, there are no hard and fast rules to which shutter speed you must use, and it's possible to produce stunning images by intentionally using really slow speeds to produce abstract shots where emphasis is placed on the fluidity of movement rather than what the subject is – try photographing people walking using a 1 second exposure, or a car on 1/4sec.

Another useful trick is to include something static in the picture so the movement is emphasized even more. If you're photographing people on a dance floor in a disco, for example, ask one person to stand still and look at the camera, so he or she comes out sharp while everyone around is blurred. This can also work well when photographing people walking along the street or a busy station platform at rush hour – all you have to do is take an assistant along to stand in the crowd and provide a natural foil to the hustle and bustle going on in the rest of the scene.

Panning

A more effective way of emphasizing movement is to use a technique known as panning. This involves tracking your subject with the camera using Servo or Continuous autofocusing and tripping the shutter while still moving the camera. The result should be that your subject comes out relatively sharp but the background is reduced to a series of blurred streaks.

The key to success is in the smoothness of the pan. If you follow your subject at an even pace then it will come out sharp against the background because its position in the viewfinder remains the same, but if the pan is uneven you'll get blur in your subject as well as the background. Both outcomes can produce superb results, but smooth panning takes time to master.

Shutter speed choice can also make a big difference, because the slower the speed is, the more difficult it is to maintain a smooth pan and keep your subject sharp – panning at 1/60sec is easier than panning at 1/4sec.

As your experience grows and your panning action becomes smoother, you can use much slower shutter speeds and still keep your subject sharp while capturing much more blur in the background. Slow speeds can also be used to intentionally introduce subject blur and give a more impressionistic effect. Try taking a panned shot of a fast car on 1/15 sec, or photograph a person jogging at 1/4sec or slower.

The ideal stance to maintain a smooth pan is standing upright with your elbows tucked into your sides, your legs slightly apart and your back straight. Panning is then achieved by swinging your upper body from the hips. With long lenses, a monopod can be used to aid panning and will help to keep the camera level as you swing. Panning should also continue after the picture has been taken to give a smooth effect.

SLOW-SYNC FLASH

Another way of adding excitement and drama to your action picture is by using a technique known as slow-sync flash. This can be practised using an ordinary portable flashgun or your camera's integral flash, and involves combining a burst of electronic flash with a slow shutter speed, so you get a blurred and frozen image of moving subjects on the same frame.

Sport and action photographers often use slow-sync flash because it helps to capture the feeling of speed and action that tends to be lost by using a fast shutter speed to freeze all traces of movement. However, you can use it on any moving subject, from mountain bike racing in dark woodland to outdoor athletics at dusk – and people having fun on fairground rides (see page 145).

Many modern SLRs and compact cameras now have a slow-sync flash mode that allows you to use the technique automatically. If your camera doesn't, chances are your flashgun will. This means that if you set the camera to aperture priority mode, it will not automatically set the shutter to the recommended flash sync speed, which is too fast to capture any blur, and instead sets a shutter speed that is correct for the ambient (existing) light. Ideally you need a shutter speed around 1/15 or 1/8 sec to get sufficient blur, though it's worth trying slower shutter speeds, down to 1/2sec or more.

SECOND CURTAIN FLASH SYNC

Many camera and flashgun combinations operate using a system known as 'first curtain sync', where the flashgun fires at the start of the exposure rather than the end. With 'second curtain' or 'rear curtain' sync, the opposite occurs, and the flash fires at the end of the exposure instead.

In most situations, either can be used and you wouldn't know the difference, but when using slow-sync flash to capture moving subjects in low-light, second curtain sync gives a better effect because you get the blur of your subject caused by the slow shutter speed trailing behind the frozen flash image, instead of the other way round.

Not all cameras and flashguns offer the option of second curtain sync. Some allow it when used with a certain flashgun, while others are capable of first and second curtain sync with any flashgun, so check this out.

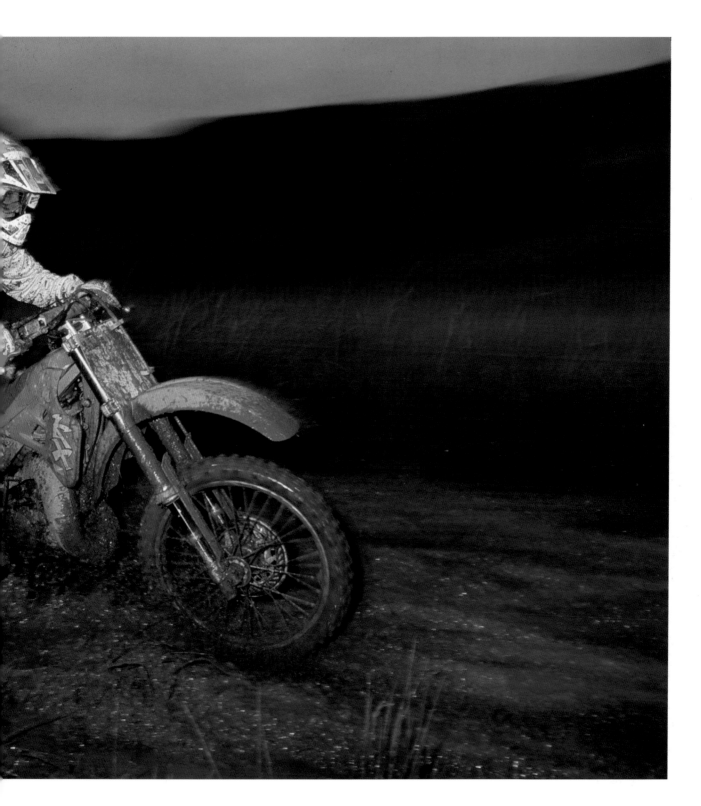

▲ **Peterborough, Cambridgeshire, England**
Slow-sync flash really comes into its own when you want to freeze fast-moving action in low
light but still retain a sense of drama and action. This motocross rider was practising in some
deserted brickworks so I asked him if he'd repeatedly ride up and down a stretch of muddy
track while I photographed him. As he passed by, I panned the camera and fired the shutter.
The flash froze the biker while the slow shutter speed blurred the background. This is a
fantastic technique to use on any moving subject in low light.
OLYMPUS OM4-TI, 28MM LENS, VIVITAR 283 FLASHGUN, 1/15SEC AT F/5.6, ISO100

BUILDING INTERIORS

Interiors differ enormously in terms of their size, style and the quality and type of lighting used to provide illumination. A twee thatched cottage full of dark, shady corners will present a different set of problems to the interior of a modern glass and steel office building with towering windows that flood everywhere with daylight. Similarly, the cavernous interior of a cathedral, with a mixture of natural and artificial light sources, will require a different approach to a bustling shopping centre.

What all building interiors have in common, however, is great photographic potential, and when treated in a considered, sympathetic way, they can be the source of superb low-light pictures – as the images in this chapter, hopefully, demonstrate.

◢ Teatro Tomas Terry, Cienfuegos, Cuba

The interior of this wonderful old theatre has remained unchanged since it was constructed in the early 20th century. As well as the original wooden seating and columned balconies, it also boast a beautiful painted ceiling. Taking all this in in a single frame is impossible as space is limited and visitors aren't allowed to stand on the stage, so in order to capture the ceiling I had to resort to using a 15mm full frame fisheye lens. Distortion at the frame edges is extensive, as you can see, but there was no other way to capture the ceiling in all its glory.

CANON EOS 1DS MKIII, 15MM FISHEYE, TRIPOD, 1 SECOND AT F/8, ISO200

◢ The Point Hotel, Edinburgh, Scotland

This large hotel in central Edinburgh is a classic example of a building where lighting has been used purely for effect. In certain areas the interior is illuminated using banks of coloured fluorescent tubes and the results are striking, with vibrant, clashing colours bathing the wall and floors. Who'd have thought green, shocking pink and yellow could look so good! I booked a night at the hotel during a visit to Edinburgh with my children, specifically so I could photograph the very unusual interiors. They thought I was mad and couldn't see what the fuss was about. I, on the other hand, had a great time.

CANON EOS 1DS MKIII, 17–40MM ZOOM, TRIPOD, 4 SECONDS AT F/11, ISO400

EQUIPMENT CHOICE

The type of lens you use will be governed by two main factors: how much space you have to work in and how much of the interior you want to record in a single shot.

For general interior shots you will find yourself reaching for a wide-angle lens more than any other, and usually a moderate 28mm or 24mm will satisfy your requirements. The only time you'll need anything wider is if you're trying to photograph a small interior where space is restricted, or a large interior where obstacles prevent you moving back sufficiently to get what you want in the frame. In these situations a lens with a focal length between 17–20mm should do the trick. Ultra wide-angle lenses are also ideal for shots of interiors that have particularly high ceilings – by turning your camera on its side you will be able to include everything from the floor up. And if you want to produce more unusual interior shots, nothing beats a full-frame fisheye lens with a focal length around 15mm.

Interior photography isn't just about the bigger picture, however, and in most buildings you will find other smaller details that can make interesting pictures – stained glass windows, ornate architectural features, the play of shadows on a wall, to name just

▲ St Clement's Church, Rodal, Isle of Harris, Scotland
This tiny 16th century Hebridean church was built for the Chiefs of the MacLeods of Harris, and contains the tombs of three Chiefs. The interior is dark and mysterious, which only adds to its appeal and on the day of my visit it was pouring with rain outside so light levels were even lower. Initially I concentrated on wide-angle views to try and capture the character of the interior, and as contrast was so high I shot sequences of exposures then combined them using HDR software (see page 186). However, on closer inspection I also realised the interior was also full of amazing details – such as intricate carved stonework that has survived for almost 500 years. This detail (left) appears above the wall tomb of Alastair Crotach MacLeod, 8th Chief and dates back to 1528.
CANON EOS 1DS MKIII, 24–70MM ZOOM, TRIPOD, (RIGHT IMAGE) 0.5-8 SECONDS AT F/8, ISO100, (LEFT IMAGE) 8 SECONDS AT F/8, ISO100

a few. So pack standard and telezoom lenses as well so you can fill the frame with more distant details, and maybe a 50mm prime lens so you can shoot handheld in low light.

Another essential piece of kit is a sturdy tripod. Light levels in interiors are generally quite low, so exposures of several seconds will be necessary when using small lens apertures for increased depth-of-field and a low ISO for optimum image quality. Add a cable release too, so you can trip the shutter without touching the camera, plus a small spirit level for the hotshoe so you can check the camera is perfectly square.

COMPOSITION

Composition needs to be given special thought when using wide-angle lenses to photograph interiors, as they stretch perspective and make everything appear further away from the camera than it really is – as well as increasing the apparent distance between elements. On the one hand this is a benefit, allowing you to capture a broad area in a single frame, but at the same time it can result in rather empty, boring compositions, with the foreground filled with acres of empty floor space and the more interesting parts of the interior condemned to the background.

To overcome this, look for features in the interior that can be used to add interest and depth to the composition. The bold lines created by rows of pews or seats in churches and cathedrals are

ideal. Ornate patterns on the floor can also be used, as well as statues or other architectural details to fill the foreground.

If you do include foreground interest, a small lens aperture such as f/11 or f/16 will be required to provide sufficient depth-of-field so everything is recorded in sharp focus. This will make exposure times longer, which is why a tripod is essential for interior photography.

CONVERGING VERTICALS

If you tilt the camera back when photographing an interior, any vertical lines in the scene will lean in towards the top of the frame. This is converging verticals, a common problem when shooting architecture. If you exaggerate the effect by using a wide-angle lens and really tilting the camera it can work in your favour, adding a dynamic feel to the composition, but moderate convergence tends to look odd and should be avoided.

The easiest way to avoid converging verticals is by using a 'tilt-shift' or perspective control lens. The front end of the lens can be shifted up and down, so when shooting an interior all you do is set up the camera on a tripod so it's level and square – and there are no converging verticals – then move the front section of the lens upwards to achieve the composition you require without having to tilt the camera back. Sadly, these lenses are very expensive so unless you're likely to use them on a regular basis it makes more sense to find alternative ways to avoid converging verticals.

When shooting exteriors, backing off and using a longer lens is one option, but inside, where space is limited, you won't be able to do that. Instead, switch to a wider lens and compose the scene with the camera level and square so there's no convergence – a small spirit level slipped onto the hotshoe can help here. This will often mean than you end up with too much floor in the shot, but it can be cropped out later to improve the composition. Another possibility is to shoot from a higher viewpoint – maybe there are some stairs you can stand on or, if not, how about taking a stepladder along? Or you could do it the digital way, using Photoshop to

Building on Concordia, Havana, Cuba
This beautiful apartment building in Havana has been in gradual decline since the revolution of 1959, but despite the obvious dilapidation it's still full of character and charm and offers a fascinating glimpse at Cuba's one-time wealth and prosperity. I used this marble staircase as foreground interest, to lead the eye into the image. It also enabled me to keep the camera level and square to prevent converging verticals, without ending up with an empty foreground.
CANON EOS 1DS MKIII, 17–40MM ZOOM, TRIPOD, 1 SECOND AT F/11.3, ISO100

correct convergence. This is a quick and easy technique and can be used to correct fairly serious converging verticals. Here's a quick step-by-step guide:

① Open your image then go to Select>All. Next, go to View>Show>Grid to put a grid over the image to aid correction of the verticals.

② Now go to Edit>Transform>Distort, click on the top left corner of the image and drag the cursor out to the left to correct the verticals, using the grid lines as a guide.

③ Repeat the same process for the right side of the image. Save the changes then go to View>Show>Grid and uncheck the Grid.

④ If the image looks a little squat, as it often will, go to Image>Image Size, uncheck the Constrain Proportions box and increase the height of the image by 5–10%

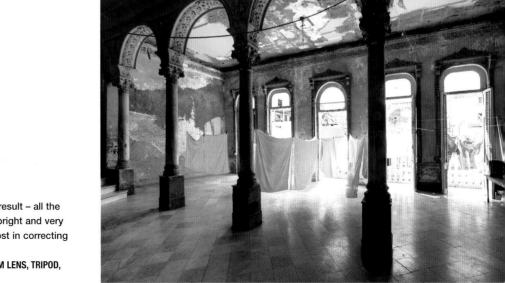

▷ And here's the end result – all the verticals are perfectly upright and very little of the image was lost in correcting the convergance.
CANON EOS 1DS MKIII, 14MM LENS, TRIPOD, 1/2SEC AT F/11.3, ISO100

LIGHTING

The type and quality of lighting used to illuminate interiors varies enormously. Some are lit solely by natural daylight flooding in through windows, others are lit by artificial means and more still by a mixed lighting, be it artificial and natural or different types of artificial lighting such as tungsten and fluorescent.

Older buildings are often poorly lit because the windows were intentionally kept small to minimize heat loss, whereas modern buildings are designed with quality of light in mind so big windows are installed to make best use of daylight, and much thought is given to the use of artificial lighting to create a suitable environment – be it domestic or commercial, for work or pleasure.

Establishing exactly what you've got to work with is therefore of paramount importance before you start taking pictures, because it will govern your approach more than any other single factor.

The easiest interiors to photograph are those lit by one type of lighting, be it natural daylight or tungsten, because a uniform source is easy to deal with. Natural daylight can be supplemented by electronic flash to produce more even illumination, without colour casts being created, while your camera's white balance can be adjusted to cope with specific types of artificial lighting such as tungsten or fluorescent.

Where lighting is mixed, the situation becomes more complicated because by dealing with one source you create problems with another. The Tungsten white balance preset can be used to produce natural colour rendition in tungsten lighting, for example, but if the interior is also lit by windowlight, the windows and areas affected by the light coming in will take on a blue cast. Similarly, if you control the green colour cast caused by fluorescent lighting using the fluorescent white balance preset, any areas lit by daylight in the same interior will take on a magenta cast.

One solution is to wait until night so the interior is lit by artificial means only, but then you'll get black windows that look odd. Another is to compose the shot so no windows are included, but that isn't always possible. What I do is simple – I usually leave my camera's white balance set to AWB (Auto White Balance) or Daylight, shoot in RAW format, then when I process the RAW files I adjust the colour temperature until I'm happy with the look of the image. I don't actually mind colour casts affecting certain areas providing the dominant light source is balanced to look natural – in fact, colour casts can look very striking, and in some interiors, coloured lights are used specifically for effect.

USING FLASH

Another option is to use electronic flash as your main source of illumination, so colour casts can be avoided and you have complete control over the quality of lighting. Professional architectural and interior photographers often do this as a matter of course, setting up their lights to mimic the effects of windowlight and in sympathy with any artificial lighting.

This is a highly skilled practice that takes years to perfect and involves lots of planning and so is out of reach to most enthusiasts.

A more accessible alternative is to use your portable flashgun to provide illumination. This may seem like a David and Goliath

◤ Ait Benhaddou, Morocco
This is the inside of a traditional Berber house in the fortified mud-brick village of Ait Benhaddou. The warmer light in the background is created by strong sunlight beaming down a staircase and reflecting off the orange mud. The rest of the interior is also lit by daylight, but it's reflected from a street outside and therefore more subdued. As I didn't have a tripod with me I was forced to shoot handheld, pushing the camera's ISO to it highest setting and shooting with my lens at its widest aperture. Despite this, the image quality is still very high.
CANON EOS 1DS MKIII, 17–40MM ZOOM, 1/50SEC AT F/4, ISO3200

Cienfuegos, Cuba

Stairwells make great photographic subjects, not only because the quality of light is often very interesting, but also because the 'Z' shape of the stairs creates an eye-catching pattern that adds impact to the composition. As Cuba enjoys a very warm climate, exterior doors to the old apartment buildings are usually left open, so you can see inside from the street – that's how I discovered this staircase, and given the rich colours and amazing light, I couldn't resist stopping to capture it. Again, as contrast was high, I shot a series of five frames with the exposure compensation varied from -2 to +2 stops in full stop increments then merged them using Photomatix Pro software (see page 187).

CANON EOS 1DS MKIII, 50MM PRIME LENS, 1/125-1/8SEC AT F/4, ISO800

Hotel La Union, Cienfuegos, Cuba

Many interiors are lit using a mixture of light sources – either different forms of artificial lighting or artificial and natural. If you want to capture everything looking natural, this creates a problem because by balancing colour casts for one lightsource you create them for another. Fortunately, the colour casts created by artificial lighting can look as effective inside buildings as they can outside, so I rarely bother trying to balance them – this scene was shot with my camera's white balance set to AWB. The contrast between the pools of yellow light on the ground floor and the blue railings works well.

CANON EOS 1DS MKIII, 17–40MM ZOOM, 13 SECONDS AT F/11, ISO100

For small interiors, the size of a domestic living room, you can supplement available light by bouncing flash off a ceiling. Doing this will not only increase the coverage of the flash so a wider area is lit, but also reduce the harshness of the light and provide softer shadows than if you fired the flash straight into the interior.

Many flashguns have a bounce head that can be adjusted to a suitable angle so the flash can be directedd towards a ceiling while the gun is mounted on the camera's hotshoe, though you don't need this facility because the gun can always be taken off the camera and physically pointed in the right direction.

White ceilings are more suited to bounced flash because, as well as reflecting more light than other colours, they also produce neutral illumination. If you bounce the flash off a coloured ceiling, on the other hand, the reflected light will take on that colour and add an unwanted cast to your pictures.

For bigger interiors, a single burst of flash will be insufficient so you will need to use multiple flash bursts to light different areas and gradually build up the light levels. This technique, known as 'open flash', involves locking your camera's shutter open on B (bulb), then during an exposure of many seconds you walk around the interior, firing the flash at different areas to fill-in shadows and emphasize interesting features.

Open flash is easier if you take a friend along to help out – perhaps using a second flashgun to light other areas so you can complete the task is less time, or asking them to stand at the camera and cover the lens up with a piece of card between flash bursts while you wait for the gun to re-cycle and move to the next position.

◣ ▷ Camera Obscura, Edinburgh, Scotland

I often carry a smaller camera with me when away on days out or family trips because you never know what photo opportunities might reveal themselves, and the model used here is particularly well-suited to handheld low-light shooting. Both shots were taken while visiting the Camera Obscura, a well known tourist attraction in Edinburgh. I discovered some fantastic, space-age interiors that were more interesting than the camera obscura itself! The globes were part of an eye-catching display – of which I ended up taking literally dozens of different shots. The tunnel of light trails was a bridge surrounded by spinning lights; an illusion that makes anyone walking over the bridge feel like they're toppling over. I waited until it was empty, jammed my camera against a wall and used a long exposure to record the spinning lights in the tunnel as colourful trails.
PANASONIC DMC GF1, 20MM F/1.7 PRIME LENS, (GLOBES) 1/30SEC AT F/1.7, ISO800 (TUNNEL) ½ SEC AT F/1.7, ISO1600

LOW-LIGHT PORTRAITS

There are more pictures of people taken each year than every other subject put together, but then that's hardly surprising when you consider the significance these pictures have in our lives and the number of occasions when we are inspired to pick up a camera and capture those around us.

Pictures of people are special because they remind us of specific times in our lives – holidays with family and friends, parties and celebrations, the arrival of a baby, or just ordinary moments that capture the happiness and laughter of everyday life. People also provide keen photographers with an endless supply of ideas and inspiration, which is why portraiture ranks as one of the most popular subjects.

Whether they're mere snapshots or considered, creative photographs, these pictures tend to be taken indoors, so certain restrictions are immediately imposed, mainly by the lack of light. No matter how well-lit a location is, the level of lighting indoors is almost always lower than outdoors in natural daylight and in some cases, almost non-existent.

Many photographers overcome both these problems by reaching for their flashgun – camera manufacturers promote such an approach by building them into so many modern cameras. But while doing so is the best option in some situations, more often than not you'll produce far more evocative images by capturing the ambience of the available light, whether it's natural or manmade.

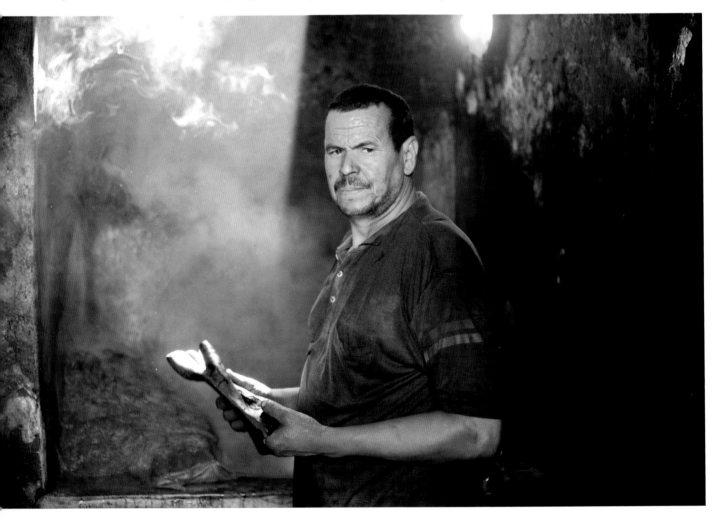

WINDOW LIGHT

Of all the different forms of illumination you can use to take photographs indoors, window light is considered by many to be the most effective. This is mainly because it's so versatile – prevailing weather conditions, the time of day, the direction the window faces and the size of the window all influence the quality of light passing through. You can also control the quality of light further by reducing the size of the window opening, using reflectors to bounce it around or by placing translucent materials over the window to diffuse the light. Consequently, it's possible to achieve a wide range of different lighting effects in your own home, completely free of charge.

The main drawback with windowlight is that it tends to be of relatively low intensity compared to daylight outdoors, and the level of intensity falls off rapidly with distance so that the area lit by the window is limited. There are exceptions to this, such as modern buildings that incorporate huge windows to make full use of natural daylight, or in structures such as conservatories and summerhouses that contain lots of windows, but in the average house, windows are or modest size so your subject needs to be close to them in order to be well-lit and to keep exposures as brief as possible.

Bright overcast weather tends to produce the most flattering window illumination because with the sun obscured by cloud

▽ Ait Benhaddou, Morocco

Daylight flooding through windows and open doors is perfect for gentle, flattering portraits as illustrated by this photograph. My subject was sitting in the doorway of her house and as I wandered by I noticed the beautiful soft light on her face. Her mother was nearby so I asked permission to photograph the little girl, who proved to be a perfect model, totally unfazed by the camera and lost in a world of her own. The warmth in the image is natural, created by daylight bouncing off the nearby mud walls and picking up traces of its rich red colour.
CANON EOS 1DS MKIII, 70–200MM ZOOM, 1/160SEC AT F/4, ISO400

◁ Souk Teinturiers, Marrakech, Morocco

The most testing environments usually produce the most satisfying and dramatic images due to the combination of factors you're faced with – but the chance of failure is also high so you need to keep your wits about you. This portrait was shot in the Dyer's Souk in Marrakech, a busy, noisy and confined area where people are constantly rushing around and work never seems to stop. The dyers are generally reluctant to be photographed, but after I persisted and pleaded for several minutes, this man eventually softened and turned fleetingly towards the camera. I just found the whole environment magical – the shaft of sunlight beaming down in the background, the swirling smoke, and piles of steaming silk… It captured the mood of the souk perfectly, a dark, medieval place where people work hard for very little. Yet again, my trusty standard lens saved the day.
CANON EOS 1DS MKIII, 50MM F/1.8 PRIME LENS, 1/125SEC AT F/2.8, ISO1600

Vinales, Cuba
This portrait was taken inside a tobacco drying hut on a tiny farm in western Cuba. I know the family, having visited them numerous times over the years, and they always welcome me when I'm in Cuba leading photography tours. The photographers in my group also relish the chance to shoot portraits of the family members in different settings. The young mother and her child were standing inside the doorway of the hut, watching myself and the group in action and I couldn't help but notice the beautiful light flooding their faces. I love to photograph people in available natural light – it has a magical quality that's hard to beat, so I immediately stopped what I was doing and asked the woman if she'd mind being photographed. Conditions couldn't have been better, and yet it was all totally natural and spontaneous – no setting up of lights, no posing, just a chance opportunity taken advantage of.
CANON EOS 1DS MKIII, 50MM F/1.8 PRIME LENS, 1/80SEC AT F/2.8, ISO400

the light is very soft, and if your subject is close to the window, shadows will be relatively weak. This is ideal for portraiture and classic nude studies. As the weather becomes progressively duller, so the light becomes softer and shadows weaker. You can take beautiful window-lit photographs on grey, rainy days but light levels fall too, so longer exposures are required. The lighting effect you get by shooting in windowlight on an overcast day is very similar to that achieved by fitting a large softbox to a studio flash unit.

In sunny weather, windowlight is much harsher. This is especially so with windows that admit direct sunlight, and you may find that the light is just too intense at close quarters.

One solution is to move your subject further away from the window so they're in a pool of light spilling on the floor or opposite wall. This effect is often seen in older buildings such as public houses, barns and warehouses, where sunlight shining through small windows has an almost spotlight effect, illuminating a small area while everything else is plunged into deep shadows. This play of light and shade can produce incredibly atmospheric pictures if you use your imagination.

Another option is to wait until later in the day, when warm light rakes through the window from a lower angle, casting long shadows and a golden glow on anything it strikes. This type of light is ideal for portraiture as it makes skin tones more attractive.

Alternatively, find a window in your home that isn't admitting direct sunlight. North-facing windows are ideal in sunny weather, because, even though the light is intense outdoors, they only admit reflected light so the quality of illumination is much softer.

Direct window light can also be controlled by covering the window with a translucent material such as tracing paper, a white cotton sheet or white muslin material. Even net curtains can work well. The effect of doing this is similar to placing a softbox or brolly over a studio flash unit – the light is softened and spread over a wider area while shadows are weakened. Once you're happy with the window set-up, think about where your subject will be positioned in relation to it. The classic approach is to pose your subject with the window on one side so one half of their face and body is lit while the other half fades into shadow. Depending on the size of the window and the harshness of the light, this approach can produce anything from bold side-lighting, where the shadows are black, to a gentle fall-off in illumination.

Either way, if you want more even illumination, place a large reflector opposite the window so it bounces some of the light into the shadow areas. White is the traditional colour for reflectors, but gold is also useful for colour images as it warms the light it reflects to give more flattering results. Make your reflectors from sheets of white card or board painted white, and glue gold foil over one side so you have a dual-colour reflector.

Another lighting option is to ask your subject to look at or through the window, so their face and body is flooded with light and any shadows fall away from them. For tight headshots your subject could be close to the window and gazing out of it, while for half or full-length shots, ask them to stand a couple of metres away from the window so you can stand next to it and look into the room towards them.

The third option is to use the window as a background, so the side of your subject facing the camera is in deep shadow. You can then either record them as a silhouette by exposing for the window, or record detail in the shadow areas so the window burns-out. If you go for a silhouette, your camera's integral metering system will do this automatically if you take a general reading. To record detail in the shadows, increase the exposure by 2–3 stops using your camera's exposure compensation facility.

PORTRAITS IN ARTIFICIAL LIGHT

Although windowlight is an ideal source of illumination for people pictures, often you'll find yourself in situations where you have to work with artificial lighting – pubs, clubs and restaurants being good examples. This needn't be a problem – artificial

▼ **Bar El Floridita, Havana, Cuba**
Photographing people indoors often pushes you to the very limit of technical possibility in order to take successful shots, but working in extreme situations is easier now than ever before thanks to digital technology. For this shot I was not only forced to use a fast prime lens at its widest aperture, but also set my camera to its highest ISO – and I was still left with a shutter speed that could quite easily have led to camera shake or subject blur. In many shots I had one or the other, but this was one of the few 'keepers'. You only need one!
CANON EOS 1DS MKIII, 50MM F/1.8 PRIME LENS, 1/50SEC AT F/1.8, ISO3200

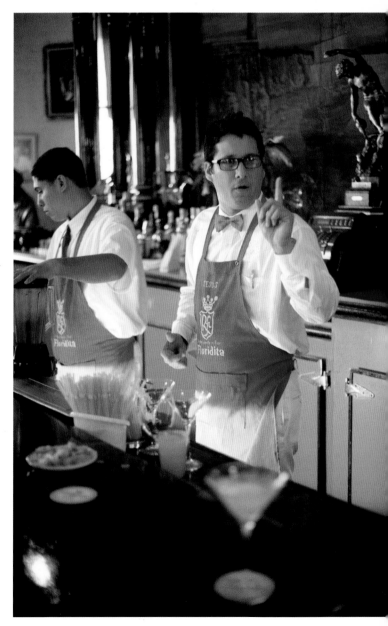

lighting can produce very atmospheric results – but in order to avoid disappointment, you need to be aware of the limitations it imposes and how you can overcome them.

Firstly, you will have little or no control over the lighting, so you simply have to make the best of what you're given. Secondly, light levels will be lower than windowlight, making exposures longer and the risk of camera-shake higher. Thirdly, the light source or sources will create colour casts that you may need to deal with.

Overcoming low light levels is easy – simply increase your camera's ISO. If you're taking candid pictures indoors in available light you'll need to shoot on at least ISO 400, probably ISO 800 or ISO 1600 if you're handholding with a telezoom lens. I always try to keep the ISO as low as possible for optimum image quality, but increasingly find myself shooting at ISO 3200 in low light (my camera's highest setting) as the image quality is still surprisingly good. I'd rather have a grainy image that's sharp than a grain-free one that's blurred by camera shake.

Lens choice will also help you cope with low light. I swear by my 50mm f/1.8 prime lens – it's lightweight, compact, and most important of all, fast – with the aperture set to f/1.8 and the camera's ISO at 3200, I can take successful handheld shots in situations where I wouldn't have bothered when shooting film.

Colour casts are easy too. Most interiors where you're likely to take people pictures will be illuminated either by tungsten or fluorescent light. In the days of film, tungsten had to be dealt with either by using a blue filter over the lens (which increased the exposure by at least one stop; hardly convenient when light levels are low) or tungsten-balanced film, of which there were few options. Fluorescent light needed a weak magenta filter to balance the green cast it produced on normal film. But in this digital age, all you do it change the camera's white balance to a suitable preset to achieve natural-looking results, or shoot with the white balance set to Daylight or AWB then correct any colour casts when you process the RAW files.

PARTIES AND SPECIAL EVENTS

Birthdays, weddings, Christmas gatherings, anniversaries, the annual office bash – life is full of celebrations and rarely a month goes by for many people without at least one opportunity to let their hair down.

For the partygoers themselves, fun is the name of the game, and for photographers this means one thing – the chance to take great pictures. Most adults become shy and embarrassed when a camera is aimed at them, but combine high spirits with alcohol

and all that changes as inhibitions are thrown to the wind in favour of a good time.

The best way to capture this is by adopting a sophisticated snapshot approach. In other words, you take pictures quickly and instinctively, so the moment isn't lost, but use your creative and technical skills as a photographer to produce something a little more interesting than the average compact-toting party-goer. This may mean taking a back seat from the antics yourself – at least for a little while any way – so you can concentrate on what's

happening around you, but if great pictures are your goal, it's a necessary evil.

Most parties take place indoors and usually at night, so light levels are low and more often than not provided by artificial means. The easiest way around this is by using flash, for several reasons: it will allow you to use a low ISO for high quality pictures, you can set a decent lens aperture to provide sufficient depth-of-field, and you can work at a fast enough shutter speed to freeze both subject movement and camera-shake.

Halloween, Alnwick, Northumberland, England
Although I try to avoid it when I can, in some low-light situations the only way you're going to take an acceptable shot is by resorting to flash – simply because light levels are so low. This Halloween snapshot is a good example. It was taken outdoors at night, well after dark, and even the fastest lens and highest ISO would have failed to make any difference. A burst of flash did the trick though, lighting the children and really emphasizing the vivid colours in their costumes.
SONY CYBERSHOT COMPACT WITH FIXED ZOOM, 1/60SEC AT F/2.8, ISO80

▶ Venice Carnival, Venice, Italy

Flash can also be invaluable as 'fill-in' when shooting outdoors in contrasty lowlight situations. At the annual Venice Carnival – well worth a visit if you've never been there – some costumed participants gather near St Mark's Square before sunrise, ready to pose for photographers. This is all very pleasant, except that against the bright predawn sky the figures are reduced almost to silhouettes, and increasing the exposure to overcome that would burn-out the vivid colour in the sky. The solution is to combine a burst of flash to light the subject with an exposure that's correct for the ambient light – a very easy technique in these days of dedicated flashguns.

NIKON F5, 28MM LENS, VIVITAR 283 FLASHGUN, 1/8SEC AT F/5.6, ISO100

Flash is so convenient at parties and special occasions because you can just wander around, looking for interesting expressions, and take a picture instantly. The lighting isn't particularly flattering, but it makes colours look vibrant and will allow you to take bright, crisp shots in the poorest of lighting.

The main thing you need to watch out for when using flash is red-eye, which is caused by light from the flashgun reflecting off the retinas in your subject's eyes and causing them to glow bright red. The risk of red-eye is increased in low-light situations because our pupils dilate to take in more light. Alcohol also causes our pupils to dilate, so at parties you have the worst possible combination.

Many flashguns today have a red-eye reduction mode which fires a series of pre-flashes or shines a light in your subject's eyes before the main flash is fired, to make the pupils constrict. Few are effective though, particularly in low-light, and with some the strobe-like pre-flash sequence can be positively off-putting for your poor subject. Fortunately, there are other ways to reduce or eliminate the problem.

A common cause of red-eye is the flash being too close to the lens axis. Bouncing the flash from a wall of ceiling will prevent this and also improve the quality of light. In many party situations, bouncing the flash may not be convenient or possible, so instead consider investing in a flash diffuser.

If you're using a camera with a built-in flashgun, your options are far more limited because the position of the flashgun can't be changed. What you could try, however, is asking your subject to move

to a brighter part of the room or to look at a light for a few seconds so their pupils constrict. This isn't ideal, because it loses the spontaneity of the moment, but it's better than nothing. And remember, red-eye is only caused when your subject looks directly at the camera, so if you're photographing people candidly, chances are they won't be.

Slow-sync flash is also a handy technique worth trying at parties and special occasions, as it will help you to capture the fun and frolics of the event. This is achieved by using as slow shutter speed with a burst of flash, so you get a frozen and blurred image on the same shot. At parties, this usually results in a sharp, flash-lit subject against a blurred background because people have moved or the camera has moved during exposure.

Many cameras with an integral flash can produce this effect automatically – look out for a Slow-sync or Night Portrait mode. Many dedicated flashguns and digital SLRs also have a slow-sync flash setting.

PEOPLE AT WORK

Photographing people in their place of work is both challenging and rewarding, as every occupation brings with it a different environment and a different approach. However, all can produce fascinating pictures that say far more about the subject than a traditional portrait taken in a formal situation. People also tend to relax more in their place of work, as they're in familiar surroundings where you are the naive layman, instead of them.

Manual occupations tend to be the most interesting, simply because they take place in more photogenic locations and feature characterful people. Think of a farmer milking his cow in the light of a single light bulb hanging from the barn rafters, or a blacksmith hammering white-hot steel in his dimly-lit forge. The more low-tech the profession and primitive the setting, the better from a photographic point of view.

To get the best possible results when photographing people at work you need to spend a little time analyzing the environment, the lighting and how you might overcome any technical problems. If the location is lit by tungsten or fluorescent lighting, for example, you need to be aware of the colour casts they will produce and act accordingly by changing your camera's white balance setting or shooting in RAW format, or both.

Alternatively, you could simply make a mental note of the light

▽ Metalworker's Souk, Marrakech
People and working environments provide fantastic photo opportunities – and the more industrial the occupation, the more photogenic it tends to be. While wandering through the metalworker's souk in Marrakech I peered inside a workshop and noticed this man busy welding. Protective clothing is a luxury few can afford – many of the welders in the souk only have cheap sunglasses to protect their eyesight from the intense brightness. At least this chap has some proper welder's goggles. Once he noticed me taking photographs he intentionally started creating more sparks and flashes while I fired away. Every shot proved to be different – this is one of my favourites, with the intense light illuminating my subject's face.
CANON EOS 1DS MKIII, 50MM F/1.8 PRIME LENS, 1/200SEC AT F/2, ISO1600

source then ignore it, as the addition of a colour cast may improve rather than spoil the picture. Think of a steelworker's face lit by the orange glow from the furnace he's tending. Would you want to lose the wonderful glow that's so characterful of his occupation and environment?

The way the subject is lit should also be considered, irrespective of the light source, as this will have a strong influence on the mood of the pictures you take. Brightly lit locations are the easiest to deal with but tend to produce the least interesting pictures because they appear rather sterile. At the other extreme, environments that are poorly lit, such as old workshops, are trickier to photograph but the lighting is far more evocative, so you have to weight up convenience with creativity.

In some situations you may also be able to employ your own lighting, in the form of electronic flash, to provide illumination or for creative effect. If your subject is engaged in an occupation that involves a lot of running around, slow-sync flash will help to capture the energy and activity of that occupation, as well as overcoming the problems of low-lighting, which limit your choice of shutter speed.

The lens you use will also depend on the situation. In confined spaces, a moderate wide-angle focal length from 24–35mm will be invaluable for including your subject and at least some of their surroundings. This tends to produce more interesting results than capturing your subject alone, as much of the picture's appeal will come from the clues offered by the environment. Where space isn't limited then you obviously have more choice; use a 50mm prime lens, perhaps, or a standard zoom.

Whichever lens you're using, always remember to focus on your subject. It doesn't matter if other parts of the scene you are photographing don't record in sharp focus, but if your subject is unsharp, the image will be a failure. I almost always focus manually when photographing people in a work environment because it means I don't have to worry about where they're positioned in the frame and if an active AF sensor is over them. It takes practise to focus

The Malecon, Havana, Cuba
Sunset is a very atmospheric time of day, with the sun's golden orb and the orange sky providing an attractive backdrop for portraits and candids. I spotted this cyclist sitting on the sea wall along Havana's waterfront, enjoying the warm air and watching the sun go down. Framed by the graphic silhouette of his bicycle, he made an irresistible subject.
NIKON F5, 80–200MM ZOOM, 1/250SEC AT F/2.8, ISO100

quickly and accurately by hand in low light, especially with your lens set to a wide aperture so depth-of-field is shallow. But it's worth the effort as your hit rate of successful shots is likely to be higher.

Fast lenses (with wide maximum apertures) are ideal for taking handheld shots in low-light, or capturing moving subjects, as they allow you to work with faster shutter speeds. However, if you can get away with mounting your camera on a tripod and using slower shutter speeds (with smaller lens apertures) do so, as it will increase the level of control you have over the situation.

Some occupations require slow shutter speeds to bring out the drama of the work being done. Welding, grinding and steelworking are good examples of this – a slow shutter speed will allow you to capture lots of sparks and flames, just like you would use a long exposure to record a firework display or a sparkler on Bonfire Night (see page 151).

The key to success when photographing people at work is judging each situation on its merits and responding accordingly. So begin with an open mind and just follow your instincts, using the techniques and ideas covered in this book to take extraordinary photographs of ordinary occupations.

◢ Noah at the Doctor Who Exhibition
Being a photographer, I find it hard to switch off and wherever I am I can't help but see the photographic potential in a situation. It's just the way it is! While attending a Doctor Who exhibition with my son, I noticed that intense coloured lighting was being used in certain areas, to illuminate the exhibits, so I asked my son to stand in one of the pools of light while I took a quick shot of him. I didn't have a 'proper' camera with me but I did have my iPhone, which has a 3Mp integral camera, so I used that – and it worked a treat!
APPLE IPHONE 3GS, 1/17SEC AT F/2.8, ISO640

Kitty on her 7th birthday ◣
I always keep a compact camera handy so I can grab photographs of my children, especially on special occasions such as birthdays and Christmas. The quality of modern digital compacts is superb, and the capability at high ISO means you can take high quality shots in available light without having to resort to flash, which can destroy the mood.
SONY CYBERSHOT 6MP COMPACT WITH FIXED ZOOM, 1/30SEC AT F/2.8, ISO400

LOW-LIGHT PANORAMAS

Panoramic photography has played a central role in my career for many years now. I was first inspired to try it back in the early 90s and immediately felt as though I had found the missing piece to my own creative jigsaw. After months of saving I managed to scrape enough money together to buy a second-hand Fuji G617 and it marked the start of a love affair that endures to this day.

I've owned and used a range of different panoramic cameras but since switching to digital capture in 2008, I've discovered a whole new side to panoramic photography in the form of image stitching, and I have to say, I'm impressed. Initially, I refused to believe that any digital technique could match the quality I was achieving with my Fuji GX617 and Fuji Velvia slide film. Then out of curiosity, I shot a sequence

of images with my Canon EOS 1DS MKIII, stitched them together, sat back and thought, 'Wow!' Creating digital panoramas is not only easy, but it's versatile and offers almost endless creative potential.

STITCHING SOFTWARE

At the heart of creating digital panoramas is the software you use to stitch the images together, and the good news is that it's better than ever, making the task of creating perfect results with the minimum of fuss both quick and easy.

A friend of mine started making digital panoramas in the days when each frame had to be picked up and dropped onto

an enlarged canvas in Photoshop and manually blended, using layer masks and the Brush tool to merge them together without showing the joins. The results looked fantastic, but it took hours for him to construct a single panorama, and he was already a Photoshop wizard. Looking back, it was probably watching him that put me off digital imaging – it seemed far more complicated than just pressing the shutter release of a panoramic camera and capturing a scene on film.

But like most things digital, advances and improvements have been made and all you need to do now is put the individual images that will make-up the final panorama into a folder on your computer, open your stitching software, browse your folders to find the right one, click OK, and sit back while the software does all the hard work. Minutes later, a perfect panoramas appears on your screen like magic.

I use Photomerge in Adobe Photoshop CS3 to do all my stitching at the moment, and I have to say, it's fantastic. But Photomerge in CS2 was pretty terrible in comparison. So if you've tried stitching with software that's more than a couple of years old, only to be disappointed with the results, it's probably time to upgrade to a later version, or try a different package altogether.

If you don't have a recent version of Photoshop that you can upgrade, or you don't use it at all, you'll need to by some proprietary stitching software, of which there are various options. I know several photographers who use PTGui (www.ptgui.com) and they say it's fantastic.

▽ Val d'Orcia, Tuscany, Italy

This is one of my favourite views in the entire world and no matter how many times I gaze over it, I never fail to feel inspired, impressed and humbled by the beauty of Mother Nature. You couldn't invent a more beautiful landscape if you tried. Of course, it lends itself to the panoramic format and having shot the scene on various panoramic cameras, after my switch to digital in 2008, I was desperate to create a stitched panorama at dawn. This is one of my first efforts. Conditions were perfect, with delicate mist laying in the folds of the hills, a soft predawn glow warming the sky and Belvedere sitting high above the valley. I shot a sequence of 12 frames and stitched them together using Photomerge in Photoshop CS3.
CANON EOS 1DS MKIII, 70–200MM ZOOM, 0.6ND HARD GRAD, TRIPOD, 1 SECOND AT F/11, ISO100

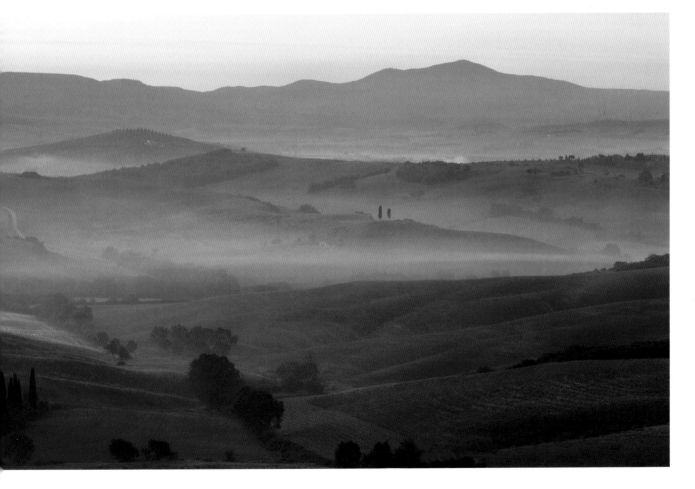

PLANNING YOUR PANORAMA

Given that the latest software will handle the stitching, all you need to do is make sure you produce a set of images that the software can work with to construct a seamless panorama.

The key here is control and planning. You need to decide what you're going to do before you do it, get yourself organized, and establish a work routine that you can repeat time after time so it becomes almost second nature.

You can shoot sequences handheld then stitch them – I have, on many occasions – but there's a greater chance that the camera will drift out of level as you move it between shots. This means the software has to work harder and you end-up with a jagged edge to the stitched panorama that must be cropped off, which could mean losing vital subject matter, like the top of a building. To avoid that, set your zoom to a wider focal length so you've got more room for error if you do have to crop.

Far better is to mount your camera on a tripod so you can level it properly, keep it level from frame to frame and not have to worry about camera shake (see panel).

Though it isn't essential to do so, it also makes sense to turn your camera on its side so that the pixel depth of the panorama will be maximised – with my Canon EOS 1DS MIII on its side the output depth at 300dpi is almost 19in, whereas in landscape format it's under 13in.

With the camera on the tripod you need to decide where the panorama will begin and end. In the countryside I rarely cover more than 90° and more often than not much less. However, in urban locations or when shooting interiors, markets and so on, you could go for a full 360° pan – the results look amazing.

In terms of lens choice, that's really down to individual situations and needs. I tend to use my 24–70mm zoom more than any other, and occasionally a 70–200mm. If you go too wide there will be a lot of distortion in each image and even if the software manages to cope with it, the results can look odd. Saying that, you don't always have to create panoramas that look natural, so be prepared to experiment and throw caution to the wind – you could be surprised by the outcome.

Whatever type of scene or location you shoot, be aware that moving elements can cause problems. If you have to use long exposures, blurring in the sky and sea or things like breaking waves may cause alignment problems. Similarly, urban scenes where there's moving traffic or people – or both. If in doubt, give it a try and see what happens. It may be that you have to do a little retouching in post production, perhaps using the Clone Stamp tool to remove unwanted or repeated elements or to soften visible joins between images. The more experience you gain, the more straightforward these problems are to solve, so don't let the risk of them put you off trying.

△ **St Mary's Lighthouse, Whitley Bay, England**
I initially photographed this dusk scene in a single frame, but as
I scanned across the horizon I realized that a stitched panorama
would perhaps capture a better impression of the lighthouse's
location, on a small tidal island off the northeast coast. Though it's
not obvious in the image, a gale was blowing and I did wonder how
I would manage to keep the camera steady. In the end I had to park
my 4 x 4 on the edge of the tidal causeway and shelter by the side of
it. Six frames were combined to create the finished panorama.
CANON EOS 1DS MKIII, 24–70MM ZOOM, 0.6ND HARD GRAD, TRIPOD, 0.4SEC AT
F/16, ISO100

KEEP IT LEVEL

A crucial part of creating digital panoramas is
making sure your camera is level. There's no
point setting up your tripod, sliding a spirit
level on the camera's hotshoe and levelling
the camera as you would to take a single
shot, because chances are, as soon as you
pan left or right to take the next short in the
sequence it will fall out of level.

To avoid that you need to make sure the
base on which the tripod head sits is level in
all directions – either by laboriously adjusting
the tripod legs or, much better, by purchasing
some kind of levelling base that sits between
the tripod legs and the tripod head. I use
a Gitzo levelling base on my tripod and it
provides 15° of adjustment using a cup and
half ball design so I can get the tripod head
– a Manfrotto 410 Junior Geared Head – level
even if the tripod isn't perfectly level.

Once the platform on which the tripod
head sits is level, you can then adjust the head
itself to make sure it too is level with the aid of
spirit levels in the head itself or using a small
spirit level on the camera's hotshoe. Once
you've done that, it should be possible to
rotate the camera through 360° and maintain
the level, though if there's a little deviation the
stitching software will correct it for you.

CREATING A DIGITAL PANORAMA

① Mount your camera on a tripod in vertical format and make sure the tripod head is level so that when you rotate the camera between shots it doesn't go out of square. Do a quick practise scan across the scene to decide where it begins and ends.

③ Swing the camera to the far left of the view you want to capture, focus manually and take a shot of your left hand with your fingers pointing to the right. This denotes where the sequence begins so you don't get confused later.

④ Take the first shot in the sequence, move the camera slightly to the right and make your second exposure. Repeat this until you reach the other end of the scene, making sure you overlap each image by 30–40% to enable easy stitching.

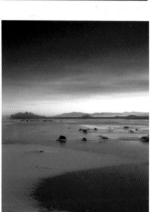

② Take a test shot from an average part of the scene – not the lightest or the darkest – check the image and histogram and if all looks okay, set that exposure with your camera in manual mode so you use exactly the same exposure for each frame.

⑤ Take a shot of your right hand with your fingers pointing to the left to denote the end of the sequence. When you download the files to your computer you'll know that all the images between the two hand shots are in the same sequence.

EXPOSURE AND FOCUSING

A couple of mistakes beginners to panoramic photography often make are leaving their SLR set to autofocus and auto exposure. The first error may not cause problems if you're shooting with a fairly wide focal length set to a small aperture such as f/11 or f/16 because there will usually be sufficient depth-of-field to achieve front-to-back sharpness even if the lens adjusts focus from frame to frame. That said, it makes sense to switch the camera to manual focus so that once you set focus you know it will stay the same

throughout the sequence.

Shooting on auto exposure is more serious and almost guaranteed to cause problems because the camera will adjust exposure for each frame, which means image density varies from one frame to the next and the stitching software won't be able to blend the images properly.

To avoid this, point your camera to a part of the scene you want to shoot that looks fairly average – ie not the brightest or the darkest area – and take a test shot. If the exposure looks okay, switch your camera to manual mode, set the required exposure,

⑥ Download the images to a computer. If you shoot in RAW, batch process the RAW files from the sequences so they all receive the same adjustments and corrections, otherwise inconsistencies will creep in. Place those images in a folder.

⑦ Open Photoshop and go to File>Automate> Photomerge. Select the layout style you want to use. Auto usually works fine. I also use Cylindrical and Perspective. Next, click on the Use tab, select Folders then click on Browse.

⑧ Click on the folder containing the images you want to stitch and they will appear in the Photomerge dialogue box. Click OK and let Photomerge perform its magic. This can take a few minutes, so put the kettle on and make yourself a cuppa!

⑨ By the time you're back at your computer the stitch should be complete. You may need to crop the edges to tidy it up. This is common if you don't use a Nodal Point bracket to eliminate parallax error (see panel) but nothing to worry about.

⑩ After saving the stitch and flattening the layers (Layer>Flatten Image), make any further adjustments until you're happy with the overall look of the image and remove any distracting elements with the Clone Stamp tool. Job done!

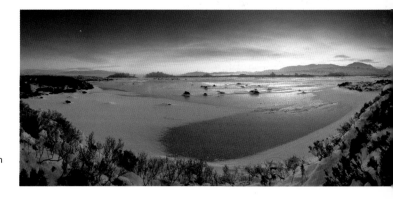

and use exactly the same exposure for each frame in the sequence. In contrasty light it may mean that some parts of the panorama are underexposed and others overexposed, but if you want a seamless end result you must keep the exposure consistent.

Don't use a polarizing filter when shooting sequences of images to stitch – polarization will vary on each image and you'll end-up with a weird, wavy effect in the sky as it goes from light to dark to light to dark. It's also a good idea to set the camera's white balance to Daylight rather than using AWB (Auto White Balance) as

you may find that in AWB, the white balance changes from image to image when shooting in low light so the sequence will have inconsistent colours. If you shoot in RAW, this can be corrected when you batch process the files as you can synchronize all changes so they're applied to every file in the sequence. However, if you do it in-camera it gives you less to think about later.

Finally, make sure you overlap each image by at least 30 per cent so that the stitching software can find a convenient path through each pair of images and blend them seamlessly.

HDR AND EXPOSURE FUSION

No matter how clever technology gets, there is still one major obstacle that photographers have to face – contrast. The latest digital sensors may be good, but the brightness range that they can record successfully is still only 5–6 stops. Once contrast goes beyond that, which is often the case when shooting night and low-light subjects, something has to give – either you expose for the highlights and let the shadows 'block-up' or you expose for the shadows and let the highlights 'blow out'. The latter option can work well creatively as it produces atmospheric, dream-like images, but on the whole when using a digital camera you should avoid blowing the highlights if optimum image quality is required.

Back in the days of film there was no way of getting around high contrast – you simply had to accept the limitation imposed by the film and do the best you could. Fortunately, with digital it doesn't have to be that way because it's possible to combine images of the same scene or subject shot at different exposures and increase the brightness range of the final composite. The result is that no matter how contrasty the original scene was, you can still produce an image that retains detail in both the shadows and the highlights.

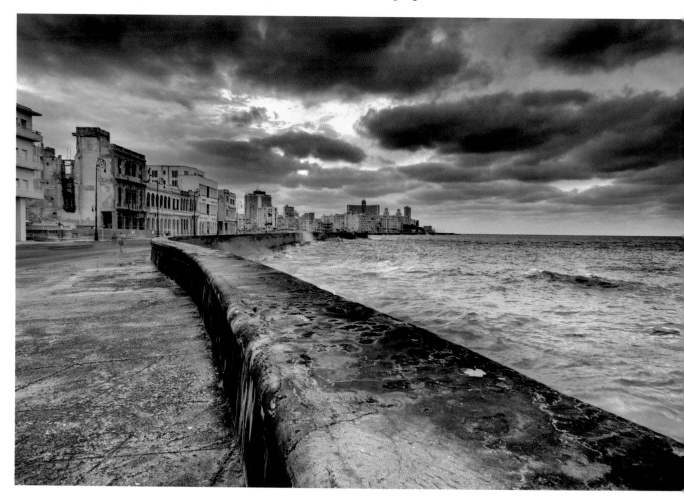

HIGH DYNAMIC RANGE

This post-production technique is commonly referred to as HDR – High Dynamic Range.

HDR is considered by many to be a gimmicky special effect that produces unnatural images, so it tends to have a poor reputation among serious photographers. There is no doubting that it can be taken a few steps too far – though I'm a great advocate of experimentation and see nothing wrong in trying something different. But that's down to the individual – it doesn't have to be over-the-top, and when used in a subtle way, HDR can solve the common problem of high contrast but also produce a realistic end product. If realism is what you want.

MULTIPLE IMAGES

There are two ways to generate the images for an HDR merge – you can either shoot a series of frames at different exposures or take one RAW file and process it several times, adjusting the exposure for each one.

You may be slightly confused by the latter option, but a single RAW file actually contains far more data that you can use in a single image so it does give you the option to bracket a range of exposures from it then merge them to increase the dynamic range of the final composite image. It's actually a great technique to use if there's any movement in the subject or scene you shoot. I often use it to for portraits shot in low light as it's difficult to take a sequence of images of a person without there being some movement between frames – even if it's just the blinking of an eye. The downside of generating source images from a single RAW file is that there will be more noise evident, and the effect is pseudo rather than true. If you decide to photograph a static scene with the HDR treatment in mind, you're better off mounting your camera on a tripod and shooting a sequence of images that can be merged later.

◁ The Malecon, Havana, Cuba

This is a classic HDR effect. Just look at the amount of detail that has been resolved in the single, final image – you can clearly see the texture in surface of the sea and the concrete of the sea wall, which has a wonderful 3D quality. Meanwhile, the drama in the stormy sky has been retained along with the rich colours in the buildings. The only way you can create this kind of effect is by shooting a sequence of RAW files to capture a broad dynamic range, then combine the images using suitable software – in this case Photomatix Pro.
CANON EOS 1DS MKIII, 17–40MM ZOOM, TRIPOD, 1/4SEC, 1/8SEC, 1/15SEC, 1/30SEC, 1/60SEC AT F/11.3, ISO100

The exposure increments you use are down to personal choice and how contrasty the scene is. As a minimum, shoot three frames at metered, +2 stops and -2 stops – use your camera's Auto Exposure Bracketing (AEB) to save time, or the exposure compensation facility. I tend to shoot -2, -1, metered, +1 and +2 stops, though if the scene is very contrasty, such as an interior lit only by windowlight, I may bracket from -3 to +3 stops in full stop increments so I end up with seven images to combine.

Once you're back at your computer, all you do then is download the RAW files, open up your HDR software and leave it to do all the hard work.

STEP-BY-STEP TO HDR

Recent versions of Adobe Photoshop have an HDR option – File>Auto>Merge to HDR. However, I never found it to be particularly effective and instead prefer to use a third party application known as Photomatix Pro (see www.hdrsoft.com), which tends to be the first choice of HDR fans as it's quick and easy to use, but highly effective and controllable. If you want the final image to appear reasonably realistic you can, but equally, if you want to create a fantasy effect you can do that too.
Here's a step-by-step to creating an HDR image using Photomatix Pro version 4.0.2:

① Download the RAW files to your computer then launch Photomatix and click on Load Bracketed Photos at the top of the Workflow Shortcuts box.

② Drag and drop the files you want to combine into the next box that appears, or use the Browse option to find and select the relevant files. Click Reprocess.

⑤ Experiment with the sliders and see how they change the image. You can either go for realistic or weird and wonderful. When you're done, click Process.

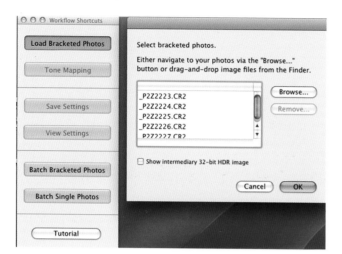

③ The time it takes to combine the images depends on the number of bracketed images you've selected – in this case, with five images, it took around 40 seconds.

④ Once they've been combined, the composite image appears along with a toolbox and lots of sample images created using presets within Photomatix Pro.

⑥ The latest version of Photomatix Pro comes with lots of presets. By clicking on one of them from the strip below the main preview images you can see the effect.

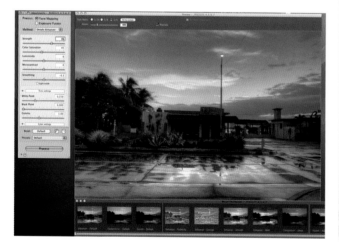

⑦ Once the Tone Mapping has been applied to the image, save it as a 16-bit Tiff file, re-name it and choose a location where it can be saved to.

⑧ You can then open the HDR image in Photoshop like any other and apply addition adjustments if required – in this case I tweaked Curves and saved.

Punta Gorda, Cienfuegos, Cuba
Here's the final HDR image, with detail retained everywhere from dark shadows to bright highlights – and it looks realistic! The five source images show just how contrasty the original scene was – with the sky correctly exposed the buildings and trees are grossly underexposed while exposing to show detail in the buildings resulted in a totally washed-out sky. The only option was to shoot a sequence of images from -2 stop to +2 stops and combine them using Photomatix Pro software.
CANON EOS 1DS MKIII, 24–70MM ZOOM, TRIPOD, 0.4SEC, 1/5SEC, 1/10SEC, 1/20SEC, 1/40SEC AT F/8, ISO200

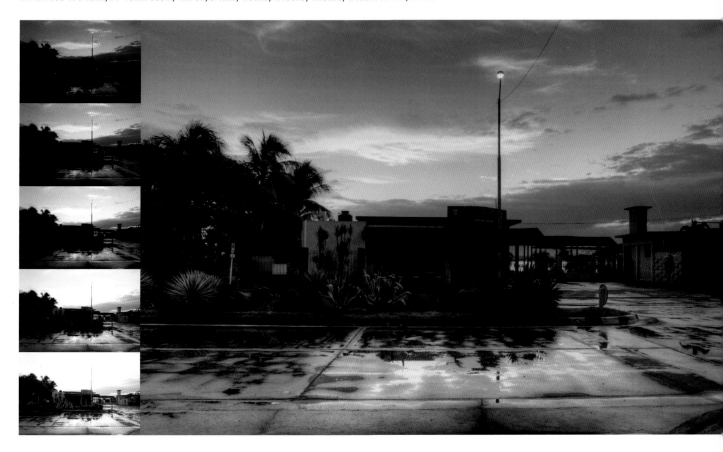

EXPOSURE FUSION

If HDR seems too wacky for your liking, or you simply can't get the look you're after, exposure fusion may be the answer. Exposure fusion is a very close cousin of HDR but, whereas HDR enhances detail, fusion is more basic and aims to take the correctly exposed sections from a series of bracketed frames and combine them to give a realistic effect. It's about evening out the exposure, in other words, rather than retaining a huge range of detail.

Photomatix Pro software has an Exposure Fusion option and I started to experiment with it after becoming disillusioned with HDR itself. Often, I resort to combining a series of bracketed exposures when it's not convenient to use an ND grad filter to balance the contrast between the sky and foreground, and while HDR will do that, the tendency towards a rather unreal look can be counterproductive – solving one problem and introducing another. Exposure fusion is usually a more satisfactory solution and I now use it more often than HDR. In fact, if I find myself in a situation now where using an ND grad isn't giving me what I want I simply shoot a sequence of bracketed frames knowing I can deal with them later.

Given the choice, I prefer to get my images as close to completion as I can 'in camera', as it had to be with film, but if I can't then I will let modern technology offer a helping hand.

Controlling the sky

A good example of where exposure fusion comes in handy is when shooting urban landscapes, where often all you see is a 'V' of sky, with buildings rising up on either side of the frame to the top corners of the image. Use an ND grad to tone down the sky and you also end up darkening the tops of the buildings. At dawn or dusk, when contrast is very high, this can look very odd as a 0.9 ND grad is usually required to hold detail in the sky, but in doing so also darkens anything else it effects by three stops. It may be possible to select the darkened parts of the building during post-production and lighten them, but this rarely produces convincing results.

Cienfuegos, Cuba ▷ ▷
Although I could have tried to shoot this scene using a strong ND grad filter to control the sky, doing so would have caused underexposure of the tops of the buildings as they all break into the skyline. By shooting a bracketed sequence of images from -2 to +2 stops then merging them, I not only solved this problem but was able to reveal more detail and create an image that captures the scene as it appeared to the naked eye.
CANON EOS 1DS MKIII, 24–70MM ZOOM, TRIPOD, 5SECS, 2.5SECS, 1.3SECS, 1/2SEC, 1/4SEC AT F/11, ISO100

EXPOSURE FUSION - STEP-BY-STEP

① Mount your camera on a tripod, compose the scene and shoot a series of bracketed exposures - from -2 to +2 stops in full stop increments is usually enough, but in really contrasty situations you may need to bracket as wide as -3 to +3 stops.

② Download the RAW files to your computer and batch process the images in the sequence by clicking on Select All then assigning a name to the batch. Save the images as 16-bit Tiff files on your computer desktop.

③ Launch Photomatix Pro, drag and drop the set of Tiff files into the dialogue box and click OK. When the next window opens, check that Align Source Images, Reduce Noise and Reduce Chromatic Aberrations are selected then click Reprocess

④ Once the images have been merged and the preview image appears, click on Exposure Fusion in the control box to the left and make sure the 'Fusion - Adjusted' preset from the strip below it has been selected. This usually gives the best result.

⑥ When you're happy with the look of the image, click Process then, once processing is complete, go to File>Save As and then save the image as a 16-bit tiff file to your computer's desktop, re-naming it at the same time.

⑤ Try the other Fusion presets to see if they give a better result and experiment with the sliders in control box. Often the basic fused image looks flat so you may want to boost the contrast and colour a little.

⑦ Open the image in Photoshop and make any final changes. You may wish to adjust Levels and/or Curves, tweak the colours or, as I did here, crop the image to improve the composition. Once you're done, save your changes.

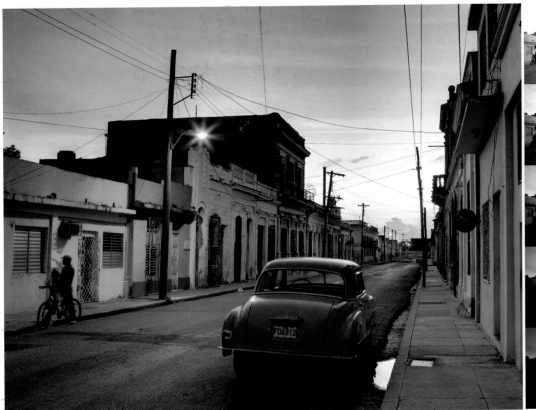

INDEX